The Horizon

The publisher gratefully acknowledges the generous support of the General Endowment Fund of the University of California Press Foundation.

The Horizon

A History of Our Infinite Longing

Didier Maleuvre

UNIVERSITY OF CALIFORNIA PRESS
Berkeley · Los Angeles · London

University of California Press, one of the most distin-
guished university presses in the United States, enriches
lives around the world by advancing scholarship in the
humanities, social sciences, and natural sciences. Its
activities are supported by the UC Press Foundation
and by philanthropic contributions from individuals
and institutions. For more information, visit www
.ucpress.edu.

University of California Press
Berkeley and Los Angeles, California

University of California Press, Ltd.
London, England

Library of Congress Cataloging-in-Publication Data

Maleuvre, Didier.
 The horizon : a history of our infinite longing /
Didier Maleuvre.
 p. cm.
 Includes bibliographical references and index.
 ISBN 978-0-520-26743-5 (cloth : acid-free paper)
 1. Civilization—History. 2. Horizon—Social
aspects—History. 3. Boundaries—Social aspects—
History. 4. Wonder—History. 5. Philosophy—
History. 6. Religion—History. 7. Art—History.
I. Title.
 CB151.M224 2011
 909—dc22
 2010021801

Manufactured in the United States of America

20 19 18 17 16 15 14 13 12 11
10 9 8 7 6 5 4 3 2 1

This book is printed on Natures Book, which contains
50% post-consumer waste and meets the minimum
requirements of ANSI/NISO Z39.48–1992 (R 1997)
(Permanence of Paper).

To Juan

I am tormented with an everlasting itch for things remote.
—Herman Melville

The longing for the infinite must always be a longing.
—Friedrich Schlegel

Only a poet could frame a language that could frame a world.
—Jeanette Winterson

Contents

Illustrations

Preface

This book invites the reader on a journey through the changing attitudes and ideas concerning the ultimate framework of existence in Western history. In this thematic journey, the horizon holds an image of human finitude—our limitedness in time, space, and comprehension. The horizon isn't an objective boundary; it isn't really the place where earth and sky weld shut. It marks not the factual edge of the world, but the shifting line where perception trails off.

A reflective phenomenon, a horizon bespeaks a beholder—the who, where, and when of its sighting. The "where" in particular: inasmuch as it limits perception, any horizon assumes the presence of a perceiver dwelling *within*, rather than above, the landscape. The horizon entails a ground-level immanent viewpoint on reality. It forbids the all-knowing proverbial eye in the sky. Not that the sky and what it symbolizes (the beyond, the unseen, the transcendent) is absent. On the contrary: the horizon arises from the action of casting an internal perspective on the faraway. Speaking theologically, it is a groundling's view of a world rife with transcendental openness.

I am aware that the word *history* in a book title raises great expectations. It implies authority, purpose, completion. One hardly writes a history without suggesting that it aims in a general direction, and that it marshals its twists and side stops into a tidy grand march. I must warn the reader that, so far as my intention goes, the present history features no such smooth narrative arc. For obvious reasons (the chief

of which is that it is an effect of perspective), the horizon defeats the attempt to march all the way through it. The horizon teases the thirst for resolution but never satisfies it. If there is a continuous theme throughout the following pages, it is the story of this unsatisfied drive. As a history of longing, of *dissatisfaction,* the form of this book is episodic and peripatetic—notwithstanding its chronological layout. In any case, I have not attempted anything so mercurial as a theory on the progress of history, and I take no part in the debate as to whether the engine of civilization is principally spiritual or material. More modestly I offer a series of episodes for which the forms of a religious emotion, a transcendental aspiration, provide the recurring motif.

It became clear early in this undertaking that I was facing a world-size storehouse of material and would trudge through a millennial span that would exhaust me before I exhausted it. For every artist, thinker, or achievement set forth in these chapters, the reader will adduce a myriad others. There is no end to which the volume could be enlarged. Aware of scaling a mountain, I therefore opted for a subterranean style of exploration, stopping at this or that niche of the great cultural archive, following a sometimes capricious course of leaps and twists that land the reader in medias res, face-to-face with a thinker in the solitude of his writing closet, an artist, a scientist, a fictional protagonist. The horizon appears to a concretely situated viewer; for this reason, I deemed it essential to maintain the sense of specific *circumstance* (literally, of being surrounded) in a situation. Each chapter springs from an anecdote, a location, a historical or fictional moment that is at once circumstantial and emblematic. These points of entry aren't there to suggest that the zeitgeist rolls itself up in one titular locale or person; they only mean that a crucial aspect of the age flashes up there and then. It is thus the small circuitry of history, not the royal road, that I invite the reader to explore and, in this or that corner, chance upon individuals who tell us in their own voice what *it is like* to behold their horizons. No doubt the selection of these moments is arbitrary. But this peripatetic license will seem forgivable if the reader considers that a vast, encyclopedic panorama would have been contradictory. I have listened here to the voice of individuals thrown into the muddle of existence. A fly-over synthesis of this blindsided engagement, even as it struggles to see past the horizon, would somehow miss the point.

With respect to scope, several reasons (besides competence and a reasonable fear of hubris) have urged me to confine this episodic history to

the Western tradition. Fascinating accounts of the ontological horizon exist in other civilizations—the Chinese, the Hindu, the Islamic—that parallel or anticipate the terms in which it is articulated in the West. But such is the strength and originality of these traditions that I scarcely could integrate them into this volume without either dismantling its unity or appending them as the side windows of a main building—giving rise to the woeful impression of a mother culture (the Western) for which neighboring civilizations provide the quaint side dish. By Western tradition, this book designates the cultural mindset born of the split rootstock of the Judaic and Hellenic civilizations, whose history roughly embraces the western dominions of the ancient Roman Empire and, more recently, portions of the American continent. Naturally neither ancient Israel nor Hellenic Greece sprang ex nihilo, and the first two chapters establish their foundations in the Egyptian and Mesopotamian parent civilizations. Among cultures that have fed the Western metaphysical imagination, no doubt this book could have widened its own horizon by deepening a dialogue with rabbinical Judaism, the Quran, or Sufi traditions. The downfall of focus is limitation, just as the risk of ecumenism is dilution. Between these pitfalls, I offer here an ongoing horizon of research, not a canon, which I trust others will be inspired to enlarge.

A word on comparable studies that, ranging over the same scholarly turf, have also inspired me to assay my own steps. Besides the raft of books that I prospected for factual knowledge, three clusters, encountered at various stages of my exploration, stand out that helped chart its course.

My first inspiration is a tableful of studies from an era of criticism and scholarship now ages away from our academic mindset: one has perhaps come across these well-worn, yellowed volumes on the less-visited philosophy shelves of the library, volumes with sonorous titles like "Man's Place in the Cosmos," "The Self and the Universe," "Philosophy of Man and the Universe," "Freedom and Nature," "Form and Soul," or "Cosmos and Psyche." Their titles hark back to an old-world academe that passionately dabbled in Jungian metaphysics, Continental existentialism, and religious humanism. Today these books are likely to earn a smirk from the doctoral student on his way to the Bourdieu or Zizek stack shelves. They do not square with the current temper in the humanities, which has grown rather technical-minded, juggles specialized idioms, and looks askance at plain prose and universal values. Universality is,

piquantly enough, a point of contention in universities, in part because it is the academe's mission to ruffle conventional wisdom. Titles such as "Man and the Universe" or "The Self in the Cosmos" invites the skeptical questions: *Which* man? *Which* universe? *Whose* idea of the cosmos? The motley of cultures, languages, traditions, and geographies inhibits saying anything universal about such plaster effigies as *man* or *reality* or *truth*. The humanities today tend to avoid big questions and prefer the social to the cosmic.

I propose neither to slay this Goliath nor to resuscitate donnish humanism. Nevertheless, such as they are, these dusty volumes hold a reminder still worth heeding: it is part of the humanities' mission to play our academic reflections against the large why and wherefore of existence. What eludes thought, and not just what furnishes its contents, should focus the examined life: the fraying edge where—shadowed by the unknown, death, the cosmic silence—human knowledge reflects on its ultimate value and purpose. Granted that the human world is not *man* but countless men and women from myriad places and ages: how have these men and women expressed their existence in relation to what is not them but surrounds them completely, whether we call it universe, nature, God, or Being? Can a story be told, starting humbly within our Western horizon, of the way in which culture stays in dialogue with the transcendent? How do we survive without discoursing with ultimate meaning? What remains of us when we sever contact with what we cannot know—with, as the philosopher Theodor Adorno put it, "the extremity that eludes the concept"? It is by way of working out an answer to these queries, and to encourage us to reengage with the broad meaning of existence, that the present study owes its first, faint spark of an idea.[1]

This existential (as opposed to airlessly theoretical) approach necessitated a verbal adjustment. Wishing to address not just the academic expert (either in others or in myself) but mortal intelligence in everyone, I felt it crucial to adopt creative exploration rather than abstract disquisition as my lingua franca: the very language in which we normally voice our thoughts about birth, life, suffering, death. There are times and places to trot out the *cogito* or *dasein* or the mysteries of the triune God. However, the time when a child is born, when a relative faces terminal illness, or when a friend is heart-broken isn't likely to be one of those moments. And the task of the humanities is also to help us articulate these expressions in the light of what ultimately matters. I remember the story of an eminent quantum physicist telling

his graduate students that, unless they could explain their theories to, say, their taxi driver, there was a good chance those theories were false. Maybe he overstated the case; but the point is worth considering, particularly by those of us humanists, whose professional mandate is to make sense of things human *to* human beings. Part of my work here has been to translate ideas, which by professional default occurred to me in the dialect of academic criticism, into a hospitable mother tongue. Happily, this exercise did have the effect of treating many an idea to the paring knife of logic and commonsense. Keeping my imaginary taxi driver in mind and suffering him to ask, "Just what exactly do you *mean?*" at every turn helped produce what I hope are clear and, above all, meaningful ideas—ideas that speak to the mortal soul in us, be it religious, skeptical, or atheist.

Now, with respect to monographs with which mine can be understood to maintain an explicit dialogue, two stand out. The first is Alexandre Koyré's *From the Closed World to the Infinite Universe* (1968). This work remains one of the most thoughtful studies on modern cosmological thinking, the first of its kind to weave a historical narrative out of the various scientific and philosophical ontologies of the period between the fourteenth and the early eighteenth century. Expectedly, it touches on many of the figures discussed in the middle section of this volume. In fact my narrative of a *materially* expanding worldview does not differ in a fundamental way from Koyré's. Yet there are substantive differences. First, obviously, is one of scope: Koyré restricts his inquiry to the pivotal shift from medieval scholasticism to the scientific method between 1300 and 1700. Within this period he focuses on the barefaced *concept* of infinity as discussed by scholiasts, scientists, and philosophers. His book doesn't enlarge on the religious, moral, emotional, or aesthetic resonance of these explorations. It does not enter into the lived content of worldviews, their ways of being inhabited by feeling and thinking persons. In Koyré, the shape of the world begins and ends in the philosopher's head and doesn't affect the ground on which he sets foot, nor the landscape he gazes upon, nor his own mortal horizon. Which, by contrast, are the experiences I have sought to make sensuously and sensitively relevant. In the end, Koyré's interest in concepts really makes his book into a study on infinity; mine—this is no small difference—forges on at the ground level, existential experience of finitude. And at this ground level, things indeed look quite different. For if it is correct to say that, scientifically and cosmologically, modernity is a journey from the closed world to the infinite universe (Koyré's thesis), at the moral and aesthetic level, modernity

takes the reverse trip from infinity to finity, and from transcendence to immanence. The historical periods of my book (late Gothic, Renaissance, and Baroque, or chapters 12 to 15) that chronologically overlap with Koyré's argue in fact that the modern "look of life" springs from this clash of the outbound world of science with the inbound modern soul.

Closer to my commitment to a phenomenological immanence is Edward Casey's *The Fate of Place: A Philosophical History* (1998). Faithful to Husserl's and Heidegger's call to *localize* metaphysics, Casey writes a philosophical history of cosmological speculation that gives pride of place to place, or the sense of physically being situated. Cosmology, he argues, is first and foremost topology; cosmogenesis begins with a topogenesis. A vision of the whole entails either a place to put it in or a place from which to see it. My approach—critical, literary, aesthetic—assumes a similarly phenomenological sensibility, but differs from Casey's interest in two essential aspects. Unlike Casey's, this study extends beyond philosophical texts. No doubt my approach is philosophical, but its philosophy doesn't stop at the reading of philosophical works. In fact it recommends that we step into the expressive world of artifacts—poems, stories, and artworks—that by nature offer a more *situated* and existential (rather than theoretical) experience.

Hence the role of works of creative imagination—narratives, fables, myths, poems, pictures, sculptures, edifices—in this journey. Perhaps more directly, or more empathically than theories, creative images draw a lived-in picture of a moment, a concrete problem, a tangible encounter. Given their central images, philosophy and religion feature prominently in this volume. But if this book's organizing images tell us anything, it is that neither religion nor philosophy holds the patent on eschatology, on the language of ultimacy. Wherever there have been human beings engaged in thoughtful activity, a general picture of life emerges. This thinking may take the form of a treatise but also of a song, a poem, a piece of sculpture or pottery, a work of architecture, or a scientific theorem. We think not just in ideas but also in forms. Whenever we speak of "lifespan" or "mortal limits" or "reach of knowledge," a picture, a metaphor, guides our thinking. Both religion and philosophy are woven of such artful metaphors.

The entanglement of religion, philosophy, and art underwrites the method adopted here, of pursuing an aesthetic reading of religious and philosophical expressions on the one hand, and a theological or religious-minded reading of artworks on the other—reading artworks as acts of religion, and religious texts as artistic constructs. I make no

claim for this being the definitive method, only an inlet worth exploring. One of its shortcomings is to pass over aspects of art, religion, and philosophy that have more to do with the material arrangement of society. The reader must consider that, running alongside this history of spiritual horizons, there exists a correlative history of these same horizons understood as political worldviews. A full account of these stoutly institutional social horizons would require other volumes, which I hope others will be inspired to write.

To return to the matter of situating my study among comparable works: a significant difference between my study and studies such as Casey's consists in the ultimately open-ended sense of reality I propose. Casey's notion of *world* tends to be self-contained and spiritually parochial. His central tenet is that we are placed inside an unsurpassable phenomenological horizon; my approach is to take seriously the image of horizon to show that, as *horizon,* this boundary is turned outward rather than inward.

What interests me about a place is its sense of leading elsewhere. Immanence without transcendence is a prison—and, I suspect, a conceptual contradiction. It is from the horizon—from an absolute and unanswerable objection to immanence—that we derive a sense of place. This is why the philosophy of space is in my view inseparable from a theology of finitude, and why there is no place in the following pages that doesn't feature its horizon. Thereto I now propose to set course.

Acknowledgments

I would like to thank the University of California, whose policy of sabbatical leave allowed this book to see the light of day. Many thanks also to my department colleagues for allowing my writing and thinking to flourish. Special thanks to my colleague Jon Snyder for his friendship and moral support. My gratitude to Jimmée Greco at UC Press for her final honing and tuning of the manuscript. Above all, I wish to thank my editor, Reed Malcolm, for his complete faith and support: I provided the sail, he the wind.

Introduction

> The sea-reach of the Thames stretched before us like the beginning of an interminable waterway. In the offing the sea and the sky were welded together without a joint. . . . A haze rested on the low shores that ran out to sea in vanishing flatness.

This image, the opening of Joseph Conrad's *Heart of Darkness,* is this book in a nutshell. A seafarer faces the open sea. Above is the sky, implacable; below is the fathomless deep. Nature appears in the primeval, geometric, naked fact of it: there is the earth and there is the sky. Nothing is hidden, nothing obfuscated. Yet the scene is profoundly mysterious. Its immensity kindles thoughts of ultimate concern. The human gaze spans the near and the far, the familiar and the remote. We become conscious of what Blaise Pascal might have called "the grandeur and misery" of human perception: we, voyagers, can dream of would-be places and faraway worlds; we intuit the infinite; yet all this infinity highlights is, in the end, the limit of human knowledge: in the end we see only as far as we *can* see. And the more we know how limitedly we see, the more our imagination ventures beyond the blurry boundary, and the more we realize how bound-in-a-nutshell we are.

This book offers a journey through the changing ideas and perceptions of the ultimate scope of human existence—where it goes, how much we can understand where to draw the line between the known and the unknowable. For this intellectual journey, the horizon provides the lodestar—a

mirage, a destination. Insubstantial yet insuperable, the horizon symbolizes the shifting frontline between knowledge and reality. It is an image of the elusive, slippery, onward character of our limitedness in time, space, and understanding. Like the end of existence or the outer edge of knowledge, the horizon at the far end of earth and sky does not come up and unveil itself there, earth and sky do not come lip to lip. Drawing not the empirical boundary of the world but the soft edge where perception fades off, the "offing" is really a trick of vision. Where it glimmers, sight beholds its own vanishing. This vanishing—the trace of human vision seeing itself out—is indeed what we mean by horizon.

Both knowledge and human life are shaped like horizons: knowledge ends not where objective reality waves a stop sign, but where it runs out of ideas. It is an inwardly drawn limit, which moves in time with the knower. It is a historical limit—in the dual sense that it follows historical development and also marks its outer reach. All historical knowledge pushes against a horizon, and the journey of history itself is both a conquest and a forced march toward the open unknown.

What goes for historical knowledge obtains also at the individual level. No one knows (save for the death-row inmate and the fastidious suicide) the hour of one's death. And to know it would certainly not cast any light on its dark side. The limit of death is drawn by a purblind artist: I know my life is to end, but the ending paradoxically brings no closure. This paradoxical experience of a limit without an end, of a finishing line that does not materialize, of being bounded by something that is not there—these are the nuances that the word *finitude* brings to the stone-faced lexicon of *end, boundary, borderline,* or *terminus.*

Horizon highlights the subjective, makeshift nature of perceived reality. It makes the viewer intensely conscious of his perception, his position, his own self. A horizon reveals a perceiver who knows, if he knows he is looking at a horizon and not, say, the Pillars of Hercules. The offing relates to the place he stands on. To perceive oneself perceiving is, inevitably, to look inward; it is to become conscious of the reach of human experience. Images of the horizon crystallize perennial preoccupations with the overlapping limits of knowledge and existence—and it is on this mixed zone of epistemology and eschatology that the present study finds its hunting ground.

Like all human constructs and apprehensions, "the shape of the world" is born, submits to the tribulations of time, and dies. Whereas the *contents* of reality are largely objective features, the boundaries of

reality are drawn by speculation—this is true whether we are loftily contemplating the cosmos, whose ultimate perimeter is unimaginable, or mapping our practical surroundings. Whether cosmic or domestic, the limits of reality are mental projections that reflect changing mores and beliefs. Armed with Iron Age assumptions, the Mesopotamian traveler of four thousand years ago could not have seen the same horizon that Magellan glimpsed, even if both voyagers stood on the same spot. Ways of thinking and believing create their own circumstances. We imagine worlds and then end up living in them—often becoming strangers to each other's horizon. Better than one horizon, in sum, we had better speak of horizons. Any cultural history of the horizon, even within the same theological and philosophical tradition, should expect to sail, not under a gloriously seamless sky, but across a foldout of jumbled and jagged horizons. Such is the creative plasticity of our worldviews that we cannot, and must not, expect uniformity and continuity.

Together with the latter two, we should expect to part with finality. The horizon is the child of curiosity—it is the inquiring, expectant, far-looking mind that beholds a horizon. To this extent, the horizon is wedded to the concept of transcendence, a concept that is not inherently high-flown or mystical but underpins everyday human knowledge. Outside religion, *transcendence* designates the second-guessing nature of human consciousness, the fact that, self-limiting as it is, knowledge is moved to wonder about the space beyond its perimeter. An animal—so it seems—doesn't draw a distinction between its perception and reality: what it knows and what exists are the same. Not so with human beings. Aware of the distinction between mental representations and their objects, we are in touch with the borderline of consciousness. This going-to-the-limit is innate in human intelligence. To it we owe, among other things, the idea of *truth,* which endeavors to line our conceptions toe-to-toe with what they stand for. A quixotic venture though this matchup may be, we should be sorry to give up trying. A world without that kind of transcendence would be oppressively hidebound.

Transcendence is the mental experience that consists in regarding the plane of known reality as open-ended. Now, the horizon beckons toward transcendence but does not fulfill it. A gateway it isn't. It points to finality but leaves the élan in mid-stride. In philosophical terms, we may say that the horizon is the creation of a diligently immanent observer possessed by an unrequited longing for the unseen. It is this love that keeps him gazing upward and outward; and it is perhaps the

love of his own gazing, and the humble acknowledgment of his finiteness, that keeps him from claiming to know or possess the other side—if an other side there be. Put otherwise, the horizon arises from a religious longing that chooses not to avail itself of the available answers—those by which the satisfied longing settles into dogma. The horizon is the theological mirage-object of a contradiction on two legs—the nonreligious, unknowing believer.

This ambivalent beholder—protagonist of the horizons of the following chapters—helps explain why the book, though steeped in religious and theological thought, is not primarily concerned with religion; or why, when it addresses religious texts, it is interested less in their dogmatic and sociopolitical strictures than in their wavering zones, their fragile, poetic self-construction, their self-doubt also. The social role of religion is curative and pastoral. Religion patrols the outlying areas of human knowledge and existence, with the ultimate aim of pacifying the region for its hopeful occupants.

On the whole, the mode of religion is declarative. The folk tales, myths, sayings, and parables of which it is made tell the believer what to know. Religion affirms that the basic existential questions are answerable even when, oddly, it declares the ordinary human mind unfit to comprehend them. Frequently, it urges us to adopt the revealed truths especially *because* they make no sense. However, to believe with complete certainty something we cannot actually know overreaches human finitude. We depart from the horizontal plane of knowledge and commune with celestial entities, call them Brahma, Yahweh, or Allah, in whose viewpoint it all makes sense. We believe that *they* know; we believe that when or if we abandon our human horizon, we will know too. In other words, we believe there is an exit from human knowledge, and we begin to see ourselves from the thither side of this opening, through God's eyes.

This is where the horizon works its creative cure. Although undeniably aglow with religious feeling, the horizon disappoints this radiant promise. No one can logically or practically travel through the horizon. An optical dream of transcendence, it actually plants us deep in immanence. The horizon holds in tension the antinomy of transcendence and immanence and gives a spatial image of their exquisite union *and* separation. Let either transcendence or immanence tip the balance to its own camp and the horizon vanishes. The horizon is just the forever-suspended eventuality that one may dominate the other.

As the substance of a book, so much thin air may be cause for intellectual unease. We are dealing with an unfinished and interminable balance between the known and the unknown. A tension rather than a synthesis, the infinite longing sits ill with certain ideas regarding historical progress and resolution. In fact, "a history of our infinite longing" is an oxymoron under a thin crust: by history we mean an onward narrative that knows where it is going, if not in actual fact, at least in the minds of those who bundle history into learned volumes. We *can* write episodes in the changing history of horizon gazing and transcendence sighting; we *cannot* round up this history in a nugget. The horizon itself forces us to be piecemeal rather than mercurial, analytic and not synthetic. The following chapters are a history of irresolution, of baited knowledge—a reason why I have preferred the soft-spoken voice of poets or, when listening to the seers and theologians, to heed the poet in them. It is an open question whether religions go through a historic journey of progressive clarification; but it is quite clear art and poetry obey no such progress, and no critic would get very far on the thesis that, say, T. S. Eliot solves or resolves the formal and spiritual disquiet of *Gilgamesh*. Art, like religion, is moved by transcendence; it is human expression probing the limits of the utterable. Unlike religion, it is passionately committed to the immanent plane. To the convinced religionist, the horizon holds majesty but no mystery; to the materialist, it holds mystery (one can always travel farther and gain more) but no majesty. It is to the poet-philosopher, the hoping skeptic, that the horizon really and beautifully shimmers.

A word about philosophy, which, next to religion and art, lays down the third layer of our overlapping approach. On the face of it, the words *transcendence* and *philosophy* seem like natural-born strangers. The philosopher's job, ever since Socrates politely asked the gods to stay out of the human conversation, is to articulate sensible thoughts about what we can observe and verify. Philosophy does not telegraph its answers from heaven. It plods on at ground level, framing reasonable questions about what we usefully know and perceive. Our knowledge never transcends space-time; neither, therefore, should our explanations, or the method we use to sort them out. In this respect, philosophy is faithful to the horizon of human knowledge.

Being faithful to this horizon, however, need not imply the absence of wonder. One can agree that philosophy's job is to discourage us from articulating worldviews from a standpoint no human being can occupy;

but, consistent with this view, one can also sensibly argue that contemplating the bounded horizontality of human knowledge urges us to ponder our finitude, even to suffer its exiguity. Only through great intellectual self-mutilation can we suppress wondering about what we cannot know. After all, it is knowledge itself that creates nonknowledge, and we would have to give up knowledge to stop marveling at our finitude. To draw the limits of thought, as philosophy does, is to invite us to peek beyond. Let those realms beyond human intelligence be undiscoverable: still we don't just give up the intuition that their undiscoverableness is *our* business. "The supreme paradox of all thought," the nineteenth-century philosopher Søren Kierkegaard wrote, "is the attempt to discover something that thought cannot think."[1] The human experience would be the poorer for not plying this seam of contradiction—which admits that philosophy, any more than art or religion, is expected to resolve the horizon. Philosophy too walks the tightrope between immanence and transcendence.

Given this irresolution and the corresponding lack of historical momentum, we need to explain why the following chapters fall into a chronology of civilizational ages (the Archaic, the Philosophical, the Theological, the Scientific, the Subjective, and the Mathematical). These "ages" are too broad to carry real scientific authority, and no such claim is made here on their behalf. It would be fatuous to suppose that the people of one epoch thought "archaically" but not "philosophically" or "philosophically" but not "theologically," or that as soon as scientific materialism and humanism took over the zeitgeist, the old archaic theological questions simply went to pasture. In many ways, these ages live concurrently in the moral life of Western civilization. For instance there is no reason why, had I veered into one path rather than the other, the Theological Age section could not have come ahead of its contemporary, the Philosophical Age.

By way of clarification, *archaic* as used here means what comes first in the story (from the Greek *arkhç*, "beginning") rather than "antiquated." The Philosophical Age designates the awakening of a broad cosmic awareness of the oneness of nature, of a single universal horizon arching over all there is. The Theological Age derives certain monotheistic assumptions from the Philosophical Age, and it is through these assumptions that religion became, at least in the West, the main and sometimes jealously guarded way of imagining the boundaries of knowledge and experience. Continuous with this age, there arose a more rationalistic method of organizing the known world along mechanical

templates, the Scientific Age, which captures a mindset that by and large lasts into our own age. The Subjective Age and the Mathematical Age must be therefore regarded as tributaries of this scientific current: the Subjective Age expresses the high-flown, enthusiastic affirmation of the human center of scientific knowledge; the Mathematical Age recounts a manifold campaign to kick this human center from knowledge, to establish an immanence without man which, in the end, begets a religious renaissance by the back way.

Here, then, are the main segments of what is, and is not, a narrative: it is a narrative inasmuch as it contains definite, overlayered periods and episodes; and it is not a narrative because it stays put, because we at the end are no farther or closer to seeing our way through the questions that initiated its quest: Where do we come from? What are we? Where are we going? To which questions we might also add the Kantian "How much can we know?" It is, I realize, no small contradiction, indeed a possible sign of a misconstrued vocation, to proffer a study on a topic about which, ultimately, we know nothing—let alone to construct the "history" of a striving that stays put.

To answer this paradox, I must doff the mantle of scholar, under which this book is ostensibly written, and claim the words whose spirit guided my endeavor. Thus speaks Socrates in the *Theaetetus* on the greatness and poverty of knowledge: "Like the midwives, I am barren, and the reproach which is often made against me, that I ask questions of others and have not the wit to answer them myself, is very just."[2] I would be betraying my topic if the history of an insoluble tension claimed the certainty that is not found in philosophical inquiry. All we can expect of art and philosophy is to ask reasonable questions. A history of questions is therefore a journey through puzzlement. This is especially true of a history of sightings of the horizon, which outruns the human gaze. A history of longing need not proclaim the futility of human knowledge. As Socrates saw it, wisdom consists less in what one knows than in the capacity to venture questions. Human intelligence is a going forth: whereto, it does not know. If this book succeeds in conveying the thrill and urgency and necessity of this adventure—if in its modest way it helps keep alive the zeal and venture of its protagonists—then it will, so I trust, prove a friend to its reader.

The Archaic Age

Permanence

Egypt, 2500 B.C.E.

In the beginning was no beginning, and no end.

The first record of an enduring, self-possessed artistic and religious tradition arises out of ancient Egypt. It is there we find the first archeological and textual evidence of a single people possessed by an overriding idea that builds over a continuous historical period starting, in most estimates, around the fourth millennium B.C.E. Notwithstanding a short interlude in the thirteenth century B.C.E. during King Akhenaten's reign, this record remains constant in outlook and, in its basic political and religious lineaments, remarkably of the same cut. Egypt's fertile Nile Valley alone is not responsible for this longevity; all civilizations seek to endure, but Egypt really made an institution and a cult out of permanence. This idea seems to have channeled all of Egypt's cultural energy, religious imagination, and institutions. To the Egyptian mind, there seemed to lurk no greater evil than change—particularly the change that most rattles human existence: death.

One historian of religion has remarked that to expect a coherent Egyptian theology was like looking for a tree where there is only inextricable brush.[1] This historian nevertheless distinguishes three overlapping spheres of cultic activities in ancient Egypt: one devoted to creation (the sun), another to procreation (cattle-headed gods), and the last to resurrection (the earth). All three assume the desirability of permanence, cyclical stability, and the absence of progress. No other culture has quite matched the ancient Egyptians in so single-mindedly

mobilizing against change.[2] *Neheh* and *djet* summarize the dual aspect of Egyptian thinking on time: the former designates cyclical ritual time; the latter, permanence. Both sturdily stand against change. If it is true that full-fledged civilization began with Egypt, then civilization is synonymous with hatred of death and, therefore, denial of nature. The ancient Egyptian liturgy, hymns, and festivals all have but this one aim: to ensure that life goes on. Thus the hymns, incantations, and mortuary spells collected in the *Egyptian Book of the Dead:* "The Chapter of Not Dying a Second Time in Khert-Neter"; "The Chapter of Not Perishing and of Being Alive in Khert-Neter"; "The Chapter of Not Rotting in Khert-Neter"; "The Chapter of Not Letting the Heart-Soul of a Man Be Snatched Away in Khert-Neter." Nothing, it seems, was so odious to the Egyptian mind as the idea of giving back what is apportioned at birth. Only one outcome could satisfy it: immortality—the burden of which (in its exitless boredom) never seemed to have troubled the ancient Egyptians. Is a life everlasting more meaningful than a mortal one? There is no sign that the Egyptians ever weighed this question. Having little sense of existential duration (or finding the idea redolent of mortal unfinished business), the Egyptian imagination did not contemplate what it must feel like to endure infinite time. The terror of death blinded the Egyptian to any other concern. "I shall not decay, I shall not rot, I shall have my being," reads the papyrus of Ani.[3] This incantation of the *Book of the Dead* is not prayer or entreaty but prognostication. It is faith that time ultimately can stand still, poised like the capstone on the obelisk where all cardinal points terminate in a dead point. The only worthwhile equilibrium is changeless.

This fixation on permanence appears to be the oldest prevailing feature of the Egyptian civilization. Excavations of burial chambers from the predynastic period, around the fifth millennium B.C.E., show early evidence of mummies being buried with food vases, flint tools, knives, chisels, and sundry crockery that the dead were expected to need in the afterlife. Death indefinitely prolonged life: everything would go on as it always did, in a place that scribes of the Old Kingdom (2630–2134 B.C.E.) described as the "Beautiful West": a place not above nor beneath nor apart from the earth, but somewhere to the west, a short boat ride away. Not for the Egyptian the uncrossable ontological gulf between life and death. "Rise up, O Teti" intones a prayer to the dead king Pepi. "Take your head, Collect your bones, Gather your limbs, Shake the earth from your flesh"; "Rise up, O Teti, you shall not die."[4] Everything, from embalming to food offerings, denied that any irreparable alteration

could occur. Preempting decomposition was a way of beating death to the mark: to humanize death before nature had its awful way with the body. The three-millennium-long tradition of apothecary burial rites, like the ceremony of the Opening of the Mouth, suggests the prospect of a rather domestic, physical afterlife. And where death promised ever more of the same, the same smacked ever more of death. A considerable share of life's activities went to planning death—the only sort of life insurance that mattered to the pharaoh or priest or plenipotentiary, who, not uncommonly, began drawing plans for his tomb whilst still a teen. Living and funeral planning were hand-in-glove through the span of an Egyptian's life. Where death was one way of being alive, being alive was also a death-in-waiting. Whichever the case, the expression "being dead" was not the oxymoron it ought to be.

This simultaneous coexistence of life and death brings us before the most admired of Egyptian gods, Osiris. According to the mythology, Osiris had once died, had gone to sit with the Lords of Eternity (the dead), and had managed to experience, and enjoy, being dead. As historian Henri Frankfort puts it, Osiris "was not a dying god but—if the paradox be permitted—a dead god."[5] Rather than return to life (why go back to square one?), Osiris cleverly decided to live out death, to *be* dead. One advantage of this position is that, unlike the resurrected, the living dead never have to endure dying again. And it is to Osiris's life-in-death that the Egyptian appealed when preparing his tomb. The more lavish sepulchers featured dining quarters, latrines, washbasins—any amenity the Egyptian royal might be expected to need in eternity. Death was domesticated, defanged, washed of its pale terror. The ubiquitous mausoleums did not house the nothingness of death at all, but its concrete somethingness. The monumental effort to which Egyptian civilization committed its spiritual and physical resources, its wealth, its public works for three millennia had but this one main: to make death tangible, to make it into *something*. It was to impose the conviction that death simply was *not*.

Of course, the Egyptian denial of death really magnified an attitude common to most human societies. Historians trace the first unambiguous evidence of burial sites to between 120,000 and 90,000 years ago—as early as the first signs of civilization.[6] Burial reveals that a population has begun to give thought to the afterlife, and therefore draws an elementary intellectual distinction between matter and mind, between nature and humanity. It shows man wishing to escape the natural cycle of annihilation. Thus the earliest stirrings of civilization seem to coincide with

the moral elevation of man over nature. Often the gods of the primeval religions were deceased relatives and fellow tribesmen—ancestors who, perhaps, had conquered death and, by doing so, asserted their humanity. This suggests that, at some point in our development, being human became synonymous with being immortal. It is therefore reasonable to suppose that humankind started with the denial of its mortal condition, or that such a denial was a cognate feature of incipient civilization. And it is the case that, in a historical sense, collective scale, all civilizations take an implicit oath to endure, which means that all civilizations, in the end, build on a hopeless promise.

In ancient Egypt, the denial of finitude was not just an aspect of civilization but its driving force, its unifying center, its fundamental outlook. It conditioned its understanding of man, nature, the heavens, and the gods. Though its mythology alludes to a cosmic beginning (i.e., the earthly mount surfacing out of watery mass), Egypt did not generally conceive of the world as budding out of a primal seed. The ancient Egyptian preferred to regard creation as a daily occurrence, hence cyclical and timeless, that coincided with sunrise.[7] The sense that something begins contains the admission that it must end. In contrast, by regarding creation as continuous, the Egyptians could thereby deny its temporality. Accordingly the gods were praised not for spawning the world, but for begetting and maintaining it daily. "Like Re when he rises in lightland, He places light above the darkness, He lights the shade with his plumes. He floods the Two Lands like Aten at dawn," sings the "Great Hymn to Osiris."[8] The god is a reliable worker; therein lies his godliness. Witness this hymn to Napi, the personified divine Nile: "Lawful, timely he comes forth, Filling Egypt South and North."[9] A unique papyrus dating from the Middle Kingdom recounts the "Tale of the Shipwrecked Sailor," a proto-Odysseus who washes on the shore of a desert island belonging to a god. But it is not a horny, cantankerous enchanter the sailor meets, but an obliging tourist-bureau god who informs the hapless mariner where and when and how, down to the precise time, a rescuing ship will drop anchor at the island: and lo!, the rescue mission arrives exactly at the appointed time, true to this bellwether god's word. Timely to a fault, the gods ensure the future so fully that when it happens, it hardly feels like an occurrence at all.

A comparison with ancient Sumer or Athenian Greece highlights this Egyptian obsession with predictability and stasis. Babylonian religion accepted the ever-pending possibility of disorder. Destruction, a cataclysmic storm, a flood kept the gods of Sumer always in a fighting state

of alert.[10] Variety, contradiction, changefulness, and complexity pull at the lives of these busy Sumerian gods and goddesses.[11] The Greeks too accepted change and death as elements of the cosmic balance. Even their gods were born and suffered reversals of fortune. Gaia and Uranus sprang from Chaos; Kronos castrated his father; Zeus was issued of Gaia. The eighth-century B.C.E. poet Hesiod's *Theogony* swarms with gods who all suffer the nicks and wounds of fortune. In sum, ancient Babylon and Greece had propitiatory religions mindful of the fleeting world, eclipses, earthquakes, floods, rainbows—tokens of natural evanescence that, contemptible as all transience is to the Egyptian mind, the priests of Osiris pretended not to notice. Fixity did not have in Babylon and Greece the talismanic power it possessed in Egypt. What lasted or recurred (the diurnal cycle, sunrise and sunset, the Nile's yearly flood): this alone was true for the Egyptian; it alone was excellent, and only it deserved to be called *nature*. Osiris, lord of the underworld, had once been the fertile corn god of the yearly crop.[12] Thus the begetter god also oversaw the career of the dead. "Lord of eternity" is the title that most frequently tags the names of Re, Osiris, and Amun. The ritual interment of the grain god Osiris, so like a funeral, doubled as a fertility rite.[13] The corn seed entrusted to the earth contained the power of death, which is the power of rebirth and the triumph of permanence. The corn will grow not of its own vital accord, but because it packs the concentrated force of eternity. The price of a secure destiny, it seems, was to confuse life with the everlasting predictability of death. If to die was to be born, then was not to be born a kind of birth into death?

Evidently this assimilation of life and death comes at a price. Existence mutates into the administration of stasis: personal life and social affairs become subsidiaries of the afterlife. Osiris held eternal office with the help of forty-two councilors, the number of Egypt's administrative districts.[14] Is it society that projects the afterlife, or does death project society? Where the political life reaches into eternity, eternity returns the compliment by clasping society in its deadly embrace. What is, has always been, and shall always be: the life of the mind makes a god out of rigidity. This may be why, despite its bloated class of priests, scribes, and administrators, the Egyptian thanatocracy showed little inclination to innovate in intellectual matters. It is the nimble Greeks who gave birth to philosophy, the mode of thinking that changes its mind, second-guesses itself, and accepts the dialectic drift of truth. By contrast, the hieratic Egyptian mind mostly cleaved to ritual and mathematics—the language of changeless axioms.

The ancient Egyptians so hated life's termination, and so blindly denied it, that they mimicked death to fool its coming. A personality that imitates rigor mortis suffers little change when it dies. The head that tops Egyptian statuary is really a death mask. Expectation, longing, hope: these moods that we in modern times regard as essential to human expression are absent from the Egyptian physiognomy. What they carved in rock is the hard stare of compulsive serenity, of a mind set in foregone conclusions. Longing tends to stretch the boundaries of reality; it opens up prospects, possibilities, contingencies. So long as one hopes, one puts oneself at the mercy of the future. He who hopes also admits his finitude in time (where he confesses lacking what may come to fulfill him) and in space (where his knowledge only sees so far). But this expecting mode is absent in Egyptian statuary, the faces and forms of which feature none of the muscular readiness of Greek figures. The latter wade in the stream of time, on the watch for the unforeseen, ready to contend. Whereas the Egyptian statue expects nothing from the world: its blank equanimity is not even the quiescence of stoic wisdom, but of a mind dead set against wonder.

Of course, forsaking hope brings a kind of tranquility: inure to what may come, we live in the present moment, familiar and protective. The temporal and the horizontal are kindred ideas (we think of duration as unfolding lengthwise, and we think of space in terms of the time it takes to cross it). To leave the temporal is also to exit the horizontal and stand in the vertical—a direct conduit between heaven and earth. Cultures that emphasize the changeless instinctively embrace an aesthetic expression dominated by the vertical style—the very style that by and large shapes Egypt's forms, its architecture, statuary, and script.

Here, too, Egypt seems to set a milestone. Prior to ancient Egypt, representations of the human form came predominantly in the guise of clay figurines, common to archeological grounds around the Mediterranean and Mesopotamia, which depict round, full-bodied figures. The curvy fertility goddesses, pregnant Venuses, and "fat ladies" that strew the sites of Neolithic settlements, glorify birth, the fruitful womb, the egg that begets life.[15] Early religious cults throughout the Levant and the North Atlantic likewise center on the goddess. The plump and the rotund prevail; the mood emphasizes earthly ease, the comfort of a sated or pregnant belly. But it is something strikingly lean and cerebral that emerges during the ancient Egyptian kingdoms. Religious worship shifts from the earth, from the mother goddess and the

bull gods (which, the historian of religion Mircea Eliade says, "united al the proto-historic religions of Europe, Africa and Asia"), and turns sharply skyward.[16] Osiris, who began as god of the crop, ends up the hierophant of a death cult. Not earthly fertility but the transcendental ether, the unreachable stars, sun, and moon, now magnetize the religious imagination—a shift we observe in all Iron Age religions where, frequently, the word *god* is a byword for *light* (Uranus originally symbolized the sky, and the Indian god Dyaus and the Greek Zeus descend from an ancestral sky god).[17] It is a tendency common to the religions of the post-Neolithic that their belief systems veer heavenward. Fertility and animal worship recede, while preoccupation with the afterlife, death, and the transcendental moves into the liturgy. In several ancient idioms, the verb *to die* is associated with the action of climbing a mountain, a ladder, a rope, a high road. In a world where the real abode is not the loamy earth but thin air, any self-respecting human life must culminate by some summit-climbing caper.

Yet no other ancient civilization emphasizes the vertical axis quite like the Egyptians. At no time is the architectural form or the sculptured body allowed to relax. The Egyptian figure almost always stands on its feet; it seldom reclines or crouches. It never eases into the pleasures of corporeal existence and never betrays the strains of being the two-legged upright animal. On frescoes depicting everyday life, it is more often shown bustling about, either building, tilling, harvesting, hunting, fishing, or plying a trade. The Egyptian is always at work building and erecting. Even death is no occasion for slacking off. The corpse is padded, propped up, cemented, even outfitted with metal sheaths and braces. Even when seated, the figure stands on guard. Sarcophagi were placed upright so the deceased would never sleep or mistake death for rest. Verticalness affirmed the Egyptian commitment to being homo erectus—a creature firmly possessed by the mission to tower over nature, its head close to the sun in the vicinity of the unchanging heaven.

In general, Egyptian art seldom embroiders or rhapsodizes on the pedestrian aspects of existence. Instead of life as it happens to be, ancient Egypt chooses life as it ought to be—life in the light of the supremely human will to escape nature. Its greatest artistic achievements are therefore ceremonial, and even when turning to mundane subjects, the Egyptian artist favors the typical action (often a trade) over the one-of-the-kind gesture. Anyone expecting the so-called autobiographical inscriptions on tombs of the Old Kingdom to rise to self-baring, soulful acts of inner exploration will be disappointed: the hieroglyphs reel

off the curriculum vitae roll call of honorable accomplishments.[18] The emphasis on typicality and officialdom explains why art in its modern understanding could never have sprung from the Egyptian mindset. An artwork that explores a personality (a character, the artist) and illuminates the contingent individual side of life was unknown in ancient Egypt. Its culture did not know enough of the inner subjective life—of what the Sumerians and Greeks knew as individual perspective and development—to produce genuinely expressive, self-searching forms. Greek and Roman statuary are not averse to the idiosyncratic touch, the hint of artisanal pride. Goading one another by displays of skill, the Greek craftsmen prodded art into taking chances. But one is hard put to make out any individual touch, any hint of mood or fancy, from the ancient Egyptian guildsman, who, admittedly, worked under strict priestly control. Egyptian artisans never seek to express how the world looked from their standpoint. The notion was, for all it seems, unthinkable. And only because it was inconceivable can we understand why stylistic evolution stalled during the three millennia of Egyptian civilization. No culture to date has so neutralized the incidental perspective; correspondingly, no full-grown society has ever been so content staying put.

Impersonality of expression stymies the development of immanent, horizontal experience. By definition a perspective takes up one position among others. The fact that I stand here logically admits the possibility of my having stood over there: any position is contingent. The Egyptian worldview, however, represented the world seen from no particular standpoint. This in part stems also from the mortuary function of Egypt's grandest frescoes and sculptures: the dead were their intended audience. *They* possessed the right perspective, which was to have none. And so it was perhaps through the eyes of the dead that the Egyptian sculptor or carver gazed at the world, through the ubiquitous Eye of Horus—the eye of the sun god Re, who sees universally and instantaneously without turning its head, for it has none, and commands the proverbial view from nowhere.

The fusion of divine vision and sun underscores the overlap between seeing and being in Egyptian cosmology. According to the liturgy, Re begets the world every morning by blinking his eye.[19] Whereas the modern mind tends to pair vision with phenomenon (appearance), ancient Egyptians linked vision primarily with ontology (being). To see is to shine, which is to give life. Appearance does not wedge into the process. Hence the matter-of-fact, non-illusionistic quality of Egyptian art. It is

hard to imagine an artistic tradition less given to optical whimsy. The carved or painted image never seeks to eclipse the masonry on which it hangs. Lines and colors do not fake volume. It is as though to tamper with vision was to tamper with life itself. Just as it is impossible for a thing to be and not be at once, so no object can be seen and not seen at once, or partially seen, or seen in dream. No figure hints at a hidden thither side. What is not seen lacks existence, and nonexistence is ferociously shunned by the Egyptian mind. Thus every object tends to appear in its ideal entirety: everything, in short, is seen in the light of its eternal idea rather than glancing aspect.

Egyptians represented less what they saw than what they *knew* was there: not human beings such as they are, in their less-than-perfect incidental and varying features, but human beings such as they ought to be. From there comes the stiff geometricness of Egyptian statuary: it is of a body, not shaped by the accidents of life but set at the zenith of young maturity, in the health and vigor of its essence. And like the idea of a pyramid, a triangle, a cone, or any geometric figure, the essence of human life must not be subject to mutation. This is why, over three millennia, Egypt managed to maintain one unchanging pattern of human figuration. From the statue of King Kafhra (2558–2532) to that of Ramses II (1279–1213), the formula is stunningly intact: the colossus sits erect, arms in armrest position on the thighs, face and eyes level with the horizon, body as rigid as the throne it models. The Egyptian word for *sculptor* was "he who keeps alive." But the condition of being kept alive, it seems, was to fit the geometric template. One must play dead to exist always; the price of eternity is to adjure initiative and activity. The enthroned king gazes straight on as though only one direction were available to him. Not once in three thousand years does the face turn to cast a sidelong glance—the one-off look that betrays surprise, wayward interest, the spark of wit: it never seeks an unexpected angle. The eye simply is not curious.

Emphasis on essence rather than appearance explains the odd distortions of natural perspective. When, say, representing a fishpond in a garden, the painter draws a full rectangle, such as the pond might appear to Re up in the sky. Likewise, in presenting the human body, the Egyptian artist delineates each anatomical part separately, after what he *knew* the object to be. The human torso has two arms: two arms, therefore, must be equally visible. Also, a foot is best seen from the insole, with the big toe upfront: both feet will therefore point in that direction, notwithstanding the ungainly contortion forced on the posture.[20] Profile painting stems

from the same principle: from full-on, facial features flatten and overlap; in profile, they jut out, like hieroglyphs, independently delineated from their living context. With the eye, however, painters hit a snag: seen in profile, the eye looks like a crushed oval. To remedy this injury, the artist drew the eye full-on, even on the profiled face. The rather fish-like result, to us, violates the standards of nature. But the natural was, to the Egyptian, what exists absolutely and inclusively—and a human body should not go about missing eyes and limbs just because the viewer has changed location. This denial of appearance puts paid to the idea of a spectator enmeshed in place and time. We must imagine the ancient Egyptian to look on the human figure as not dwelling in space, but absorbing space and time into itself. It was seen not at one moment, but in all moments. If it seems to lack momentum, it is because it has nowhere to move—reprieved from finite existence.

The same principle rules sculpture and architecture. An Egyptian statue, unlike its Greek counterpart, does not invite the viewer to pace around for fresh, interesting angles. There is only one right way to see it, and that is from the spot right before and below it. One must not believe, as one does footing around the *Victory of Samothrace* (Greece, third century B.C.E.), that new angles should add surprising facets. On the whole, there are no facets, "takes," or interpretive zones. From whichever point we look, the pyramid is perfectly pyramidal. Appearances will pass, but the idea of the equilateral triangle endures: by sticking as much as possible to the geometric form, architecture reduces the contingent, and it is no coincidence the pyramid, a funeral mound, enshrined a state of human life freed from accident. Geometry is abstraction triumphing over circumstance. All points on the pyramid's surface lead to the apex. Unlike a dome, which acknowledges the creaturely need for shelter, the pyramid tapers away from the ground, squeezing its own mass to nil. It is architecture dedicated to eliminating everything architecture stands for: the reality of habitat and humble earthly things. The pyramid is extension pared down to the capstone, to, in mathematical terms, the point. Open space allows contingency (where there is room, things can occur). Succinct to a fault, the apex makes room for itself only. The point, which Euclid called "that which has no part," knows no self-relation, longing, or tension. It is indeed its deadpan neutrality, its indifference, its nullity that Egyptian architecture covets, the zero of convergence where the structure (pyramid or obelisk) swallows itself up. A miracle of crushing, unanswerable simplicity.

Stability rules Egyptian architecture. Absent are those shapes (curves, domes, cupolas, vaults) that evoke ellipsis and motion—shapes that hint at an arc of development, a middle term between the horizontal and the vertical. Egyptian roofs and lintels almost always lie flat and at right angle with the wall. There is no compromise between up and across: neither yields to the other. Compromise suggests a willingness to adjust; it entails the relaxing of purpose, makes concessions to the input of nature. But to the Egyptian eye, compromise kowtows to contingency, and compromising architecture lacks confidence, admits incompleteness and impermanence. The Egyptian distaste for curves (see the ruler-drawn slats of its painted dramatis personae) proclaims the death of compromise, and with compromise, the obliquity of change, expectation, the tangent of possibility.

Averse to the idea of development and perspective as Egyptians were, it is a wonder the Egyptian mind should have ever cast an eye to the horizon. But puzzlingly, the horizon looms large over the literature of ancient Egypt—though we need understand that it is not a horizon proper, not a gateway to the unseen, but a sentry cordon that brackets off any inkling of escape. The Egyptian horizon is not where the world sinks away but where it snaps shut. It imparts universal containment. As Osiris proclaims in a hymn from the *Book of the Dead,* the god settles the horizon: "I have taken my seat in the horizon. I receive my offerings of propitiation upon my altars. I drink my fill of seth wine every evening. I come to those who are making rejoicings, and the gods who live in the horizon ascribe unto me praises, as the divine Spirit-body, the Lord of mortals."[21] The horizon is a seat, a temple, sometimes a city. "I have found for myself the boundary. I have found the frontier," says Osiris.[22] It is part of a god's workday to shore up boundaries. He ensures that the world is definite, thing-like. As ruler of the horizon, encompasser of the finite, girder of the sky, the horizon god *consolidates* the world. Whence the association of horizon with *rising* sun, flooding light, the end of dim uncertainty. Hymns and praises to Khepera, the sunrise god, significantly outnumber those to Teru, the sunset god. The horizon is a foundational milestone. Not for the Egyptian the poetry of vanishing points.

Perhaps such poetry—the mortal aesthetic of sunsets—is the indulgence of societies that have secured their means of survival, of people who, having mastered artificial lighting and crop timing, can face the long benighted winter with equanimity. Historically, sun-centered religions

correlate with the shift, roughly six thousand years ago, from hunter-forager to crop-gathering societies.[23] By the time northern Neolithic groups began erecting megaliths to coax the sun back from its winter solstice, they had completed their transition to an agrarian society. Agriculture, unlike hunting, depends for its life on a timely solar cycle. In such a society, the horizon is more likely to seem the fountainhead of life rather than its bittersweet exit. This is why, in agrarian Egypt, the supreme deity Re squats over the horizon. "How beautiful you are on the horizon of heaven. . . . Mighty king who lights the horizon, Glorious god within his shrine, lord of eternity in the midst of his skyship."[24] Far from a sinkhole to nowhere, the horizon cements reality.

Upon death, the pharaoh thus was believed to travel horizonward on a reed-float and dwell with Re. As an inscription from the *Pyramid Texts* (circa 3000 B.C.E.) states: "Ferries is this Unas to the eastern side of lightland [horizon], Ferried is this Unas to the eastern side of the sky . . . Unas has risen again in heaven, He is crowned as lord of lightland . . . Unas' lifetime is forever, his limit is eternity . . . as he dwells in lightland for all eternity."[25] The horizon is closure, shelter, repose. It silences questions about what lies beyond.

> I am encircled by the Netherworld,
> Pure and living in the horizon.
> It is well with me and with them [deceased relatives]
> It is pleasant for me and for them
> Within the arms of Atum.[26]

The Egyptians managed the intellectual feat of contemplating the outmost edge of vision *without* expressing the wish to stray beyond. One reason is the aforementioned analogy of being seen and existing (the denial that there is more than meets the eye); another reason is Egypt's atavistic pragmatism. On balance, its religious creed was more human-bound than god-ward. The sun came to man, not man to the sun. The Egyptian gods never thunder or overwhelm man with displays of might; they seldom humble him (as Krishna silences Arjuna in the *Mahabharata*, or Yahweh, Job in the Hebrew Bible). Rather than the browbeat, awe or stun, the Egyptian religion administers comfort. Its scriptures are not rapturous, but consolatory. Attaining immortality (or in the pharaoh's case, divinity) means keeping one's identity forever. Thus the passage into the afterlife does not release the dead from the finite world but instead pushes them deeper into it: one goes to the

kingdom of death trussed up in a double- and triple-lined cedar sarcophagus (not released by the flames). Immortality preserved, rather than transfigured, human life. Meanwhile, the gods staffed the team of undertakers; they, like the rest of culture, ministered to the hatred of death. "Your foe [death] is fallen, he shall not be! / I am with you, your body-guard, / For all eternity."[27] Thus speaks the god Nephtys, pledging his eternity of indentured service to death-hating man.

Lack of interest in matters that transcend the human scope and the wish not to die led the Egyptian mind to bleach infinity of any metaphysical color. It was a very levelheaded people (the same people who calculated a man's soul by weighing his heart on the scales) that used the infinite as a bookkeeping devise: *infinite* in the Egyptian hieroglyph doubled for the number *100,000*, which, under certain circumstances, designated "many." Infinity was a great quantity, a thing: the contradiction did not trouble the Egyptians. Given that *to be* and *to have* a body were synonymous, the infinite could exist only as a thing, a whole lot of *something*, which means, in the main, not infinite. Not for the ancient Egyptians the delights of imagination drifting out of bounds. Not for them the charm of the subliminal edge, the thrill of vague ideas that do not line up with facts. "I shall not pass it northward ever"; "I shall not pass it southward ever"; "I shall not pass it eastward ever": thus read the boundary stelae inscriptions placed by King Akhenaten on the three sides of his capital, Amarna, built on the Akhetaten—the horizon home of the supreme god Aten.[28] Horizon meant the stolid, the limited, the reassuringly finite—anything indeed but the infinite.

Zero, as a concept, did not fare much better. The Egyptians did not have zero proper (it is a seventh-century C.E. invention, probably from China, via India, via Syria) but nevertheless used a related symbol, transcribed as *nrf,* to designate a neutral base point.[29] The leveling line in construction, for instance, was called *nrf*. In bookkeeping, *nrf* symbolized, rather than nothingness, the absence of a given quantity. Tellingly, the hieroglyph for *nrf* also designated "beauty" and "completeness"—to mean, in other words, the opposite of what lurks inside zero, that is, the formless. Egypt's zero partnered with images of foundation: instead of luring the imagination down the rabbit hole to nothingness, zero functioned like the pyramid's apex: it fixed the place where opposites lean to rest. Zero was not where nothingness began, but where numeric reality started. Here again Egypt battled formlessness and converted the void into its opposite. Thus death became life eternal. The infinite was a sum,

zero was an anchorage point, and thus, also, the horizon came to symbolize, not the pale and slippery side of reality, but its wraparound shell.

Only one seeming exception shakes this three-thousand-year-long denial of sublimity. It occurred over the short reign (1353–1334 B.C.E.) of King Amenhotep IV during the Middle Kingdom. This interlude marks the first known creation of a monotheistic state religion of which Amenhotep IV appointed himself the chief hierophant. Renaming himself after the sun god Aten, King Akhenaten (meaning "effective spirit of Aten") abolished the pantheon of gods and intellectually went straight to the source of creation. If the universe gelled together, it is because it partook of a unifying life force. To Akhenaten, this principle was light—"the day's light perfection." Akhenaten did not invent the cult of light, nor was monism his creation *stricto sensu*, since early Egyptian cosmology allowed for a primal cosmic oneness.[30] Nor in fact is it right to speak of bona fide monotheism, since there was as much autocratic expediency as mystical fervor to Akhenaten's religion.[31] Nevertheless, one discerns a definite new spirit of sublimity about Akhenatenism. Pronouncements like "there is no other god like him [Aten]" of the early years of reform gave way to "there is no other but him" in the heyday.[32] As Aten evolved from being the greatest god to the only god, Akhenaten ordered the old temples closed.[33] Archeological evidence suggests that the populus did not take readily to Akhenaten's theological-political experiment and discreetly continued trundling homemade effigies and amulets of the traditional gods.[34] As a matter of official policy, however, Aten reigned alone, with Akhenaten as head priest. Of importance, really, is that religious *change* actually came to Egypt for the first time in seventeen centuries. It proved that permanence was not necessary to religion. Since gods could supplant one another, it followed that time was not incompatible with divinity, or, as we shall see, with human beings.

Unique and absolute, Aten could not be compared with anything on earth or heaven. He was not a servant of rituals, and he was not a god of embalming, fertility, war, or the Nile. He was a principle from beyond the world, its prime mover: "You create the numberless things of this world from yourself, who are One alone. . . . For it is you who are Time itself, the span of the world; life is by means of you."[35] Aten has no personality, no story, no miraculous birth, no father and mother. He is the essence of all, time and space, context and event. Indeed he is not a god

of the world, but the one wherein the world is. In this sense Aten was not just an absolute god, but an abstract god—a god so removed from the vicissitudes of material existence that he could not be said to exist in any ordinary sense.

As evidence of this abstraction, depictions of Aten broke dramatically with the representations of anthropomorphic and zoomorphic gods. "No craftsman knows Him," Akhenaten decreed, proscribing the making of figurines.[36] Anything seen, imagined, or sculpted bears the risible traits of human limitation. Transcending the human level, Aten outstripped anyone's idea, dream, or imagining of him. The god became unthinkable: he did not, like Re, rub the balm of familiar certainties onto the wound of death. Aten exposed the limitedness of human thought. "Risen, radiant, distant, near. You made millions of forms from yourself alone. Towns, villages, field, the river's course. . . . There is no other who knows you," sings the "Great Hymn to Aten."[37] Mortals cannot see or imagine the incomparable Aten. This limitation effected a profound change in the very shape of reality, which became open-ended, sublime, god-ward. The temples built by Akhenaten in his new sun-capital Amarna were notably roofless: no longer did the cult concentrate on chanting mortuary rites in underground vaults; prayers were now sent forth up to the unbounded sky, to uncontainable nature itself. With the cult of Aten, an ecstatic gulf began to yawn between god and humans.

Carved reliefs and tomb murals of Akhenaten's seventeen-year reign saw the traditional jackal- or bird-headed gods disappear, replaced by a simple solar disk. But the disk is really a symbol: it evokes something celestially unrepresentable. And the Aten is always above: the carved reliefs clearly mark off the earthly plane (where mortal man sits) from the divine (the solar disk). An effect of this celestial removal was to let man be human, physical, and mortal. Carvings of real-life human beings—flawed and vulnerable to age—first appear during Akhenaten's rule. The few images of Akhenaten extant (his heresy was methodically wiped out after his death) seem piteously lifelike next to the hulking colossi of pharaohs before and after him. A famous relief (now at the Egyptian Museum in Berlin) catches the king and his queen, Nefertiti, in a family moment—pot-bellied, slack, fond Akhenaten holding up his baby-heir for a kiss while his queen coddles their other child. Another relief depicts the king and queen taking a meal. Never had a monarch been depicted with such acknowledgment of creaturely needs and frailties.

As Akhenaten allowed himself to personalize the god, so he also personalized the monarchy and, to the extent that his royalty was divine, humanized religious experience. On this relief and others (like the one depicting the tearful funeral of Akhenaten's second daughter), the gist of existence is less immortality than human attachments in mortal time. By pressing Egyptians to contemplate the transcendence of Aten, the new cult injects space into the religious experience—the distance between the perfect and the imperfect. Intimacy with the divine is no longer a birthright; it has to be striven for. The focus of worship is no longer on what it will be like to live forever, but on what it is to exist as mortal. It sets the human gaze ecstatically outward, on the Most High, at what is infinitely unlike us.

> Splendid you rise, O living Aten, eternal lord!
> You are radiant, beauteous, mighty.
> Your rays light up all faces
> Your bright hue gives life to hearts . . .
> Every heart acclaims your sight . . .
> Their [people's] arms adore your *ka*,
> As you nourish the hearts by your beauty . . .
> All creatures leap before you.
> Your august son exults in joy,
> O Aten living daily content in the sky.[38]

The "Short Hymn to the Aten" is no funeral dirge but a quiet song of praise, joy, love—the song of a deity unveiled by the more generous, unstinting tendencies of our emotional repertory: a resolve to venture forth rather than shrink back in protective propitiation.

In fact it is a story of ecstatic venture that founds Atenism. A boundary stela of Amarna recounts a direct theophanic encounter between Akhenaten and Aten during year five of his reign: the king reached a spot in the desert where Aten pointed the gateway (the *Akhet*, or horizon) through which its light floods the world.[39] No doubt the episode bespeaks as much genuine religious feeling as megalomania. (Akhenaten wanted a capital all of his own, politically removed from the priesthood of Memphis and Thebes.) But the episode also reveals a new individual resolve to leave the burial chambers and stand before the stark infinity of earth, sky, sunrise: to engage the divine on its own field, in preamble to the future anchorites of Hebrew desert literature who went and stood alone before the oneness.[40] Of course Akhenaten did clap this infinity inside city walls; on the other hand, the city itself was designed as a gigantic temple, a numinous spot that, says one boundary stela,

"belongs to my father, Re-Harakhti-who-is-Aten, who gives life forever, with mountains, deserts, meadows, new lands, highlands, fresh lands, fields, water, settlements, shorelands, people, cattle, trees, and all other things that the Aten my father shall let be forever."[41] There shines the vibrant spirit of Akhenaten's religion, its wonder-struck awareness of nature in the fulsome blinding fact of it, the oneness flooding the apparent variety, the stirring of something enthusiastic and god-ward about life rather than mournful, morbidly prudent, and niggardly.

Of course, one must not be over-romantic about Akhenaten's religious revolution. His monotheism was strongly monarchic. In the end, Atenism passed away with its chief priest. Soon after Akhenaten's death, his son Tutankhamen restored the cult of Osiris and the Egyptian pantheon; Amarna was abandoned, and all but a handful of Akhenaten's open-air temples were laid to waste.[42] Pharaohs went back to the petrified posture of living gods, of immortals-in-waiting, and the gods returned to their job as morticians. Once more the Egyptian statue stared blankly at eternity, the quiver of feeling extinguished. For all that, the fourteenth century B.C.E. does set a milestone in the evolution of religious thought. Akhenatenism proved that denial of death is not the alpha and omega of religious feeling. It uncovered an aspect of the religious experience that centered not on our pathetic wish for godhood, but on an awe-struck celebration of universal nature, the totality of being. This, at any rate, remained—the "Great Hymn to Aten":

> O living Aten, creator of life!
> When you have dawned in eastern lightland
> You fill every land with your beauty.
> You are beauteous, great, radiant,
> High over every land;
> Your rays embrace the lands,
> To the limit of all that you made
> Being Re, you reach their limits.[43]

Here is the dawning of the vision that soon triumphed in the Hebrew god Yahweh: Aten hovering over the face of the deep, over a world not yet wrinkled by human self-regard, a world indeed in which we play no part. The "Great Hymn" sings of universal wonder rather than consolation. Contemplating the universality of god, we soon accept the contingency of man who is a part and not the whole. To worship is to see, not with the eye of gods, but with the eye of mortality from whose viewpoint perspectives lengthen, dwindle, and fade away.

This reorientation of religious feeling came to Egypt in the fourteenth century, a period that coincides with a spiritual groundswell that shook nearby societies of the Fertile Crescent and that saw the decline of animist, fertility, and sacrificial cults, which were steadily eclipsed by a more poignant, existential, mortal sense of religion. To follow this transformation, we travel to Uruk, capital of the ancient kingdom of Mesopotamia, the setting of the oldest piece of literature on record, the *Epic of Gilgamesh*.

Astonishment

Mesopotamia, circa 1900 B.C.E.

Though it dates from the third millennium B.C.E., the *Epic of Gilgamesh* made a rather recent entry into world literature. Its clay tablet manuscript was discovered by the British archeologist Austin Henry Layard in 1948 on the site of the ancient library of Nineveh. The twelve tablets engraved in Akkadian cuneiforms recount the story of Gilgamesh, a king thought to have ruled in Uruk around 2600 B.C.E.[1] Part legend, part myth, and part philosophical tale, the story tells of a hero who tests the limits of human experience and discovers death: "He who saw all, throughout the length of the land, came to know the seas, experienced all things."[2] He saw the "Deep" (*nagbu*, in Babylonian), the outer sea, that which a human being sees only if he agrees to die: the substrate of all being.

When the poem opens (in the old Babylonian version, from around 1600 B.C.E.), Gilgamesh is a mythical king-hero, two-thirds god and one-third human, "as strong as a savage bull," protector of Uruk and builder of its great rampart. But Gilgamesh is also an overbearing ruler. Soon the people of Uruk find themselves imploring the gods to send some fierce contender to tame his bullish ways. The goddess of creation, Aruru, hears their plea and begets the wild man Enkidu. But instead of fighting, Gilgamesh and Enkidu become bosom brothers, launch into wondrous adventures, conquer the mythic Cedar, kill Humbaba, and slay the Bull of Heaven sent down by the goddess Inanna. They defeat the divine forces of nature one by one. But the gods are a merciless sort,

and one among them, the god of sky and earth, rules that Enkidu must die. With Enkidu laid to his grave, Gilgamesh grieves extravagantly for seven days and seven nights. Inconsolable, he is a changed man, more inward and pensive. No longer a Herculean he-man, he broods over the wherefore of existence. "What sleep is this that seizes you?" he moans over his friend's dead body, "You have grown dark and cannot hear me!"[3] Gilgamesh discovers mortal limits. Unable to reach Enkidu, he awakes to his own existential solitude. One's life ends where the other person's begins. Love and attachment, however powerful they are, cannot save us from death. Existentially, man is a solitary creature. A fallen immortal, Gilgamesh now has but this one ultimate aim: to obtain the secret of eternal life.

He travels to the end of the world where, legend says, lives Utnapishtim, a patriarch whom the gods have graced with immortality. Ferrying across the sea of death to the place where the sun sets, Gilgamesh reaches Utnapishtim but soon discovers that, having given immortality once, the gods will never bestow the favor again. So Gilgamesh, too, will someday die. Gilgamesh (whose real-life correlate was probably regarded as a god throughout Mesopotamia) is now fully human.[4] He has gone to the ends of earth to discover his mortality: this is his ultimate achievement, his towering exploit. In unflinching epilogue, the tale depicts Gilgamesh, the once mythic man, dead on a slab: "Like a hooked fish he lies stretched on the bed."[5] This is, as we shall see, death by storytelling. The hero as a mortal, as human being, is born.

The poem opens on an encomium: "I will proclaim to the world the deeds of Gilgamesh. This was the man to whom all things were known. . . . He was wise, he saw mysteries and knew secret things, he brought us a tale of the days before the Flood. He went on a long journey, was weary, worn-out with labor, returning he rested, he engraved on a stone the whole story."[6] To see and know all: alive already is the impulse to shape life into a finite whole, to experience it creatively, not just as environment but as an object we can knowingly set down before ourselves, alive yet distinct from us. Traveling to the ends of the world plays out the primitive wish of storytelling, which consists of beholding existence as a complete whole. Then we stop being its helpless playthings and become its master. But for every act of hubris there is a blowback of nemesis: ironically, the overview of existence also brings the knowledge of mortality, and to see all is to see where it ends. The *Epic of Gilgamesh* discovers the particular suitability of storytelling for encapsulating mortal existence—which means, in the bargain, discovering

man as a creature for whom, as existentialists used to put it, existence is now an intellectual problem that the consolations of religion simply cannot soothe. Let us therefore preface Gilgamesh's journey with some remarks on the existential nature of storytelling.

The narration of Gilgamesh's adventure assumes that, insofar as the events go, the journey has run its course: "This was the man to whom all things were known . . . he went on a long journey, . . . returning he rested, he engraved on a stone the whole story." By the time the tale begins, Gilgamesh has already returned to engrave his story. Where storytelling begins, time is finished. The premise, and promise, of any story is that it conveys *all* there is to say—unlike history, which wades waist-deep in the infinite incompleteness and multiplicity of reality itself. Perhaps fiction was invented to dam up this exhausting flow. No story can fail to feature a beginning, progress, and an ending, and no storyteller undertakes a tale on the premise that it cannot be started and brought to a close. This is not to say that storytellers control all the ins and outs of their tales before putting down the first word; it is to say that they know they will eventually say all there is, or ever was, to say about the characters, objects, or settings *inside* the story. For example, it is absurd to think there are hidden facts or aspects of Anna Karenina left unsaid in Tolstoy's narrative. Everything Anna was, is, will, or can be holds inside the novel. The blue ribbon she wore in her hair one day, which Tolstoy omits to mention, never existed, nor the day, nor her hair on that nugatory day. (This is not true of historical lives. About them there is always more to find out: we can never get to the end of what can be trawled out of Tolstoy's life. This is not true of Anna's.)

We have fiction so as to see life as a finite sum—to jump beyond the horizon and behold the whole thing, round like the Earth seen from outer space. Although the dream of leaving the earth is not explicit in all tales, the fantasy of transcending the mortal horizon lies just below the surface: it is the implicit outline of *all* tales. Not only do storytellers know things no human being can know (such as other people's thoughts), they see and know things from an extra-temporal perch. However chance ridden and open the narrative seems, both writer and reader know that each character's life is already carved in stone. The first-time reader may not yet know that Anna Karenina is crushed by a train at novel's end, but no one can doubt that die is what she is forever meant to do, in just the way she does. Her life reads like it is made of possibility: in actuality, it is made of fate.

"He brought us a tale of the days before the Flood," *Gilgamesh* begins.[7] How can the storyteller know what preceded the beginning of time? Simply because, although history is written in the course of time (history is a part, and time the whole), storytelling *contains* time. A story is the whole of which time is a part. The storyteller can see before the beginning of time because, in narrative fiction, no time exists before the telling. What is Crusoe's island like before he washes up on its shore? Nothing. What it "was" before Crusoe's arrival is a refraction of his arrival. The time before the story exists only if the story looks back on it. Common sense informs us that Anna Karenina must have been a child once if she is a woman now, but her youth unfolds out of her grown-up self, not the other way round. As a creature of fiction, she was once young because she is older now. Thus the storyteller conquers time. He is lord of ages: he *knows* the time before the flood because that time exists in him.

"He went on a long journey, was weary, worn-out with labor." (Kovacs's translation reads, "pushing himself to exhaustion"; another, more poetically, proposes, "He journeyed beyond exhaustion").[8] Full of essence, the character of fiction never falls short of the distance: he covers the lengths of the possible, leaves nothing of his fate unperformed. Let life be a voyage: the fictional character loops together east and west. He is never exhausted—instead he does exhaustion in. Even when he dies or vanishes or proves a dismal letdown, no fictional character stops short of doing and being everything the story means him to be. His life never peters out. Of course it is the case that Ahab will never see his white whale trussed up at starboard. It is also true that Hamlet dies short of moral adulthood. And Vladimir and Estragon will always be waiting for Godot. But it is absolutely beyond doubt that the chasing, longing, and despairing are what their fiction means them to do. Everything and everyone stand as they should; are rounded; and belong in the adamantine order wherein nothing occurs at random, remains at loose ends, strays from its right place, or diverts from the law that there *is* a right place for every element to fit as it is meant to. Put theologically, art casts human existence in the light of revelation. Though a secular form, it essentializes existence.

We may always wonder what it means *for us* to watch two hoboes waiting for Godot; in their image-world, however, these two wretches are luckier than gods because they can *only* be waiting for Godot. It cannot occur to us to see them doing, or being about, anything else. Unlike us, they have found their end, and their end is contained in their

essence. At every turn of his fictional life, the protagonist of fiction is cloaked in destiny. He exhausts the horizon—the vanishing line that runs the rest of us mortals ragged.

"Count no man happy till he dies," the chorus sings at the end of *Oedipus the King*. So long as we live, we are the playthings of fortune—creatures at the mercy of change. On this premise, only fictional characters can know happiness. We live forward, freely and therefore anxiously; they live retrospectively, necessarily in blissful completion. In the ancient world, this bliss was symbolized by the Isles of the Blessed, where kings and heroes consorted eternally with the immortals. The novelty of *Gilgamesh* lies in its hero's strikingly different choice of destiny. The two-thirds god that is Gilgamesh, the larger-than-life hero who could have the storied life of myths, chooses humanity. This choice can have but one satisfying expression, that is, storytelling. This explains why the story of Odysseus—the spiritual heir of Gilgamesh, the birth of narrative—also entails rejecting the halcyon life on Calypso's island.[9]

Traveling the path of storytelling, Gilgamesh receives a spiritual wound for which nothing in his solar-king upbringing can have prepared him: physical blows he can take, for they make him stronger. But when his bosom friend Enkidu dies, Gilgamesh discovers affliction. Life suddenly seems unjust—anticlimactic, grievous, devoid of heroism. "I have wept for him day and night, I would not give up his body for burial, I thought my friend would come back because of my weeping. Since he went, my life is nothing," Gilgamesh moans.[10] Now he has but one ambition: to gain understanding. He trudges to the edge of the sea to question the gods "about the living and the dead." There, he meets Shamash, lord of wisdom, who speaks thus: "'No mortal man has gone this way before, nor will as long as the winds drive over the sea. You will never find the life for which you are searching.' Gilgamesh said to glorious Shamash, 'now that I have toiled and strayed so far over the wilderness, am I to sleep, and let the earth cover my head for ever?'"[11] Gilgamesh cannot hide his bitterness: he has gone very far, across the cosmic sea *(tâmtu)* and the waters of death *(mê mûti)*, which, in the Mesopotamian cosmology, marked the distant reaches of the world.[12] In psychological terms, he has gone the distance and gained awareness of his self in the cosmic scheme, but this wisdom does not give him eternal life. He has journeyed far enough to understand that human life comes full circle, locks itself up, and extends no further (this, perhaps, is the meaning of Gilgamesh's traveling into the sunset horizon, through the tunnel under the earth, to emerge on the sunrise horizon whereupon

we imagine Gilgamesh sighing, "Is this all there is?" This bathetic realization seems to inform the goddess's revelation that there is nothing more to human life than the time of it: "Gilgamesh, whither are you going? Life which you look for, you shall never find").[13] And so comes Gilgamesh's complaint: "Am I to sleep and let the earth cover my head for ever?"[14] Was my task to glimpse the boundary and never catch up with it? This is hardly the voice of religious consolation, and indeed no archeological evidence suggests *Gilgamesh* featured in temple hymns and recitations.[15] It is the first genuine piece of secular imagination that deals with religious silence, the impotence of the gods, the finitude of man. Now Gilgamesh feels his solitude and smallness in a universe knocked out of bounds. He, the hero-builder of Uruk's fortifications, the world-encompasser, discovers an untamable force, and this force is none but his own existence. He will never get a purchase on his own self. He knows he will never know. Now he is a creature of becoming, stranded on the shore, facing the unlimited. Through him, consciousness is poised on a new age, the heroism of moral fortitude.[16]

Having begun the day a god-taming hero, Gilgamesh faces nightfall the mortal captive of a drama that waits and waits for Godot. A protagonist of fiction and no longer a figure of myth, he has wandered, not to the edge of life proper, but into the sort of life that has no clean edge: he has, to borrow Joseph Campbell's terminology, "the champion of things becoming, not of things become."[17] Which implies that the hero is intrinsically mortal. Not for the Sumerians the consolatory myths of resuscitation on which the Egyptians so immoderately fed. The Sumerians, like the Hebrews after them, entertained a rather deflated view of the afterlife, which brought neither transcendence nor moral resolution of life.[18] In one Akkadian story contemporary to the Gilgamesh epic, "The Descent of Ishtar to the Underworld," the goddess Ishtar goes down that road "where traveling is one-way only."[19] She gets to escape in exchange for her husband who, poor soul, never returns.[20] On this distressing sense of the urgent one-wayness of life, *Gilgamesh* sprinkles the bitter knowledge that man cannot even see the end of this one-way catastrophic slide:

"You will never find that life for which you are looking . . . Gilgamesh, there is no crossing the Ocean; whoever has come, since the days of old, has not been able to pass that sea."[21] Condemned to exist once only and never to know wither and wherefore, Gilgamesh is intelligent enough to see the boundless horizon but not able enough to conquer it. On that forlorn shore, then, is Gilgamesh doomed to stand: neither a god nor

a beast but a tragically incomplete creature, incomplete because he is insatiably far-gazing; overreaching yet mortal, infinite in desire though finite in the span of life given to quench this thirst for knowledge. He is a creature whose destiny is to travel and never arrive, to long and never touch, to hope and never gain: in him longing finds a human vector. Existence—Gilgamesh dies finding out—does not have a shape. Thus speaks the paradoxical wisdom of the biographical totality that is a story.

Only the longing, self-aware type of intelligence can behold the horizon: the horizon is not an empirical, objective limit but viewer-relative: it marks the limit of how far the eye *sees* it can see. The horizon therefore invites expansion yet also announces that we can never see beyond the range of perception of which it is the refracted mirage. This casts into a new light Gilgamesh's discovery of "the mysteries and secret things": in reality, the hero uncovers no secret, at any rate nothing that surpasses knowledge.[22] Instead he comes to understand what human knowledge and experience consist of, their reach and amplitude, their finiteness also. If it is a mystery, it is hidden in plain sight, or else it is the mystery of human consciousness itself: that is, how it should be that, although a finite creature, man can intimate the infinite. Can the mind somehow entertain an idea (the infinite) that it really has no room for? This is the new mystery: not the unfathomable heavens but the riddle of man facing the heavens. In other words, the riddle of the shape of human existence: that it is finite, that we are able to see this objectively, but that seeing it brings no respite from finitude: "What can I do?" wails Gilgamesh, "the rapacious one sits in my bedroom, Death! And wherever I may turn my face, there is, Death!"[23] Wherever I turn my face indeed I am bound to see only as far as I can see: I see my existential horizon.

"If our life were without end and free from pain," writes the German philosopher Arthur Schopenhauer, "it would possibly not occur to anyone to ask why the world exists, . . . but everything would be taken purely as a matter of course."[24] The question of why the world exists stems from the realization that existence is finite. Man is the thoughtful animal because he is the mortal animal: "No beings, with the exception of man, feel surprised at their own existence. . . . [Humanity] marvels at its own works and asks itself what it itself is. And its wonder is the more serious, as here for the first time, it stands consciously face to face with death and beside the finiteness of all existence, the vanity and fruitlessness of all effort. Therefore with this reflection and astonishment arises the need for metaphysics."[25] Schopenhauer writes this in the nineteenth

century, but the emotion is as old as written thought. Pain is the root of metaphysics and the raw material of narrative fiction. For it is the pain of life's finitude that storytelling, by its very form, makes visible. The metaphysical shock of storytelling lies in the horror of seeing that life rounds up to a story, that it is story-like.

In the end, it is the shape of existence, not its vicissitudes, that runs Gilgamesh into the ground. Gilgamesh is exhausted by the adventure of finding himself in a story—he who was made for myth.

> Then Siduri said to him, "If you are that Gilgamesh who seized and killed the Bull of Heaven. . . , why are your cheeks so starved and why is your face so drawn? Why is despair in your heart and your face like the face of one who has made a long journey?" . . . Gilgamesh answered her, "And why should not my cheeks be starved and my face drawn? Despair is in my heart and my face is the face of one who has made a long journey, it was burned with heat and with cold. Why should I not wander over the pastures in search of the wind? . . . Because of my brother [Enkidu, who died] I am afraid of death, because of my brother I stray through the wilderness and cannot rest.[26]

Now the theme of exhaustion eclipses the theme of Gilgamesh's god-like strength. Why, if you are the great hero Gilgamesh, are you tired? asks the goddess. What sort of hero is a tired hero? Is it true to mythic form for a hero to tire out? The gods, who are incapable of fatigue, wonder at this quaint feature of human experience: hanging at the end of one's tether. Gilgamesh's truculent answer defends his exhaustion: his low spirits, his defeat—they are a badge of honor. Why should I not be tired? Why should I not run ragged after the wind? Why should I not live in the fear of death? Like Vladimir and Estragon, he has only his exhaustion to cleave to. But that is not nothing. It says that human life is struggle, not for survival (this struggle does not typify humans), but for the sake of suffering. The fight cannot be won—yet should we finish in anything less than complete exhaustion, then perhaps we would fail to live. To exist humanely is to see oneself out to the end. Only then do we draw the outline of existence. Exhaustion is the mode in which man operates as the artist of his own life. It is the way we write life as a story.

Evidently this exhausting way of living baffles the goddess Siduri. The gods only know repose: they never *strive* to be who they are. But her bafflement simply means that human beings have become opaque to the gods. This opacity suggests that the focus of religious thought is shifting away from the gods to the mortal individual—as if the great question is not how man fits in the natural scheme of things, but what, indeed,

he should make of it. Religious thought henceforth will concentrate on negotiating this conundrum, this lack of fit between man and nature.

Art, like religion, is a rejection of despair. But whereas religion numbs anguish with the balm of belief, art keeps human life raw and mortal. Fiction separates gods from humans: it tells the former that they have little clue about what it is to be human—the longing that drives us, the dignity of our defeat, the tiredness that ennobles; and it advises humans to put away the childish dream of immortality. In Siduri's garden, gems and lapis lazuli hang on fruit trees: nature and the supernatural entwine. But Gilgamesh will not stay. He wants neither the supernatural nor the natural, and the goddess, who cannot understand a third way, wonders where he is soldiering to: "Gilgamesh," she says, "where are you hurrying to? You will never find that life for which you are looking . . . Gilgamesh, fill your belly with good things; day and night, night and day, dance and be merry, feast and rejoice."[27] Seize the day. Drink the wine of oblivion. Live as gods and beasts do, who know no yesterday and no tomorrow.[28]

This invitation stands for a real danger in the hero's life: the temptation to throw off existential adulthood and regress *ad uterum* to magic and ritual. In Siduri's garden, Gilgamesh knows a brief failure of nerves: "Young woman, maker of wine, since I have seen your face do not let me see the face of death which I dread so much."[29] But Gilgamesh sees the contradiction in this request: what we understand, we cannot not understand again; we cannot *will* not to know what we already know. This is why, in the end, Siduri's invitation angers Gilgamesh: the idea smacks of dereliction. Admittedly, he began the journey flying from death; yet he completes it by facing mortality.[30] Now he takes up his ax and dagger and stands before the open sea that alone dignifies his existence. The parting of the ways is complete: to be a god is to be intoxicated always; to be human is to be (resiliently, uneasily, mournfully) sober onto death. It is to be the character of one's own (godless) story.[31]

Acceptance of mortality, fear of death: they goad the hero into action. Why do you strive in spite of adversity and guaranteed failure? asks the goddess. Precisely because of adversity and guaranteed failure, answers the hero, now a full-fledged human protagonist whose cheeks are hollow and heart is heavy but whose eyes glow with a discovery they will not blink away from: the horizon. The journey across the waters of death, the voyage into the horizon, *is* the narrative of human existence.

This is where *Gilgamesh* breaks with other Sumerian poems such as "Dumuzi's Dream," where most of the action consists of tricking, eluding, and fleeing death.[32] Here we must picture Gilgamesh marching straight toward death.

As the timeless world of theology wants cyclic incantation, so mortal existence calls for the horizon narrative. The former speaks to gods, the latter to humans. If there is something the gods are structurally unable to grasp, it is permanent dissatisfaction. Siduri cannot understand Gilgamesh's arduous longing. This is why narrative will never be hospitable to gods—just as incantation will never do to express human existence. *Gilgamesh* describes the descent from myth to storytelling. It is the story of humans becoming unintelligible to gods. The gods, for one, do not become incomprehensible to man; instead they become uninteresting. Their charmed life is renounced; their supposed happiness looks infantile—a hidebound life blind to the horizons. In the end, Gilgamesh goes back to Uruk, points to the famous city walls he once built, and, in one version of the story, dies—an inmate in the house of human existence.

To follow this affirmation of the mortal, we move from Asia Minor to the Aegean archipelago and from one seafarer to another: the horizon-sailing Odysseus.

Enterprise

Aegean Sea, circa 725 B.C.E.

> Atlas' daughter it is who holds Odysseus captive,
> Luckless man—despite his tears, forever trying
> To spellbind his heart with suave, seductive words
> And wipe all thought of Ithaca from his mind.
> But he, straining for no more than a glimpse
> Of hearth-smoke drifting up from his own lands,
> Odysseus longs to die.[1]

Why is King Odysseus so sad? Cajoled and caressed by the enchantress Calypso of the blessed isle, Odysseus wastes away with longing, "gazing out over the barren sea through blinding tears," and "weeping there as always."[2] Odysseus pining before the horizon like the moping romantic he is not: this is the first glimpse Homer gives of the great hero. Not battle-ready on the Trojan fields of glory, nor in the exercise of his proverbial guile, but woebegone and useless. He who has strength, fame, and a goddess's favor wallows in sadness. What ails the great man? How did an Iron Age warrior turn into this milksop?

It does not pay to read Odysseus's depression too psychologically. He is no Hamlet; nor is his the gloom of denied freedom. Odysseus wants not to be free but to go home—hardly the acme of buccaneering freedom; and he wishes to resume his journey fully aware that he is abandoning perfection on earth (a capsule of the Golden Age when men and gods communed in harmonious kinship, according to Hesiod). So when Homer says that his hero longs to die, he means it literally: the hero, held

in timeless captivity, yearns to rejoin the home of mortality. He declines the gift of a goddess who offers to make him "immortal, ageless, all his days."[3] She puts every imaginable blessing and pleasure, health, and eternity at his feet. But he wants none of it. Nor does he turn down the gift once: after Calypso's come other offers of godlike Halcyon bliss and knowledge—tendered by Circe, the queen of Aeaea, and the omniscient sirens (the cyclops Polyphemus is an odd variance since being devoured by a son of Poseidon is a dubious pleasure; on consideration, it does offer reabsorption into the earth, of which the chthonian cyclops is an archaic dweller). This is Homer's starting point and leitmotif: a hero hankering after the human lot, rejecting the lotus-eating of magic, religion, myth, superhuman glory, the Egyptian dream of immortality. The springboard of storytelling (of the individual life seen as a narrative) is the divorce between humans and gods, the existential from the religious. Whereas the *Iliad* signals the irreversible tragic awareness that man is not God, the *Odyssey* marks humanity's decision to claim, rather than bemoan, the difference.[4] To regret the distance between immortals and us enchains us to them; it is a form of piety. To take pride in the divide, on the contrary, leads toward an existential account of life. This may be one reason Plato listed the *Odyssey* under the rubric of tragedy, and why Aristotle detected the tragic streak in Homer's poem.

The archaic heroes of the *Iliad* hold out for nothing less than mythic transfiguration. Agamemnon, Hector, Achilles—all regard their lives as gateways to divine fame. They play up to the tribune of posterity, armored up to the ears in their glory, jockeying for first place in the martial pantheon. Odysseus, by contrast, merely wishes to fulfill his life as a mortal, a husband, a landowner. He prefers to die as a human than live as a god. Drawing the divide between gods and man time and again, he throws doubt on the wisdom according to which divine immortality is the supreme good. "No, I am not a God. . . . Why confuse me with one who never dies? No, I am your father," he says, chastising Telemachus for setting him on too high a pedestal. And he never fails to remind other protagonists that he is no demigod: "'Alcinous!' wary Odysseus countered, 'cross that thought from your mind. I'm nothing like the immortal gods who rule the skies, either in build or breeding. I'm just a mortal man.'"[5] Humility can be a devious form of self-congratulation, but Odysseus is not boasting that he, a mere mortal, has defeated divine monsters and hatchlings. He affirms the humble, the earthbound, and the mortal as *achievements* in their own right—achievements that see him not vying with the gods, but begging out of being counted among

them. The archaic curse of being mortal—which myth and religion shun, deny, exorcise, and find a thousand ways to avoid—Odysseus pins to his chest as a badge of honor.

What we know of myths and epics before the *Odyssey* almost always entails ascendant scenarios of heroes scaling the throne of divinity. This dream of god-likeness typifies Akhenaten, Gilgamesh, and Achilles alike. Hector flies into battle praying that men will forever worship his effigy alongside Athena's and Apollo's.[6] Not so Odysseus. Here is a levelheaded hero who longs for the mortal plains of Ithaca. Human fate, the *Odyssey* suggests, is no curse to be exorcised (in an Egyptian sense), denied (in a Hellenic sense), or atoned for (in a Judaic sense); it is a prize to be wrested from the jealous gods, from immortal timelessness. It is this bliss (the paradise of beasts and gods) that Odysseus strenuously declines over the course of his now embarrassed, now apologetic, now indignant yet always unwavering rejection of immortality. "'Ah great goddess,' worldly Odysseus answered, 'don't be angry with me, please. All that you say is true, how well I know. Look at my wise Penelope. She falls far short of you, your beauty, your stature. She is mortal after all and you, you never age or die. . . . Nevertheless I long—I pine, all my days—to travel home and see the dawn of my return.'"[7] Home stands for fidelity to the earthly self, to self-discipline; Odysseus is the anti-hubristic Hellene—what in man does *not* crave divinity: "'True enough, Calypso the lustrous goddess tried to hold me back, deep in her arching caverns, craving me for a husband. So did Circe, holding me just as warmly in her halls, the bewitching queen of Aeaea keen to have me too. But they never won the heart inside me, never.'"[8] "The heart inside," like "home," is synonymous with human dwelling, the humble acceptance of earth and death.

"Bring the trial on!" Odysseus cries out to Calypso, imploring her to release him back to the sea of time.[9] Life on the enchanted isle is boundless and eternal. But what fate is worse than the inability to die a little, to change, to hope, to fear? The bitter wisdom that the Babylonian Gilgamesh was forced to swallow, Homer holds up for a trophy: man is mortal because he likes it. Death is terrible only to those who do not stand up to it—those who cower or daydream time away or merely wait for the ax to fall. Among the pitfalls awaiting the Homeric Greek is the abrupt, unsought, accidental death—like the one that kills the hapless Elphenor, who, sleeping, rolls off a roof and breaks his neck. This is a death fit for the fatted heifer. A human being should die as a matter of purpose. He should die conscious of death, facing death, choosing death. "Odysseus longs to die": thus the hero expresses authorship

of his existence; he wants to meet death on human, meaningful terms. Death should not just happen; it should issue from the labor of progress. Beware, therefore, the lotus-eaters that quash the sailor's resolve; beware the honeyed song of sirens "who know it all"; beware Circe and her eternal spa treatment; beware the female principle, the uterine, the oceanic, the cosmic, which soften purpose and bewitch the thought of death—a thought that, from the moment he escapes Calypso, never leaves Odysseus.

And mortal danger does relentlessly stalk Odysseus after he leaves the blessed isle. It sounds like the price of freedom; actually, it is the coveted *prize* of freedom: Odysseus wants the freedom to die; he wants his prow pointing to the horizon of mortality. So even if he were to die before reaching Ithaca, in a sense he would reach Ithaca nonetheless—because Ithaca, or "home," really means "choosing mortality."

A faraway home, Ithaca is steeped in the purple hue of longing. In one respect, the motif of exile is a natural offshoot of a seafaring culture—which the Greeks were assertively becoming throughout the eastern and western Mediterranean.[10] In another respect, it betokens the awakening of the philosophical intelligence. Exile is a spiritual emotion as much as a physical fact. As an emotion, it partakes of the philosophical temperament that considers all things, near and far, through the lens of reflection. Reflection, however, entails an imperceptible loss. As soon as we become crisply aware of an object, we step back from it. The thinking mind knows no such thing as parochial intimacy. Odysseus will never again belong in Ithaca: his home, the home of reality, will always be colored by loss. This is why, no sooner back in Ithaca at poem's end, he vows to launch into further adventures. Gods perfectly inhabit the world; we are in search of it. They are complete; we seek reunion. The divine shape of life is the circle; mortal, the horizon makes visible the pushing toward a place which, because precisely we *know* it, we can never fully embrace.

The horizon represents human consciousness: first, because the horizon marks a limit, and limitation is inherent to consciousness. To catch oneself thinking and perceiving, one need be aware of what one is and what one is not. I cannot know that I exist without being conscious of entities that are not me—entities that define me by limiting me (if I were all things I would be none in particular, and therefore not a self). Likewise, in temporal terms, being aware of one's life entails the realization that one might not exist, did not exist once, and will not exist someday. To be humanly aware is to be consciously finite.

Yet this ontological limit is not a wall. A partition has concrete existence whether I acknowledge it or not. A horizon, by contrast, is relative to my knowledge. Unlike a wall, which I can always scale, it is impossible to leap beyond one's own mind. An actual object can logically (if not practically) be overcome; but to reach beyond one's perception can never be done. Try as we may, we never sail through that, or any, horizon.

Awareness of one's limitedness is awareness proper. When unconscious, the self knows no limit and is therefore not a self. One has to face the horizon of one's perception to be a self. This means that the shape of the human world is both finite and infinite: finite because I know that I do not know everything; infinite because my cognitive horizon surrounds me wherever I go and allows no breakout. (I can never see or know beyond the range of what I *can* see and know.) This dual finiteness and infinitude is just the thrall of horizons.

When we first meet Odysseus, we find him in serious danger of losing sight of this experience. Calypso offers ambrosial timelessness—life without horizons. But this god-sent gift, variously proffered throughout the voyage, arouses suspicion. Why do the gods insist on sharing their immortality with us? What's so charming about this charmed life of theirs, and why must they force it on us? If they are so blessed and we so unhappy, what galls them so about the way we humans live and think, love and die, long and hope?

Unlike the gods, we imperfect creatures tend to deteriorate (this makes gods luckier than us), but we can also reinvent ourselves (this makes us more interesting than them). Cocooned in perfection, Zeus lacks enterprise. What he cannot know, in his corset of excellence, is the joy of surprise. For a god there can be no journey, hence no story. There is no experience, and consequently none of its precious sediment, wisdom (i.e., knowledge plus the journey of attaining it). Here is what Odysseus discovers on Calypso's island: the gods are bored and boring. The gods are stuck. Their infinity is a glorified dead-end, and the quiescence they fob off on Odysseus hides a claustrophobic lack of enterprise. Why are the gods interested in mortals to begin with? Their very interest reveals a void in them (unlike the God of platonic Christianity, whose interest in humans comes from a surfeit of perfection that expresses itself in love). Whether it vents itself as rage (Poseidon) or conniving obstinacy (Calypso, Circe), the gods' medddling bespeaks fascination for what they do not and cannot possess:

the license to invent themselves, to exist before a horizon of becoming. Theirs is the clenched exasperation of jealousy.

"What does it [the Divine Being] think of?" Aristotle (384–322 B.C.E.) asks.[11] The answer is that he thinks of nothing. Divine omniscience inhibits God from thinking *about* something: to direct thought on an object admits there is more to find out about this thing. This incompleteness is inconsistent with omniscience. Therefore, Aristotle argues, the divine mind simply thinks itself thinking: there is nothing for God to discover. The only mental activity available is for the divine mind to contemplate its mental perfection—a situation that, even Aristotle concedes, must prove monotonous in the long run. In humans, it would be downright mind crushing.

Besides lacking intellectual progress, the Supreme Being is powerless to change itself. Four hundred years after Homer, Aeschylus (525–456 B.C.E.) pointed out the straightjacket of necessity that weighs on the Supreme Being. "Not even Zeus can escape the thing decreed," the playwright avers in *Prometheus Bound*. "What is decreed for Zeus but still to reign?" What is, is thus and not otherwise. This is true of all things, but worse even for Zeus (so Aeschylus implies) because, unlike the swift-footed humans, he can never depart from the exclusive role assigned to him. Zeus can only be ruler; man can be rogue or hero, fail or succeed, live long or die early, and pick from an infinite array of destinies. We can *make* something of ourselves—and this self-creation is nothing short of divine: this is enough to drive a god mad with envy, and the Homeric gods are nothing if not epidemically jealous.

The ancient Egyptians scarcely lent their gods much feeling; had they done so, jealousy would surely have come last. In the Sumerian religion, humans often expressed envy for the gods, but the feeling was not reciprocated. In ancient Israel, Yahweh experiences many adverse emotions (exasperation, rage, peevishness, regret, disappointment), but envy of the human lot, never (though Yahweh is notoriously jealous of other gods). Jealousy of humans seems to be a Hellenic peculiarity. One way to explain this originality is the anthropomorphism of the Athenian gods. A more interesting explanation is that the Greeks imagined more deeply than other cultures into the mind of divinity, and dared ask: *what is it like to be a god?* Theirs was a stunning answer: being a god leaves much to be desired. Plato took Homer severely to task for this impiety.[12]

Yet what else but their dull life explains their resentment? In the *Odyssey,* King Menelaus rallies his kinsmen with these words: "Both fellow-countrymen, how often we'd have mingled side-by-side! Nothing

could have parted us, bound by love for each other, mutual delight . . . till death's dark cloud came shrouding round us both. But god himself, jealous of all this, no doubt, robbed that unlucky man, him and him alone, of the day of his return."[13] Thanks to death, man has companionship and love: only beings that are thrown asunder can feel mutual longing. No power in the world can make Odysseus be Penelope, and Penelope, Odysseus. (Circe, who can change Odysseus's very essence, cannot understand that.) The solitude by which every human being constitutes a horizon of knowledge and experience to every other kindles the human need for union and fellowship—what Plato in the Symposium would call *eros* and illustrated through the memorable allegory of the hermaphrodite. "The gods, it was the gods who sent us sorrow—they grudged us both a life in each other's arms," Odysseus explains to his long-separated Penelope.[14] The gods cannot know longing: they do not self-invent or alter, nor choose to be who they are, nor seek to become. Theirs is a life devoid of seeking, hence of longing and love. Of lust they are capable; about the deep appreciation of a cherished other, however, they know nothing. And of the mystery that a person poses to any other person they are equally ignorant: their awareness knows no horizon, no onward boundary. No wonder they are always threatening Odysseus with imprisonment. Parochial limitation (spiritual, emotional, cognitive) is all they know; it is all they have to offer. Hence the epic-long spasm of divine jealousy: "Zeus is still obsessed with plans to destroy my entire oarswept fleet and loyal crew of comrades"; "The deathless gods despise him so"; "The immortals hate you."[15] The gods revile man for showing up the flaw in their adamantine facade. There exists a plain of experience, a brisk feeling for life, a sparkling urgency that they can never attain.

In the sixth century B.C.E., the philosopher Heracleitus blurted out the truth that Homer had only dared whisper: "Immortals are mortals, mortals immortals: living their death, dying their life."[16] This is terse but not indecipherable. Immortals are mortals because, ensconced in an essence that is never born nor passes away, their life is a kind of tomb. They may as well be dead. In contrast, mortals *die over their entire lives:* existence to them is change, decline, loss. Every second, death whittles away at us, sharpens our prospects, urges us onward. But why call us immortals, as Heracleitus does? Because so long as we live, we are not dead. We are immortal in the sense that death occurs not *in* life, but once it is over. And once dead, no mortal being has to worry about dying again (in case there is an afterlife) or about being dead (in case there is not). We are free from dying and from death as

only the immortals are rumored to be. Death is a horizon we will never penetrate: this, of course, is what makes it a horizon.

Death quickens human existence, gives it drive, urgency, and value. Death is our blessing, our exclusive property—off-limits to the gods, whose immortality is not mastery of death but ignorance of it. Homer puts it thus: "But the great leveler, Death: not even the gods can defend a man, not even one they love, that day when fate takes hold and lays him out at last."[17] Stronger than the gods and monopolistically human: death is that aspect of the human experience that limits their power. A great many things they can and will do, but to know what it is like to be us, over that they will never have any purchase. No wonder Calypso tries to trick Odysseus out of his death: it is the one thing she will never have.

The divine immortals can never hope to die and therefore live in perpetual death; they expect nothing, dread nothing, hope for nothing, and are therefore creatures of the past. We, on the contrary, move toward death but never reach it. We can only expect, dread, and hope and are therefore creatures of the enhanced present and future. It is we, depressed creatures of limits (e.g., the forlorn Odysseus who longs for home), who are truly alive. The gods are capable of childish impulses (anger, envy, frivolity), but it is humans who put to fruitful use the grownup emotions (love, longing, fidelity).

Of course we must be wary of modernizing the ancient Greeks. As the Classics scholar Bernard Knox reminds us, the Greek mentality was firmly retrogressive.[18] To them, the past was so real and tangible that they spoke of it as standing before them, whereas it was the future, still unknown, that they kept behind *(opiso)* their back. Seeking to reach home, Odysseus's future winds back to the domestic past. But this past, we note, must be won back. The pathos of the *Odyssey* is that Odysseus is not ensconced in his people, his rituals and traditions. These are in need of recapturing. Though ideally it should perpetuate the past, the future will not happen on its own. For the better stretch of his story, Odysseus is as distant from the future as from the past. He plies the choppy straits of the transient present, between Charybdis and Scylla, nowhere at home.

There Odysseus discovers an emotion of little currency in bardic heroism: love. Genuine love is distinct from the enjoyment of possession (something Calypso does not understand as she like other gods, only plans to smother). Love minds the distance between the self and the beloved; it accepts the limited reach of one's knowledge, prods us to ponder the horizon that any human being presents to any other

(one's knowledge of strangers and intimates alike will always stop short at the fact we can never see the world through their eyes). Human society is a patchwork of mental horizons—a jumble of exiles. Whoever cannot handle the straits of interpersonal exile had better remain on Calypso's isle. Odysseus never so much understands home (i.e., human society) as when, out on the vast ocean, he gazes longingly to the horizon. Home is not permanence. (Odysseus flees stability in all its forms, whether he is marooned or trapped in the cyclops's cave: he daydreams, schemes, leaps into perils, and begs to leave the lavish court of the great-hearted Phaeacians.) The real human home is the precarious exile, the race to nowhere, the place never-to-be-reached: there Homeric man hits his mark, dying his life away.

A bane to the Egyptians, mortality goads the Hellenic consciousness to a fuller existence. What cannot be avoided must be met head-on. Thus Sarpedon, a Trojan warrior in the *Iliad*, rallies his comrades-in-arms: "Ah, my friend, if you and I could escape this fray and live forever, never a trace of age, immortal, I would never fight on the front lines again or command you to the field where men win fame. But now, as it is, the fates of death await us, thousands poised to strike, and not a man alive can flee them or escape—so in we go for attack!"[19] Here is what the Homeric fighter would rather avoid: victory at any cost. "Ah for a young man all looks fine and noble if he goes down in war, hacked to pieces under a slashing bland, he lies there dead . . . but whatever death lays bare, all wounds are marks of glory," says Priam, who has just lost his sons.[20] Hedging one's bets is good for slaves; the noble life is to fight to the death with brutal, joyful, ecstatic contempt of limbs and life— the blood-drunk rampage, or *aristeia*, that happens when, enthralled by the god Ares, the warrior really lets fly. But there is another meaning to Sarpedon's words. As he lunges into the fray, the warrior affirms that, were he sure of surviving the fight, he would abandon it. Action sanitized from the risk of dying is not worth undertaking; life without limits (life not shadowed by death) is ignoble. It is in the pursuit of death that the Homeric individual finds himself. His life gains form when he goes out to its brink. Teasing and working the lurking substance of nonbeing as a craftsman would, he pulls himself into shape and thereafter stands forth.

Here the image of the Greek statue comes to mind. The ancient Greeks pioneered the full-limbed, lived-in human figure in life and art. More than any culture erstwhile, they lavished exquisite attention and study to contouring the human body. But this exploration implied some acknowledgment of the finite, existential singularity of

a human being. If craftsmen could begin to carve the human figure in the round and set off from the architectural frieze or pediment, it is because in the cultural mindset human existence had begun to acquire an autonomy of its own. To a degree greater than other arts, sculpture is branded by the tragic awareness of limitation. It divides matter from space, bringing form out of the background of existence. Whereas a painted figure never floats free of its material context, a sculpture stands forth—alone, finite, unsheltered. If so much of Greek statuary depicts the human body quietly asserting will and strength (the gymnast staking his ground, the caryatid hoisting herself up, the resolute kouros stepping forth), it is out of awareness of the vulnerably, heroically finite character of life. This is the reason behind the alleged "solemnity" of Greek sculpture.[21] Never playful or trifling, Greek statuary shows man intimately wedded to the void: emptiness nests in its every sculpted curve and lineament. It is through nothingness that a statue stands forth. Small wonder the art of sculpture sprang up with such vitality precisely among an ancient people who learned to live philosophically with death, in the shadow of death, in heroic partnership (and not enmity) with death.

But this does not mean that Odysseus rushes headlong into a fiery death, like the *Iliad* warrior. The heroes of the Trojan battlefield court death, honor death, exalt death, but really, in the end, deny death. (The warrior thinks that by causing death—to himself or others—he thereby masters it. This, too, is denial of death.) Odysseus accepts the possibility of death—indeed has nothing but its possibility in mind—but never *aims* at death. Odysseus steers between the Charybdis of divine immortality (the Egyptian formula) and the Scylla of ecstatic *aristeia* (the warrior death cult formula). He resists mysticism and myth. Both tempt him to forgo his humanity; both lure him toward the ecstastic expansion. But what typifies Odysseus (unlike Agamemnon and Achilles) is restraint: the art of self-sculpting. Physically and psychologically, he knows when and how to reign himself in. He is *sculpturally* aware of who he is and where he ends. At every turn of the narrative, Homer is spellbound by his hero's ability to pause, bottle up anger, tame his temper, impose cool reason. "He steeled himself instead, his mind in full control."[22] Moments when Homer pauses the narrative to describe his hero strategizing are the filigree of the *Odyssey:* they are the verbal contouring between self and other, inner and the outer, that recounts Odysseus's victory over himself and nature. Odysseus is an artist of boundaries. His self-sculpting is the real story—the individual wrestling himself out of the world of Greek myth where "the hero does not plan,

make preparations, or look ahead" or confine his action to fulfilling divine decrees but sallies forth into a world where personal identity is not a bond of man to god but of man to himself and his kin.[23]

No doubt, Odysseus's self-possession alone is a silent rebuke to the godly way of life. Next to our sailor, Poseidon the earth shaker is a seething pot of unchecked fury. Greek mythology is an orgy of divine misbehaving, of temper lost, of indulged impulse and caprice. The gods do not do self-restraint very well. In the *Iliad,* they watch approvingly as humans mimic their tantrums and follies; in the *Odyssey,* they and their henchmen watch helplessly while a sly smark alec outwits their traps. In the process, it is they who begin to look dull and primitive, a rather rough and shallow crew. Unlike the *Iliad,* the *Odyssey* in fact shows scant interest in the goings-on of gods on Olympus.[24] It is man, a creature of infinite reflection, who possesses real depth and height. No wonder the gods harbor such ill feelings. They are dealing with a self-creator.

Self-possessed Odysseus sculpts himself to the edge of mortality. In the *Iliad,* death sweeps up the warrior in a cymbal strike of gore and brutality. In the *Odyssey,* the matter receives a far more down-to-earth treatment. For Odysseus, the ultimate horizon leads not out of the human realm, but back to it. Our hero will die, as per Tiresias's prophecy, on the day he comes "to a race of people who know nothing of the sea, whose food is never seasoned with salt, strangers all to ships with their crimson prows and long slim oars, wings that makes ships fly. . . . When another traveler falls in with you and calls that weight across your shoulder a fan to winnow grain, then plant your bladed, balanced oar in the earth. . . . At last your own death will steal upon you."[25] Domestic, sedentary, unassuming: the exemplary man seeks reckoning, not trance. The hero will die on the day he trades the oar, symbol of adventure, for a farming instrument (a winnowing fan). This is death in the pastoral mode. Any fool can die by falling off a roof and breaking his neck or in the fray of battle; the wise man, by contrast, cultivates his mortal destiny. At his funeral we must imagine Odysseus being lowered into a deep-dug grave and not, as for the warlords of the *Iliad,* smoked skyward on a funeral pyre. Whereas the *Iliad* is the poem of the bellowing, white-knuckled death, the *Odyssey* is that of disciplined, cultivated, quiet death.[26] The mature self dies well, on terms of good husbandry, having worked mortality into the weft of existence, not by brutal accident. This level-mindedness—the idea of human life as laboring unto the horizon of finitude—is the key moral achievement of the *Odyssey.*

At some point, Odysseus's renunciation of the death beautiful, of apotheosis and immortality confronts the religious tradition. The hero journeys to the kingdom of the dead. To the Homeric Greeks, that kingdom occupied a place somewhere beyond the edge of the world, past the giant circumscribing stream known as Oceanus that was thought to exist beyond the straits of Gibraltar. In the underworld, Odysseus comes across his mother, together with kings and heroes. But the show-stopper occurs when Odysseus meets Achilles and lauds his god-like fame. In retort, the arch-hero rebukes the mortuary paean:

> No winning words about death to me, shining Odysseus!
> By god, I'd rather slave on earth for another man—
> Some dirt-poor farmer who scrapes to keep alive—
> Than rule down here over all the breathless dead.[27]

Immortality is no enviable fate. Achilles admits preferring life as a yeoman's slave than immortality as lord of the Elysian Fields. Human life solves nothing by extending indefinitely. Achilles sends Odysseus back to the earthly life with the knowledge that man's lot is to stand *toward* death rather than to tower *in* death. "Scraping to keep alive" may not sound like a lofty ideal; to the hoplite warrior, it may even be a dishonorable turn; yet maintaining one's existence against the power of gods and nature is the gift of Odysseus's journey. Scraping to stay alive means squaring soberly with death: neither embracing, nor denying, nor exalting, nor telling oneself soothing lies. Odysseus is a creature of forethought, toil, fortitude, and above all patience. Through him, we can read the Greek intellect of the eighth century becoming disenchanted with the traditional explanations of religion. Of course we must not press Homer's disaffection with the Olympians too far; the poem opens and ends with a conclave of the gods.[28] Undeniably, however, like his spiritual ancestor Gilgamesh, Odysseus and forgoes the consolation of magic and myth. His poem carves the passage of archaic Greece to a cultural "exorcism of fear."[29] His destination is the mortal horizon of Ithaca, not apotheosis in heaven or hell.

What was needful in the centuries to come was for religion to catch up with this human-oriented wisdom—lest it, religion, sink back to folk superstition. The invention of a religious mythology directly bound up with the pathos of human finitude is, as the next chapter unveils, the achievement of the Hebrew Bible.

Tremor

Northern Kingdom of Israel, 500 B.C.E.

In the beginning God created the heaven and the earth. And the earth was without form, and void; and darkness was upon the face of the deep. And the Spirit of God moved upon the face of the waters. And God said, Let there be light: and there was light. And God saw the light, that it was good: and God divided the light from the darkness. And God called the light Day, and the darkness he called Night. And the evening and the morning were the first day. And God said, Let there be a firmament in the midst of the waters, and let it divide the waters from the waters. And God made the firmament, and divided the waters which were under the firmament from the waters which were above the firmament: and it was so. And God called the firmament Heaven. And the evening and the morning were the second day. (Gen. 1:1–8)[1]

Written to answer the basic question, How did being begin? Genesis starts too late. In fact, the first verse nullifies the very question. Any cosmogenesis assumes the existence of what it purports to establish. It explains being by the prior existence of being—a preexisting oneness Genesis calls "God" (or "Elohim," as the writers of Genesis, probably of the priestly school known as P, call him). We can infer one of two things about Elohim: either he is the whole of being and therefore brings the world out of his bosom, or he is the important denizen of a super-cosmic world. In either case, some kind of universe antedates the creation, and Genesis therefore fails to take us to the absolute beginning. (Note that we see God already in motion *before* there is a time-space in which to move about.)

Genesis rides on the notion that existence needs explaining and that the best way to go about this matter is through storytelling, which instead of cosmic fixities, reels out the actions of intelligent beings (god, man) plotting their way through time and space.[2] A wild growth of exegetical schools (theological, historical, canonical, structural, ideological, anthropological, socioeconomic, etc.) effloresces around the Bible;[3] more recently, certain critics have taken the story-like structure of the Bible as an invitation to ply the tools of literary criticism on the grandfather of all Near-Eastern and Western books.[4] If the ancient Hebrews chose prose narration to convey their theological vision, then certainly there is something about prose narration (plot, character, mood, and the subtle uncertainties of the subjective voice) that connects with the Hebraic idea of the divine. As one biblical interpreter puts it, literary biblical criticism consists in putting oneself in "the world-story," the concrete psychological situation of the story.[5] But what world-story are we dropped into at the start of Genesis? Analyzing the opening section of Genesis is an interesting test of the literary approach because it requires imagining a space in which there is yet no space, a time when there is no time, a world without people, save for some mysteriously solitary character named El (or Elohim), whose existence precedes the narration proper. On this head, Genesis is a narrative about the time before narrative, about the possibility of narrative. And this situation of course is bound to get the philosopher's ear. A world-story without a world—what better goad to philosophy?[6]

In the crucible of theology, narrative, and philosophy that is Genesis, we share the standpoint of a supremely solitary character—God—at the moment he undertakes the creation. The point of *narrating* a cosmic-philosophical problem (why the world?) is to set us *inside* the situation—and a part of the theological meaning assumes taking this internal position. Let us therefore hover with Elohim in nonspace (the darkness of the face of the deep) and wonder what it is like to exist in a yet nonexistent cosmos.[7] Read backward, Genesis is mythological potboiler; read forward, from the cockpit view of its main character, it is a philosophic thriller featuring intelligence face-to-face with the horizon of being. Now is nothing; later there will be something. Now is the darkness on the face of the deep; sometime after there will be light. What is it like to behold the whole of being in the offing, about to be, a mere intention?

This situation is none other than that of self-conscious philosophical thought; it is an emphatically human quandary. As soon as we conceive of the world's existence, we cannot refrain from considering how strange it is that it is at all. In a sense the character Elohim in chapter 1, verse 1, enacts this pause of estrangement from being on our behalf. The universe is yet to be. It is without form and void—*tohu wa-bohu,* a term that the ancient Hebrew associated with the emptiness of the desert.[8] Might it just as well not be? Creation narratives of the ancient Near East are seldom concerned with puzzling out the ontological fact of existence; their more proximate and practical preoccupation is to draw a rough, functional map of the cosmos.[9] Owing to the prose narrative form and strong characterization of the creator God, Genesis is an exception. Readers miss its meaning if they don't enter, even for a moment, a situation where the world is nothing but possibility. The very thought plunges all existence into unreality—a well of nonbeing implied by the creation ex nihilo, out of the *tohu-bohu.* For where the world issues from nothing, one can always ask why nothingness could not go on for all eternity.

Ancient Hebrews were actually somewhat hazy on the particulars of this pre-world nothingness. The text of Genesis can be read as accepting, in the manner of neighboring Egyptian, Mesopotamian, or Greek cultures, the primacy of some watery chaos, cosmic egg, or primal act of parricide.[10] But as the Hebrews strove to distinguish themselves from their polytheistic neighbors and pursued the idea of the unique, omnipotent God, so it must have seemed that nothingness (i.e., no world, no other gods, nothing greater than God) was the only fitting backdrop for the fiat lux.[11] This doctrine, nowhere explicitly stated in Genesis, waited a few centuries to be explicitly recorded in subsequent books such as Job, which insist on Yahweh's triumphant, omnipotent exclusivity: "He hangeth the earth upon nothing" (Job 26:7).[12] But if nothingness is essential to God's exclusivity, one may legitimately wonder what led him to shatter this clean nothingness. Could not Elohim timelessly delight in his supreme, self-sufficient existence? If creation is the process through which the one became the many, why did unity need a manifold? The very fact of the world's existence throws a shadow on God's fabled self-sufficiency.

Is there a world because God abhors nonbeing? Not likely. For God is not nothing and could presumably have luxuriated in the ontological fullness of his existence. In fact, insomuch as the world is dated but divine being is not, Elohim must have hovered in ageless eternity

before making the world. But the point is this: we are never shown Elohim doing nothing and basking in his essence: "In the beginning, God created the heavens and the earth." Nothing is spoken of Elohim doing nothing. The human mind, it seems, cannot imagine consciousness without agency. An intelligent being that would be absolutely idle is inconceivable. Being is action. Action, however, presumes an arena to act in, a thing to react to or interact with: it assumes the existence of something other than the actor, that is, something whose objectivity is tested, played off, or contended with. The parable of a bustling demiurge who cannot stay put illustrates the basic intuition that life unfolds within limits, that without some kind of boundary, consciousness flounders. In short, there is no such thing—or at least no enviable thing—as absolute, indeterminate awareness. Even God needed limits. This is why he invented the world. The world is boundary: this is its primal shape or characteristic.

In point of fact, Genesis is sown up with boundaries. To create is, for Elohim, to gerrymander: his creation launches a flurry of chopping and divvying up and splitting (heavens from earth, light from dark, water from firmament, and ocean from land, not to mention the myriad subdivisions of fauna and flora, "each according to its kind"). A world is whatever exists by being fenced in. To be is to be apart. Or as the Psalmist sings: "The mountains rose, the valleys sank down to the place which Thou didst appoint for them. Thou didst set a bound which they should not pass" (Ps. 104, RSV).[13] The building block of life is the line.

Perhaps we need to understand Elohim's division making in a more general sense. In Proverbs, the voice of wisdom recalls the fiat lux: "I was there when he set the heavens in place, when he marked out the horizon on the face of the deep (Prov. 8: 27, NIV). The word *horizon* marks the primordial act of division: it is, in Job, the *hwg smym*, or primeval bisection, by which came a here and a there, darkness and light, earth and heaven.[14] There was a time when Elohim was all there was; after the creation there is Elohim and something else, a gap or a line, a horizon of difference. The horror exorcised by the creation is, one might say, that of unlimited being, that is, unchanging immortality. Indeed, it seems as though Elohim created the world to flee from everything he is: unchanging, perfect, Egyptian immortality.

If division does generate life, and if life is *generation* (etymologically, the production of distinct kinds, or *genera*), the question arises whether the universe is enough of a distinct entity for Elohim. Can the world really satisfy his need for boundaries? Does it really provide the resistant

material for agency to exercise itself on? After all, what is a boundary to an omnipotent being who can blot, break, or skip it at will?

Evidently, nothing that would be quite agreeable to divine taste. Else he would have rested for good at the end of the seventh day of Creation. He would have breathed a sigh over a job well done and forever seen "that it was good." But it was not good enough. So it is the eighth day, or the ninth day, or the millionth day, and Elohim shuffles around the pieces of his world. He stirs up a mist and causes rain to fall. But this is not much action. Then he hits on the real problem: there are mist, rain, and earth, but, "there was no man to till the ground" (Gen. 2:5). This is puzzling. We wonder what keeps the all-mighty Elohim from creating farmland and crops with a sleight of hand. Why does he need that strange new creature, tiller of the earth, *man*, to do a job he could dispatch in a trice?

Let us also note that, as the creation broaches the human level, an important change comes over Elohim. He changes his name from Elohim to Yahweh (biblical scholars generally agree that from chapter 2, verse 4, onward, Genesis is the work of a different writer named J, after "Jehovah").[15] Elohim is the name of the cosmic God; Yahweh is the name of the God who interacts with man—the name of a protagonist contending with an antagonist.[16] As antagonist, man performs an action Yahweh apparently will not do for himself (tilling the earth); he also baffles and disobeys Yahweh, generally complicating his world: all and all, he makes life less receptive, less pliable, more alien to Yahweh. This distancing God could not do perform alone. This is why he needed an antagonist: to limit him. By tilling and growing crops, man transforms the divine element (nature) into human work (culture): for God, however omnipotent, cannot take the world out of his own hands. So Elohim becomes Yahweh when he creates man to limit and contextualize him. Were he to till the earth, Yahweh would certainly be omnipotent; but he would also be the cosmic, unlimited God who does not quite know himself, because nothing, or no one, can quite tell him what he is not. He would live in an undifferentiated world, a world without limits, a *tohu-bohu* for always.

Thus Yahweh's initial surrender of property: "Let them have dominion over the fish of the sea, over the birds of the air, and over the cattle, over all the earth and over every creeping thing that creepth upon the earth" (Gen. 1:26). This is a creature of spectacular entrepreneurial character he has in mind. Begetting man in his own image, Yahweh produces a fellow maker with whom he now shares the world—a fellow

maker, perhaps a demigod, who can do for Yahweh what he couldn't logically do alone (i.e., limit himself). No wonder, then, that Yahweh can establish a relationship with this being. Of all creatures, man has enough autonomy to provide Yahweh with real companionship, not just ontological furniture. Yahweh says, "It is not good that the man should be alone" (Gen. 2:18). But given that Yahweh also made us in his own image (Gen. 1:27), does it not follow that it is not good for God to be alone either? Elohim the cosmic God becomes Yahweh, the personal God, to kill solitude. Accordingly, the signal feature of the new creature, man, is interpersonal relation. "God created man in his own image, in the image of God created he him; male and female created he them" (Gen. 1:27). The strange wording has sparked plentiful debate: Does Yahweh create one or two beings? Is humanity unitary or originally dual? Contradiction bedevils our birth: it seems that we are both singular ("he created him") and binary ("male and female he created them"). Perhaps we can work out the contradiction thus: biologically we are one species; metaphysically, spiritually, morally, the self is relational. It relates to, and is therefore distinct from, others. The human self lives among other humans knowing he is not them, only like them.

Thus Yahweh made man in order to not be alone; but making man in his own image, he therefore made man (the species) divided and internally unable to be alone. Adam is short of Eve, and Eve short of Adam. The human world is separation. Henceforth separation rules: between Adam and Eve, between man and Yahweh, who, understanding less and less his creature, increasingly turns into the god of tantrums, nepotism, and possessive rage. Between him and his charges, intersubjective misunderstanding rules.[17] Perhaps Yahweh begot more than he bargained for. He created man so that he would not be alone, but not being alone is to reckon with the existence of beings from whom one is terminally separate—a separation not to be bridged by physical movement, since it is the infinite separation between two minds.[18]

As God's boundary, man gives his maker no end of trouble. No sooner born, Adam and Eve *cross* their begetter, trespass the limit he had set up to restrict their freedom: of this tree you shall not eat. Very little is told about Adam and Eve's life before breaking Yahweh's command, nor about their interaction with him: disobedience is the action that pricks Yahweh's interest in them. Apparently Yahweh minds the whole thing (becomes the indignant, regretful, disappointed, angry, but always narratively and psychologically intense character) only when it begins to challenge, and therefore restrict, his godhood.

On eating of the forbidden tree, Adam and Eve achieve maturity. The scales fall from their eyes. They see themselves and how they are separate from God, henceforth creatures of time, mortality, and self-awareness. Self-awareness above all, which means they are creatures of knowledge. Yahweh's initial intent, we surmised, had been to create a companion, but he can have true companionship only with a like creature, in this instance a free and self-conscious being—whose freedom logically includes that of *not* doing God's will. And this is indeed what he gets, a being who disobeys, or (put otherwise) exercises freedom. Then the story of their difficult friendship can begin. Prior to disobedience, there is little interaction between the three protagonists; after disobedience, there is plenty of discord but also, finally, dawning relationships.

Now the world features a limit that is hard even for God to fathom. Looking at man, God sees through a glass darkly. Everything else in the cosmos is gossamer to Yahweh's all-seeing eye. But not man: here is a boundary he cannot peer through. (Any person is mysterious to any other. Each is liable to foil, baffle, or upset: the plot, and marplot, of Eden in a nutshell.) Yahweh is like the befuddled parent who understands, too late, that the apple of his eye has grown into a willful, wanton, rebellious, worrisome, but endlessly *fascinating* self: "Behold the man is become as one of us," Yahweh says in dismay (Gen. 3:22). No longer cosmically alone, Yahweh discovers that sharing the world brings anxiety. He loses his bearings. "And the LORD God called unto Adam, and said unto him, Where art thou? And he said, I heard thy voice in the garden, and I was afraid, because I was naked; and I hid myself. And he said, Who told thee that thou wast naked? Hast thou eaten of the tree, whereof I commanded thee that thou shouldest not eat?" (Gen. 3: 9–11). *Where are you?* Short, direct, urgent, yet also mind-boggling: how can God, who knows *all,* not know where Adam is hiding? This does not sound like a cat-and-mouse game. Yahweh realizes he has begotten a creature he literally cannot locate. Unable to place his ward, Yahweh is lost, exiled in his garden, which contains a blind spot, a horizon beyond his knowledge. Yahweh is no longer at home in the world. Man has made the world dusky and inhospitable to him. Yahweh's vengeance, when it comes, takes an eye for an eye: he inflicts disarray on us who caused it. As Yahweh loses the world, so do Adam and Eve—doomed henceforth to roam, at home nowhere, eking out a living wherever they go. And just as man became worrisome and impenetrable to Yahweh, so Yahweh becomes mysterious to us. In fact, he disappears. He flies back to the darkness upon the face of the deep, cloaks himself in transcendence, becomes the ineffable

God of Israel, no longer a casual visitor in Eden who was seen "walking in the garden in the cool of the day" (Gen. 3:8). He appears once more, to Abraham on the plain of Mamre (Gen. 18:11), and, with greater reticence (see chapter 5), to Moses. Barring these exceptions, he is heard of but no longer seen.[19] He inflicts on us what we inflicted on him, the opacity of one person to another. A "Where are you?" blurs the edge of his vision of us, and of our vision of him. We bedevil God's knowledge, and he bedevils ours.

Augustine suggested that, by asking Adam "Where are you?" God actually forced man to see his own wretchedness—a question asked not "in ignorance of inquiry, but to warn him [Adam] to consider where he was, since God was not with him."[20] Adam and Eve are plunged in becoming, sentenced to fret about the unforeseen. The *hortus conclusus,* the enclosed garden of Eden, gives way to the arid plain of mortal destiny. In sum, Adam and Eve enter a life that, says Augustine, "forces us to be anxious."[21] Henceforth, they exist before an existential horizon, their eyes set warily on the offing, and more warily yet on each other.

Homo homini mysterium: man is a mystery to man. Any person is potentially ominous. You may know things that I do not, or withhold information, or hatch sinister plans. "I will put enmity between thee and the woman, and between thy seed and her seed," Yahweh says in spite (Gen. 3:15). Strife rules over the human race, each person a stranger to the rest, man against wife, sisters against brothers, parents against children, the social animal perpetually at war. We puzzle, bewilder, deceive, and disappoint one another in turn. Whereas animal grouping is woven of indifferent closeness, human society is held by wary distance. The space is vaster between one human being and another than between the opposite ends of the universe. No matter how closely we attend, watch, or study other people, they recede in proportion to the scrutiny. They vanish horizonward.

The philosopher Martin Buber maintains that, according to a Jewish legend, Adam and Eve saw the sun set for the first time on leaving Eden.[22] Hitherto they had basked in the noon light of divine omnipresence; now their eyes are open to the lengthening, shadow-casting light of sunset, the fading horizon that suggests mortality. Yahweh warned that by partaking of the tree of knowledge of good and evil, Adam and Eve would die. In actual terms, they do not die; instead they gain mortal awareness: they become *mortal.* What, in the context of Genesis, is meant by the "knowledge of good and evil"? Yahweh fears that

partaking of this knowledge will make man and woman "as one of us, knowing good and evil" (Gen. 3:21). Some commentators have defended an ontological reading of the "knowledge of good and evil" alongside the traditional ethico-religious interpretation.[23] How, indeed, could Yahweh wish to keep his wards from the knowledge of the *moral* good and evil, when, by forbidding access to the tree, he acknowledges that Adam and Eve already grasp that it is morally good to obey and pernicious to disobey? Besides, what sort of good parent keeps his children from knowingly doing good and knowingly shunning evil? Another way of reading this antinomy considers good and evil as overlaying the cosmic binaries of life and death, being and nonbeing—as Buber puts it, the "yes-position and the no-position of existence."[24] The first use of the word *good* (and therefore of its implicit opposite, *bad*) in Genesis occurs in a nonmoral sense. Upon creating earth and sky, water and fire, beasts and birds, God repeatedly sees that "it was good": good by opposition to nonexistent, rather than wicked (since nature is not yet perverted). To be is good; not to be is bad. What is good, is; what is bad lacks existence.

Only Yahweh, who pulled the world out of nothing, knows the difference between nonbeing and being. Thus to know the distinction is, in a sense, to know as much as the demiurge, to stand where he stands. And this is just the knowledge that the disobedient couple gain in their trespass: they find out what it is to be and not to be. They understand life and death, fullness and lack. For instance, nakedness now strikes them as being without clothes, and they hasten to cover themselves. They also become mortal: beings who, although alive, live with the consciousness of their eventual demise. Mortals hold the awareness of their own nonbeing inside their being (animals, who do not know being and nonbeing, carry no such burden). Adam and Eve see themselves as though from a distance: today they exist, but someday they will be no more. They are haunted by the knowledge of what they once were, what they will, could, or should be.

Partners in being, but also partakers of nonbeing, Adam and Eve now exist in the temporal dimension—the conscious level where yesterday is shunted aside by today, as tomorrow will destroy today. The fullness of the day is undermined by the knowledge that it will be over in a short while. The temporal *now* harbors its nonbeing. Hence Adam and Eve's newfound anxiety: they have begun to long, to wish, to consider their present situation as unsatisfactory. Nullity colors their outlook (they are

not merely naked; they are *without* clothes). The interplay of being and nonbeing molds the landscape: they exist before a horizon—the very horizon over which, according to the Jewish legend, they behold the sun set for the first time. The light, once so good in Elohim's eye, now pours mortality over the earth.

In actuality, the woeful knowledge of being and nonbeing precedes the fateful act of disobedience. Arguably, as soon as Yahweh forbids eating of the tree, he ploughs a line right through Eden. What was once immanence now features an ugly scar dividing here from there, the actual from the possible. This is Yahweh's precise command: "Of every tree of the garden you may freely eat; but of the tree of the knowledge of good and evil you shall not eat" (Gen. 2:16–17). A distinction cuts between what man can do and what he must not do. Capable of assimilating a wisdom that will make us godlike, we are kindly asked to desist from it. Yahweh thus endows us with freedom, on the condition that we not use it (i.e., the definition of freedom: not to do whatever one wishes, but to pick, and therefore control, one's impulses). You are free, says Yahweh, but freedom means exercising self-restraint. Man is handed the power to define his own self, that is, to give himself limits. In this sense, man's creative dominion over the beasts and the fields of the earth now extends to his own self. He too becomes a field to till, a project, a work in progress. Before the tree that they can but must not touch, Adam and Eve understand that human existence unfolds within limits and that those limits are, to a large measure, drawn by their own hand.

But how can one receive creative license over one's destiny without kindling the desire to exercise it? No sooner we see a wall than our imagination jumps to the other side. From the moment they behold the tree, Adam and Eve see their own existence in the light of possibility: who and what they are now is shaped by who and what they can or could be. Put otherwise, Adam and Eve have evolved an onward *horizontal* perspective on their existence. And since what-is-to-be does not exist now, it follows that Adam and Eve have been touched by the awareness of nonbeing. Evil, that is, the attraction of nullity, burrows in them. It is this attraction that opens the human eye to the horizon, the gateway from actuality to possibility, from here to there, from the present to the future, from what-is to what-is not.

And so, as the legend claims, Adam and Eve behold the sunset beyond Eden. Hitherto their awareness has been whole, instantaneous, epiphanic; now it is splintered, drawn-out, horizontal, incremental,

incomplete. Before, embryonic immanence; now, the fall into *experience:* etymologically, the *ex-periri* (or "going beyond limits") of human becoming. From here on, humankind exists in continual exile: erasing and redrawing our outlines as we stab westward. The horizon is now our backdrop, exodus our narrative, and the declining sun our ambient light. The world has become dynamically amorphous.

Like *Gilgamesh* and the *Odyssey,* Genesis offers a narrative of how humankind comes by the knowledge of death; how, in other words, we achieve moral adulthood. Unlike its Mesopotamian and Greek cousins, however, Genesis figures in a religious framework and explicitly contains the story of a broken covenant: as religions go, this one centers on the *withdrawal* of its deity. Adam and Eve's first free action was to separate from God and thus force God into hiding. A believer in Yahweh is asked to exist as an estranged child of God. There is, from the start, too much distance, too much space, too much separation in the world.

At the outcome of chapter 3, Genesis finds itself in the difficult pass of losing sight of God.[25] If it is not to lapse into nihilism (so early in its career), the religion of Yahweh therefore has to invent a narrative that can reconcile existential exile with the concept of God: a theology that represents God in a world where we have lost sight of him, a world shaped by absence, incompleteness, and death rather than by the good things bestowed by God (i.e., presence, fulfillment, eternity). Can the idea of God survive in a hopelessly open-ended world? Genesis is a theodicy as much as anything else: as Elohim was a god of the idyllic orchard (*paradise* derives from the ancient Persian word *pairi-daeza,* "walled enclosure"), so Yahweh will have to exist as another kind of god—the god of the horizon.

Chapter 4 of Genesis ends with a short verse bluntly out of context with the foregoing list of Adam and Eve's descendants: "Then began men to call upon the name of the Lord" (4:26). As men and women multiply, they drift away from the source. Then suddenly they begin to pray. What is prayer? A prayer is future oriented: one prays for the future, the yet-to-come, the hoped-for. As the generations of Adam stretch into temporality, away from Eden, prayers are needed to maintain contact with the remote God. Prayer bridges distance but also reveals it. It is the utterance of humanity inhabiting a world of distance—the opposite of magic, which is the expression of a world in direct contact with the divine.[26]

The God who lived in the garden with Adam and Eve is not the same God worshipped by Abraham and Moses: the former was immanent; the latter must be looked for, called upon, prayed for. The former was synonymous with enclosure, the latter with the wasteland—the desert across which the children of Israel, taking up their parents' doddering steps, stumble in search of a home, a home beyond the horizon. The story of this exile (the story of prayer) unfolds the next chapter of our history.

The Philosophical Age

Exodus

The Desert of Moab, 450 B.C.E.

"God led the people about through the way of the wilderness of the Red Sea. And the children of Israel went up harnessed out of the land of Egypt. . . . They took their journey from Succoth and encamped in Etham at the edge of the great wilderness. And the LORD went before them by day in a pillar of cloud to lead the way, and by night in a pillar of fire to give them light, to go by day and night" (Exod. 13:18–21). Thus Moses—a Hebraic Gilgamesh, a Jewish Odysseus—pauses on the edge of the desert. He has led the children of Israel to the great Sinai. Behind their back lie three hundred years of Egyptian servitude; before them is a promise, the shimmer of milk and honey; in-between stretches a desert plain, bone-white under the blazing sky, across which Moses is destined to trudge for forty disheartening years, till his eyes burn with the distance, and his heart sinks, and his strength finally founders, a mere day's journey from deliverance.

In the desert, there is only the earth, the sky, and man in between. The land, the sky, and man gauging the gap. There, only geometrical absolutes obtain: up, down, across, and nowhere to hide. "God called to him from the midst of the burning bush and said Moses, Moses! And he said, Here I am" (Exod. 3:4). What else is there to say in this primal nakedness? The desert pares being down to a heart-sinking geometric austerity: here I am. Where else can one ever be? What else can one ever say for oneself? Every second of my existence sees me being where and what I am. There is no circumventing that. The desert makes this

eye-burningly clear: I ever see things but from where I stand, from *here.* And the "here" of the desert has this peculiarity that it lets me see, pro-verbially, as far as the eye can see. I perceive the extent of my perception all the way to its very edge, which looks like, but is not, the edge of the world. *Here I am* therefore means also: here I self-knowingly stand.

Why does God lead his "people around by way of the wilderness"? Why this forty-year-long trial by fire, hunger, privation, and doubt? Why not the fast track to the promised land? Why should the forty years of man's life be spent eyeing the heartless horizon? These questions invite us to consider Moses's journey as founding not just a religion of the desert, but a religion *by dint of* the desert: a desert-shaped cult.

If the Bible is full of deserts, it is first because of plain geographical realism. The ancient Hebrews set their national epic in the habitat they knew, a straggling strip of land between the sea and the immense Ara-bian Desert. Their god took on the color of their natural surroundings. Just as forests produce sylvan gods, and seafaring spawns sea gods, so the ancient Judeans saw God in the desolation they glimpsed from their tents. What met their gaze at morning was a great swath of nothingness *as far as the eye could see.* Geographic emptiness imparts something crushingly out of scale, imperial, inhuman. It is as good an intimation of a universal, abstract god as any natural habitat can give.[1]

Initiation and protocol also explain why Yahweh leads the tribe into the desert. Exodus is not just a historical event, but a permanent symbol of the relationship between Yahweh and the Israelites.[2] "The Lord God led you all the way these forty years in the wilderness, to humble you and test you, to know what was in your heart" (Deut. 8:2). The god of the Israelites was born of a grudging land where only punishing labor keeps starvation at bay: believers imagined that God, too, must be hard-won. The Hebrew God is the god of a hard-bitten people who put a high premium on perseverance; hence a god who comes with a bill of conditions and contractual pledges: a god who holds his payoff against a forty-year investment. Where life is eked out by toil, the gods too are won by sweat and tears. The lush tropics will produce gods of cyclical plenty (e.g., Brahma in India, *mana* in Polynesia); in the desert, one can-not count on the timely monsoon. The subsistence farmer or goat herder must plan ahead, hope ahead, fear ahead. The nomad must economize his slender reserves, practice careful husbandry. "Prepare in the desert a way for the Lord," proclaims the prophet, "make a straight highway for our God across the wastelands" (Isa. 40:3). Before the forty-year exo-dus in the desert, the children of Israel are an amorphous, frightened,

indecisive people: a huddle of slaves whose main asset is a high fertility rate. After the exodus, they are a proud, war-like, headstrong ("stiff-necked") people, confident in their laws and rituals. They have given birth to themselves by hard scrabble. Such a people will beget a god not of plenty but scarcity: a hidden god, a god of promises, a god who keeps himself in the offing at the end of a grueling horizon.[3] Yahweh's forty-year game of desert hide-and-seek is the Jews' labor of self-definition.[4] This labor perhaps explains why, as has been noted, ancient Israel was alone among ancient Near Eastern religions in articulating its religious epic in prose rather than poetry.[5]

But Exodus also solves a problem left unsolved in Greek polytheism. The Olympians always meddled with human affairs, mostly, it seems, to kill boredom, to forget they had nothing crucial to do. The Greek gods were gods of the past, of tradition, of the already established. Locked up in their essence, their repeated message to humans is to keep to the containment pen of humanity. Hubris is smacked down by nemesis. Self-creation, self-discovery will get you flayed alive. But the ancient Hebrews were a self-inventing people, a people *in statu nascendi* who felt the precariousness of their situation. They therefore relied on a god who aided human inventiveness, a god who goaded man onward. Such was the Yahweh of the desert exile: a god always a step ahead, a god who teases us, who indulges our hubristic urge to chase him, who relishes his winning advantage at the game of becoming if only to bait us further.

There is evidence Yahweh changes over Exodus. At the outset of the journey, Yahweh does not quite know who he is or what he is about.[6] He wavers, postpones dealing with the pharaoh, is easily swayed by Moses's remonstrance. He also tries to kill Moses but rather un-omnipotently fails. Less than transcendent, he is really the god of an ethnic tribe. By the end of the epic trek, however, Yahweh waxes larger than the landscape; he is larger than the sky, wielding not just physical but also moral and intellectual authority. He is as huge and hollow and ungraspable as the desert. He is god of all, the god that has routed all other gods, the deity of the mystical horizon. At the start of the journey, Yahweh is present in the burning bush, and nowhere is the distance between man and deity so close; toward the end of Exodus, even Moses cannot rest his eyes on God.[7] In the desert, Yahweh becomes sublime.

Hence the question: what about the desert enables God to become the transcendent God? How does the desert—land of geometric emptiness—enable God to become metaphysical?

To answer these questions, we must step into the perspective of the ancient Israelites. It seems that, at least at the beginning, the desert was foreign to them.[8] Else Yahweh would not offer himself and his guidance by a pillar of smoke and a pillar of fire. He travels "the way before you to search out a place for you to pitch your tents, to show you the way you should go, in the fire by night in the cloud by day" (Deut. 1:33). How could the desert be anyone's home? It belongs to sandstorms alone, and no one could want it. It is unmarked, untouched by the civilizing hand of commerce, travel, property: an otherworldly place where only gods roam, a dropped fragment of the cosmic emptiness. Thus Jeremiah recalls the exodus:

Where is the Lord
Who brought us up out of the land of Egypt
Who led us through the wilderness
Through a land of deserts and pits,
Through a land of drought and the shadow of death
Through a land that no one crossed
And where no one dwelt? (Jer. 2:6)

We need to picture nature at its unearthliest: a place where no plant grows and animals die; a land no one claims or dares travel through; a land of nowhere; a land where (as Gertrude Stein said of Oakland) there is no there, there. Or perhaps there is only "there" and not much else, not enough at any rate to sustain human life. It is, one might say, the domain of God—of everything that is absolutely *unlike* man. "I bore you on eagles' wings and brought you to Myself," Yahweh says on Mount Sinai (Exod. 19:4). From which we infer that there is something about the desert that is *like* God and allows him to be more tangible and more intelligible than any other place.

Etymologically, the desert is a *deserted* track, a place from which something has been removed. By the same token, it is not quite empty: there lingers a trace of some departed quantity. Perhaps this near-emptiness testifies to what Aristotle called our natural abhorrence of the void. Nothing is nothing, the Greek philosopher Parmenides said: the only way we can conceive nothingness is as negation (the absence of something). And so it is with the desert: the very word signals that it is echoingly full of what it lacks: entities, beings, people, generally the sort of things that a world is made of. As the philosopher Martin Heidegger densely put it, a world *worlds*: what we expect a world to do is to make up a positive sum, the sort of vital fullness that prompts

Yahweh to declare *it* (the world) good—good, that is, as opposed to nonexistent.[9] Incidentally, it is the goodness of existence that explains why, defined by absence, the desert can be called a "badland," that is, a world that *unworlds,* undoes the work of God and is therefore not good, or godless.

There is much in the Bible that justifies this pairing of desert and godlessness. When God drives Adam and Eve from his presence, he sends them to the accursed land of thorns and thistles that henceforth is the world (Gen. 3:17–18). The weeds stand in contrast to Eden's orchard, a sign that perhaps God has let the world go to seed. God's absence makes the earth into a "great and terrible wilderness, in which were fiery serpents and scorpions and thirsty land where there was no water" (Deut. 8:15). Deserted of God, the desert is the anti-Eden, the kingdom of the serpent. In the New Testament, accordingly, the devil appears to Jesus in the desert: a place that must be god-forsaken enough for Satan to carve out his corner (for where God universally is, evil cannot logically wedge in).

But if the foregoing holds true, we come to a puzzling pass. Why does God lead Moses's people into a place of godlessness to reveal himself? Exodus reads like a sustained theophany (or unveiling of God), though ultimately the long trek leads to God's passing out of sight, and out of direct human contact. This seeming contradiction requires looking into.[10]

The desert is not just an obstacle on the way to God; it is also God's chosen medium (a burning bush, a voice in the whirlwind, engraved tablets). Thus we need to understand what is God-like about the desert, or desert-like about God. To suppose there is something god-like about the desert suggests there is something godless about God (since the desert is the anti-Eden). But this is illogical, unless we consider that, next to the motley pagan gods of folk cults, Yahweh must have first struck the early Israelites as a puzzling deity (as ungod-like as Jesus would seem someday). Yahweh, too, was once a maverick god. Next to Baal, Moloch, Dagon, and the bevies of gods who patrolled the sky or the storm or the volcano, Yahweh must have seemed an etiolated creature: a god of words and laws rather than muscle and magnificence (which he still is in Genesis: e.g., the flood); a god who hides inside a pillar of cloud, tells Moses no man is ever to behold his face (Exod. 33:20), and becomes a voice in the whirlwind, then an idea or ideal, a law, the silence of contemplation.

This process of abstraction parallels the ascendancy of philosophical monism in the ancient world. By monism, we mean the insight that, behind its manifold aspects, the world is one; that all existing entities

share a common substance in the absence of which they would not exist: that is, being. It is one logical short step from monism to monotheism.[11] Monism deduces the necessary oneness of all existing things, and monotheism, similarly in search of a unifying principle, translates this oneness into a supernatural entity: the god of all gods, the jealous god, the one God, or *monos theos*. If being is all but God does not subsume it, then either God is kept from the world (which thereby limits his power) or God is a resident of the world, but in any case less than the world: in either case, God is not all-powerful, omnipresent, and universal; he is not the "jealous god" next to which nothing greater can be conceived (Exod. 34:14; Deut. 5:18). This is why monism and monotheism walk in tandem: God must not be less than the sum of existence, and the sum of existence cannot be anything apart from God. This, in much fewer words, is the vision conveyed by the opening line of Genesis: "In the beginning God created the heavens and the earth." The whole of being comes out of God, not God out of being.

The one God, however, sets before the believer a practical problem. How does man worship the oneness? How do we address an entity that pervades all existence? With a god that was one among many, who dwelt in a sacred grove or a mountain or a tabernacle, the believer could deal in personal terms, as one being to another; but how to turn to an all-pervasive essence that floods everything inside and out? The monotheistic God is not *in* the world; he is that by which the world exists. This idea is not altogether clear at the outset of Exodus. The chieftain god that shows up face-to-face with Moses is clearly less sublime than the Elohim that hovers over the face of the deep. And it is still an insecure god that hands down the first commandment. How could an absolutely all-embracing cosmic god possibly be bothered by the existence of other gods? (They, too, would be him, as the four faces of Brahma are Brahma.) "Thou shalt have no other gods before me": the commandment makes no sense unless Yahweh sees himself battling other deities for human attention. And so long as man can stray to worship at other altars, God, one might say, is yet to exist fully in the part that seems to matter most to him: human consciousness.

Exodus, however, achieves this transition establishing Yahweh as the exclusive deity, the *monos theos*.[12] There the unique God reminds Moses that "all the earth is Mine" (Exod. 19:5). As to what this master of the horizon should be called, God offers this suggestions: "When they ask you what my name is," he tells Moses on their first encounter, "you shall say to the children of Israel, I AM [*Ehyeh*] has sent me to you. . . . This is

My name forever, this My appellation for all eternity" (Exod. 3:14–15). God is still Elohim when Moses approaches the burning bush; after the encounter, he is Yahweh, the kind of deity that self-consciously says "I AM" (it would be illogical for the being out of which all beings proceed not to contain the awareness that it exists).[13] God is not just Y-H-V-H (the primal "be") but also *Ehyeh* (i.e., the kind of "be" that exists as an "I").[14] When, in response to Moses's question, God says, "I AM THAT I AM" (*Ehyeh-Asher-Ehyeh:* "I be that which I be"), he corrects the archaic reduction of God to a mere entity (Exod. 33:19) and conveys that he is not to be thought as existing in the ordinary sense. Being is not a contingent quality he happens to have; rather, being comes from him and is inconceivable apart from him.[15]

This is a nice development because, although we have but the vaguest knowledge of what counts as the groundwork of all beings, we certainly know, from human experience, what having self-awareness is like. We therefore feel licensed, in theory, to imagine, worship, and address the supreme deity as an intelligent self-conscious entity, indeed a monarch—which Yahweh ostensibly embodied for the nation of ancient Israel.[16] This assumption, in fact, gives flesh and bones to God in the first chapters of Exodus and allows him to sit with Moses at the tent (Exod. 16:10) or to chisel commandments with his own finger.

As reassuringly familiar as this anthropomorphic god would have been to his early worshippers, he must have struck the Hebraic monotheists as sacrilege. Around the same time monotheism was coalescing in Judea, the Greek philosopher Xenophanes quipped, "If men were horses, God would look like a horse."[17] Was it not absurd to imagine God with human moods and affections? And didn't the very notion of God encased in personality offend the concept of limitless and supreme godhood? Some writers of the Tanakh, the Hebrew canon, thought so: "You cannot see My face; for no man shall see Me, and live," says Yahweh to Moses (Exod. 33:20). Indeed the first commandment (that Yahweh be all) necessitates the second commandment (that there be no likeness of Yahweh). For a god who appears in person is no longer everything but something. The turn between first and second commandments hinges on the principle that, if God is all, it is illogical and sacrilegious to squeeze him into a picture.

This realization gathers momentum through the Pentateuch, the first five books of the Hebrew Bible, but only comes clearly to light in the later books. This is what the prophet Elijah learns from his forty days in the desert: "And behold, the LORD passed by, and a great and strong wind

tore into the mountains and broke the rocks in pieces before the LORD, *but* the LORD *was* not in the wind; and after the wind an earthquake, *but* the LORD *was* not in the earthquake; and after the earthquake a fire, *but* the LORD *was* not in the fire" (1 Kings 19:11–12). Gone are the days when Yahweh impressed mortals with wonder-working tricks. Just as a container cannot fit inside its contents, so the Lord God cannot be *in* the wind, the earthquake, or the fire. The world of appearances is contained in God, not God in them. God, if you will, is the backdrop against which mountains, rocks, fire, wind, and earthquake body forth. In painterly terms, he is the vanishing depth that pushes things to the fore.

Now, should we want to imagine this God of distance, we need a medium as vast and void and bare or universal of features as him; a medium that reminds us that we cannot actually pin down God; a medium that signals the god-shaped formlessness out of which things stand forth. In the desert, we see as far as the eye can see; we thus see human perception limiting itself, seeing how much it cannot see. The desert, in this sense, is full of the reminder of the invisible. There, we see that we cannot see God. How else can the universal God appear if not by humbling the eye? And what humbles the eye more implacably than seeing itself vainly chasing after the horizon?

As promised, God unveils his glory in the Sinai desert. But his glory lies not in things seen; instead it transcends sight, touch, and taste.[18] The pagan, magician mind feasts on jangle and dazzle, shiny tokens like a golden calf, whereas the monotheistic mind is mesmerized by what eludes the eye. When it sees God, it sees something passing out of sight. God's glory consists in his vanishing. So Yahweh seems to convey when announcing that he is henceforth to be seen receding away: "So it shall be, while My glory passes by, that . . . I will cover you with My hand while I pass by. Then I will take away My hand, and you shall see My back; but My face shall not be seen" (Exod. 33:22–23). People turn their back on an interlocutor either to leave or impart rupture. On the desert plain, we have magnitudes of space to watch the caravan dwindle out of sight. This is how God wants to be known: as the back or backdrop that fades away. The god of the desert appears as horizon; he is god of the horizon. This is the image seared into our eyes as we trudge across the desert plain: distance exhausting vision, God exhausting knowledge, the horizon exhausting us.

Yet the desert is more than a symbol for the vanity of human knowledge. It is also the place chosen by Yahweh to impart the imperiousness

of his existence. To understand why Yahweh elects "a whole land of brimstone, salt, and burning" (Deut. 29:23) leads us to investigate the kinship between God and nothingness. What could possibly draw God to nothingness?

The desert is creation pared down to its core elements: sky, earth, and the human hyphen that stands in between. It is the blueprint of a world, its outlined possibility, its schematic essence. There, we perhaps glimpse at the world before creation, the darkness upon the face of the deep. And it is then, when "the earth was without form, and void" (Gen. 1:2), when he holds back from actuality, that God is most intensely transcendent. In a created object, the craftsman objectifies, and thereby limits, himself; his exhausted creative power is contained by the created. In the uncreated object, by contrast, the maker hovers as pure creative power. This is Elohim moving over the face of the waters. That God is the power of creation, which is much greater than all created things. For whereas the power of creating can beget an object, no object can beget the condition of its begetting. It is therefore in the desert of the first verse of Genesis, before the possible turned into the actual, that God is most quintessentially himself, that is, a demiurge.[19]

The initial desert of Genesis raises other perplexities. Where is God in the darkness of the deep? Surely he cannot be a creature, because a creature entails a world in which to find itself—whereas a world here is yet to be supplied. Thus the demiurge is not a being in the worldly sense. His paradoxical existence strains the imagination: an intelligent nothingness cruising through the nothingness of the unbegotten cosmos. "Nothing comes out of nothing," says Parmenides (King Lear agrees). But in fact it does—at least in the first cosmic moment. If the world began, it can only have sprung out of a force utterly unworld-like: so utterly unlike existing things that "nothing" seems the only proper word for it. This religious realization of the embeddedness of being in nothingness is what overwhelms the desert pilgrim. In the desert, we behold the world tottering on the edge of nonbeing. It is still brimful of the nothingness from which creation sprang forth. Though blazingly bright, the desert trails vast swaths of the dark, primal nothingness. We wonder how it is there at all. The wasteland holds on to existence by the thinnest thread—it is being in its raw, bare, stripped-down fact. This is why Yahweh chooses the desert: its emptiness echoes with the cosmogony; there we still feel the demiurge moving over the world without form and dark. The desert cleaves exquisitely close to the void. The pencil of the designer God still hovers over it.

But nature, Aristotle said, hates the vacuum. The void is unlivable. In the face of such emptiness, it is natural to yield to the temptation of a vernacular, tangible God. Journeying forty years in so much emptiness, one is excused for thinking this much absence a proof of Yahweh's nonexistence. In the desert man finds, but also loses, his religion. The horizon exalts and exhausts prayer: after forty years, we come round to the belief that the horizon simply has nothing to give. Monotheism starves the human need for personal contact; it is too cosmic, too abyssal. So we turn to the idols once more. And thus the peaks and troughs of Israel's journey through conversions and apostasies, the relapses into Baal-worship harlotry, and Yahweh's disgusted wrath.

But in fact the risk of losing God is integral to the desert. Those who wrote the life of Jesus, himself a Jewish prophet, understood this. They also understood that a believer needs to go through the starvation and the temptation of idolatry before finding God. Like Moses, who remains forty days face down on the ground, or like Elijah, Jesus spends forty days in the wasteland. There, he endures the extreme absence of God. "Jesus, being filled with the Holy Spirit, returned from the Jordan and was led by the Spirit to the wilderness, being tempted for forty days by the devil" (Luke 4:1–2). Observe that it is the godhead who calls Jesus to the desert and therefore to Satan. God wants the son to feel his absence (epitomized in the person of Satan). But Satan the contrarian wants the son to adjure God's invisibility. Turn these stones to bread, the adversary urges. As if to say: embody God's power! Furnish the desert that we may see God! And when this does not work, the second temptation: If you are the son of God, throw yourself down from the top of the temple and walk away unharmed. As if to say: show that the world is full of God and physical reality is his to play with. To yield to this temptation would make the world less forlorn, more magic-filled. But must we believe in God because we see him? And if we see him, have we not trapped him in an inadequate appearance? Finally the last temptation: Satan invites the son to leave the desert in exchange for the kingdoms of the earth: all he need to do is reject the disheartening concealment of God to be restored to Eden. Forgo this god of emptiness, embrace the tangible! But Jesus chooses the desert; he triumphs by going to the very lengths of the wasteland, into the depths of the vanishing trace of God. Anything else is idolatrous; anything else abuses the monotheos.

Yet there is one more trap the devil forgets to spring on the pilgrim. Once we have shunned Baal and the golden calf and the childish need to embody God, there remains the temptation of worshipping our inability

to know God: the temptation to worship, so to speak, the desert of our worshipping. This is a snare because, as Jeremiah says, in the desert "no one dwelt." We must not make a cult out of the desert, lest we make something out of nothing. The desert is God's place, not ours. Can a temple ever contain the horizon?

This is the question on which the Mosaic journey finally runs aground. For Yahweh sentences Moses never to reach the land of milk and honey, but to die agonizingly short, indeed within sight of the promised land: "Go up this mountain of the Abarim, Mount Nebo, which is in the land of Moab, across from Jericho; see the land of Canaan, which I give to the children of Israel as a possession; and die on the mountain which you ascend. . . . You shall see the land before you, though you shall not go there" (Deut. 32:49–52). Condemned to perish *within view* of the land he is never to reach, Moses should die *and* see the distance at the same time. As though he should perish *from* hankering after the horizon—death by yearning. "This is the land of which I swore to give Abraham, Isaac, and Jacob, saying 'I will give it to your descendants.' I have caused you to see it with your eyes, but you shall not cross over there" (Deut. 34: 4). God wants Moses to die seeing the gap between hunger and food, between man and God. He wants man to see the horizon forever: the longing and the cosmic backdrop, always a length ahead. Moses expires gazing at God's disappearing back: following the final theophany of Mount Sinai, God is a passing presence (Exod. 34:6). Perhaps Moses dies from having seen God; he certainly dies *to* see God.[20] The condition of being Yahweh's hierophant and prophet, it seems, is to lack him always. For God's chosen one, God is a horizon, a promise, a future.

As for his people, however, they must not fall to idolizing the unsated longing. Yahweh is jealous of the cult we may be tempted to make of our infinite hunger for him. "So Moses the servant of the LORD died there in the land of Moab, according to the word of the LORD. And He buried him in a valley in the land of Moab, opposite Beth Peor; but no one knows his grave to this day" (Deut. 34:5–6). Yahweh lays Moses down in an undetectable grave so as to avoid a second-order idolatry. Moses has given his mortal soul to the horizon, and the horizon swallows it. So supreme is the infinite longing that it blots out the longing worshipper: no grave for Moses; only the desert. When nothing remains of us to encounter him, not our grave, not one human trace, then the god of monotheism will descend. But the desert must not house a monument to our disappearance. The unmanifest God will return where and

when there is nothing and no one to comprehend his return—in the absence of man.

In summary, Mosaic monotheism draws the picture of a world hollowed by the divine. It marks the world out as absence—absence of being, of the absolute, of the true reality that is God. But this cosmic emptiness, at its purest, turns out to be the proper conduit for divine representation. The One cannot be presented; the world embodies its absence, but by embodying absence, gives the only proper representation of the divine. In these dialectic twists, we witness civilization moving toward a more cosmic, spatial, less encumbered idea of the ultimate reality. It is then, around the seventh century B.C.E., that men and women began setting their sight on *the most distant things*, rather than the needful things of daily life (animals, ancestors, the weather) to symbolize their relation to the ground of being. It is then, in other words, that absolutes like the void, empty space, distance gained ascendancy in human worldviews.

Yahweh is the personification of Hebraic monotheism; he embodies one way, but by no means the only way, to work out the intellectual complexities of monism, that is, the intuition that the one underpins the many. In fact, at roughly the same time the lineaments of Moses's epic were written down in their known form, around the fifth century, a new experiment in drawing the larger shape of reality was under way on the Ionian coast of Anatolia, in what was becoming known as the Greek Mediterranean.

Synthesis

The Hellenic Archipelago, 500 B.C.E.

It is evidence of Homer's great influence that nearly nine hundred years after his poems were committed to writing, savants still cobbled their map of the world from snippets of the Homeric text—stitching up the map with the golden thread of poetry. We have the first-century Greek geographer Strabo (63 B.C.E.–24 C.E.) to thank for collecting this lore into his seventeen-volume summa *Geography*, a compendium that heartily mixes observation, geopolitics, hearsay, and sailors' tall tales. At its widest span, the world was thought to be bounded by an expanse of water, called Oceanus, beyond which the imagination dared not stray: "We may learn both from the evidence of our senses and from experience that the inhabited world is an island; for whenever it has been possible for man to reach the limits of the earth, sea has been found, and this sea we call Oceanus."[1] Strabo had this fact on the highest authority: "Homer declares that the inhabited world is washed on all sides by Oceanus."[2] So long as the ancient world remained factually bounded, mythology prevailed. Oceanus girded the world, and there conceptual imagination dropped anchor and rested.[3] It woke up on the day the inquisitive mind could no longer ignore the question as to why and how the world was bounded. Prephilosophical Greece was limited by what otherwise nourished its poetic genius: its attention to the variegated facets of the sensual world. Homeric poetry is shot through with Hellenic empiricism. The concrete mind at its most artful, Homer can detail the gildings of a shield, oars spanking the froth-speckled surf, an ax

hacking into a heifer's neck with an almost sensual directness. But this naturalism glides from one bright thing to the next in a forest of facts, and seldom climbs to take in the ontological panorama. In the Homeric mind, being is beings, and the world is the multiplicity of the things it contains. The Greek word for "is," *esti,* applied chiefly to material bodies. The archaic Hellene said "this is" and "that is" and showed little inclination to parse the "is" on which "being is beings" hinges—until, that is, the period to which we now turn, which saw the philosophic springtime of Greek thought.

The metaphysical mind was born when, not content with asking what something is, man was moved to asked what "is" is.[4] What sustains the existence of a thing? Is it self-contained? What substance binds it to its surroundings? For instance: is Oceanus unbounded, and is that conceivable? Or if it is not, what does it rest on? *Where,* come to think of it, is the world?

The first thinker to be struck by these questions loosened the cognitive hold of mythology and invented philosophy. He is known as Thales of Miletos (c. 624–546 B.C.E.), and with him begins the adventure of ontological inquiry—the labor of wondering what "is" is. All we know about Thales derives from secondary sources, and so a definite portrait of either the person or his philosophy is conjectural. He lived in the Greek city of Miletos, in Asia Minor, which during his lifetime was occupied by the Persians. There, he may have come into contact with monotheism: as Herodotus notes, the Persians had little regard for the rag-tag family of Olympians and believed that their Zeus encompassed the whole firmament. This may have inspired a thinker like Thales to train his eye on the largest possible reality. In *Lives of the Philosophers,* Diogenes Laertius records a detail of Thales's life that epitomizes the philosophical temperament. When asked why he did not have children of his own, Thales answered: "because I love children."[5] Thales loves the *idea* of children too much to muck about with actual children. The drawback of the philosophic cast of mind is that it overlooks the tangible rarities of individual beings; its advantage is to shield the mind from parochial biases. It considers things from the broadest possible angle, including one's own life, indeed life itself. Thales once stated that death is really like life. When a wag asked him why he did not just die, Thales replied, "because it makes no difference."[6] Indeed it makes no difference *in the cosmic scheme of things,* which alone matters, whether the incidental life of one Thales ends today or tomorrow.

Now, what did Thales see when he looked at the totality of life? What did all children in the world, but also the trees and birds and clay jars and temples and philosophers, have in common? What was the governing principle (the Greeks used the word *arche*) underneath it all? Thales's famous answer, "water," matters less than the fact that it broke with the old way of thinking piecemeal. In "All is Water" it is *all*, not water, that matters.[7] Thus began what Arthur O. Lovejoy called the "monistic pathos": the habit of looking for the *arche*, the first cause and ground of being underneath the forest of facts.

But there comes the rub: notwithstanding the *arche* itself (i.e., whether it is, as other Ionian and Eleatic philosophers ventured in turn, water, air, or fire), a valid question was to ask, Where is the *arche*? Where is the everything? The answer of course is that, being everything, the *arche* is also everywhere; and since there is no place that is not *arche*, the *arche* is therefore infinite. This conclusion was reached by Anaximander (610?–546? B.C.E.), a pupil of Thales and fellow Milesian citizen. His reasoning seems to have been that the "all" could not be merely a large, nor even the largest, measure of things, since to speak of comparative and superlative entails comparing between different sets. The all makes up a unit that exists next to no other. It is a paradox: the one that is not a number, the thing of no dimensions whatsoever. For a thing is by definition finite. And it is necessarily somewhere, more here than there, which evidently cannot be true of the universal being, which floods all places at once.

Following this logic, it is obvious that the *arche* could not possibly be an element, neither water, air, nor fire. Accordingly, Anaximander unhooked the cosmic totality from matter and posited a noncorporeal, truly infinite principle, a being beyond beings that did not just make up the world but instead *was* it. Anaximander, Aristotle writes, "said that the infinite is principle and element of the things that exist. He was the first to introduce the word 'principle.' He says that it is neither water nor any other of the so-called elements, but some different infinite nature, from which all the heavens and the worlds in them come into being."[8] To this all-pervading principle, Anaximander gave the name of *to apeiron*, whose etymology (*a-peros*, the "without-limits") underscores the intellectual nature—a fruit of logic, not observation. To the second-century commentator Hippolytus of Rome, the significance of Anaximander's *to apeiron* really lay in its being ideational rather than substantial: "Anaximander said that a certain

infinite nature is the first principle of the things that exist. From it come the heavens and the worlds in them. It is eternal and ageless, and it contains all the worlds . . . Anaximander said that the infinite is principle of the things that exist, being the first to call it by the name of principle."[9] Whatever Being was, it could not begin or stop at something that was not being. For suppose it ended before a point; this point necessarily was part of Being. Five centuries later, the Roman philosopher Lucretius came up with the related allegory of the spear of Archytas: imagine (he proposed) the world to end somewhere; clearly, this limit assumes there is a space within as well as without. Should Archytas throw his spear at the outermost boundary, the javelin will not just disappear. Or if it does, it would be correct to say that it went somewhere. The spear can therefore fly into more space and so on till eternity. Ergo, the universe stretches infinitely in every direction.

That was Lucretius's take on *to-apeiron*. Anaximander's endeavor to convey the underlying universality without reference to anything corporeal was a perfectly coherent move: the unlimited is not established by observation or by mathematical circumvolution. If the unlimited truly is so, no effort at designating it will get off the ground. Reason, it seems, had stumbled on a concept that, born of reason, could not be adequately grasped by it. Paradoxically, it was the inability to fit the world inside a concept that yielded insight into the cosmic whole.

Given the speculative rather than empirical origin of the concept of infinity, we can say that Anaximander created a reality shaped by the intellect: it was by speculation, not observation, that he contoured the world. Anaximander cannot have observed that the world is infinite. To fathom reality man had turned inward. (This slide from the object-world to the subject-world underlies the difference between Thales and Anaximander: the former's notion that all is water derives from watching the sea, the sky, clouds, vapors, the human body, plants, etc.; the latter's *to-apeiron* is not observable.)

Anaximander's *to-apeiron* certainly must have jolted the early Greeks out of their entrenched empiricism. It must have seemed that wherever they looked, horizons sprang up. Behind any thing, there were always more things, and beyond the farthest reach it was always possible to make out further distances. The world, it seems, had been knocked out of bounds. And this helter-skelter universe, in fact, is the notion that galvanized the philosophy of the next great pre-Socratic thinker, Heracleitus. In his vital universe, the world rolls and quakes, streams and ebbs and

mutates always. This motion, he called *logos,* a word distinctly lighter on rationalistic associations than in the meaning later imparted by Platonists. By *logos,* Plato understood an intelligent, guiding nomenclature behind the wilderness of appearances; Heracleitus's *logos* more messily expressed the stream of change, action, and process that roils through Being. Rather than a universal lump, the cosmic totality is a scrimmage of tumbling forces. "All things are in motion and nothing remains still," says a fragment by Heracleitus.[10] War is the origin of all. The same river is never crossed twice. Every entity, every unit of being, every smidgen of matter slips down an internal horizon of becoming—it seeps, melts into other forms. "We are and we are not," he mysteriously says.[11] This is because we are always in between two states, straddling what we were and what we will be. The one indeed is not a thing, nor a place. There is no "is" there; no there, there. The world is whirl and shuffle.

This picture of a quicksand universe must have struck the ancient Athenians as unnerving, indeed a touch too oriental. (Thales, Anaximander, and Heracleitus all hailed from Ionia, in Asia Minor, the most eastern of the Hellenic provinces.) The northern Greek sensibility that gave rise to Doric architecture, to mathematics and strophic poetry, evidently flinched at all this arabesque cosmography. Thus it is a philosopher from Elea (on the Italian coast) who pointed out the flaw in Heracleitus's cosmos-in-motion: Parmenides (520?–450? B.C.E.) asked whether, taken as infinite, the one could actually change at all. Parmenides must have argued that change entails cessation: to change, a thing must stop being what it is and resume elsewhere under an altered form—or else nothing changes. Such interruption, however, cannot occur to ubiquitous and eternal Being. For the cosmic totality to change, it would have to change into something else: but how can it change into something else when it is all? Moreover, being ubiquitous and omnipresent, there is no unfilled place for it to effect a transition into. As infinite, perpetual, and complete, Being is necessarily immutable. As Parmenides asserted, "[What exists] is now, all at once, one and continuous. . . . Nor is it divisible, since it is all alike; nor is there any more or less of it in one place which might prevent it from holding together, but all is full of what-is."[12] "What-is" never began, since it is inconceivable that the world came out of nothing. Nonbeing is not merely absence or void, but the impossibility of there being something at all, including the void, including even the existence of that impossibility. What-is was not born, cannot end (where could it end?), and therefore

does not transit in between. "What-is was not in the past. What-is will not be in the future. What-is is now, all at once, one, continuous."[13] Being is already here, there, and everywhere, and forever.

Heracleitus's mind worked inductively: extrapolating *what* the world is from his observation of *how* it functions. By contrast, Parmenides' method grew from speculation: his intuition of the world derived from a logical definition of its concept. He showed change to be a logical impossibility, and from this logical impossibility he worked out a picture of how things stood empirically with the world.

On the face of it, the pre-Socratics seemed to have had little to say about the gods, about mortal existence, indeed about morality and the metaphysics of human existence. Theirs was a vision strained on the macrocosm, depersonalized, de-deified, and mostly divorced from ethical concerns.[14] Some thinkers, however, drew the practical upshots. The philosopher and poet Xenophanes of Colophon (570–480 B.C.E.) concluded that a monistic universe required a monistic deity, not the pantheon of human-shaped gods, and neither anthropomorphism nor polytheism has a place in religious worship, which, though it transcends reason, should not offend clear and logical ideas. For if by god we mean the highest being, it follows that that being cannot be less than the universe itself and that, not being a thing but the source of all, this deity had to be impersonal faceless life force.

Taken seriously, this conclusion marched the rowdy Olympians into retirement. Heracleitus's contention that the cosmos is of necessity eternal meant that the notion of a creator god, a Yahweh jumpstarting the world, was laughable. The cosmos knows no creator and no beginning (here Thales, Parmenides, and Heracleitus all agreed); God therefore had to be a way of referring to the cosmos and its ageless primacy. This conclusion definitely shut down the cosmogonic sideshow: the universe being timeless, there is no world-creation tale to tell— no history between God and the world. Whoever recounts a creation story, lies.

For all that, there was no lack of poetry to pre-Socratic philosophy, particularly Heracleitus'. His vision of changeful Being gave reality a dramatic pulse, the ruptive intensity of an organism still working out how to exist. Reason forces us to admit Parmenides' view that the universe *as a whole* is still; direct observation, however, tells us that *within* the whole all objects and phenomena are in perpetual tumble. The texture of reality is wonderfully plastic. It is not made of things but fluxes. Concepts are mere attempts at chasing the tail of phenomena. Not just

the world as a whole, but everything within it is ungraspable because it is always becoming.

This is a far cry from the epic of Genesis. Still, the pre-Socratics were moved by cosmic awe no less keenly than the writer of Genesis. It is just that, to them, conveying this awesomeness entailed banishing the anthropomorphic element. Taken together, the pre-Socratics promulgated a moral attitude that urged human beings to look at the universe above their bread-and-butter concerns. They strove to make sense of the universe without necessarily making it cozy and human-sized. This attitude recommended an ethos of cosmic imagining, of opening human intelligence to ideas for which it can have no use: the infinite was one such idea, one that became the only logical candidate for thinking about ultimate reality. The pre-Socratics plunked us down in a reality absolutely out of proportion with the compass of the human mind. Spiritually and intellectually, we then began to live before an infinite horizon—a world that is impossible to draw, humanize, personify, or circumscribe. Whichever god came in the wake of this realization would certainly have to catch up with this new picture.

The quartet of pre-Socratic philosophers (Thales, Anaximander, Heracleitus, Parmenides) demystified the relationship between man and nature. It jarred man out of his enthrallment with the gaudy pageant of gods and heroes, sacred groves and dark Oceanus, gloomy Tartarus and mist-shrouded Olympus; it said that man dignified his intelligence by facing the infinite in its stark, inhuman mystery. "There is one god, greatest among gods and men, similar to mortals neither in shape nor in thought," said Xenophanes.[15] Depersonalizing God followed from the fact that, although we can intuit the infinite, our mind is not capacious enough to circumscribe it, and that it is therefore preposterous to lend it a human face. But what justification has Xenophanes in giving the name *God* to that limitless entity? Besides, was this impersonal god not too far removed from the practical cultic needs of men and women? Indeed, taken altogether out of the range of understanding, the One lacked meaning and purpose. The whole vision shaded into nihilism.

What was the infinite being for? Indeed, how could it have any meaning at all? Meaning needs limits: anything derives meaning from its mode of connecting, serving, and more generally interacting with other things (the meaning of the hammer is, as it were, the nail). But what about Being as a whole? Being all that is, the One cannot logically interact with externals. It cannot serve or hinder any purpose. To say it is self-contained scarcely solves the matter because unless a container

shuts something out, it can hardly be said to contain anything. In sum, philosophic rationality leads to a vision of the universe that means nothing, a universe that has, in the Greek tongue, no *telos*.

Indeed the god of Xenophanes could only be a very dull, enervated thing (it does not want, seek, wish for, or effect anything). A saying of Heracleitus suggests that he, at least, considered the problem: "The god, whose oracle is in Delphi, neither affirms nor denies, but points."[16] The idea that the All stands for nothing, nor defends any principle, nor wishes for anything did not seem to trouble the pre-Socratics overmuch. This placid nihilism, however, proved harder to swallow for the next generation of thinkers, who found it difficult to accept a universe with no residue of rationality. These philosophers, associated with the heyday of Athenian rationalism, must have believed that the universe that produced a creature of reason, man, had to be rational in some fashion. Though infinite, the universe had to possess a measure, hence a way of understanding and placing it in a conceptual framework. This was what the next generation of thinkers set out to prove in the fourth century B.C.E., and in so doing, whipped reality back into shape.

Closure

Athens, circa 400 B.C.E.

The movement known as the great Athenian achievement sprang from the graveyard of sixth-century B.C.E. philosophy. Heracleitus, Anaximander, and Parmenides devised a language in which to express rational ideas about the universe. The next generation of thinkers accepted this mode of thinking but recoiled from the world it was unveiling. That world proved too wide-open to their taste. The people who designed the six-column facade, invoked Apollo, chiseled the gymnast body, wrote in iambic meter, and cherished democratic self-rule were not romantics of infinity; they were people of measure and law—a staid people willing to impose terms to thought and put barriers on the runaway imagination.[1]

That there is virtue in containment is a conviction palpable already in Zeno (c. 490–c. 430 B.C.E.) who, though a pupil of Parmenides, questioned the free-floating cosmic intuitions of his master: "If there is space, it will be something; for all that is, is in something, and to be in something is to be in space. This goes on ad infinitum, therefore there is no space."[2] Should space be something, it is therefore somewhere; but to be somewhere is to be in space; thus to say that space is in space is to say nothing, or to open up infinite regress. Better, therefore, to think that space does not exist. It is difficult to know when Zeno merely wants to puncture a commonplace or speaks in earnest. Whichever the case, Zeno's point is quintessentially Hellenic: to be and to be something are synonymous. Existence is *something* existing. Which means that, since

the infinite cannot be something (i.e., a unit), it cannot exist. Thus Zeno reasoned the infinite into nonexistence, and a version of empiricism, once again, gained the field.

Socrates (470–399 B.C.E.) did not dilate much on the infinite; his disciple Plato (428–348 B.C.E.), by contrast, did. The way Socrates drops an argument in midair, admits ignorance, or, as in the *Symposium*, flirts with mysticism—all this suggests a Heracleitean sensibility comfortable with, if not infinity, at least the indefinite. Plato's intellectual temper too was given to mysticism, but even more so to categorical order. He proposed that the infinite was an idea—an idea without a tangible referent, an idea of nothing at all, merely the mind at play. Zeno's riffs on infinity simply showed that it was useless to think about the infinite in concrete terms. Thus the cosmos, Plato argued in the *Timaeus*, had to be finite. The proof is, the cosmos is palpably something, since it can be perceived; and, being perceptible, it is therefore contingent (it can be perceived earlier rather than later, here rather than there). The cosmos is therefore steeped in becoming, hence in motion. The rule of motion, however, is that nothing moves except with respect to an external point; so the cosmos, if it moves, must move relative to something outside it. This external point must also be the force responsible for setting the whole thing in motion. Plato calls this external force the Craftsman: the primal intellect who rigged up the universe and set it into motion. A plan, blueprint, or idea antedates the world, which, inasmuch as it began, is not infinite. What are infinite, instead, are the mind that thought it up and the plan according to which it moves. Hence only the divine idea of the world is infinite. Hence only the mind is infinite. Hence infinity is mind-like, spiritual, intellectual—anything but stuff.

Plato further developed this philosophy in *The Republic* under the theory of the Good. "The Good therefore may be said to be the source not only of the intelligibility of the objects of knowledge, but also of their being and reality; yet it is not itself that reality, but is beyond it, and superior to it in dignity and power."[3] The Good begets and orders everything that exists according to pattern, or *eidos*. Being is reason. As Cicero would argue in a Platonic vein, we "cannot understand this regularity in the stars, this harmony of time and motion in their various orbits through all eternity, except as the expression of reason, mind and purpose in the planets themselves."[4] The Postmodernist may smile at this, though in fact there is nothing mysterious in the notion that there is a way in which the world works and that it is therefore susceptible to

rational investigation. Even a dyed-in-the-wool empiricist would agree that the possibility of primeval plutons, gluons, and quarks fizzing into existence at the big bang must have preexisted the particles themselves. For anything to occur, the law of the possibility of its occurrence has to antedate it. Plato called this precondition the Good. And since we cannot reach back further than that (i.e., into the law of the possibility of the occurrence of the law of possibility of any given occurrence), it seems wise to suppose that this law is timeless and self-establishing. On this principle, Plato argued, only the *eidos* of existence deserves to be called infinite. Everything else—that is, everything material—is finite.

Aristotle (384–322 B.C.E.), the other great proponent of Greek rationalism and a pupil of Plato's, took his turn at explaining why the cosmos could not be infinite. The argument comes up in book 3 of his *Physics:* a thing, Aristotle argues, is by definition its own thing and no other; it is therefore bounded by all the things that it is not, which clearly means it cannot be infinite. "The view that there is an infinite body is plainly incompatible with the doctrine that there is necessarily a proper place for each kind of body. . . . How can the infinite have one part up and the other down; or an extremity and a center?"[5] It is impossible for the infinite to be somewhere in particular since it encompasses all places. Yet the idea of a body that we cannot imagine standing or moving somewhere flies against the very notion of "body." Hence the infinite is necessarily incorporeal or (as Plato had argued previously) an idea: "If bounded by a surface is the definition of a body there cannot be an infinite body either intelligible or sensible."[6]

An empiricist, Aristotle authored a treatise of astronomy, *On the Heavens,* to demonstrate how this intellectual logic conformed to cosmological reality. The cosmos, he contends, cannot be infinite for the good reason that we can see it moving in a circle. A circle assumes the presence of a hub, which the infinite could never have since "there is no such thing as an infinite square or sphere or circle."[7] Nor could the infinite move at all because first, there would have to be a place to move into, which is preempted by infinity's ubiquity; second, an object is said to move only with respect to a fixed external marker, whereas there is no point outside of the infinite; and third, the infinite would take an infinite amount of time to move even by the smallest degree, since an infinitely distant point from this tiny shift would require infinite time to reach it. All of which licenses Aristotle's firm conclusion that "the body of the universe is not infinite."[8]

Like Plato, however, Aristotle believed that just because the infinite was unthinkable as a body did not mean it was nonexistent. The fact that one can discuss it is evidence to the contrary. Though unclear, his argument basically states that the infinite exists *potentially:*

> We must not regard the infinite as a "this," such as a man or a horse, but must suppose it to exist in the sense in which we speak of the day or the games as existing things whose being has not come to them like that of a substance, but consists in a process of coming to be or passing away; definite if you like at each stage, yet always different. . . . The infinite, then, exists in no other way, but in this way it does exist, potentially and by reduction. It exists fully in the sense in which we say "it is day" or "it is the games"; and potentially as matter exists, not independently as what is finite does.[9]

The infinite, in other words, is the idea according to which *potentially* more can be added to or subtracted from a material body. What it is not, however, is an *actual* infinite adding or subtracting. In his *De Aeternitate Mundi contra Proclum,* the philosopher John of Alexandria (c. 490– c. 570 C.E.) put the matter in a syllogism: should the infinite consist in endless addition, each new added object would make the resulting infinite sum greater than the previous one; but the infinite cannot be greater or smaller than another infinite. Hence, the infinite is not quantitative but ideational. The infinite "exists fully in the sense in which we say 'it is day,'" says Aristotle. What does this mean? Perhaps that "it is day" assumes that "for the day to be, there needs to have existed the possibility or potentiality that it actually came to be." It is this potentiality that is truly timeless and infinite. For whereas the day began when the sun came up over the east, the possibility that it would dawn today has endured since all time and will never pass.

Abstraction notwithstanding, these Platonic and Aristotelian exercises sought to ward off a very real Greek anxiety regarding the void. Aristotle cleverly adduced the nonexistence of emptiness by defining it as a place where no body could be. But if there is a space no object can conceivably inhabit, then the place that space takes up is also therefore nonexistent. From which it follows that the void, understood as infinite space, cannot exist. The world neither extends to infinity (this would not be a world), nor is wrapped in thin infinite matter (such as empty space). But then what was it and where was it? The universe, if it was *materially* finite, had to stop some place that was not material (lest that place too be a part of the universe, and so on, until we end up again with an infinite universe, which is what agoraphobic Greek rationalism

would not accept). The upshot is that the universe had to terminate on something immaterial—on *spirit.*

But now Aristotle faced the mind-boggling task of explaining just how this bounded material world docked into spiritual "stuff." Wasn't pure thought too thin a substance to act as a membrane? "It is clear," he argues in *Metaphysics,* "that there is a substance which is eternal and unmovable and separate from sensible things. It has been shown also that this substance cannot have any magnitude but is without parts and indivisible . . . and that it is impassive and unalterable."[10] This is all very well, but how can something of no magnitude and unalterable (even by the alteration of containing something) swathe the world?

Aristotle did not elucidate the riddle, and if he had, might have spared early Christendom the countless synods, conclaves, and charges and countercharges of heresy over the problem of delineating just how finite matter abutted on infinite spirit; how, in other words, the world and God joined together (see chapter 8). Aristotle bequeathed the strange cosmology of a world sheathed in a substance *that does not touch it.* As he claimed in *On the Heavens:* "We may infer with confidence that there is something beyond the celestial bodies that are about us on this earth, different and separate from them; and that the superior glory of its nature is proportionate to its distance from this world of ours."[11] These are mystical heights indeed: the world is wrapped in an envelope with which it has no contact. The enveloping substance is unthinkably removed from the enveloped: but then how can the substance be said to envelop it at all? This was a mystery.

Meanwhile, it is clear that tales of earth and heaven, matter and spirit being kept apart by Atlas, the sky-bearer, no longer satisfied the fourth-century Hellenic intellect. Rationality, not the gods, was in charge of shouldering the horizon and describing how the earthly and the heavenly meshed together. And the problem was that rationality had exiled God to a place where he could not genuinely mix with the world. The limit between gods and humans, it seems, had mutated into a horizon: the closer we came to it, the more it withdrew.

By trying to provide a rational picture of the cosmos, Greek rationality unwittingly split the cosmos between an unimaginable divine substance and matter. As Plato put it in the *Parmenides,* the gods have no idea what it is like to see the world from within it, just as we cannot imagine what it is like to see it from high up in the heavens. The infinite cannot know what it is like to be finite, nor can the finite imagine the infinite. As Plato also avers in the *Timaeus,* "That which is created

must, as we affirm, of necessity be created by a cause. But the father and maker of all this universe is past finding out; and even if we found him, to tell of him to all men would be impossible."[12]

The influence of this unthinkable, unapproachable god courses through antiquity and the Middle Ages; it informs Aquinas's *Summa Theologica*, surfaces in Spinoza's notion of Substance, and quietly underwrites the eighteenth-century Deist idea of an absentee God. This is not without practical problems. A product of the philosophic temperament, this rarefied God was of little use to the everyday needs of believers. What was the pious orthodox to make of a god who, as the Neoplatonic philosopher Plotinus (c. 205–70 C.E.) summarized, did not exist in the ordinary sense ("The awesome existent above, the One, is not a being for then its unity would repose in another than itself"); a god of inhuman autonomy ("It needs nothing outside itself either to exist, to achieve well-being, or to be sustained in existence"); a god of no wish or project ("If the One were to aspire to anything, it would evidently seek not to be the One, that is, it would aspire to that which destroys it"); and, most perplexing of all, a god could not even be said to think ("The One is not an intellective existence; if it were it would constitute a duality. . . . Anyway, what would it think? Would it think itself? If it did, it would be in a state of ignorance before thinking").[13] From there it was only a step, which the late medieval philosopher John Duns Scotus took, of declaring that, so deep was God's mystery, that God himself could not pierce it ("God does not know Himself, what He is, because He is not a *what;* in a certain respect He is incomprehensible to Himself and to every intellect").[14]

Such intellectual lacework suggests a certain mannerist twilight gathering over Western theology in the post-archaic period. The Olympian gods may have been a raucous bunch, and Yahweh's tetchy tantrums often looked undignified, but at least they were gods one could hold onto. The Christian philosopher Origen (c. 185–c. 254) opined that the ethereal, infinite God would necessarily be amorphous, indeterminate, and thus ignorant of itself. This is the infinitely cumbersome ethereality that the incarnate god of Christianity would be sent to palliate, if not solve (see chapter 8).

The agoraphobic worldview of Classical Greece laid the basis for a cosmology that in the main stayed in currency until the early Renaissance. In retrospect, one can understand why Christian theologians eagerly latched on to the abstract God of Plato and Aristotle. The God of Genesis made for an exciting read but, intellectually, raised more questions

than he answered, such as who is God? What did he do before the world began? What role does he play in the universe? Plato and Aristotle gave Christian theologians the material they needed to complete the Hebrew transformation of Yahweh to a purified ether of abstraction.

More important, Greek philosophy shifted the focus on infinity from an external to an internal standpoint. Greek rationality established that there was nothing to be made of a description of the universe as materially infinite; what was infinite, instead, was God, who is pure intellect. In other words, the Greeks seeded the idea that the infinite is *projected* onto the world: it is not the universe that is infinite (anyway, we would have no way of actually testing that possibility, since it would take an infinitely long time to do so); rather it is the mind that reads infinity into the world. The infinite, therefore, is in the eye of the beholder. It is we who set the world out of bounds.

This had the effect of dignifying human intelligence, which, though puny and significant in the vast universe, nevertheless was capable of entertaining ideas *larger* than the world. In religious practice, this discovery gave new wings to the idea of transcendence. Now it was possible to picture humankind, not forever crawling off from Eden under the eye of a glowering disgusted God, but nobly gazing far, indeed farther than the visual boundaries allowed. The infinite dwelled in us; the habit of seeing far, of reaching after horizons, of thirsting for something not found in the world was ours. We had become agents of transcendence, not the cringing victims of divine lust, wrath, jealousy, or legislative whimsy. God-like, we project the infinite onto the world. The horizon, whose receding fringe was a curse to Adam and Eve, could now be construed as the emanation of a divine power in us—a transcending force that could reach for God with the godlikeness of human intelligence.

All this pointed to a spiritual environment eager to enlarge and advance the powers of apprehension. This new religion of the intellectual likeness of God and humans was, of course, Christianity. Its core belief—that of a god descending from the timeless into the temporal, taking human shape and becoming man, and then raising a ladder back up to the Spirit for all mortals to climb—told a tale of human transcendence. Pre-Christian Jewish thought had primed the ground for this ascent. The Essenes, a separatist Judaic community of the second century B.C.E., believed in the human soul's ability to enshrine the Holy Spirit, indeed to anticipate the Messiah.[15] Likewise, Jewish apocalyptic literature of the second and first century became rife with messianic beliefs in man's potential return to the "Infinite Source of Light."[16]

Destruction of the temple of Jerusalem and the Roman occupation of Israel inspired many to wish for an endtime that would see man's restoration to God.[17] Apocalyptic eschatology and mysticism nurtured this belief in the residual trace of eternal knowledge in man—a knowledge that was not beyond rekindling. To reach the horizon of God, we must travel inward. This inward direction, always a trait of Jewish ethical purity, was to climax in the teachings of an eccentric Galilean preacher, a Jesus whose ragtag band of followers took to be part man and part God: a bridge made visible, a horizon incarnate.

The Theological Age

Distance

Nicaea, 325 C.E.

Saul of Tarsus was on his way to purge Damascus of Christians when a shaft of light knocked him to the ground. By the time he recovered his sight, he had become Paul the Apostle (?–67? C.E.), chief member of the very sect he had hounded and head theologian for its charismatic Galilean rabbi, executed some twenty years earlier on the charge of rabble-rousing. Paul recounts the occurrence thus: "And I fell unto the ground, and heard a voice saying unto me, Saul, Saul, why persecutest thou me? And I answered, Who art thou, Lord? And he said unto me, I am Jesus of Nazareth, whom thou persecutest. And I said, What shall I do, Lord? And the Lord said unto me, Arise, and go into Damascus" (Acts 22:7–10). On the face of it, this reads like a conversion; on reflection, it is obvious Paul is already shaping the religion to which he professed conversion. Initially the resurrection of Yeshua, the rabbi, must have been a tale told by his beleaguered band of disciples to weather the terrible shock of his execution. But Paul trod new ground in addressing Yeshua as the *Lord* Jesus, as a god. It was one thing to imagine that Jesus, faithful to God to the end, enjoyed special afterlife status with the one he had called the Father (*Abba* in ancient Aramaic); it was quite another to claim that the Nazarene preacher was the Lord God himself, the same God worshipped by Abraham and Moses. This assimilation violated the Hebrew divide between gods and humans; it also smacked of polytheistic paganism, of Roman emperor worship, and of the megalomaniac Alexander who called himself the son of Zeus.

A Hellenized Jew and a Roman citizen, Paul was familiar with Orpheism, the victorious return from the dead; he also knew about the deification of the Roman Caesars. At first blush, there seemed nothing terribly earthshaking about his deification of Jesus. But Paul did not mean just to elevate one man to the pantheon, and he was not a polytheist.[1] He meant that one man had actually been not *a* god, but the only God there is: that one mortal man had partaken of the very essence and substance of the universe. Paul was a preacher of considerable visionary and poetic force. What he was not, however, was a logician. So while his vision of heaven and earth commingling in one person (both descending sky god and ascending chthonian hero) fired religious faith, it would go to inflict no end of intellectual contortion to theologians for five centuries to come.

Outside of the Judaic faith, demigods were not uncommon. There is even a giant race of them tucked away in Genesis, known as the Nephilim: "The sons of heaven had intercourse with the daughters of man who bore them sons. They were heroes of old, men of renown" (Gen. 6:1–4). Fortunately, this was before the Lord God drowned all but Noah's clan in the great flood. This saved postdiluvial humanity the vexation of cohabitating with demigods. Other religious traditions showed greater tolerance for human-divine miscegenation. Hinduism has had avatars since its ancient dawn, and Vishnu or Shiva has continuously peopled India with human descendants; devotees believe Buddha or Ramakrishna to be avatars of Brahman. Ancient Egypt too had interceding gods, like Thoth, and divine pharaohs. Animist and witchcraft religions allowed for spirits and ghosts. Ancestor worship, prevalent in the Far East, regarded the dead as immortal entities capable of interceding in favor of their living relatives. And of course the Hellenic world was chockablock with demigods, mostly the fruits of dalliances between Zeus and cornered maidens (Theseus, Perseus, and Achilles are all sons of Zeus). Finally, even ancient Judaism had allowed intermediary stages between god and humans: "You have made him (man) a little less than the angels," we read in the Psalms (Ps. 8:6). But angels, though a little more than man, were markedly less than God. No one claimed divine status on their behalf.

Whereas followers of Jesus did. Though not always lucidly, Paul was extremely militant about the man-god *(theanthropos)*. Not only had this man vanquished death and been reborn ("If Christ be not risen again, then is our preaching vain, and your faith is also vain" [1 Cor. 15:14]); he had also proved himself to be more than just favored by

God, but was equal and identical to him: a *Christós* in Paul's Greek. "For in Him dwells all the fullness of the Godhead bodily," he declares (Col. 2:9). Jesus was God visible, the universe present in a fragment, the infinite in finite form. Thanks to this mystical fusion of part and whole, Jesus Christ and God were interchangeable names—which Paul summarized in the moniker "the Lord Jesus." The point, which appalled the Hebrews, was that Jesus Christ had somehow been around during the days of Abraham, going all the way back to Exodus and Moses: "All were baptized into Moses in the cloud and the sea . . . and all drank the same spirited drink. For they drank of that spirited Rock and followed them and that Rock was Christ" (1 Cor. 10:1–4). (In the third century, Origen would claim that the relation between the Father and the Son was without a beginning.)

However incoherent, the idea was firmly implanted in Christian theology by the time of the apostle John (roughly a half-century after the time of Paul's epistles).[2] The belief, in fact, is the lynchpin of Christianity and certainly the central message of the Gospel of John, the most Hellenistic of the quartet. "He who has seen Me has seen the Father," John has his Jesus declare (John 14:9). "Believe Me that I am in the Father and the Father in me" (John 14:11). Or, as phrased it in its famous opening line: through Jesus, the Logos became flesh and dwelt among us. In short, Aristotle's infinite spirit had gotten itself a human face. The divine and the earthly conjoined in Christ. He, a horizon deity, embodied the distance between earth and sky. He solved the problem of binding finite and infinite.

Or did he? To begin with, Jesus was a conceptually thornier case than that of the demigods. As god-men go, the historical Jesus cut a rather unassertive, equivocal figure. The synoptic Gospels of Mark, Luke, and Matthew (deemed historically closer to the source of Jesus's life than the Gospel of John) describe a Jesus far less certain of his godhood than what Paul envisioned.[3] All three gospels recount the episode of the rich young man who calls on Jesus: "'Good Teacher, what shall I do that I may inherit eternal life?' So Jesus said to him, 'Why do you call Me good? No one is good but God alone'" (Mark 10:18; Luke 18:18; Matt. 19:7). It seems that Jesus accepted being the messenger and prophet of God but not his incarnation. Likewise, the Roman soldier's unanswered taunt: Why could the Son of God not come down from the cross and save himself? Could God want to die? How could he die? Gods were almost by definition immortal. So either Jesus had really died, in which case he was not a god, or he was truly God and could not have died in

the first place, and therefore had never resurrected, in which case there was little reason to worship him for vanquishing death—and little reason to be a Christian at all. What use could we have for a god that had feigned dying on a cross?

The matter was deeply vexatious. Who was Jesus? How did divinity and humanity conjoin in him? How could they conjoin in the first place? How to describe his in-betweenness? Tackling these questions sounds like the work of professional hairsplitters, but in the second and third centuries B.C.E., the Christian faith hung on making sense of them. The urgency of the man-god problem is testified by the noise and frequency of theological squabbles, synods, and schisms that rattled Christendom through the middle of the fourth century. The Romans and early Greeks certainly never held *their* gods to philosophical account; on the contrary Christianity centered on the existential death of its god, which required that divinity be humanly intelligible.

Roughly put, there were four ways to balance the god-man mix in the person of Jesus. One, Jesus had been more divine than human; two, he had been more human than divine; three, divinity and humanity were indistinguishable in him; four he was simultaneously, though distinctly, god *and* man.

The first doctrine, known as Docetism, was propounded especially by second-century Gnostics and cleaved to the spirit of Paul's teachings: Jesus had been essentially divine. Only figuratively had he walked and eaten and died among humans, like an image. The second doctrine, known as Arianism, was named after his chief initiator, the priest Arius of Alexandria (c. 250–336 C.E.). It held that Jesus had been created by God and was therefore not of equal nature. In the scale of divinity, he ranked lesser than gods but higher than angels. How else, asked the Arians, could he have suffered and died? Or why would he have cried out to his Father on the cross, "My God, why has thou forsaken me?" (Mark 15:34). Clearly Jesus could not have felt bereft of God if he had been seamlessly one with God.

As logic goes, this was perfectly sound. But what is good for logic is not necessarily good for theology. Arius's contention shocked the hierarchy, including Arius's own bishop, who proceeded to silence him: if Arianism was correct and Jesus had been created by God and was therefore inferior to God, Christians were de facto polytheist idolaters, worshipping a secondary god as though he were God himself. And if that was the case, what was the point of being Christian at all? Why pray to a middleman? Why not go back to the God of the Hebrews?

Arianism caused such dissension among bishops of the Christian Roman Empire as to give its emperor Constantine serious worry. Schisms have a way of splitting nations, and Constantine wanted his house entire. In 325, he convened the bishops to the imperial palace in Nicaea, in Asia Minor, under the express mandate to hash out a consensus. Details of the Council of Nicaea are patchy; its outcome, however, was the promulgation of an orthodoxy, known as the Nicene Creed, which in its basic lineaments crystallizes the essence of Christian dogma to this day. It was then ruled that Christ was "at all times fully God and fully human, with two natures, without confusion, without change, without division, without separation."[4] To be Christian henceforth meant subscribing to the exquisite harmony of humanity and divinity in Christ, known as the dogma of *homoousios* (of identical substance).[5]

The Christological debates of the fourth and fifth centuries have importance beyond the walls of the bishopric. First of all was the existence of the controversy itself. It proves that an unprecedented step had been taken in the development of religion: people now debated the nature of God and rested the creed on the outcome of those discussions. This would have bemused Greeks and Romans. The Olympians did not need to make sense—this was one privilege of supreme chieftaincy. With the Christian God, the need arose for some rational justification of his authority. Already the Hebrews (e.g., the book of Job) had felt the need for a god who exhibited moral intelligibility. Now Christologists wanted also logical, philosophic, existential intelligibility. After all, by incarnating himself in a man, God himself had suggested that the divine requires the leaven of mortality. Here was a god who had needed the human form of life to remain relevant. And so it was quite consistent to apply features of the human form of life (reason, knowledge, experience) to portray God. In the third century C.E., the theologian Origen contended that Plato had incorrectly declared God as impossible to declare. Christ invalidated this ineffability: if God really partook of man, then man possessed spiritual kinship with God.

The Nicene Canon should have settled the controversy *in saecula saeculorum*, except that it left open the precise manner in which the divine and the human bricked together in Christ. The formula "without confusion" yet "without division" was not without problems: if two things are not fused, they are therefore distinct.[6] A doctrine, known as Nestorianism, arose in the fifth century C.E. to flesh out how heaven and earth came together. Nestorius (386?–451? C.E.), bishop of Constantinople, proposed to split Christ right down the middle into hemispheres.

For this (and for refusing to acknowledge Mary as the Mother of God), he was severely taken to task. The idea of a sundered God was an offense to his universality. For inasmuch as the divine half of Christ ended at his human half, it followed that divinity was limited; hence, the divine could no longer be said to possess wholeness. Moreover, there was the problem of how one essence interfaced with the other. What was the exact nature of this inner divide? Did it not assume the existence of a third element to cement the two halves, divine and human?

These questions were sufficiently troublesome to convene yet another synod at Chalcedon in 451 C.E. Bishops and papal envoys gathered, debated, and, on October 22, anathematized the Nestorianist creed as empty babblings—promulgating the orthodoxy known as the Chalcedonian Creed, which reaffirmed then and forever the Nicene orthodoxy: "We confess that one and the same Christ, Lord, and only-begotten Son, is to be acknowledged in two natures without confusion, change, division, or separation. The distinction between natures was never abolished by their union, but rather the character proper to each of the two natures was preserved as they came together in one person *(prosopon)* and one hypostasis."[7] The so-called Communication of Attributes (*communicatio idiomatum,* literally "communication of idioms") decreed against the notion of a Christ half-god and half-human. Nor had his infused dual nature spawned a third kind of essence distinct from God and humans. Instead Christ was a person in whom the divine and the human, though separate, existed in harmony. Christ could not have been human without being God, and he could not have been God without being human. The former statement was standard hero stuff; the latter was the gist of the religious revolution begun by Paul: the idea (nowhere explicitly stated though ready to burgeon) that the Christian god was God thanks in part to the side of him that had been human.

Why had God embodied himself in human form? According to the orthodoxy, it was to redeem humankind and renew the covenant. But the covenant needed renewing, one assumes, because God was casting about for relevance. God cast himself into the human *I* to add some hitherto lacking element to his nature. Perhaps God needed to see himself as humans do. Christ on the cross shows God enduring mortality and yearning for transcendence. He is a god dying to unite with himself, ragged with inner division. He is a god who misses himself, who wants to see the world as humans see it, bereft of God, needing God, dying to see God. Through Christ, God wanted to behold the world as distance and separation. For God can know all things except this: separation,

distance, lack of knowledge. This ignorance of ignorance creates a lack in him that mocks his omniscience. A god who is truly universal and omniscient must know finitude. And this is what the Passion offers: a god *who had wanted to know what it feels like to long, to suffer distance, to die.* The divine needed to add mortality to its stripes. As if to say: to really understand the sublime mountain-top, one must see it from the valley floor—for perhaps it is there, in the longing for it, that it throbs alive. In sum, God became Christ because he wanted to behold the horizon.

How (so Paul may have reasoned) can God be perfect so long as his perfection fails to comprise the knowledge of death? What kind of infinite knowledge does not include the experience of finitude? Paul therefore concluded that "It became Him, for Whom are all things and through Whom are all things, in bringing many sons unto glory, to make the Author of their salvation perfect through suffering" (Heb. 2:10). Perfect as he was, the disincarnate God lacked the perfection of knowing finitude. God can never truly understand humans as long as he does not understand that.

By agreeing to embrace finitude, however, the Christian God brushes with imperfection (a paradox). To be imperfect means one can always get better, which is how the Christian God turns into a god of historical becoming (another paradox), a Heracleitean god who is and is not quite himself (at least not before the Resurrection), a god, in fact, who split into three personalities.[8] Pondering these matters in the fifth century, Augustine explained how the Father, the Son, and the Holy Ghost really symbolized ways in which the Godhead relates to himself. The God of Christianity is not a monolith: he has dispositions and attitudes with respect to his own existence. "The three are one, and also equal, viz. the mind itself, and the love and the knowledge of it," Augustine explains.[9] The Father stands for spirit; the Son embodies the love of spirit; and the Holy Ghost represents spirit aware of itself: "But as there are two things, the mind and the love of it, when it loves itself; so there are two things, the mind and the knowledge of it, when it knows itself. Therefore the mind itself, and the love of it, and the knowledge of it, are three things, and these three are one; and when they are perfect they are equal."[10] This is not as obscure as it sounds. No intelligent being is complete unless it esteems itself and also knows itself. The Son adds the experience of self-seeking, and the Holy Ghost, that of self-reflection. Thus the triune God encapsulates human consciousness made perfect: that is, knowledge that knows and cherishes itself. The trinity prized open the idea of God, that is, of the One. Absolute Reality (though one and whole) is crisscrossed with inner channels of

self-communication, a network of psychological tensions. God is a dialectical entity. His essence is actually existence, self-relation, becoming, distance. The fabric of reality is streaked with gaps—the cracks that even God, who is absolute unity, needs to create and maintain his unity.

This bold formula is a Christian invention: it signals the triumph of becoming over the ancient culture of being, the hinge between "ancient" and "modern." Jesus is a harbinger of the modern. For all his divinity, he faces death, knows doubt and despair (e.g., Gethsemane), craves reunion with his own godhood, dies half in failure, half in regret. He is a deity who casts a suffering eye on the whole of existence, including himself. Christ is God standing before himself as if before an other, an exiled son before his father. Next to the Apollonian gods, the unflinching Re, or power-engorged Marduk, even next to the historical Buddha, the god-man Jesus (especially in Mark and Matthew) cuts a positively manic depressive figure—holding out for the highest and self-condemned to the lowest, strung out between the presence of God and his disheartening silence, between the Sermon on the Mount and the ordeal on the cross. Jesus oscillates, the god-man alienated from his godhood, uncertain of his mandate, hesitant in his mission ("Abba, Father, all things are possible unto thee; take away this cup from me" [Mark 14:36]). Arms outstretched before the Godhead, Jesus is at once intoxicated and heartbroken by the distance, torn between heaven and earth and at home in neither. "The kingdom of God is among you," he declares in Luke (17:21), but "My kingdom is not of this world," he decides in John (18:36). This does not leave him much room to exist in. Neither of this world nor of the next, neither here nor there, the god-man is stretched on the rack of a stop-and-go transcendence.

Hence the symbol of Christianity after the third century: the cross, a horizontal axis between heaven and earth cut across by a vertical line. A symbol of cutting and joining, of distance and closeness: Christ is quartered on the paradox of distance in proximity, of intimacy and exile. There Christ is most fully himself, not sky god but horizon god. The cross is to the modern worldview what the circle or the pyramid is to the ancient: it dramatizes a conflicted (as opposed to hieratic), dynamic (as opposed to fixed), and romantic (as opposed to classical) sense of reality: it is the symbol of going the distance.[11]

This Christian sense of reality as distance visible entailed a great deal of liturgical reconfiguration. In general terms, the Hebrew Bible wants the believer to bow and cover his head in dust. "By Your wrath we

are terrified," says the Psalmist (Ps. 90). But now Christ speaks of a god we should support, love, seek. The Christian disposition is expectant and ascendant, enthralled by possibility. "Faith is the substance of things hoped for, the conviction of things not seen," says Paul (Heb. 11:1). Unseen things do not urge resignation; instead, they fire the believer to reach beyond. They kindle utopian yearnings, love for the faraway. (Paul's Greek word for hope, ελπίδα, "elpis," also described open-ended time.)[12] In principle, the Christian attitude opposed tragic submission. Its spirituality was activist. It *sought* God's presence, yearned, endeavored to be like Christ, to bring forth divinity out of humanity—the so-called *imitatio dei*. "Therefore you are to be perfect, as your heavenly Father is perfect" (Matt. 5:48). The Christian soul loves elevation: it prefers striving over intellectual quietude. Its God beckons, provides a destination, a horizon to look forward to. Aspirational Christianity promised that, provided we follow Christ, we too could become god-like. *Imitatio dei* consisted in stretching one's psyche toward the heavenly. Its basic attitude was one of longing.

Accordingly the Christian afterlife does not, as to the Homeric Greek, promise an eternity of piteous reminiscence. Christian death is transformation: it embosoms the believer in the divine spirit. (Let's imagine the Athenian moribund looking forward to melting into Zeus, and we get the irresistible selling point of Christianity.) Just as God had become mortal flesh, suffered, died, and resurrected *as man*, so there is nothing inherently human about man. The human condition is a gateway; it is a through-station, a cross if you will: it *stretches* between earth and heaven. As second-century Bishop Irenaeus of Lyons summed it up, "God became man that man might become God."[13]

This reformulation altered human identity to the core. In essence, the Christian religion suggested that we are not what we are; that we are what we *will* be—gods in waiting. Our essence is potentiality, not actuality. We, like Christ, are creatures of finitude who stretch into the infinite. We, too, are beings of the horizon.

Often rancorous, the second- and third-century battles over the Incarnation aimed to sort out the territorial relations between the infinite and the finite. Initially confined to the episcopate, these debates eventually settled into the official elements of a creed and a liturgy that told ordinary men and women what to think of their existence. It engineered a new way of being human and of deporting oneself toward life and

death. Nevertheless, four hundred years into its inception, the new religion still awaited a theologian with the argumentative and imaginative power to transform this often rough-and-ready patchwork of ideas into a practical ethos and a cultural attitude: this powerful communicator Christianity found in the person of Augustine of Hippo, the man who set the moral and existential lineaments of Christendom from the Low Middle Ages until the rediscovery of Aristotle in the thirteenth century.

Trembling

Hippo, 410

Augustine, bishop of Hippo (354–430 C.E.), hailed from northern Africa, imbibed Christianity at an early age from his mother, studied under the formidable Ambrose of Milan, then returned to Hippo, in today's Algeria, where besides his pastoral and episcopal duties, he marshaled his rhetorical skill, vivid confessional streak, keen logic, and enormous writing output to build the missing theological bridge between the Christian age and the ancient world.[1] To vindicate the Christian message, he showed its seed already alive in Platonic philosophy, and expounded the new Christian ethic in three basic volumes of astonishing breadth and visionary power: *City of God, On Christian Doctrine,* and *Confessions.*[2]

What is a Christian? This is the question at the heart of Augustine's writings. It is one thing to pray in a basilica rather than sacrifice to Jupiter, but what does a Christian think? How does he feel about his existence? In his youth, Augustine had professed Manichaeism, a doctrine regarding the world as a pitch battle between good and evil. Then a stay in Milan in 384 brought him into contact with the writings of Plotinus, Porphyry, and other Neoplatonists. It dawned on him that evil was not a cosmic force but a tendency of human volition. This convinced him to turn his theological attention to the inner twists and byways of individual conscience.

The essence of Christianity is interiority. This principle, alive in Jesus's remonstrance against the Pharisees, takes a philosophical turn in Augustine's writings. "The knowledge that one is alive is better than

life itself," Augustine insisted.[3] Awareness, not life, is the highest good. It is better for man not to be than to live like a beast with no coherent mental picture of his own existence. "Men go forth to marvel at the heights of mountains," he writes in the *Confessions*, "and the huge waves of the sea, the broad flow of the rivers, the vastness of the ocean, the orbits of the stars, and yet they neglect to marvel at themselves."[4] With this inward turn, Augustine cast the problems of theology in psychological terms, folding God into belief, and the transcendent into the mental actions of willing, choice, intention, and other vicissitudes of self-knowledge and self-deception.

Augustine brought this mentalist approach to bear on his lifelong preoccupation with evil. He reinterpreted evil as a basic failure to heed the inner life and, conversely, as an excessive attachment to physical reality. In *Confessions,* he recalls the precise words of Paul that led to his conversion: "Spend no more thought on nature and nature's appetites."[5] Matter is incurably sinful because it is devoid of interiority: it cannot rise above itself, cannot yearn to be other than it is. The opposite of the good (evil) is also the opposite of awareness, which is not unawareness *stricto sensu* (lest all plant and animal life and unborn babies be sinful), but the deliberate cultivation of obscurity—that is, desire for the flesh, for lack of awareness, for spreading the night, snuffing intelligence, and imposing nothingness.

Pursuing his meditation on sin, Augustine thus developed the first sustained, systematic analysis of nothingness: not the nothingness of there being nothing, but the nothingness of *willing* that there be no Being.

Burning at the core of the Christian experience for Augustine was the Fall of Adam and Eve—an event as real and crucial to him as Jesus's resurrection had been to Paul. How did we exercise our freedom to turn away from God? How could we reject the plentifulness of Being and consciously follow what hinders, impairs, and lowers life?[6] The story of Adam and Eve recounted how we had willfully ushered privation and death into the world. *We* had sought death. It did not inhere in the world; it was the result of human psychology. But why did we break away from the Good? Why did mortality result from it? What does it mean to live before the horizon of finitude? It is the rumination of these questions that, owing to Augustine's influence, was to feed the Western psyche for the next thousand years.

These questions come to a head in book 7 of *City of God.* In it, Augustine tackles the perennial riddle of how evil could arise in Eden. How could perfect goodness beget evil and deficiency? How could

timelessness spill over into time, the infinite rot into the finite? How could perfection secrete its own destruction? To answer these questions, Augustine sketches a definition of evil: evil, he maintains, has no initiative value, only reactive: it is deprivation of quality. Evil subtracts, slackens, rips asunder. It is "defection of what supremely is, to that which has less being."[7] But how can Supreme Being become less supreme? "How can it come to pass that a nature, good though mutable, should produce any evil?"[8] The answer lies in the special nature of man and woman. In fact, it is because humans are quite good that they can sink to iniquity. Here is how: the highest good, we recall, is awareness and self-awareness. But to think on oneself has a strange distancing effect: the conscious person sees herself existing and becomes both actor and observer. A tiny crack opens in the texture of Being. One, as it were, steps aside from oneself. Now the world is no longer full; because of man (by which nature sees itself), Being is inwardly split. Through this channel, evil flows into Eden.

Augustine derives his philosophy of nothingness (i.e., of evil) from a philosophy of mind. Mind, he says, has the power to wreak havoc on the world *just by thinking about it*. Thinking discerns, makes distinction, breaks up the organic plenum into petty categories. Moreover, thought is unable to stay focused on any object. In fact, to identify an object snips it from the surrounding background. So any object, as soon as it is thought of, is shadowed by its opposite, that is, what it is not, its nonbeing. This duality applies to space as well as time: to think of an object carries the tacit knowledge that it is here rather than there and that it may not exist tomorrow, indeed that it did not exist yesterday or might not have existed today. A chasm of nonbeing opens up everywhere consciousness alights: everything drains into its opposite; a horizon gapes in every surface. The breath of nonbeing blankets the world. "In the day that you eat thereof you shall surely die," warns Yahweh in forbidding the tree of knowledge (Gen. 2:17): we die on the day we start *knowing*. As it happened, we did not actually die on that fateful day; instead we became aware of our impending death. We gained mortality and contracted the woeful habit of beholding existence under the shadow of nonexistence. To say, "I am," implies the thought, "someday I will not exist." In nature everything dies, but only man is mortal. Mortality and humanity hold together and, in fact, if we follow Genesis, arose in tandem. To be human is to be mortal; he is human who links being together with nonbeing. This nullifying outlook thus places evil at the root of the human way of life, that is,

consciousness. If the human disposition toward being may be described as evil, *it is because we read death into everything:* to think *is* to see nonbeing everywhere. On this basis there is no such thing as a good thought. All thought casts the evil eye.

The nothingness that is thought is never more at home than in mortal musings. The thought perplexed and goaded Augustine into dense meditation:

> No one is dying unless living; since even he who is in the last extremity of life, and, as we say, giving up the ghost, yet lives. The same person is therefore at once dying and living, but drawing near to death, departing from life; yet in life, because his spirit yet abides in the body; not yet in death, because not yet has his spirit forsaken the body. But if, when it has forsaken it, the man is not even then in death, but after death, who shall say when he is in death? On the one hand, no one can be called dying, if a man cannot be dying and living at the same time; and as long as the soul is in the body, we cannot deny that he is living. On the other hand, if the man who is approaching death be rather called dying, I know not who is living.[9]

At first blush, it seems Augustine philosophizes death into nothingness: but this is because death is nothingness. Someone who is alive is not dead, and therefore death is nothing to him. As for someone who is dead, he cannot die again; therefore death is nothing to him either. Hence death occurs neither to the living nor the dead. Then whence comes the fact that we do die in spite of all? What edge do we go over, and does such a moment occur in time? Where and when do we end? On these questions rides no less than our existential shape. But this shape, Augustine argues, is basically untraceable: "Between these two states the dying condition finds no place; for if a man yet lives, death has not arrived; if he has ceased to live, death is past. Never, then, is he dying, that is, comprehended in the state of death. So also in the passing of time, you try to lay your finger on the present, and cannot find it, because the present occupies no space, but is only the transition of time from the future to the past."[10] While we are, death is not; and when death is, we are not. Augustine rehearsed this well-known Stoic argument to generalize death—make it less a moment in time and more the substance of time. Does every second not chip away at what we have left to live? Every breath draws us closer to the abyss. Life is an hourglass. Death weaves through the very woof of existence. Or as Augustine piquantly puts it, "man begins to die so soon as he begins to live."[11] "For if man is not in life, what is it which is consumed till all be gone? And if he is not in death, what is this consumption itself?

For when the whole of life has been consumed, the expression 'after death' would be meaningless, had that consumption not been death. And if, when it has all been consumed, a man is not in death but after death, when is he in death unless when life is being consumed away?"[12] Beyond the logic chopping, Augustine is actually busy dismantling the monolithic opposition of life and death. We are and we are not at the same time. The Christian self has no definite shape; we are dimness and shade. Positive and negative incessantly swap places, so that to be *is* also not to be: "Men will not be before or after death, but always in death; and thus never living, never dead, but endlessly dying."[13] The peppering of Roman Stoicism is only surface-deep. The Roman Stoic fixed his thought on death to spare pain, whereas Augustinian man believes in nothing but death; we are put on this earth to die. Thus death is not a precipice out there but a horizon pulling at us now: we never stop ending; we are always at loose ends. The horizon teases the here and now. This is what being conscious means: to empty life of its contents so there remains only the knowledge that the end is always ahead and yet also now.

Augustine thus solves the conundrum of why there should be evil: so you may find God. Negativity broke upon the world with the birth of consciousness; without this negativity that makes life a trudge through the valley of death, there can be no pathway back to God.

This original sketching of the human experience solved the problem of death, not by saying that we are never around to see it happening (as Seneca liked to think), but that it is happening now as we live. This reorientation deeply reshaped human experience, our relation to nature, the body, and to fellow beings. It transformed the *form* of life. To see how, we turn to the expression by which we convey plastically our sense of reality, that is, art.

We can epitomize the aesthetic difference between Classical and Christian by appealing to the idea of definition. It is a feature on which Classical culture set great value. One could even argue that Classical aesthetics really consists in the work of drawing clear, strong, vigorous lines of definition. A Classical statue generally does not flirt with coyness and ambivalence and half-measures. Whether Grecian grace or Roman gumption, the Classical figure always knows who and what it is: an Atlas in its own right, it rises from the earth-floor to the sky-roof (its ancestry is, structurally, the caryatid or temple column) and stands its ground. The Christian form, by contrast, is far less architectural, hence less assertive. Next to

the Greco-Roman athlete, it is a wavering, doubtful thing that clings to the friezes of Christian sarcophagi and skulks on catacomb paintings of the fourth and fifth centuries. Next to the hale and stalwart figures created by Classical draftsmen, they look like scrawny afterthoughts, the work of a scribbling imagination. Where the Hellenized body stands before the ages, the gnarled human figure of early Christian art apologetically slinks by, rough-hewn, a gnome down on its luck. The Greeks and Romans expressed their belief in the positivity of material life through solid, full-bodied forms that bespoke human confidence; to the opposite measure, Christians conveyed their sense of worldly nullity by makeshift artistry. The early Christian body is a stunted affair. The figures are neither here nor there; they hesitate; they doubt their own substance; they have not yet decided to be or not to be.

The material explanation for this disaffection with the human figure lies in the beleaguered circumstances in which early Christians found themselves—often clandestine bands of worshippers without the political or economic wherewithal to raise grand artistic projects. This situation only deteriorated with the destruction of Rome, but even the Christian emperors never built public architecture on the scale of their pagan forebears. Finally, after the fall of Rome, the guilds and workshops broke up, and the vital link with ancient workmanship was lost. But material explanations only go so far. The fact remains that, once established as official religion and enjoying the full protection of the state (when, in 530, the emperor Justinian made Christianity a condition to Roman citizenship, and to life), Christianity never retrieved the clean, strong aesthetic lines of antiquity. When religious belief emphasized the spectrality of existence, life was no longer synonymous with power, nor truth with the clean, decisive stroke. Christianity professed the untruth of the world. Its follower cast an emptying gaze on the world. The frayed and fretted Christian aesthetic expresses this conviction in the formlessness and vanity of life. It is a ghost, a creature teetering on the edge of dissolution, which the early Christian artist etched on the walls of basilicas and catacombs. The scrabbling line, the misshapen body, the ungainly straddle, the disdain of proportion are products of a philosophy that saw in man a creature hollowed out by the knowledge of his nothingness.

One cannot understate the contrast with the ancient, particularly Hellenic, ethos. Long after the fall of Rome, Christians still shocked pagan observers by their cultish weakness and morbid renunciation—"a race," one Athenian denounced in the sixth century, "cringing and womanish in its thinking, close to cowardice, wallowing in all swinishness,

debased, and content with servitude in security."[14] A morality enamored with weakness, Nietzsche would someday say. The Christian soul sees the world as lack, as hemorrhage. He notices only what is absent. "Our whole life is nothing but a race toward death, in which no one is allowed to stand still for a little space, or to go somewhat more slowly, but all are driven forward with an impartial movement," Augustine reflects.[15] This brings us to another distinction between the Classical and the Christian. Whereas the essence of life for the former generally finds expression in spatial metaphors, to the latter, existence is essentially a temporal affair. The Greek statue is sovereign over its allotment of space and holds in its posture the certainty of existing for its own sake; the Christian figure by contrast is often a character in a larger frieze, an painted parable, a symbolic narrative. The Classical statue is self-explaining; it says, "Here I am." The Christian body is merely the vehicle of a greater story; it says, "There is my direction." Its incidental form is second to a developing idea. Its physical existence matters less than its participation in a message. Its significance outweighs its physicality. Second to the intellect, the Christian physical body therefore shrinks, kowtows, serves the idea.

Disdain for the flesh and emphasis on *meaning* also explains the disproportionate attention given to the head, and particularly the gaze, in early Christian portraiture. On icons, the face radiates sun-like and concentrates all reality to its enlarged eyes. Where the Roman face was all jowls, mouth, and forehead, the Christian portrait (e.g., pictures of Jesus as the good shepherd) is all eyes—large, doleful, impossibly evocative eyes bursting with the need to express (literally, to leave the body). They are the eyes of a human being who wishes he were elsewhere, who yearns for release from the tangible. (The historian Tacitus—c. 55–115 C.E.—wrote that Christians were executed for "hatred of the human race." He could have also said, "hatred of the human body," for this is indeed what a Roman would make of a cult that sanctified martyrdom.)[16]

As we have seen, the Christian distancing between body and mind goes back to the figure of Christ, who, following the Councils of Nicaea and Chalcedon, became officially a god split between two natures—at once God and man and therefore neither in full: a god who is not quite what he is, a god with something ajar, distinctly un-serene, déclassé about him; a god of inner opposition, now more, now less, depending on whether he is father or son. Early representations of Christ, such as the mosaics in Ravenna's Arian Baptistery (c. 500 C.E.), capture

something of this god that would not behave like one. A particular mosaic in Ravenna depicts Jesus's baptism by John in the Jordan. He wades in the river, water lapping his pink body, a god in the flesh. But Christian doctrine holds the body an inadequate vessel for the spirit. This inadequacy is for the face to convey—an enlarged head, almost hydrocephalic, that meekly makes apologies for the moral unsightliness of existing at all. Anything that exists is by definition misplaced ("And Jesus saith unto him, 'The foxes have holes, and the birds of the sky have nests; but the Son of man hath not where to lay his head,'" [Matt. 8:20]). The body intimates its incapacity to house the soul, which yearns to get out, indeed to escape the form.

This split between soul and appearance had a surprising, original, and deepening effect on the nature of images in Christian art. It gave the image room to breathe: it granted it depth—not the depth of pictorial space (this would come later), but moral depth, one that sees appearance as the skin of an inner reality that yearns to leap free. It was an accepted tenet of the faith that Christ's appearance falls infinitely short of his divine glory: aware of this infinite inadequacy, the artist cannot rest satisfied with the tangible: he is therefore wary of his image making. His creations are tinged at once with hope and despair: hope of going beyond the merely sensible, and despair that this might not be practical, for it would after all spell the end of images (the rationale of iconoclasm). Conscious of what it cannot do, the image is full of what it wished it could do (render the spirit). In every admission of insufficiency, there flashes the appearance of what is missing, of the ideal. The Christian image, aware of its insufficiency, thereby becomes soulful. Longing to be more than it is, it gains depth.

This particular soulfulness is scarcely found in Greco-Roman art. The Classical sculpture is second to none in conveying certain emotions such as self-confidence, pain, defiance, or desire. Forlorn detachment from the corporeal, however, it does not know and does not do. Yet, paradoxically, it is to this depreciation of the image that we owe the blossoming of pictorial expression in Western Christendom. The assumption that, however artful, an image of Christ always falls far below his divine essence paradoxically freed the image to explore, to create forms. Inferior by birth and understood to be so, the image posed no serious sacrilege. Admitting its own makeshift and approximative character, it professes to represent the divine essence only remotely and by default. Doing its own mea culpa, the Christic image is therefore at liberty to invent, represent, stage Christ and man in a variety of scenes and gestures.[17]

This is why representation of Christ thrived in the West but remained stiffly stylized and abstract in Eastern Christendom. Where it was well understood that Christ was an image of God, not God himself, no depiction of Christ, however humble, was deemed impious. There depiction thrived because it could lean on the part of Christ that was man. But where, on the contrary, doctrine maintained the pure and unalloyed divinity of Christ (the so-called *monophysis*), as in the Orthodox Eastern Church, the image fell under the charge of sacrilege.[18] The iconoclast backlash that raged through the eighth and ninth centuries and led to the banning and burning of divine images was quite virulent under the Byzantine church, while the Western popes, for one, took a far more sanguine view.[19] In the Eastern Church, the artist contended with having to convey God himself, flesh flushed with the numinous. The art of icon painting grew out of this predicament. Byzantine icons presented Christ not as a historical person who walked among human beings, but as the already transcended Godhead, Christ in glory, often dressed in the sacerdotal cloak of church emperor (or *Jesus Pantocrastor*, ruler of all). When it does not simply drop out of the picture, the body tapers to a haloed face that casts a supreme gaze on creation. The eyes, unlike those of Jesus as the good shepherd, are stunningly devoid of expression. Expression bespeaks the desire to communicate; he who communicates is incomplete, in want of confirmation. But it is inconceivable for the transfigured Christ to long: in him appearance and essence are fused.[20] Hence the supernatural beauty of the icon, the inorganic, incorruptible beauty of those gems and stones that were commonly encrusted on the portrait. This God looks neither outward for validation, nor inward for self-esteem. Neither a creature of the inner nor the outer, the icon gazes with eerily incurious eyes that expect nothing. It is a God too perfect to possess depth.

Hence the flatness of icons. Pictorial depth betokens movement, whereas the sovereign, universal God fuses the far and the near. He is not situated in space, but space is situated in him—a reversal the icon conveys by representing the deity, not *in* the picture, but consubstantial *with* the picture: plainly put, there is no context, no reality apart from the face. The gold background on many icons does not evoke space but nullifies it: all time and movement stands still in the noon light of divine presence. The gold backdrop conveys that nothing is hidden, that the shadow of becoming has been exorcised from the world: we are in the spaceless presence of Presence itself.

This spacelessness explains why Byzantine art generally neglected sculpture and bas-relief. The Eastern Church in fact lumped sculpture

with acts of idolatry, with the pagan gods who lived on mountaintops, in forests, or at the sea bottom.[21] Sculpture was perfect for expressing gods situated in space; just for this reason, it was unsuited to evoke the God that subsumes all space. Moreover, a sculpture invites the viewer to contemplate from varying standpoints, as though there are relative views to be had vis-à-vis God—an incoherent as well as impious proposition. The flatness of icons preempted a perspective-based looking. From whichever angle one gazed at the divine face, its eyes immovably watched the viewer, imparting that it was less an object than an emitter of sight—a presence that situates us, rather than one situated by us. In doctrinal terms, the Christ of the icon did not encourage acquaintanceship; it is imperial presence to which the only fitting response is submission: "The person who bows to the icon, bows to the King in it," says Athanasius of Alexandria in the fourth century. (Some icons were described as being of supernatural origin, *acheiropoietai*, or "not made by human hands": pieces of the divine rather than mere symbols of it.)[22]

The God of the Western Church, by contrast, maintained closer affinity with the historical Jesus of the synoptic Gospels. That Jesus never professed to be the kingdom, only the path to it. To worship that Jesus put the believer before a soul who had suffered the melancholy separation of Son from Father. This conviction gave rise to a different way of conceiving and depicting reality—and a more aspirational way of thinking about art. Through the Christic image, the viewer experienced at once the ambition and vanity of representation—always in pursuit of reality with which, being an illusion, it never really catches up. The melancholy incompleteness of the living Christ gave art a topic through which art could represent its own shortcomings vis-à-vis reality. It gave art room to move, to err, to unfurl a world—and also, to rhapsodize on itself.

The tentative, searching, proximate nature of the Western aesthetic springs also from the personality of Christ—a religious founder whose life begins in obscurity and ends in a disastrous anticlimax ("Father, Abba, why hast thou forsaken me?") and who, unlike Moses, Mohammed, the Buddha, or Confucius, leaves no organized system of beliefs but instead a ragbag of parables and epigrams; a man notably given to self-questioning and bouts of depressive humility followed by self-aggrandizement; in sum, a changeful personality who had given his life for an unrealized idea, an apocalyptic kingdom-to-be: a personality who had tasted the bitter dissonance between what is and what should be.

Given this background, the best a Christian could do was to feel and model his existence on Christ's agonizing rift between here and there, between now and then. There is a well of neurotic energy and dark vitality in Christianity that feeds an anxious attitude toward life, now pining for redemption, now ruing existence, eager to escape, as restless as Jesus trekking up and down Palestine, preaching, arguing, justifying himself, working miracles, always full of to-dos (not for him the stationary quietism of a Lao Tzu or Buddha: only Mohammed outdoes Jesus in missionary bustle). Indeed so much of European culture, which took shape around endlessly metastasizing monastic communities, owes its restlessness to this example. Judaic messianism and Christian voluntarism combined to fashion a religion out of movement, discontent, expectation. To be is to be on the move. Movement—the notion that reality is a horizon unfolding—is a defining trait of Western psychology. It emboldened an ethic that equates greatness with inner unease and striving and made a virtue of disquiet, from Augustine, Luther, Pascal, Hegel, Kierkegaard, and Heidegger to Beckett. The Judeo-Christian story (Old and New Testaments together) vindicated a certain *horizontal* mode of existence that makes the shadow of what is not, or not yet, into a reality as real to us as anything we behold.

In the medieval period, to which we now turn, the romance of nothingness that is the Western mind produced a protagonist and a narrative form to convey its notion of reality as unfolding substance: the knight errant on a quest.

Space

The Northern Forest, 1100

In evolutionary terms, a cultural form such as a myth tends to endure when it tends to bolster the institutions and beliefs of its society. Stories of no social value whatsoever have the shelf life of anecdotes; those that promote communal permanence grow into myths. Even when they leonize go-it-alone heroes and recreants, myths foment group identity. It is those cultures possessed by a strong myth of the corporate life (the Athenian city-state, the Hebraic chosen people, the Roman *civitas*, the apostolic family of Christendom) that last long enough to write their own history. Among these collective narratives, Christianity cuts an odd figure because its founding hero, Jesus Christ, was not a political leader (unlike Moses or Mohammed), a church founder (unlike Paul or Buddha), or much of a community activist. Even among the band of twelve, Jesus liked to keep to himself. His public life is a comet streak, his private life a mystery, and a lingering note of existential loneliness hangs over his ministry. Unlike Moses or King David, Jesus brought not a unified Jewish state but conflict in the temple. He professed love of everyone but required his followers to abjure kith and kin ("If anyone comes to Me and does not hate his father and mother, wife and children, brothers and sisters, yes, and his own life also, he cannot be My disciple" [Luke 14:26]). "I did not come to bring peace, but the sword," he also announced (Matt. 10:34). What discord did he mean? If not the sword of armed warfare, then perhaps that of permanent moral conflict, estrangement, incomprehension. Jesus spoke of the brotherhood of humankind

but practiced a religion of private conviction. He rejected tradition, civil and religious authorities, and ritualism in favor of a personally accented spirituality. (Whence, perhaps, its appeal: that it addresses what no human self is without, i.e., an inner sense of being one among many.)

Christ's solitude is most poignantly salient on the tragic last night of his ministry, which he spends tremblingly alone in the garden of Gethsemane. It is a puzzling episode of the eyewitness (i.e., synoptic) Gospels of Mark, Luke, and Matthew because, naturally, no one could have been an eyewitness. The whole point of the episode is that Jesus was alone and the disciples asleep. But its relevance is undoubtedly more spiritual than historical. Still, the three Gospels are consistent on this point: knowing the inevitable to come, Jesus calls on his Father for a reprieve and the sky remains silent. The hero is horribly alone, praying in the answerless night, forsaken by God and men. (The fortitude needed to endure such agonizing silence is not unlimited: Luke relents and sends a comforting angel; John omits the episode; and the Gnostic Gospel Acts of John has Jesus and his disciples form a circle of song and dance.)

Let us look at how Mark, reputedly the earliest and more artless of the Evangelists (c. 70–80 C.E.), relates the episode:

> Then they came to a place which was named Gethsemane; and He said to His disciples, "Sit here while I pray." And He took Peter, James, and John with Him, and He began to be troubled and deeply distressed. Then He said to them, "My soul is exceedingly sorrowful, even to death. Stay here and watch." He went a little farther, and fell on the ground, and prayed that if it were possible, the hour might pass from Him. And He said, "Abba, Father, all things are possible for You. Take this cup away from Me; nevertheless, not what I will, but what You will." Then He came and found them sleeping, and said to Peter, "Simon, are you sleeping? Could you not watch one hour?" . . . Again He went away and prayed, and spoke the same words. And when He returned, He found them asleep again, for their eyes were heavy; and they did not know what to answer Him. Then He came the third time and said to them, "Are you still sleeping and resting? It is enough! The hour has come; behold, the Son of Man is being betrayed into the hands of sinners." (Mark 14:32–42)

Is there a theological point to this thrice-repeated call? What is the use of humanizing Jesus to this pitiful extent? What emotion are we being asked to share? Tragic loneliness, presumably. But tragedy and theology do not make good fellows. Being the Son of God should theoretically inure anyone to existential loneliness, let alone tragic feeling: this is probably why John's Gospel (the most adamant about Jesus's divinity) bowdlerizes the episode. And yet there is something about the solitude at Gethsemane that is inherently cognate to Christ's personality and

religiously significant. Perhaps Jesus's story is not complete unless he is misunderstood, exiled, betrayed by his own brotherhood—unless he also endures the silence of the Godhead. Christianity wants us gazing into the heart of the human soul where there is no mother, brother, priest, or Caesar and where even God the Father strangely holds back. The Christian ethos wants a hero: to wit, a loner.

Essential to the heroic character is the test of solitude (e.g., Gilgamesh, Prometheus, Odysseus, Jonah, and Aenas are all, at one time or another, desolate). In part this episodic solitude, the stay in the belly of the whale, is mandated by the heroic character who almost by definition goes it alone and stands spendidly apart. In the hero is vested the faith that inside every human being there is a wholly original and ultimately unknowable way of experiencing life. We readers are not always told what the hero thinks, but we are never under any doubt that his character and destiny spring from his singular personality; that the world in which he moves is fashioned by his perspective; and that this is how it should be.

Accordingly we note that narrative is the form elected by the first followers of Christ to relate his message: not doctrinal dialogues, not a table of commandments, not a collection of sayings, but a biography. The real story behind the clichéd "greatest story ever told" is the novelty of a religion founded on a man's life story. (To this day, the articles of the Apostles' Creed form not a nomenclature of commands, but a thread of events: "I believe in Jesus Christ, his only Son, our Lord, who was conceived by the Holy Spirit, born of the virgin Mary, suffered under Pontius Pilate, was crucified, died and was buried. He descended into hell. The third day He rose again from the dead," etc.) To believe in Christ is to believe in an adventuring hero, part Orpheus, part Moses, and part Osiris.

As the arts and liturgy of the early Latin Church attests, this narrative element was instrumental in shaping Christian belief.[1] From the earliest days, painted episodes from the scriptures festooned the walls of basilicas. Believing in God and believing in a story were of a piece—an amalgamation vividly upheld through the Middle Ages in the form of Easter plays, Passion plays and Nativity scenes. The Passion play in particular: there is no time Christ is more a narrative character than on the cross. There his story culminates; there the heroic cycle of his life comes to fruition, when, a true hero, he endures the terribly lonesome face-to-face with death.

It is a testimony either to the supremacy of the Gospel story or to the decay of the arts following the fall of Rome that epic storytelling in

the western empire went into a near total eclipse for the five centuries to follow. When the art of narrative emerged again, around the ninth century on the northern fringe of Christendom, it reached right back to the hero at Gethsemane: the individual trembling in mortal agony, alone before the horizon of life.

Let us take the case of the Old English elegy "The Wanderer." A lyric of the early tenth century, the poem weaves Christian themes with strands of Norse saga poetry, seafaring dirges, exile, solitude, and longing that set the first example of a secular lyrical (not mythological or religious) voice in European literature.

> Often the solitary one
> finds grace for himself
> the mercy of the Lord,
> although he, sorry-hearted,
> must for a long time
> move by hand
> along the waterways,
> the ice-cold sea,
> tread the paths of exile. . . .
>
> There is none now living
> to whom I dare
> clearly speak
> of my innermost thoughts.
> I know it truly,
> that it is in men
> a noble custom,
> that one should keep secure
> his spirit-chest (mind),
> guard his treasure-chamber (thoughts),
> think as he wishes.
> The weary spirit cannot
> withstand fate (the turn of events),
> nor does a rough or sorrowful mind do any good (perform anything
> helpful).
> Thus those eager for glory
> often keep secure
> dreary thoughts
> in their breast;
> So I,
> often wretched and sorrowful,
> bereft of my homeland,
> far from noble kinsmen,
> have had to bind in fetters
> my inmost thoughts.[2]

The scene in this birth song of Western lyricism is the high seas; the moral landscape, however, is pure Gethsemane. To know himself, to plumb his inner substance, man must travel away from the clan and the mead hall. Company hinders self-knowledge. When he dies, the Christian individual does not return to the bosom of the community or join the ancestors. He dies existentially alone, before the silence of nature and the invisibility of God. Odysseus, like the Wanderer, endured solitude in the high seas, yet all along his aim remained to get back to his high-roofed home. The Wanderer, on the contrary, has no thought of going back: his is a one-way journey to nowhere.

> He thinks in his mind
> that he embraces and kisses
> his lord,
> and on his (the lord's) knees lays
> his hands and his head,
> Just as, at times before,
> in days gone by,
> he enjoyed the gift-seat (throne).
> Then the friendless man
> wakes up again,
> He sees before him
> fallow waves
> Sea birds bathe,
> preening their feathers,
> Frost and snow fall,
> mixed with hail.[3]

Plowing the waves, the Wanderer does not seek a conclusion either to this life or to his train of thought. To be human is to contend with the open-ended. Bare nature does not provide anchorage. Our home is elsewhere, the past is nothing, the present is desolate, the future is all, and all is therefore nothing—since what is to come has no existence now.

Another Anglo-Germanic elegy of the same period, "The Seafarer," presents a poet-wanderer in exile. His song begins in the keening tone of imposed solitude. But the mood suddenly flips: solitude becomes a badge of spiritual distinction. "Desire of spirit constantly urges my heart / to go forth to seek / the home of strangers far away from here."[4] To be alone, mortal, sailing under the vast horizon, this is man's true home. A noble soul always departs. His life is a string of abandoned "here's." "My thoughts turn widely with the following sea, / over the home of whales and surfaces of the world; / it comes back to me eager and full of longing / —the lone flier cries out irresistibly, / inciting the heart forth

on the whale's road, / over the boundless sea, / for to me the joys of the Lord are warmer by far / than this dead and transitory life on land."[5] A strange hero it is who shuns fame, power, the fawning of the subdued; it is as though Achilles happily chose obscurity, and Odysseus never again spared a thought for Ithaca. The seafarer overcomes the hero's gregarious needs. The "joys of the Lord" are not in union with the ways of society or the church but with the wasteland. Though the lyric does pay respect to Christian piety (only the Lord saves), it is the thrall of the open sea, the tossing of the waves, the cry of the gull that stir its poetic heart. It plucks a spiritual nerve hardly touched in antiquity, the idea that man fulfills himself by venturing into boundless, desolate nature. Man, it says, is the unsocial animal. Nor does he find a home out on the ocean. Instead the realization that there may be no place vast enough for him quickens his soul. The infinity without offers a fitting context for the infinite within, and the soul, newly conscious of its depth, finds a kindred element in boundless space.

As we have seen, the Classical philosophers held empty space generally in poor esteem. Aristotle denied it any reality; the Pythagoreans argued it away. It is Judeo-Christian eschatology—the theology of the vanishing deity—that first gave it pride of place. Now the proto-Gothic spirit speaking through the Seafarer seeks distance for its own sake. "The sound of the harp, the giving or rings, the pleasure in woman, or worldly glory"—all pale in comparison to the hollowing sky, the thankless ocean, the offing.[6] The Seafarer is no pilgrim: not for him the pit stops to Jerusalem. What he rejects deep down is the idea that spiritual longing can be satisfied by an object—relic or shrine. No concrete vessel is large enough to contain his longing. He needs something immaterially larger, and it is in response to this new insatiable feeling that the tenth and eleventh centuries saw the rise of a new mode of narrative the human journey of life: to wit, the quest.

In itself, the pattern of a quest is a boilerplate as old as storytelling (Gilgamesh goes after the secret of life kept by Utnapishtim the Distant, Jason after the Golden Fleece, Moses after the Promised Land); what took hold around the High Middle Ages, however, was the idea that neither the plot nor the hero really needed to reach the goal. Another kind of satisfaction could be had from questing itself. Process, rather than success, was of the essence. What emerges from the seafarer in permanent exile is, already, the Arthurian knight who, having run out of dragons to slay, castles to conquer, and maidens to rescue, launches on a quest that, from the start, promises never to end: the quest for

the Grail. And the Grail, besides being elusive, is also equivocal. Even the knight has no clear knowledge of what it consists of. What matters is that it is sought and longed for to the death. This search for the sake of searching is responsible for begetting the first genuinely non-Latin, post-Roman aesthetic worldview to issue from Christianity: the Gothic.

The French poet Chrétien de Troyes (1135?–91?) wrote the first-known Grail romance, but it is his German epigone, Wolfram von Eschenbach (c. 1170–1220), we turn to for our first taste of the quest psychology. Why does the knight take to the open road? "And Parzival went away from there. . . . Alas that many an unsweet bitter thought touched him. The width of the land was too narrow for him, and the breadth altogether too confiding. . . . He rode along many unbeaten paths where there was little in the way of roads."[7] A soul too large for a world too narrow: it is such claustrophobic jitters that knock Christian identity off from its Latin-Roman anchorage and sends it to cultivate an original aesthetic, the Gothic, the style truly expressive of Christian otherworldliness.

When Christianity received state sponsorship, around the fourth century, it simply adopted the architectural vocabulary of its erstwhile oppressor and now patron, the Roman *civitas*. The word *basilica*, which became the center of Christian liturgical life, originally designated a Roman law court. Even as a place of worship, it maintained its aspect of political stronghold—especially when, in the wake of Rome's collapse, it retreated behind fortressed walls and retreated to remote areas, a bunker of literacy in the invasion-ransacked landscape of Merovingian society. Throughout the Dark Ages and the early monastic period of Western Christendom, the basilica represented the basic symbol of the Church's focus on securing an earthly foothold rather than creating an original Christian aesthetic.

This original aesthetic slowly came to light around the tenth century when a sensibility, resolutely northern, backed first by the Anglo-Norman state power and later by the Capetian dynasty, slowly filtered down into the Roman and Romanesque South. This new sensibility, known as Gothic, is Christian longing coming into its own with a thousand-year time lag. It speaks of a Christian religion secure in its earthly realm, having spread the confession from Ireland, Germany, and Spain and to the doors of the Islamic empire on a network of monasteries answerable to a strong papacy—a religion that could now give voice to the longing

enacted in Gethsemane and cast its original theology into sculpture, architecture, and poetry.

The Grail story partakes of the Gothic first in its dismissal of architectural enclosure. From Aristotle's *Poetics* to the Roman basilica or the Romanesque chapel, containment had been the lynchpin of aesthetics. The Grail story breaks with this bunkered mindset. What the Arthurian knight wants are not facts, trophies, spoils of battle, or *results*. He wants to be on the go; he wants the fugue-like form, the soaring momentum, the Gothic élan. The Grail is not the destination but the way. Not since Odysseus's speeding trireme had we seen a hero as stubbornly addicted to purpose and hurry as Chrétien de Troyes's hero: "Perceval swore a different oath, saying that he would not spend two nights in the same lodgings as long as he lived; nor hear word of any dangerous passage that he would not go to cross . . . until he had learned who was served from the grail and had found the bleeding lance and been told the true reason why it bled. He would not abandon his quest for any hardship."[8] In fact, Perceval rides on even after he finds out about the Grail. His narrative looks not to a conclusion, in defiance of Aristotle's *Poetics*; instead it begins in order never to end, a verbal analogue to the surging arches and vaultings of the Gothic cathedral, which are capped not by a roof but a kind of architectural legerdemain, the illusion of open sky. Both the chivalric quest and the cathedral set their sight on limitless reaches. Whereas the cupola caps the Romanesque apse and the basilican barrel vault or flat ceiling bluntly tops the basilica, the sky is the intended roof of the Gothic clerestory. The latter is the horizon longing expressed in stone—as the Grail romance expresses this longing in verse.

As reinvented by Chrétien, the *Story of the Grail* (1180–91) severally departs from the chivalric playbook. The first surprise is that the hero is not the king (unlike in *Gilgamesh*, Homer's epics, the Athenian tragic hero stories, the Roman histories, etc.). While King Arthur bemoans the desertion of his knights in the background, the knight launches forth with goals and purposes of his own, and in Arthur's complaint we can hear the old Caroligian order caviling about those fidgety, never-satisfied Gothic young guns. What are they so restless about? But the knights are not restless *about* anything; disquiet is inherent in them. "The starting-point of most of Chrétien's romances," a critic observes, "is the alienation of the hero from the society around him."[9] Alienation is too technical a term for a feeling as entrenched as Christian otherworldliness. In fact, Perceval embodies the values of his society in

looking beyond the social and earthly realm for his raison d'être. This is not alienation from a worldview but its becoming perfect. Chrétien never seriously means his Perceval to meet his goal; nor, in fact, does he mean him to be particularly capable in jousting and swordsmanship. Hailed as the high watermark of chivalric literature, Chrétien's poetry is actually rather bored with *faits d'armes*. "The battle was long and hard, but it seems to me a waste of effort to elaborate upon it," is Chrétien's way of settling the action.[10] This is why the knight chases a Grail rather than a crock of coins or an enchanted damsel. Through Perceval, Chrétien speaks of a longing that as yet has no literary form and which he is at pains to express: the longing for what cannot be found on earth. Hence the trances and speechless spells that overcome Chrétien's impractical hero: these episodes do not advance the plot one inch; instead, they deepen our sense of highstrung spirituality. If Perceval knew what he was after, he would get to it. But his heart is simply too full of wordless intimations for which the chanson de geste does not have the vocabulary. The pivotal episodes (the parading of the Grail, the drops of blood on the snow) occur in a mental blur. Unable to voice his vision, Perceval often falls silent, and he is never more the hero than in those moments when speech fails him, when expression tapers to a sublime point—but pointing at what?

At the Grail, presumably, and more generally the secret in it. But what *is* the Grail? For Chrétien the answer seems less important than the fact that its strangeness silences the knight. *Strangeness* here is more apt than *mystery*, because mystery suggests covering up, whereas nothing is hidden about the Grail. It would be mysterious if it were under lock and key. That it isn't sets it apart from the Romanesque—the Romanesque and its penchant for protected mystery (crypt, catacomb, shrine, locket, fortress, basilica). The Gothic, on the contrary, hearkens to space, movement, distance. The Romanesque is really a late resurgence of the ancient mystery cults (from the Greek *mystes*, *myein*, "secret enclosure"), religions that centered on the idea of initiation and inner precincts, often a cave or cavern-like building, cryptic and esoteric and deliberately shunning of the light of day. The mysteries envisioned religious experience as a retreat to the safety of the buried, the umbilical, the finite (the Greek word *mithraion*, at the root of the Roman mystery cult Mythraism, means simply "cave"). Likewise the Byzantine basilica, the Norman style, or the Corinthian crypt invites the flock to plunge in secret darkness. Central to the mystery cult was the

tabernacle, the holy of holies, the infolded shrine that, as in the Eleusinian cult, took the form of a lidded chest. Its contents are less important than the fact they were contained and out of sight. Containment underpins the Romanesque aesthetic, and the Norman abbey squats against assault, an intellectual frontline against barbarian raids. Embattled as it is against armed bands, it also staves off the mental enemy of openness, transparency, the ecstasy of space. The Romanesque is agoraphobia expressed in stone. It advances Aristotle's idea, paradoxical on any day, that "what is limited, is not limited in reference to something that surrounds it."[11] The Romanesque transposed this syllogism into masonry.

Enters the Grail. As Chrétien depicts it in the story of Lancelot, the Grail does not hide in some inner sanctum; instead it is the object of a parade. It is peripatetic, kinetic, here one moment and gone the next. Lancelot glimpses it once, and the rest of his life is spent riding after it. Nor does it found a society of initiates. Though Lancelot beholds it in a crowded court hall, Chrétien draws a dreamlike veil over the occurrence. And when Lancelot shakes off his spell, the castle is magically emptied of its inhabitants. Appearance of the sublime object has created not a community of believers, but a lone perplexed knight speechlessly full of thought. Gothic feeling is not especially gregarious; it does not, like the Romanesque, tender a roof for the faithful to huddle under. The aim of Romanesque sacred architecture is the flock; that of the Gothic is a mirage-like intimation of the numinous. It arches back to the spirit of King Solomon standing before the Temple of Jerusalem: "But will God indeed dwell on the earth? Behold, heaven and the heaven of heavens cannot contain You. How much less this temple which I have built!" (1 Kings 8:27). The Gothic structure sends the believer's gaze into a private contemplation. The high portals, vaulting arches, flying buttresses, and fretted columnwork lure his attention away from coreligionists. His imagination gains altitude, kindling an experience that is less liturgical than poetic, less doctrinal and more ineffable—on par with the oneiric trances and interior monologues to which Chrétien's knights are cripplingly prone.[12]

Every point in the Gothic church is tautly aware of leading beyond itself; every architectural unit aspires to the one above; unlike a dome (which looks down), the ribbed vaults bulge outward. The momentum is vertical, lithe, expansive, sky-bound, ethereal to the point of unreality. The Egyptian ideal was mass; the Greek temple advertised order; the Buddhist mandala has no up or down; Islamic form is calligraphic. The

Christian symbol is an arrow aimed at the sky. The cross throws out its arms, embraces space. The Gothic cathedral is this open-armed gesture set in three dimensions. Standing at the foot of Strasburg Cathedral, an enraptured Goethe effused about the "sublime, wide-spreading tree of God."[13] And he understood that a Gothic structure demands to be seen and felt from the ground up. For it is not God's eye watching us, as in the Byzantine dome, that inspires its form, but the human eye looking skyward and losing itself in distances unseen. Where the dome of the Romanesque and Byzantine choir presents the Christ Pantocrastor staring down the faithful, the Gothic cathedral draws the human gaze beyond the corporeal and the tangible. The structure scrabbles away into thin air, lures the eye to a placeless infinite where, rather than the stare of a border-patrolling God, the believer intuits the infinitude of his own gazing. For if the cathedral overwhelms by its size and conveys the power of the church, it also nourishes the power of contemplation and imagination. To believe is to quest; it is to gaze at a mirage. The twelfth-century Christian is on a Grail journey inside a Grail structure.

By devising a technique to shift the load bearing to points *outside* the structure, the Gothic builders created an impression of open unencumbered heights. No more murky, cluttered interior. The vaults were pushed apart, an ambulatory lined the nave past rows of fluted columns, which let the eye slip into side chapels, each with its set of oblong windows and swaths of pouring daylight. The rood screen was removed so the nave would appear in one sweep of stained glass–colored air.[14] Standing inside the Bourges Cathedral (1190), one can be excused for thinking the building eager to climb out of itself, on a ladder up to thin air. A flying buttress is a wall that jumps out of its own skin, as it were; a gargoyle is a cornice that refuses to end. Pushing aside the stodgy brick and mortar of Romanesque walls, lacings and filigrees of stonework whisk away the impression of limit and partition. The Gothic cathedral indeed is linearity without a goal, the quest story set into stone.

Nor were the other arts remiss in expressing this new sensibility of boundless linearity. Music was undergoing a revolution of its own, with the invention of counterpoint and polyphony that instantly outdated the Gregorian repertoire of recitative monophony. Polyphonic sound broke the melody free from the single human voice, blending the embodied singer into multiple, vaporous choral harmonies. The Gregorian chant tended to meander, horizontal and dilatory; the polyphonic Gothic by contrast soars in ambitious sonic branches that seek air and elevation. Harmony, meanwhile, discovered the magic of echoes,

of doubling, tripling, and quadrupling notes. Whereas the monophonic chant unwinds in time, the choral hymn fans out in space, enjoins us to hear everything at once and lose track of specific voices. It sweeps the listener into a stereophonic umbrella-shape wave, for which the great cathedral supplies the luminous visual arena.

In fact, the Gothic taste for unbounded space tapped into a Christian tradition going back to the anchorite, the hermit, the spirit of the desert fathers who sought God in the wilderness. As St. Jerome, patron saint of hermits, confided: "Whenever I saw hollow valleys, craggy mountains, steep cliffs, there I made my oratory."[15] Cliffs, valleys, and peaks present a picture of the earth carved hollow by the void—the way the crenellated ridges and cornices of the great Gothic edifice are pulled and teased by the fingers of empty space, or sucked upward by an irresistible draft.

The twelfth-century cathedral wished not to crush or dwarf the believer with its presence, but to lead him to the ineffable, to a place beyond human intercourse. So, in the presence of the Grail, Chrétien's Perceval experiences a force that divorces him from common religion (from the Latin *Re-ligere,* to tie together). But Perceval does not join up with others or with the Grail; he is silenced by it. He does not understand it, and he relates neither to it nor to others. His experience, quintessentially Gothic, coincides with the more passionate and voluntaristic turn of the theological life in the thirteenth and fourteenth centuries, with the rise of lay piety, the influence of theologians such as Duns Scotus and later of Ockham and Meister Eckehart in Germany or the anonymous English monk who wrote *The Cloud of Unknowing*—contemplatives whose writings variously describe tremulous ineffable encounters, a liturgically unbridgeable distance between the finite and the infinite, man and God.

Perceval's silence before the Grail enacts this Gothic sensibility for an unsayable God. It is this silence that precipitates the quest: as Chrétien insists, it is because dumbstruck Perceval fails to ask fellow believers about the parading Grail that he is doomed to look for it. As the witch says, "You didn't ask or inquire what rich man was served from the grail you saw. Wretched is the man who sees that the propitious hour has come but waits for a still better one. And you are that wretched man. . . . Cursed be the time you failed to ask!"[16] It all begins with the knight speechlessly fascinated by a receding appearance, spellbound by a vision that dwindles out of sight. The knight enjoys *not* knowing. The quest, after all, entails permanent uncertainty (where and

what is the Grail?). But not knowing is more than the initial condition of the quest: the satisfaction of not knowing is not just that it furthers the narrative (by keeping it going); it also justifies the psychology of the *inward* individual—the individual who withdraws his stock from church-sanctioned dogma and follows the scent of personally felt truths. The knight is the forward-going individual, mesmerized by the endlessness of his wonder. His quest is Gothic space expressed in the medium of psychology.

Thus far we have stressed the constant irrigation of the Gothic imagination by northern Anglo-Norman and Germanic culture. But in fact Gothic intellectuality owes also a debt to another influence rising from the Hispano-Arabic South. This influence is most evident in science, where Arabic advances in mathematics, astronomy, and medicine beat the European Renaissance by a long head start, and in philosophy, where the Muslim Averroës (1126–98) and his fellow Andalusian, the Jewish Maimonides (1135–1204), worked out a synthesis between reason and faith without which the stream of Christian medieval philosophy and Thomism would have been a very thin trickle. In architecture, the Moorish style contributed brick vaulting; in designs, this style was responsible for the much-imitated patterns such as lozenge lacework, particularly on evidence throughout Spain and Italy.[17] Finally, the influence of Arabic poetry on European courtly love is now the object of historical revision, notably as it shaped troubadour Provençal lyricism.[18]

Of course it is a leap between Norman errant knights and Andalusian Judeo-Arabic culture (though recent scholarship has unearthed the Arabic influence on the Grail legend).[19] Yet Chrétien's depiction of the Grail apparition harks back to a central episode of Hebrew Scripture that, for Maimonides, anchored the very faith and underwrote a whole theology. This theology, known as apophatic, or "negative," theology, is Gothic through and through, and sets the Grail quest in proper theological relief. Lancelot, we recall, beholds the Grail once, during a pageant, then falls into a swoon. Perhaps the vision overloads his human comprehension. It is so sublime, so transcendental a presence, that contact with humanity must be no more than a fleeting brushing-by—like the moment when, so as not to kill Moses with the vision of his glory, Yahweh shows himself in *passing* (Exod. 33:19). As the knight will ever know but a fleeting glimpse of the Grail, so humankind henceforth sees but God's receding trace ("Thou shall see my back" [Exod. 33:23]).

Maimonides understood this episode of the Tanakh to be absolutely central to the faith and built his *Guide to the Perplexed* on its premise. A beacon of Jewish and Christian medieval thought, *The Guide to the Perplexed* is first of all a polemic against anthropomorphic images of God. Once started, Maimonides finds himself mounting an all-out argument for the inconceivability of God.[20] So great, so universal, so absolute is the divine that only those statements are correct that pertain to what he is *not*. Thus God is not physical, mutable, imperfect, or ignorant. It would be specious to say that God is incorporeal, immutable, perfect, and wise because these are attributes, and attributes modify a substance, whereas the universal and eternal God by definition cannot be modified. He is without attributes—including, crucially, the attribute of existence. So it is wrong to say God exists: "God," Maimonides teaches, "exists without possessing the attribute of existence."[21] This is no cryptic atheism; rather the opposite, in fact: because God cannot be conceived not to exist, it is incorrect to add existence to him, as one hangs clothes on a dummy. God precedes all attributes, including that of existing.

But then how do we apprehend or relate to a God so sublime? The answer is, we do not: "The difference between Him and His creatures is not merely quantitative, but absolute. . . . His existence and that of any other being totally differ from each other."[22] There is, in other words, no straight and continuous path to transit from the human to the divine. When Moses asked Yahweh to show his way, Yahweh answered, "I will make all my goodness pass before thee." But, Maimonides comments, when Moses asked, "Show me thy glory," Yahweh replied, "Thou canst not see my face."[23] This leaves open only the negative path: it consists not merely in not perceiving God, but in seeing that we do not see God. Negative theology drenches us in divine ineffability.

For ineffability is not silent—in fact it is a property of language. As such, it can free up expression—on the understanding that, given language can never reach God, it has license to meander and rhapsodize at will. This expansion through negative space is another way of understanding the Gothic style. What, after all, is the great cathedral if not lots of booming negative space that declares the sublime distance of God? What is the Grail narrative if not a trek into the sublime absence of the Answer, the Fulfillment—God? For a good reason does Maimonides defend the theological respectability of dreams, prophesies, and visions—modes of knowing and expressing that prodigally loosen expression: "It is the highest degree and greatest perfection man can

attain: it consists in the most perfect development of the imaginative faculty."[24] This unfolding of creative vision uncorked the geyser of expression that spread into the wending, reaching, architectural effluences of Gothic art.[25] Maimonides proclaimed the unknowability of God and in doing so licensed the mystical sublimity of human vision—one no longer bound by reason and measure but emboldened to make statements, architectural and artistic, that are disproportionate, as disproportionate as the cathedral's height is to the job of providing a shelter. It is this surge of vision, this trajectory of perception exhausting itself out that, by supplanting the ideology of certainty with that of negative apprehension, spurred the Gothic.

In sum, the Gothic marks the incipient transition from the classical world of essence to the modernity of existence—from a world ruled by eternal fixity to one actuated by will. Again, medieval Arab philosophy laid the groundwork, in this event through the Aristotelian commentaries of Averroës. The gist of Averroës's philosophy, as expounded in *The Incoherence of Incoherence,* is initially a defense of Aristotle against the misprisions of fellow Arabic interpreters. In rising to Aristotle's defense, Averroës stumbled upon an unsettling idea destined to loom large in the modern worldview: existence is not subordinate to essence.[26] In the first discussion, Averroës argues the correctness of Aristotle's position that the world is eternal and without beginning. But this position assumes that existence is not a supervening quality of essence. There is not first the possibility of a world and then the actual world. A nonexistent essence is nonsensical. This does not exactly lead Averroës to proclaim that "existence precedes essence," but it does occasion such statements as "the existence of a thing is prior to its quiddity" (eighth discussion), which means that existence is as much the ground of being as essence ever was. There was, in this train of thought, the beginning of a rescue of the concrete life, which, born of Aristotle, would eventually topple Aristotelian essentialism. Averroës's idea upended the hierarchy of essence (lofty, ethereal, godly) and existence (lowly, benighted, sinful). In a sense, Averroës suggested, there is no need to work out how we pass from essence to existence, from the eternal to the temporal, because nothing separates them—a conclusion that all but triumphs in the great cathedral and the quest narrative. What, in the end, is the quest narrative if not the idea that the Absolute requires continuous existential acting out?

Chrétien never completed his *Story of the Grail,* and this incompletion finely agrees with the narrative form of the Grail quest. Can we imagine

perception ever touching the sky? In his very identity, the knight exhibits some deep affinity with the apophantic unveiling of the absolute by failure of speech. The strangest episode in Chrétien's story is probably the one that has Perceval, hitherto known as "the youth," suddenly remembering his own name just when he understands the fateful consequence of letting the Grail pass him by:

> "Did you ask the people where they were going in this manner?"
> "Not question came from my mouth."
> "So help me God, now it's even worse! What is your name, friend?"
> And the youth, who did not know his name, guessed and said he was called Perceval the Welshman. But although he did not know if that were true or not, he spoke the truth without knowing it.[27]

Perceval understands *who* he is when his eyes open to the quest. In other words, it is the quest, the narrative of Gothic postponement, that begets him: I miss the Grail; therefore I am (born).[28] "Ah, unlucky Perceval, how unfortunate you were when you failed to ask all this."[29] This is unfortunate indeed only if infinite egress is a bane. Perhaps it is unfortunate not to rest on solid truths—but how liberating also! For the whole world is then yet to build. Knowledge, faith, destiny: these are no longer monoliths; instead they require partaking of, imagining into, projecting into. Historians now agree that the great unleashing of social, cultural, and artistic power released by the Renaissance had really begun earlier, in the buildup of intellectual energy over the eleventh and twelfth centuries.[30] This is the time when, from Arabic Andalusia to Cluny, Aristotelian logic and visionary mysticism replaced rote recitation in theology, when the new, enthusiastic Franciscans challenged the torpor of Cistercian piety, agitating for a more internalized and activist experience of religion. In the view of Medieval science, the eye was an active organ that sent out beams of perception, prehensile envoys rather than mere receptor.[31] To see and to look for seem to have formed a synonym. The Gothic sprang out of this climate of intellectual activism.[32] It acted on the wish to *construct* rather than receive doctrine. In the end, the keynote of the Gothic cathedral is confidence, indeed to the point of daredevilry: the sheer exhilaration of building for the sake of building, of rigging up stone scaffoldings, the way scholiasts at the Sorbonne, Bologna, Cordoba, or Oxford delighted their audience by erecting arguments matching point and counterpoint—a dialectic, disputational style of knowledge analogous to the architectural brinkmanship that built the Chartres and Cologne Cathedrals. It

is really there that European intellectual culture starts to be the thought that hates to end.

Perceval does not know where he is going, how far the Grail is, how distant his aim. His faith in his ability to maintain his intellectual tension is taut to the breaking point. He believes in the open-ended—just as the scholars in the new cathedral schools and universities learned to tense their mind rather than hoard certainties. Again the Arabic renaissance of the tenth and eleventh centuries played the catalyzing part as Persian skepticism and atheistic questioning filtered up to northern Europe.[33] It is then we find more boldly affirmed that questioning (i.e., mind under tension) is not the enemy of God, faith, or knowledge, but rather the right use of the intellect. "We seek through doubt, and by seeking we perceive the truth," said the flaming twelfth-century Sorbonne theologian and logician Pierre Abélard (1079–1142).

The courage to nurture hesitancy and two-mindedness typifies the new intellect. In his famed treatise *Sic et non (Yes and No),* Abélard deftly argued opposite sides of an argument, weaving marvels of dialectical logic clambering up to heights where he would leave his rapt audience suspended between *yes* and *no.* Peter of Poitiers (1130?–1215), the chancellor of the University of Paris, summarized this spirit thus: "Although certainty exists, nonetheless it is our duty to doubt the articles of faith and to seek and discuss."[34] Instruction at the cathedral schools often included mandatory attendance to debating jousts between famous scholars. Faith was no longer self-validating. The intellect wanted to have reasons for believing—which of course undermined the certainty of religious axioms. Certainty may exist, as Peter of Poitiers said, but only as the fruit of critical engagement with facts. The great intellectual edifice of European Gothic thought, Thomas Aquinas's *Summa Theologica* (1265–74) lists, not axioms, but propositions and counterpropositions, as though no statement is true that cannot be proven false, and vice versa. Intellectual tension runs through the intellectual structure, which, replaced the closed system of pillars and walls (of faith, dogmas and orthodoxies) with an open system of interjections. Like the Gothic structure, the scholar slides and multiplies his standpoints, postpones conclusions, opens vistas—erecting the intellectual edifice on the principle of countervailing forces, the same way a cathedral stands up not by the stocky masonry, but by parceling out its weight across a multiplicity of stress points.

Romanesque knowledge proceeded deductively from the top down: from axiomatic truths down to applications. "Do not try to understand

in order to believe; believe in order to understand," says Augustine. The Gothic edifice, on the contrary, is inductive, and induction requires guesswork and skepticism. The Gothic hero, unlike the Hercules or Achilles of yore, is given to mental vacillation. The Arthurian knight has a loyal heart, but his beliefs often waver. Chrétien's hero even flirts with apostasy. "He no longer remembers God," he says of Perceval.[35] That Chrétien could stage a momentarily faithless hero shows that doubt had become a legitimate intellectual step. Where thought became synonymous with dialectic, theology would follow the path of intellectual induction rather than dogma. It is thus religion countenanced the existential rhetoric of life in progress. As the Gothic cathedral gloriously proclaimed: all is in the building thereof.

All is atremble in the world of the Arthurian romance. Knighthood, honor, faith, sanity, selfhood, love, kinship, the Brotherhood of the Round Table: these are not facts but flickerings in boreal twilight. Von Eschenbach has his Grail narrative hinge almost entirely on Parzival's crisis of faith: "I used to serve one called God before His mercy decreed such miserable mockery over me. My senses never wavered from Him whose help was promised me. Now His help has failed me altogether."[36] Doubt is the air breathed by the Arthurian characters. "Doubt's nearness to the heart must become bitter to the soul": thus begins von Eschenbach's tale. But the knight needs this bitterness. Not that the Arthurian romance means to ennoble unbelief; at the end, this trial by doubt fortifies and individualizes faith. But it underscores that the foundation of Gothic faith needs a chiaroscuro, a dark night of the soul, the "cloud of unknowing" in which the divine is now glimpsed, now lost sight of again.

These are not just metaphors. A consequence of binding religion to the inner self was to throw religion into the realm of perspective. Where belief is fought for, not given, its existence assumes an active, contingent perceiver. This dynamic is as true to time edifices (narratives) as to space edifices (buildings): whereas the Romanesque abbey plunks down a *fact*, the Gothic cathedral suggests an experience, a perspective. "See those breathtaking perpendicular planes," it seems to say, "these columns climbing out of sight, all this arching up to the sky!" The Gothic cathedral is unabashedly a vista. It is *appearance* and *apparition:* the child of sensitive, inspired, aesthetic *seeing*. Appearance, however, assumes an observer, which in turn assumes that the perception will be fraught with error and mental wavering.

Once we understand the Gothic, we also understand its style. Again, it is useful to draw a contrast with Latin and Merovingian architecture.

The Romanesque derives its impressive power from mass. The structure makes no thrust or ornamental foray into the surrounding space: it turns its incurious bulk inward. Gothic stonework takes the opposite direction. It blooms, wiggles into floral and organic carvings, bursts out in belching gargoyles: the inner spills into the outer. It bespeaks something searching, hungry, insatiable. It opens windows and frets the masonry wherever it structurally can. Compared to the San Vittore alle Chiuse bunker chapel in Genga (1011), the prismatic Sainte-Chapelle (1248) and the Cologne Cathedral (1248) seem barely there at all. And so perhaps the Perceval character might have seemed to the Gregorian monk: as lacking substance, fitful, digressive, and unnecessarily besotted with what could or might or will be: overly concerned with his perspective on the story.

Perspective is commonly associated with Italian artists and architects of the Italian quattrocento such as Brunelleschi, Alberti, and Piero della Francesca. It traditionally links up with Renaissance humanism and a new human-based experience of the world. But this human-centered intellect did not spring ready-made in the fourteenth century but had been in the making since the twelfth-century Gothic awakening.[37] The space-sculpture of the cathedral, the grail quest, and the application of logic and reason in scholastic debate are evidence of a growingly knowledge-centered view of the world. In this outlook, reality is not a monolithic essence but the longed-for object of forward-looking, active, searching individuals—the Seafarer, Perceval, the Gothic master builder—who were already, long before Brunelleschi, personalities of the vanishing point.

Among these personalities, the Italian archbishop-theologian Anselmo deserves a mention. Better known as Anselm of Canterbury (1033–1109), this churchman is the author of perhaps the most famous piece of scholastic philosophy, known as the Ontological Argument. This argument proffers no less than a proof of God's existence. What should elicit our surprise about this argument is, first of all, its existence, which assumes that divine existence needs demonstrating is therefore open to rational demonstration. This conscripting of reason in the army of faith shows that scholiasts of the late medieval period understood religion could no longer endure as the permanent enemy of reason. (Anselm's proof appeared in a treatise titled "Faith in Search of Understanding.")

The demonstration runs like this: by God we understand the greatest, most supreme, most perfect being. Now, suppose that this being exists solely in the human mind: surely this would not be a supreme god since

it would lack actual existence. The being next to which nothing greater can be conceived must therefore exist also as fact. Ergo, God exists.

About this piece of logical ingenuity we can observe two things. First, that it gingerly subjects God to doubt. For God in need of reason is necessarily a God in whom we (can) doubt. Only the uncertain needs demonstrating. The second point is that Anselm's proof derives the *fact* of God's existence from the *idea* of God. The order of priority puts thought ahead of fact: "we believe that thou art a being than which nothing greater can be conceived," begins Anselm. The premise is not the overwhelming reality of God, but the overwhelming reality of the thinking "I." The proof runs from mind to world. It is from the *concept* of what we think God to be that we establish his empirical existence. The philosopher proceeds from the inside out. His proof is *ascendant,* constructive: the Most High *looks* high thanks to we who stand below, gazing up.

This reorientation upended the architectonics of religious faith, which traditionally laid down a *descendant* Pentecostal scheme: Moses and Abraham receive the faith; Job is silenced by it; Paul is knocked off his horse; Augustine's heart floods with the light of truth. But the Gothic believer *builds* toward God, erects scaffolds of thought that encroach right into the city of God. If the light eventually bursts into the inner crypt, it is thanks to the ingenious windows we have devised in the mental masonry. Unwittingly, Anselm's proof related God's existence to the human perspective.[38] The divine had become dependent on the thinker's constructive engagement with the problem of its existence: I have a perspective (from *perspicere,* to see clearly) of God; therefore God exists. And if this is true of God, then it is more so for reality, society, morality, indeed commerce, industry, technology. We are not just caretakers of the world but its builders. The limits we perceive are the limits we set before ourselves, and those limits move in time with us, the perceivers.

Enter the age of horizon-bound explorations.

Perspective

Mount Ventoux, April 1336

Less than two centuries separate the theologians Thomas Aquinas (1225?–74) from Nicholas Cusanus (1401–64). Though fundamentally Christian in its outlook, the form of the world inhabited by the latter might nevertheless have been unrecognizable to the former. Aquinas lived in a world whose shape conformed basically to Ptolemaic and Aristotelian ideas; it was a closed world that in its every turn proclaimed the primacy of contained form. The German cardinal Cusanus, on the contrary, lived in the century that saw a Genoese adventurer throw open the bourns of the known world and retire for good certain myths about a flat earth, a precipice-girded world, and India sharing a common sea with Portugal. In fact, the planet was proving to be a great deal larger than formerly imagined. In 1513, twenty-one years after Columbus's breakthrough voyage, Núñez de Balboa found the Pacific Ocean, and Magellan circumnavigated the globe six years after that. Setting his attention even farther, the astronomer Copernicus (1473–1543) showed the cosmos to be vaster and much differently organized than envisioned by Aristotle. Perhaps, men and women began to suppose, the world was not necessarily fitted with boundaries. Moreover, theologians had to answer for the evidence of a new continent, new lands, and people not mentioned in the Scriptures or by Aristotle. The world was not to the size of anyone's philosophy. The Spanish Renaissance historian López de Gómara wrote of this period that the discovery of the New World was "the greatest event since the creation of the world," excepting the birth of Jesus.[1] And like

Christ's advent, the New World threw overboard the notion of what a world was. Christ had reopened the upright channel between the earthly and the divine; this second revolution unveiled an earth whose teeming strangeness and variety seemed to outshine the very heavens. Nature, in other words, seemed too big to fit in a theological formula or a biblical verse; it mattered what empirical exploration uncovered. Knowledge was gained not just vertically, but by horizontal progress.

Aquinas habited a reality in which the circle of knowledge could be decisively drawn. Though revolutionary in its time, his *Summa Theologica* (1265–74) perfected the long tradition of medieval summa that purported to encircle human knowledge (in the average monastic library, generally no more than four hundred volumes) into one book. Everything in Aquinas's worldview fits in a honeycomb of logical divisions and subdivisions. For any truth that is posited, strings of demonstrations and counterdemonstrations build intellectual guardrails around it. By its form and intention, Aquinas's monument encapsulates the age of what the historian Alexandre Koyré called '*the closed world*.'

Nicholas Cusanus, the one thinker of genuine vision after Aquinas and before Descartes, was more skeptical about the idea of summation. His expository style is the first clue that an entirely different approach and sensibility are afoot—beginning with the coyly irresolute title *De docta ignorantia* (1440), *Of Learned Ignorance,* of his main treatise. Like Maimonides and Scotus, Cusanus proposes to deal with the sublimely unutterable knowledge of God. But Cusanus was interested in the ineffable because he was actually keen to show just *why* the ineffable was ineffable, and where and when reason should draw the line between what can and cannot be known. This was not a retreat of reason, but the sign that reason had grown strong enough to take on its opposite.

Cusanus casts his treatise in a loose-strung opportune series of essays that, at first glance, seemed to leave intact the Aristotelian playbook of intellectual presentation. In fact, his starting point could be lifted straight out of Aristotle's *Metaphysics:* "The fundamental situation of our cognition is this: there is no common term between the finite and the infinite."[2] On closer inspection, however, there was a shift in emphasis. For Aristotle, the incommensurability between the heavenly and the earthly was an *objective* feature of the cosmos. Whereas Cusanus was interested in describing what it is like *for us,* fitted with human eyes and fallible reason, to face this incommensurability: here the cosmic divide is experienced relative to "the fundamental situation of our cognition,"

that is, the human standpoint. The difference between Aristotle (and Aristotelian medievals) and Cusanus hinges on the matter of *perspective*.[3] While for Aristotle the unfathomable distance of God is written in the nature of things, for Cusanus it is conditioned by the shape of human thought. Where Aristotle saw a divide, Cusanus beheld a horizon.

Cusanus's worldview is subtly human centered: when I think, he explains, my mind rests on definite things, which it measures, compares, juxtaposes, and so forth. But the infinite compares to nothing else and cannot be measured: hence it is unthinkable. It is because it is unthinkable that, paradoxically, I have a notion of it. The shift consists in this: whereas once upon a time we could not fathom God because of who he is, God is now who he is because we cannot fathom him. This may sound like hairsplitting, but it is on this kind of two-steps that the stodgy medieval world tripped into the Renaissance landscape of perspective.

The other great novelty in Cusanus was his ascription of *physical* infinity to God. For Aristotle, as for Aquinas, it was nonsense to attribute both infinity and extension to the divine (an "infinite body" is either not a body or not infinite at all). But since God was supreme, he had to be infinite at the cost of extension. Hence, in the Aristotelian cosmology, we live in a finite physical world bounded by an infinite spirit. But Cusanus had no trouble representing God as, according to his famous image, "an infinite sphere whose center is everywhere and whose periphery is nowhere." This lending of physical extension to God had the effect of homogenizing the world.[4] Of course, logic balks at the idea of a circle without a periphery: under these conditions God is not a circle at all. But Cusanus's mode of thinking was more plastic and experiential than strictly logical. His sermons abound with metaphors of actual sensory experience, particularly seeing. Thus it is as an act of perception *(speculum)* rather than grasping and measuring *(ratio)* that he describes the ultimate kind of knowledge. Knowledge-as-*ratio* is self-regarding; as *speculum,* on the contrary, it embraces deep and outward things. Aquinas had corralled all there was to *know* about God in *Summa Theologica;* Cusanus's treatise *De Visione Dei* (*On the Vision of God*) signaled that perception was essential both to the experience of God (i.e., the perception of God) and the nature of God (i.e., God as perception). God, in other words, had become experience.

In fact, the Cusanian God sustains the world by his gaze. "You see all creatures. . . . For otherwise creatures would not exist, since they exist by means of Your Seeing."[5] That we exist only through God's munificent

gaze is a beautiful image. But seeing requires space, and space is sepa-
ration. God is therefore inherent not in things proper, but in the depth
traveled to reach them. Unwittingly, Cusanus injected physical distance
into the religious experience, as surely as the Gothic cathedral had made
it a medium of the liturgy. His thinking is landscape oriented, rife with
similes of boundless expansion and cosmic space—the same spatial feel-
ing that, at about the same time, produced the first genuine landscape
paintings in European tradition: those of his fellow German and con-
temporary Konrad Witz (1400?–46).[6]

Clearly it is the Italians who invented the geometry of pictorial per-
spective; yet it is northern Gothic Europe, particularly Germany and
the Low Countries, that first put space into pictures. Konrad Witz's
The Miraculous Fishing Expedition (1444) (fig. 1) breaks striking new
ground in the history of representation. The painting depicts an episode
of John's Gospel in which the apostles draw a phenomenal catch of fish
under the intercession of a water-treading Jesus. But this scene some-
how does not monopolize Witz's interest, which flies to the sweeping
landscape that stretches away behind and around the figures. Medieval
illuminists had given little thought to the natural contexts of biblical
episodes. More generally, and except for notable Roman frescos, land-
scape in art had been either absent or sketchily symbolic. The Tuscan
painter Giotto (1267?–1337) had taken significant steps in the direction
of landscape naturalism; his contemporary Cimabue and later Masac-
cio followed suit. Still, their efforts look boxed-in and stilted next to
Witz's sweeping, genuinely outdoors feeling for landscape. The scenery
here is no stage set; it runs beneath and above and around the charac-
ters, over the reflecting lake, past distant fields and hedgerows, sweeping
over sage foothills and into a cloud-rolling yonder. This is sacred history
embedded in real-life circumstances, as men and women on the ground
might have seen it, encircled by a reality that was somehow *greater* than
Jesus or the apostles, than perception and knowledge. God too—Witz
seems to say—had his feet on the ground, even when he trod on water.

To better gauge the novelty of Witz's manner, we must set it alongside
contemporary paintings. In the miniatures of the *Très Riches Heures du
Duc de Berry* by Pol de and Jean Colombe (c. 1409) (fig. 2), the land-
scape appears such as a segmenting gaze, possessed by an imperative to
organize and section off, would see it. The eye is not in space; space is
inside the land-surveying eye. Perception hopscotches around the land-
scape from one spot of interest to another, down from a hilltop view,

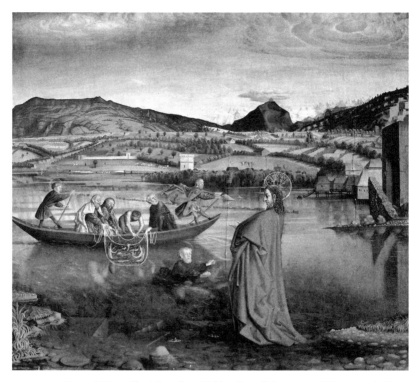

FIGURE 1. Konrad Witz, *The Miraculous Fishing Expedition,* 1444. Oil on wood. Courtesy of Art Resource.

sideways to an orchard, upward to a castle keep into whose courtyard we manage to vault to map out once again from above. The patchwork of viewpoints stitches up space into a landscape origami where spatial unity clearly plays second fiddle to the survey. What is primary is the human and social occupation of space. The landscape is not an environment proper but a miniature world.

Witz gave voice to an altogether different experience. He does not etch little liturgical motifs upon a surface; he creates worlds. If the gist of Christ's story, and of the Christian message, is incarnation, then the artist must show the spirit embedded in the flesh. A god who lived in space and time dignifies everyday reality. Extension is not just a concept in the mind of the Supreme Being; it is the ground on which he manifests himself. Extension is what Witz strove to bring forth in his painting. A life-long inhabitant of Switzerland, the artist may have

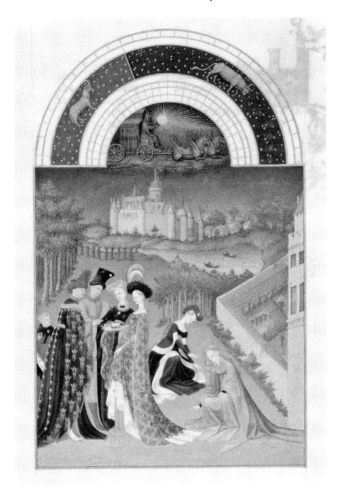

FIGURE 2. Pol de and Jean Colombe, *Très Riches Heures du Duc de Berry: Castle Dourdan*, 1409. Illuminated manuscript. Courtesy of Art Resource.

come in contact with the pictorial experiments in perspective pioneered by the Italian Filippo Brunelleschi (1377–1446) and Leon Battista Alberti (1404–72) to the south. But Witz's pictorial feeling for space really does not rise and fall with perspective. Perspective as conceived by the Florentines was a child of mathematics (both Brunelleschi and Alberti were architects who studied mathematics, geometry, and optics extensively). To them, perspective was a mathematical problem.

Brunelleschi called his invention the *costruzione legittima* (normative construction). Early Italian masters of landscape perspective such as Masaccio and Paolo Uccello tended to bring the strongly architectural framework out of perspective, often by drawing a checkerboard of colonnades, harlequin floors, and converging tangents. Early quattrocento perspective was essentially the product of urban rationalism, of science-minded men who believed nature possessed a ratio, and that it was their job to bring it to view. Architecture played the central part in developing the style of representing what was, in their mind, a line-bound reality. As the Italian architect Sebastiono Serlio put it in the 1540s, "No perspective workman can make any work without perspective, nor the architecture without perspective." "No painter can paint well who does not know much geometry," Alberti said.[7] A look at the landscapes of, say, Paolo Uccello (for instance *The Hunt in the Forest*), and one can feel the straightedge and square ruler shuttling busily beneath the surface.

This clearly is not what is at work in Witz, where the sense of depth comes not from mathematical accuracy but from expansiveness, from loosening the intellectual and architectural chokehold. Brunelleschi took space as a mechanical problem; Witz as an atmosphere, a fluid substance. In this endeavor, the northern artist was serendipitously assisted by the invention of oil painting (habitually credited to Hubert and Jan van Eyck).[8] The mixing of pigments in an oil base gave the artist unprecedented control over transparency unknown in tempera, lacquer, or al fresco. Oil textures could evoke air, haze, vapor, things faded by distance. They allowed the painter to layer blue and gray to render gauzy, faraway sights and conjure up "atmosphere"—an unexplored category of representation that suddenly became paramount in a painter's repertory. The central panel of the celebrated Ghent Altarpiece, begun by Hubert van Eyck and finished by his brother Jan (1390?–1441), creates aerial spaciousness, not by hard and fast perspective, but through gloss and layering. The light streams over objects, shines off a curve, glides over an outline, lets us imagine a world in the round. Where geometrical perspective projects frontal depth, atmospheric depth blooms out of the scene and includes the painter, who, as a colored smudge in the convex mirror, is too a creature *in* space, as in the glorious *Arnolfini Wedding* of Jan van Eyck. Spaciousness is multi-focal, a choreography of sheen and shadow. The viewer is not the exclusive, abstract observer but an inhabitant of its chromatic

atmosphere. This is a world made of space and in which space lives and moves, an almost visible medium full of possibility.

To return to Nicholas of Cusanus. In him, too, the feeling for contingent space shapes reality: the all-encompassing reality of God. The more elusive, distant, receding God is, the more intense his divinity: "And when—beyond that rational capacity and beyond every most lofty intellectual ascent—I come to that which is unknown to every intellect and which every intellect judges to be very far removed from the truth, there You are present, my God. . . . And the darker and more impossible that obscuring haze of impossibility is known to be, the more truly the Necessity shines forth and the less veiledly it draws near and is present. . . . I give You thanks, my God, because . . . You have shown me that You cannot be seen elsewhere than where impossibility appears and faces me."[9] The believer beholds God in the distance *as* distance: the more incomprehensible he is, and the more dimly we behold him, the more profoundly do we experience him.

Cusanus tapped into the nascent sensibility of mystery and inquiry. To the curious, scientific mind, remote things are more inviting, more real than the near-at-hand. The magician mindset, James Frazer tells us in *The Golden Bough*, clings to the familiar; it attaches supreme importance to proximity, similarity, metonymy.[10] It is driven by the infantile need for the tangible. Not so the scientific mindset. Scientific inquiry harkens to the unknown, takes intellectual leaps, formulates hypotheses, and strains common understanding. The more remote, the more implausible, the more puzzling, the better. Thus it is that the Renaissance mindset concentrates not just on what and how we *do* see in theology, optics, and the arts, but how we *do not* see, and how we see that we do not see: vision running ahead of itself, delighting in the spectacle of its own vanishing, the mind enamored with perplexity. Cusanus spins a whole theology out of this human perception spellbound by its own finite infinitude: it is a theology for the age of the vanishing point. "To understand infinity is to comprehend the incomprehensible," Cusanus rhapsodizes.[11] The aesthetic transcription of this insight was the rise of the horizon landscape in painting—a mysterious object that suddenly triggers the frisson, not of dread, but of beauty.

If there is a sense privileged by the Renaissance, visual perception certainly was it (unsurprisingly, given its intellectualism). The age saw great advances in the field of optics: in the technique of lens grinding, in

the taking of perspectives by means of camera obscura, in the devising of visual tricks such as anamorphosis, distortion, proportionality, or trompe l'oeil.[12] A famous episode in this chapter of our visual awakening is the fine day of spring 1336 when the Italian poet and humanist Petrarch (1304–74) climbed Mount Ventoux, near Avignon, just to take in the view.

This surely was not the first time someone had scaled a mountain to catch the scenery; but it was the first time someone bothered to write an epistle on the subject. Petrarch recounts the arduous ascent, so much like the journey of life; once at the summit, however, the tone turns decidedly less allegorical.

> On its top is a little level place, and here we could at last rest our tired bodies. . . . At first, owing to the unaccustomed quality of the air and the effect of the great sweep of view spread out before me, I stood like one dazed. . . . The Alps, rugged and snow-capped, seemed to rise close by, although they were really at a great distance; the very same Alps through which that fierce enemy of the Roman name once made his way, bursting the rocks, if we may believe the report, by the application of vinegar. I was unable to discern the summits of the Pyrenees, which form the barrier between France and Spain; not because of any intervening obstacle that I know of but owing simply to the insufficiency of our mortal vision. But I could see with the utmost clearness, off to the right, the mountains of the region about Lyons, and to the left the bay of Marseilles and the waters that lash the shores of Aigues-Mortes, although all these places were so distant that it would require a journey of several days to reach them. Under our very eyes flowed the Rhone.[13]

A crowd of impressions assails the poet's mind. First, the wonder at the vastness of it all, both in space and time, as land and as history. Then, more interestingly, amid the things that Petrarch can see, the ghost of things he knows are there but *cannot* see (the distant Pyrenees). From here follows a meditation on the greatness and poverty of human vision. A paean to the human view of the world, humanism is also self-conscious about the limits of this perspective. Together with the optimistic spirit of enterprise, of a world yet to explore and of things to discover and books to write, there comes also the knowledge of one's ignorance, the seeing of not seeing.

Interestingly, Petrarch died the same year the word *orizon* made its official entry into the English lexicon (1374)—followed by *limit* in 1375. *Orizon* hints at a new way of experiencing space that is less like the medieval quilt of cloister, monastery, fortified town, and castle; less like scholastic nomenclature; less indifferent to the world beyond Christendom. *Orizon* suggests more interest in what is not known. The new

mode of inquiry known as humanism very much saw itself as expanding the map and pushing into terra incognita. Central to humanism, to the commentaries of Marsilio Ficino and Pico della Mirandola in the fifteenth century, was the encounter with thinkers and artists of the ancient world, who did not see the world as the scholar of fifteenth-century Florence did. Studying these ancient models fostered awareness of the plurality of systems of thought. This led humanists to take a more critical view of their own tradition—which now seemed a warren of neighborhood prejudices. And yet the very idea of a family of thought (the meaning of *catholic*) became suspect, as did consensus and truism (as Montaigne put it, "judge in the ways of reason, not by popular vote").[14] Intellectually, humanists showed a willingness to set their sights far, to engage with facts, people, and problems beyond their ken. Medieval squires and villagers lived inside their keep, field, forest, or orchard; people of the Renaissance yearned to contemplate the greater sum, of which the castle, field, and forest were parts. And that sum was not Christendom but, as the study of history revealed, a vaster world of facts and ideas of which Christendom was a mere episode. Doing so, they came to delight in the realization that this sum was not absolute but proportional to their visionary power and historical curiosity.

For a good reason, then, perspective and humanism arose in tandem. Humanism strove to vindicate the human and temporal view of things, rather than the divine and doctrinal. Humanists welcomed being thrown back on their own ingenuity to puzzle out nature, society, or the conduct of life. Reality became indexed to human agency and perspicuity. (Depictions of the Greek hero Hercules, the flag bearer of human can-do, tellingly become legion in the fifteenth century.)

Hence Petrarch's panoramic ascent. To be sure, social circumstances facilitated the newfound taste for seeing far. One was the shift from a rural feudal economy to the money economy of urban trading centers. The economic activity that burgeoned in the Italian city-states of Venice, Genoa, Florence, Bologna, and Siena ran on industry, administration, craft, and commercial exchange. This was an economy less proximally tied to the land.[15] For the urban dweller, life did not hang on a plentiful crop, on hail and gale, or on the fox stealing the hens. The city merchant made his living by managing long-term outlooks, wagering on maritime insurance, banking, and investment prospects. By profession and by temperament, the merchant trained himself to gaze far, to look beyond the hills, to think of the next five years' return. So, unlike the yeoman farmer, he could afford to cast an alternatively peering or

dilettantish look at the picturesque hills seen from the window of his Florentine countinghouse. A new awareness of nature as picture-like and panoramic began to dawn.

Together with this wide-embracing way of apprehending reality came the tendency of regarding it as map-like, a scrimshaw of trading routes that connected the Italian city-states to the great cities of Europe and the Levant. The bankers of Venice, Florence, and Genoa all had office branches in places as distant as London and Antwerp. Hence the emergence of modern cartography, which replaced the medieval *mappae mundi* with more practical charts emphasizing navigation, freight costs, transportation times. New maps were drawn to aid the tradesman's journey rather than enforce dogma on, say, the centrality of Jerusalem or the whereabouts of Eden. They also greatly increased people's sense of the vastness of the world.[16] Above all, the commercial mindset turned the landscape into a medium of transit. *Space* became synonymous with *traveled space*. In this sense, it became fused with perspective: measured, calibrated, mapped out in terms of journeying, of time and distance, of intended and implemented travel. In sum, the concept of space became entwined with human agency and the idea of pushing boundaries. The world was not a fact but a set of moving coordinates and prospects that could make an ambitious up-and-comer talk the queen of Spain into, for instance, funding a voyage from Iberia to the unknown.

The Renaissance idea that space is distance-shot-through-with-agency accounts for the birth of perception (where the land fans out before one observer's gaze); cartography (where the land figures according to the modes of traversing it); and the heyday of the horizon (both as a word and an experience). The horizon exists with respect to a beholder: the latter must be aware of how far he can see and cannot see. It assumes a new intensity of self-awareness.

And it is this intensity of self-awareness before the panorama that colors Petrarch's experience on the mountaintop as he muses over where perception gives out. So whereas his gaze strains outward, his attention rotates inward, toward the source of seeing. After some time taking the view, Petrarch opens his pocket-size vade mecum (another invention of the age) of Augustine's *Confessions* to a random page: "Where I first fixed my eyes it was written: 'And men go about to wonder at the heights of the mountains, and the mighty waves of the sea, and the wide sweep of rivers, and the circuit of the ocean, and the revolution of the stars, but themselves they consider not.' I was abashed, and . . . closed the book, angry with myself that I should still be admiring earthly things."[17]

Vanitas vanitatis. Yet one thing is not altogether vain: the mind that sees its own vanity. Anything that can contemplate its own smallness is great enough to possess self-knowledge. The inbound view, as it happens, does not disappoint: "I thought in silence of the lack of good counsel in us mortals, who neglect what is noblest in ourselves, scatter our energies in all directions, and waste ourselves in a vain show, because we look about us for what is to be found only within. I wondered at the natural nobility of our soul."[18] On Mount Ventoux, Petrarch finds that true immensity lies in the apprehension. Moses he is not: for it is not the awesome magnitude of God but the greatness and misery of the human mind that sends him reeling. As an object of sight, reality is only width and height; to perceive depth of field, vastness, immensity—this requires seeing it in the light of consciousness and feeling (wish, expectation, the awareness of becoming). In a word: to behold the outer infinite assumes possessing the inward sort. Perspective is only so deep as the eye of the beholder. Depth of space is depth of soul.

Pictorial perspective is a thoroughly well canvassed area of art history.[19] This is not the place to piece out its technical nuts and bolts, but to explore its intellectual sources. The term *perspective* embraces two general meanings: one, centered on the object, refers to the depth of field (i.e., a prospect); the other, centered on the subject, designates the viewer's position. The Renaissance drawing of pictorial perspectives arose from the latter. In his hallmark study, the art critic Erwin Panofsky explains that perspective transformed reality into appearance.[20] Since appearance is relative to a perceiver (whatever appears, appears to someone), perspective really manifests the individualization of experience or, in perceptual terms, the centering of reality on the observer.

Medieval art by contrast allowed but a paltry role to individuality. The medieval eye saw things not as chance appearances, popping into sight at a bend in the road accidentally, but as they were *known* to exist. For this reason, it had no use for perspectival depth, which assumes a chance itinerant viewer. To invent perspective, it is said, Filippo Brunelleschi imagined himself looking through a peephole, that is, from a particular point *in* space (not in spite of space). Brunelleschi spoke of viewfinders and windows, of instruments that commend a mostly *visual* interaction with reality. As his friend Leon Battista Alberti put it, "No one would deny that the painter has nothing to do with things that are not visible. The painter is concerned with representing what can be seen."[21] This sounds like a truism but is not—not when uttered in the

shadow of the Middle Ages, when painting had as much to do with things *known* as with things seen.

This centering of vision on the single perceiver entailed giving up the dream of omniscience. What I see at this moment is hedged in by all that stands beyond my visual field. Interestingly, perspective is not only bounded by empirical boundaries (e.g., while I look forward I cannot see objects behind me); it is also subjectively bounded: I know that my perception is only *my* perception. Thus the vanishing point arises, not just as an objective feature of the landscape, but also as a subjective projection: it is the point where vision sees itself giving up. The vanishing point makes an interesting new kind of limit: less a hard-and-fast feature of reality than a coming to grips with its subjective makeup. This new type of limit has a name: finitude. Finitude is not a concrete limit. A wall does not rise up on the vanishing horizon: instead, seeing nothing, seeing its own nullity, vision is struck dumb, or blind, by self-consciousness.

We therefore need to qualify Panofsky's contention that "the vanishing point is . . . the concrete symbol for the discovery of the infinite itself."[22] In chronological terms, the idea of the infinite did not await the Renaissance for its discovery; what the Renaissance did was to instigate the emotional, personal apprehension of the *looming* infinite. Medieval scholasticism knew *intellectually* about the infinite but avoided knowing it sensually. The rediscovery of Aristotle during the High Middle Ages did nothing to change this confinement of the infinite to an intellectual category. The Renaissance, on the contrary, moved the infinite into the field of perception. This was a paradoxical move because perception cannot touch the infinite. So what Renaissance perspective did was to produce a way of visually representing perception's unfitness to behold the infinite. The vanishing point potentiated an experience of seeing as much as *not* seeing; of seeing nothing—or, more exactly, of seeing seeing nothing. And as the vanishing point anchored and organized depicted space, one could say that this self-inflicted blind spot became the organizing center, the black sun of Renaissance painting: an artistic expression fascinatingly in touch with the denial of vision.

This interpretation puts a check on the conventional wisdom, according to which Renaissance perspective painting was "a conquest of the visible." Of course painters did train their eyes to the vast, sensual world. Biblical episodes that medieval illuminists had drawn on a gold-leafed surfaces, Renaissance painters such as Mantegna, Ghirlandaio, or Gozzoli set amid bright outgoing vistas of terraced hills, valleys,

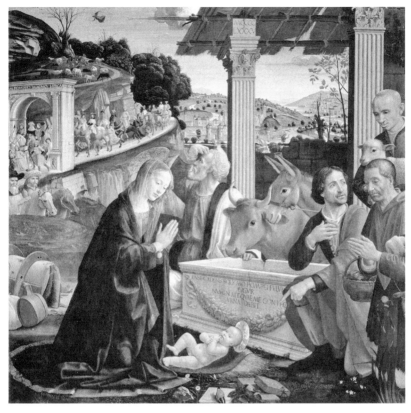

FIGURE 3. Domenico Ghirlandaio, *Nativity and Adoration of the Shepherds*, 1485. Oil on panel. Courtesy of Art Resource.

and rivers. Now the *storia* of paintings seemed a pretext for rolling out country views—sometimes vertiginous, with jagged outcrops and limestone overhangs and cliff drops, a landscape pulsating with intimations of flying and swooping through fluid space. It was space yearning to be leaped across, the very space that was to be traveled by Columbus or unveiled by Copernicus.

In the distance, past the olive groves and the oak-dotted hillocks, beyond the lilac haze of remote silver-green valley beds and azure foothills (fig. 3), Ghirlandaio evokes a place, a space, an infinity he does not actually see: the fading, tender trace of vision. Painting the horizon, the artist brings forth something no painter can ever present: for the horizon is not a place, and it is not a sight. Here painting chances upon abstraction: in depicting the horizon, nothing is painted at all; here is the place

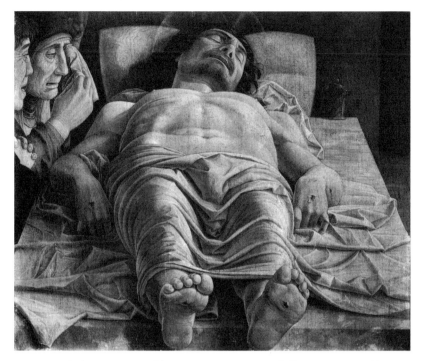

FIGURE 4. Andrea Mantegna, *The Lamentation over Dead Christ*, circa 1490. Tempera on canvas. Courtesy of Art Resource.

where vision melts away. At the very edge, before swinging over into undiluted nothingness, vision looks back on itself. Conscious of its own death, it gives a last swooning flash of beauty. At this supreme moment the painting gains depth: not just spatial but moral depth, tantamount to an acknowledgment of limitedness and mortality. At the vanishing point, the painter releases the landscape from his clutch. He accepts his finitude. He lets things go their way; he expires. Self, nothingness, finitude, death: it is really out of this crucible that perspective was smelted.

Only when seen from within does the world feature depth (to an all-knowing, all-seeing mind, such as God's, the world is flat). Depth of field entails an embodied, contingent perceiver, and the contingency of perception is in turn bound up with the awareness of one's limitedness in time and space. Perspective, in other words, is a memento mori: a reminder of our death.

We find an illustration of the *existential* nature of perspective in *The Lamentation over Dead Christ*, painted by Andrea Mantegna (c. 1490)

(fig. 4). The painting presents a strikingly anatomical depiction of dead Jesus lying face-up on a marble slab. Famously and memorably, the corpse appears from a drastically foreshortened angle beginning with, closest to the observer's viewpoint, the pierced soles of Christ's feet, followed by the gully of his draped legs and groin, the folds of a shroud, a hilly thorax, and, at the vanishing point of this anatomical landscape, Christ's head, like a sunset. Mantegna cleverly mapped the structure of landscape perceptive onto the human body. Here the receding landscape *is* the corpse: it measures the span of human existence, its extent, its ever dwindling, mortal *stretch* (of space, of time), as though the perspective that makes life mortal were the same perspective that sees depth in the landscape. Perspective is the measure of man; man is apprehension of death; apprehension of death is depth (of soul, of field, of life).

Perspective was the surface crest of a deep existential sea change: its real source was the newfound centrality of the mortal self. It is it—the finite *I*—that now defined the complexion of society and religion.[23] To this new being who stared at his own nothingness and saw nothingness into the faraway, the horizon held up a mirror, an opportunity for self-recognition. And better than a mere symbol of our finiteness, it also became the source of urgency for human action, the fountain of our reason for striving: the nothingness that propels us.

Ambivalence

Florence, 1503

The year 1482 is generally taken to be a turning point in the career of Leonardo da Vinci (1452–1519). Until then, the young Leonardo had apprenticed in Florence at the workshop of the artist Verrocchio, under whom he learned to paint in the pristine, courtly style of Lippi and Perugino. Then, after falling out of favor with the powerful patron of the arts Lorenzo de' Medici, Leonardo was sent to Milan to wait on the pleasures of Ludovico il Moro, duke of Milan. There he spent most of the 1480s; there too, far from Florence and the Tuscan masters, he came into possession of a rather more quiet painterly touch.[1] A wistful tone, some chromatic moodiness dampened his palette. Next to the ringing tonalities of Florentine and Venetian style, Leonardo's new paintings struck a distinctly minor chord, all mists and shadows, with enigmatic Virgins and saints smiling wanly through the permanent twilight. His contemporary, the Venetian artist Giorgione, too had begun painting in similar dusky, ambered, moody tones. Yet there is something new and nebulously pensive about Leonardo's new manner. "I thought I was learning to live; I was only learning to die," Leonardo writes in his diary of the period.[2] This was simply the onset of maturity, one might say, the gathering shades of mortality. This made Leonardo throw away the book of Platonic clarity, the intellectualism of the Albertinian school, and wander into the diffuse, the morose, and deliquescent. Leonardo had become a painter who declined to draw clear lines.

"Among the great things which are found among us, the existence of Nothing is the greatest," Leonardo wrote in a notebook.[3] "Existence of Nothing" is a contradiction. Nothingness is the absence of existence and by definition cannot exist; nor, as a result, can it be found. So nothingness is not empirical (the senses never perceive it) but conceptual. As Leonardo says, "it does not extend to the essence of anything"—by which he meant that nothingness is not to be found in things.[4] Yet to say that it was the greatest possible experience means that the artist cannot omit making room for it. But how does one present nothingness? Leonardo's instinct was to observe the in-between states, the ontological cracks between things. In his treatise on painting, he observes that an object never simply rests but scatters bits of itself among neighboring things, if only because it bumps into other masses and surfaces on the way to meet our eye; it also changes size and brightness depending on its surroundings. Thus an object also amounts to the sum of its interaction with others: *how* a thing slides, tumbles over itself, melts into neighboring objects—this kindled Leonardo's imagination. It led him to heed movement, the paradoxical state in which a moving thing is neither in one place nor another. Drawings of whirlpools, sluices, streams, and watery movements scrabble over the pages of his sketchbooks and notebooks. As for his famed machines, the best part concerns locomotion or propulsion—whirligigs that move, spin, career, throw, float. Movement is always in-between, it looks onward and yields its current place. It goes after the not yet, avoids settling down. It is nothingness in action.

A painter, Leonardo says, should heed this: "the embers of the fire, or clouds, or mud, or other similar objects from which you will find most admirable ideas . . . because from a confusion of shapes the spirit is quickened to new inventions."[5] Thus Leonardo weaned himself of the Italian taste for line and figure, the Michelangelesque *disegno*, the architectural lattice of Florentine painting. To him, the gist of painting consisted of color more than drawing. Of the three perspectives he identifies—linear perspective, the perspective of color, and the perspective of disappearance—Leonardo leaned toward the last two because they allow for the sapping and hollowing work of nothingness, of what erodes and wears out in the hurly-burly of life (unlike the first, which cleaves to geometrical proportion). The farther the object, the less perfect and perceptible it should seem, Leonardo observed in his treatise on painting. The appearance of disappearance, the arising of vanishing: these, for Leonardo, were as present to the painter's eye as forms. "Shadow

partakes of the nature of universal matter," he insisted.[6] A good painter will delve into the *very* blur that is organic life, which is never this or that but this *and* that. "Each object fills the atmosphere with images of itself and receives the images of all other objects surrounding it. Therefore, every object is visible through the whole atmosphere, and everything else is present in the smallest part, all the objects of the whole are visible each in all and all in every part."[7] The painter's job is not to pin down what in nature flows, swarms and swells. As air wraps around an object, it blurs its surface, pads on layers of vapor as it makes its way to meet the eye. Vision is degeneration. This disconsolate notion invited Leonardo to dampen down the plangent tonalities and lines of the generation of Botticelli, Pinturicchio, and Filippino Lippi. "The best method of practice in representing country scenes is to choose them when the sun in the sky is hidden," he recommends.[8] For then shades spread over the lighted zones, shadows liquefy in the surrounding aqueous atmosphere, and the world is washed in ambivalence, the very penumbra of Leonardo's breakthrough paintings the *Virgin of the Rock* and the *Virgin with Child and St. Anne*. Leonardo's contemporaries gave the name of sfumato ("misty," "dusky," "diffuse") to this airbrushing and melting of line and color. Even the closest object seemingly exfoliates; every thing is indecision, oscillation, incompletion. Every line fades into a horizon. *Sfumato* soaks reality in ambivalence. It is the brainchild of a man whose greatness was that he could never decide whether to be an inventor, a physician, a painter, a sculptor, or an architect; a man who also, as Vasari observed, showed a knack for never finishing projects (a mere dozen of paintings in a career spanning four decades!);[9] a man who dotted his notebook scribblings with endless etceteras, festooned the pages of his notebooks with grotesques, jottings, diagrams, anatomical doodles—a tangle of unfinished thoughts that conveys this one thought: nature is a sketch, a vortex of streams, muscular ripples, blood flows, flying machines, air, liquid, motion. If Leonardo seemed never to finish off his images, it is because they were essentially about things becoming, not things become. Not to finish, this was Leonardo's way of showing nature like it is.

The recent import of oil painting from the Low Countries was a lucky coincidence. More fluid than tempera or al fresco pigments, oil handed Leonardo the means to express his sense of natural vagueness. Also longer to dry, oil allowed revision and tentative progress, until by and by the act of painting became indistinguishable from continuous sketching

and resketching. To paint and to meander seemed more like the same activity. When working al fresco, the painter must act quickly, dash off the outlines from a cartoon, daub in the pigments while the plaster is wet; one must be masterly and decisive—a reason why Michelangelo, the master of *disegno*, disliked oil painting and declared it fit for dabblers. But dabbling allows one to protract, and this stretching of time and composition is one of the gifts of oil painting. It caters to the pensive, indecisive side of creation: the groping after the yet unformed idea, the world in *statu nascendi,* arising rather than arisen. The wavering that Leonardo beheld in all appearances, in clouds, rainstorms, muscles, and draperies, he carried into the very action of painting. Art was henceforth process over achievement, and the achievement was only as good as the meandering.

Leonardo's world of evanescence led him to question, if not the rules of perspective, at least the received wisdom according to which pictorial space was all a matter of consistently drawn geometric lines. To geometry he substituted his "aerial perspective," which veiled reality behind the action of seeing it through air. Subject and object, the seen and the seeing melt together to produce the appearance, almost totally by color gradients, especially in Leonardo's later masterpieces (the *Mona Lisa,* the *Virgin of the Rocks,* the *Virgin and Child with St. Anne*). Notwithstanding what Brunelleschi taught about perspective, space is not just a geometrical fact; it is not a plane, a rectangle, a triangle, or a circle. Space is what these geometrical figures are made of. To get to this essential space, Leonardo looked at the changing effects of air—how it dissolves, smears, and blends. "The painter can suggest to you various distances by a change in color produced, by the atmosphere intervening between the object and the eye," Leonardo proposed.[10] A tenderly shading fringe flickers between an object and its environment. "Nothing" is always at work rubbing the edge of razor-sharp definitions and forms.

The mirage-like nature of reality—the idea that Being quivers and shimmers—is the subject of Leonardo's masterpiece, breathed into reputedly the most famous portrait in European painting—indeed perhaps the very portrait of the modern Western mind—the *Mona Lisa* (c. 1502). It is ambivalence appearing in human flesh. Generations of art lovers have remarked on her quizzical smile that seems to many the visible cipher of a deeper mystery, some ineffable coyness that jointly invites and rebuffs interpretation. On consideration, she seems less to be a portrait of a person than of someone still making up her mind as to

who she is (her actual identity is, to this day, charmingly uncertain). Her bemusement at having to *be* someone, her ever-so-mocking solicitude, are psychological forms of *sfumato*: something like the moral obligation to shun ready-made identity. Perhaps she is the hybrid portrait of several women: none in particular, yet not an abstracted ideal woman either. Is her smile kind, mischievous, solicitous, disdainful? The least we can say is that she is not forthright; her smile defends personhood as mystery, process, intermediacy. She is humanity as becoming: this is why she requires interminable interpretation—as indeed she called on Leonardo to return again and again to her portrait, to touch up this and that detail, and to keep her in his possession all his life. Next to her, even the delicate psychology of a Botticelli or Raphael looks prim and pert. The *Mona Lisa* was never the best example of a lifelike portrait (masters such as van der Weyden and Fouquet had created faces that were more subtle explorations of psychological depth). But *Mona Lisa* was the first portrait to tarry in the mystery that makes one person obscure to another, to express in paint the realization that beyond honors, offices, and titles, there lingers in the human face a sketch impossible to hone. She is depth, chiaroscuro, distance made into human form. As painting, she is not the most beautiful or perfect—but this, of course, is the point.

In sum, Leonardo painted the human face as a horizon—a promise of intimacy postponed, the intuition that human identity consists not of eternal laws, but of psychological fine-tuning. We face her as a regress of meaning—perhaps, in the end, as the self-portrait of an artist who could never decide just who he was and for whom reality was a vanishing point.

What Leonardo's faces are to psychology, his landscapes are to topography: they vaporize. Even the horizon—the baseline of Alberti's geometrical universe—is out of joint: it tilts higher to the right of Mona Lisa's head than to the left. It too goes into a tangent. Like the lady of the portrait, it is not what it is. At any rate, it ceases being a mathematical cornerstone and embraces what is, after all, its inherent elusiveness.

Although Leonardo pioneered this chromatic atmosphere, it was the following generation of artists who transformed it into an all-out style called *il chiaroscuro,* or clear-obscure (the quality of being bright and dark, definite and indefinite at the same time). It is a sign of the times that chiaroscuro spread over painting as Renaissance humanism—shaken by the Sack of Rome of 1527, the decay of Florence's republican institutions, the stifling ideological assertiveness of the Papacy following the Council of Trent—slowly sank listed into self-doubt. All of a sudden

the spectral fantasies of the German artists Grünewald (1470?–1528) and Dürer (1471–1528) seemed more relevant than the spic-and-span garden-world of the quattrocento. The masters of the cinquecento such as Correggio (1489–1534) and Titian (1484?–1576) were all artists who assimilated the art of the soft focus in apprenticeship. In the mannerist style that painters affected after 1530, the world, once so brightly welcoming, seems to hang back in forlorn skepticism. Even the very near looks far in these works. A landscapist of the 1400s like Perugino, who delighted in miniature, gold-etched details—the hem of a tunic, a crenellated oak leaf—could never have understood the fudging, blurring palette of Giorgione and would have frankly bridled at Tintoretto's shady happenings. Why an aesthetic period that muddied the enamel yellows and reds and gild of medieval illuminations in all this twilight *Weltschmerz* is called *the Renaissance* is a matter of wonder (even if the term is a nineteenth-century coinage). As for the cinquecentists themselves, they regarded themselves as students of history, as lovers of the patina. And this is also what conspired to blur the landscape—a loss of temporal immediacy, the time lag of pensiveness and reflection. The late Renaissance artists were men who gazed at reality through the mists of history. They knew the uncrossable gulf between them and the Venuses and Adonises of antiquity. Their mood was that of reminiscence, of distance across time.

And as duskiness sets the mood, the scenes taken up by artists turned to those biblical episodes rife with indecision and two-mindedness: moments when the whole of reality hangs in the balance, when the absolute and the relative, the eternal and the contingent, God and man stand face to face (the Annunciation), fail to weld (the Doubting Thomas), or hold in delicate suspense. The epoch saw an intensified interest in a verse of John's Gospel that artists raised into a full-blown genre, the *Noli me tangere*. The scene is Easter Sunday in the garden of the Sepulcher. Mary Magdalene has just found the tomb empty. The risen Christ then appears before her. Disbelieving her eyes, she reaches out but Christ stops her: "Touch me not," he says, "for I am not yet ascended to my Father: but go to my brethren, and say unto them, I ascend unto my Father, and your Father; and to my God, and your God" (John 20:17). Christ is ambivalently present: neither of this world nor the next but in between—a shy deity who sidles away and shuns contact, *sfumato*-like. Mostly absent from medieval art, the *Noli me tangere* motif peeks up in the fourteenth century and is then taken up with increasing frequency by the great Renaissance masters. Fra Angelico (1425), Fra Bartolommeo

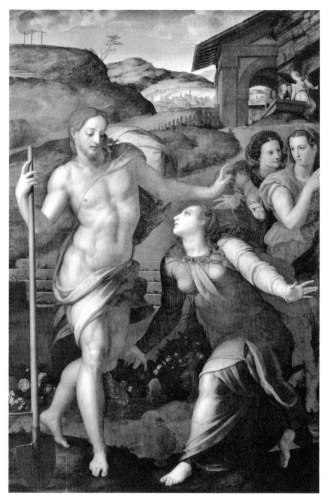

FIGURE 5. Il Bronzino, *Noli me tangere*, 1561. Oil on wood. Courtesy of Art Resource.

(1508), Titian (1514), Holbein (1524), and Correggio (1534) all take a turn at the motif. What better subject than a figure shying from touch to convey the new sensibility of expectation, uncertainty, and emotional chiaroscuro? *Noli me tangere* shows Christ at his most unsure. In Fra Angelico, he tiptoes as though on an invisible tightrope; Titian gives him a prudish, willowy sidestep; and there is something of the mannered dancer in Correggio's version. By Bronzino's turn (1561), the scene is a flurried ballet of contorted avoidance (fig. 5). Space is evoked

dramatically, by gestures rather than geometrical formula; it arises by an *act* of distancing. A gap opens between Christ and Magdalene, and their distance is psychological, nervous, gestural—not topological. The Renaissance artist discovers that space is created psychologically, though the choreography of intentions. The ways we occupy space *make* space: space is humanized, psychologized. Distance is not *in* space, but what we make of space. And since there is no space without distance, then space too is the product of human action.

Gently avoiding contact, pleading for distance, Christ communicates something of the humanist's distaste for ready-made definition. Like the *Mona Lisa*'s light-and-shadow smile, his figure asks to be imagined into, essayed, approached with the feelers of intuition, not the chisel of doctrine. He dances before Magdalene, present yet unreachable. He simply asks her to mind the space between subjectivities, the gap between one individual and the next—the spiritual privacy of the self championed by Renaissance humanism.[11] Through *Noli me tangere,* the Renaissance defends the individual's right to explore the side roads of self-creation, outside of social and religious strictures. It suggests that humanity is fashioned by leeway, the lucky stumble from the beaten path, the felicitous error that unveils new ways of being and doing.

Of course, we must not overly humanize the Christ of *Noli me tangere.* His sidestep marks a firm doctrinal separation between the sacred and the profane that Magdalene is asked to mind. Yet even this separation is hard to pinpoint: it wavers. The breach between the immanent and the transcendent is sublimely imprecise (contrast this with those medieval iconographies where Christ Pantocrator sits on an imperial throne clear above the earthly plane). The Renaissance, in other words, does not want to know where or how to draw the limit between man and God. Are we not, like the Neoplatonic Ficino and Pico della Mirandola of fifteenth-century Florence claimed, god-like in apprehension? "What a piece of work is man, how noble in reason, how infinite in faculties," Hamlet will say. Medieval man was either completely bound to this world (in life) or completely bound to the next (in death). Renaissance man feels neither convincingly mortal nor eternal. Like Magdalene reaching for the resurrected, a part of him stretches to infinity, and infinity does not roll out the red carpet or open the pearly gates. It shies away, always ahead.

This blurring of the outline of life is also seen in the Renaissance treatment of the Annunciation. Early- and mid-quattrocento artists such as Fra Angelico or Gentile da Fabriano channeled the spirit of Byzantine

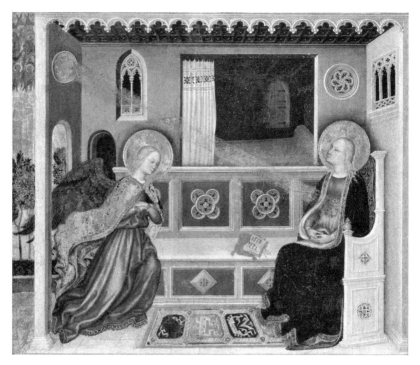

FIGURE 6. Gentile da Fabriano, *Annunciation,* circa 1370–1427. Tempera on wood. Courtesy of Art Resource.

porticos and Gothic illuminations in representing the Virgin graciously hosting the divine. In these versions, the Infinite (in the person of the archangel Gabriel) enters human space on a beam of light and floods historical time (*aion*) with the fullness of fulfilled time (*kairos*). The Virgin takes the call and saintly welcomes the eternal Kairos as Francis receives the stigmata (fig. 6). Earthly life is a grateful colony of a ruling transcendence.

Contrast this with Botticelli's *Annunciation* (1489–90) or Titian's variation (1560–65) on the theme (figs. 7 and 8). These two artists stage-manage the scene in the skirting, tiptoeing manner of a *Noli me tangere.* A human Mary—not the eternal Mother of God but a frightened maiden—softly recoils from the divine afflatus. The archangel inches forward, and through him, the infinite seeks entrance into the human. But Mary demurs, sways with indecision, torn between what she owes to God and what she owes to her humanity. The gap between the archangel's hand and her own awaits a sign of clear welcome, of

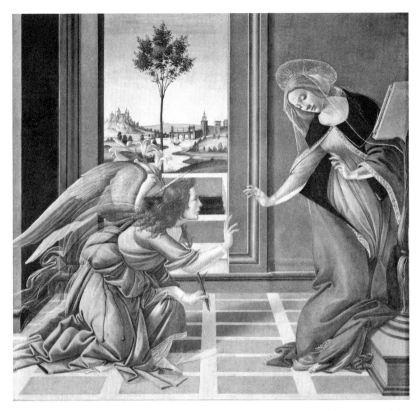

FIGURE 7. Sandro Botticelli, *Annunciation*, 1490. Tempera on wood. Courtesy of Art Resource.

sacrificial submission, that does not come. The humanist sensibility is in doubt about where, exactly, the divine infinite and the human finite meet—or indeed whether earthly time is altogether reconcilable with the infinite. The Gothic cathedral trumpeted the conviction that the infinite and the earthly do line up somehow, and that the earthly life is a conduit to the heavenly; the High Renaissance Annunciations on the contrary point to a disjunction between the divine and the human. In Andrea del Sarto's version (1528), the virgin flinches as though avoiding the sting of something not altogether welcome (fig. 9). A horizon flutters between the archangel Gabriel's hand and Mary's, and it is not clear (as with any horizon) how to bridge it—or whether one even wants to. Better, perhaps, to let it hover, as horizons will.

In sum, what is now infinite is the hesitation. Infinity migrates from theology to psychology and blossoms out of a human emotion:

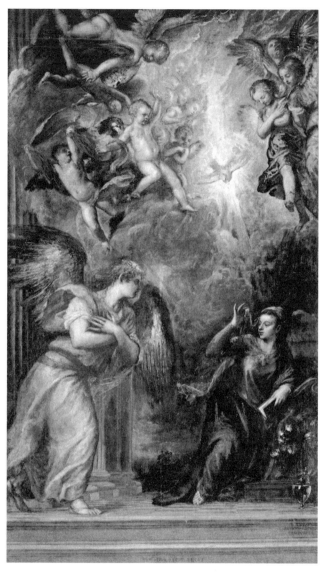

FIGURE 8. Titian, *Annunciation*, 1560–65. Oil on canvas. Courtesy of Art Resource.

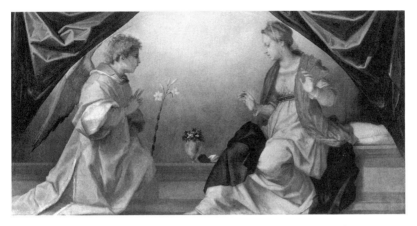

FIGURE 9. Andrea del Sarto, *Annunciation*, 1528. Oil on panel. Courtesy of Art Resource.

doubt, the hesitation of making up one's mind, indeed the experience of freedom.

This idea takes us to perhaps the most famous gesture in the history of Western art: the breathless gap between God's forefinger and Adam's listless hand that Michelangelo (1475–1564) painted near the center of the Sistine Chapel vault. Whether the two fingers are coming together or drawing apart is an unsolvable question. Better to observe that, in their near encounter, they point to a gap. They sketch out the emptiness, hold it forever aloft: the ceiling, like the Gothic vault, harbors the void. Only this void, unlike the Gothic, is not theological but gestural, the product of tension. This gap is human history itself, which will close only at the end of days. All time and space hangs in suspense on this undrawn boundary. Relative to the gorgeous sweep of the Sistine, it is a tiny gap; yet a new kind of infinite nests therein: not the theological infinite that sent Gothic masonry flaming skyward, but the infinite of irresolution, of venture and recoil caught in neurotic brinkmanship, of human identity awaiting definition, athwart between the actual and the possible. What happens between those two fingers—this horizon of tensile void— explains the decline of the Gothic space architecture of *extension* and the rise of the spatial drama of *intention*. No need henceforth to simulate the infinite by means of sky-reaching masonry because it can be intimated by tension and hesitation—that is, by mood.

Divine eternity asks for entry and we, like the Mary of Botticelli's or Sarto's *Annunciation*, delicately hesitate: something about human life demands that it too be accomplished on its own terms. Mortal

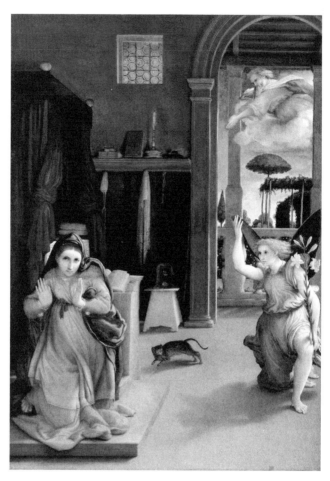

FIGURE 10. Lorenzo Lotto, *Annunciation*, 1535. Oil on canvas. Courtesy of Art Resource.

existence belongs to a place of its own over which divine eternity, if it is still the ultimate good, is not so good that it eclipses the duration of life. For time itself, though it brings us suffering, decay, and death, is our domain, the one in which we create ourselves. For all its miseries, it remains the substance out of which we mould our identity. Perhaps no painter represented this defense of the immanent as dramatically as Lorenzo Lotto (1480?–1556), whose *Annunciation* Mary (c. 1535) wheels around from her prie-dieu, the angel in hot pursuit, while in the top corner, God the Father takes aim like some county-fair archer (fig. 10). Her startled pet cat scampers off in fright. The maiden looks to us

in speechless appeal as though we are to share her quandary. Are we to excuse her from all this sky-god sorcery? Is she asking to please postpone the divine moment?

Consistent with this defense of immanent existence is the sharpening of historical awareness during the Renaissance. As the printing press and the popular availability of books produced a better-educated citizenry among the new merchant and administrative class, so people's knowledge of history deepened and instilled the realization that present-day society was embarked on a long-time endeavor called civilization. This new historical intelligence can be seen in pictorial arts, where the concern for historical accuracy supplanted the timeless and universalist approach of the Middle Ages. When the medieval illuminist illustrated a biblical scene, he simply dressed his figures in the clothes worn by the people of his place and time. His Virgin was a bonneted maid from Lyons or Bruges, his Roman centurion, a peasant soldier in chain mail and Wenceslas helmet. By Raphael and Titian's time, however, the painter wants to get the historical color right for his Greco-Roman characters. And it was not just the past that came cloaked in temporal distance but the present too, which, by virtue of figuring in a long historical sweep, also took on the patina of an historical object. Not uncommonly, as in Donatello's equestrian statue of the condottiere Erasmo da Narni (1453), figures of the contemporary political scene show up in the garb of ancient imperial Rome. Renaissance man knew that the present too was but one skein of history. He therefore represented it as it would appear before the tribune of historians, past and future. Indeed it is as though the Renaissance *remembered* the present, and as remembrance makes everything old and touches all things with the taint of mortality, so this alleged era of rebirth, saw the return of self-conscious mortality and harped on the theme of *tempus fugit* like no one since the Roman Stoics.

Of course it is not the case that the medieval person did not worry about death; yet his stout confidence in an afterlife, in everlasting hell and heaven, in divine providence—it all made the earthly life seem more like a through station and a rite of passage in a sea of timelessness. Now the humanist focus on the earth-based perspective changed all that, and life very much began to look, and feel, like an open road. One's death was no longer a timeless episode etched in God's book of ages; it loomed somewhere in the future, and one was helplessly swept toward its vanishing point. This is how, with the new emphasis on the human vantage point, the Renaissance witnessed the resurgence of memento

mori in art and poetry, in the flowering of grand funerary monuments, and in the custom of drafting a personal will. One drew installments against death; one saw it as complicating life, eating into it, robbing it of its season. In sum, mortality had begun to loom like a real problem, an existential problem and not just a religious one, that required an entire lifetime to brood over.

The Scientific Age

Mortuus sum

Bordeaux, 1574

One day he was riding his horse in the neighborhood of his manor in the Bordelais, the essayist and statesman Michel de Montaigne (1533–92) was violently thrown off his mount and, like Paul on the way to Damascus, had a revelation. As his fellow horsemen carried his unconscious body home, the moribund Montaigne was using his last glimmer of awareness to mull over the curious thought that he was dying. Ever the lover of knowledge—Montaigne recalls his intense interest in fixing the moment. The life unexamined is not worth living; neither, it seems, the death unexamined. For Montaigne, death ought to be a biographical experience. Others could have spun a theological or metaphysical disquisition from the accident; not so Montaigne. He eschewed the general and delved into the particular, the actual approaches of death, in the manner of the explorer, keeping to the sea-level view of life, his eye on the horizon, not presuming to say what lies beyond but instead dilating (with the relish of satisfied knowledge) the agonizingly temporal event.

Montaigne recounts his "death" in one of his *Essays* (1580), a volume that, to the historian of ideas, is a distillation of antidogmatic, skeptical, experimental Renaissance humanism. Equally important as the ideas is the form in which Montaigne casts them: not as axiomatic truths, but as the jottings of chance observations and anecdotes springing from the author's own life, the events great and small of his country, his readings, his health, his changing mood, the events great and small of his country. Humanism means the human view of things, and the human view of

things, so far as Montaigne saw it, consisted in being Montaigne: not a universal mind but a thinking man jostled by circumstances, changing, inquisitive, uncertain—and occasionally thrown off his horse. "The world," he writes, "is but a perennial see-saw. Everything in it—the lands, the mountains of the Caucasus, the pyramids of Egypt—all waver with a common motion and their own. I am unable to stabilize my subject: it staggers confusedly along with a natural drunkenness. I grasp it as it is now, at this moment when I am lingering over it. I am not portraying being but becoming: not the passage of one age to another . . . but from day to day, from minute to minute."[1] His subject matter is his own understanding. The world is a seesaw, partly owing to inherent properties (Montaigne shared Heracleitus's view of the cosmic flux), but mostly because the mind sets it in motion. The world is a swarm of experiences. If it seems to rush past us, as Montaigne discovers, it is really because the understanding is not capable of catching up with itself, cannot step on a platform outside its own activity. The horizon-like quality of reality, Montaigne suggests, stems from the amorphousness of self—our inability to draw the line of our own subjectivity.

For Montaigne, the elusive subjective horizon looms largest in death—a topic he broaches in the essay "Of Practice" ("De l'exercitation"). Being the only creature aware of having to die, we are in the strange position of being able to observe ourselves observing death. We do not just die; we contemplate, anticipate, conjecture, familiarize ourselves with, or, to use Montaigne's word, *practice* death. In the end, however, it is clear that all we know of death is the approaches—the mortal illness, the deathbed confession, the sick feeling that the end is nigh. Death, Montaigne writes, "is indeed the limit beyond which we shall not go and which has been prescribed by Nature's law as never to be crossed."[2] This is a way of saying that human life is horizon-like.

Here is Montaigne in wounded stupor after he falls off his horse:

> It seemed to me that my life was hanging only by the tip of my lips; I closed my eyes in order, it seemed to me, to help push it out, and took pleasure in growing languid and letting myself go. It was an idea that was only floating on the surface of my soul, as delicate and feeble as all the rest, but in truth not only free from distress but mingled with that sweet feeling that people have who let themselves slide into sleep. I believe that this is the same state in which people find themselves whom we see fainting with weakness in the agony of death.[3]

Montaigne luxuriates in the intellectual delight of *living out* his end, watching himself in slow dissolve, the boundaries of selfhood loosening

around him. Life does not look like a perimeter to Montaigne but a vanishing point.

Yet what are the implications on the very idea of biography, which consists precisely in drawing the shape of the self? Form conveys identity. It distinguishes between what a thing is and what it is not. But where we are not *formally* bounded by death, human life becomes indefinite, hence permanently in need of shaping (i.e., the very work of the *Essays*). As Montaigne confesses, "Since my earliest days, there is nothing with which I have occupied my mind more than with images of death."[4] The humanist is haunted by the *sfumato*-like imprecision of his identity. "To be, or not to be," as Shakespeare, an attentive reader of Montaigne, put it. Between to be and not to be Shakespeare places an *or*, not an *and*: now we are, someday we will not be. This insight suggests life is not necessarily followed by the long trail of eternity; it is time *or* eternity. The first does not organically mutate into the other; in between is a skip, a missing beat (*or*). The moment that gives shape to my existence is paradoxically missing.

But then what is death? It is, the humanist argues, strictly the business of the living: "The constant work of your life is to build death. You are in death while you are in life; for you are after death when you are no longer in life. Or, if you prefer it this way, you are dead after life; but during life you are dying; and death affects much more the dying than the dead."[5] Death is an outlook. It is a state of mind. It exists through us, by means of us, in man (that "quintessence of dust," says Hamlet). Though *of* us, death does not define us. Or if it makes us mortal beings, then we must admit being mortal is far from being a clear-cut affair. The occupation does not come with, as it were, clear bounds of jurisdiction.

"Where death waits for us is uncertain," says Montaigne, "therefore let us look for it everywhere."[6] Not knowing where we end means every breathing moment could be the last: the infinite *in potentia* hides inside every second. "Let us have nothing more often in mind than death," Montaigne decides.[7] The death he keeps in mind is not the eternal afterlife. It is the unknown (perhaps nothingness, perhaps not). The *I* is cloaked in the thought of its nonbeing, which is neither here nor there but consubstantial with existence. It is not over there where I meet my end; it is here, now, in the thought of my death. So perhaps the right way to put the matter after all is "to be, *and* not to be": the two are the warp and woof of self-consciousness.

What Montaigne mounts in his *Essays* is a defense of the mortal condition that gives human existence its intensity and pathos and, in parallel, a depreciation of immortality. Is it an obligatory feature of the human condition that we should we wish for eternity after death? We can hear the question worrying the English poet Geoffrey Chaucer (1343?–1400):

> For when a beast is dead, he feels no pain,
> But after death a man must weep again
> That living has endured uncounted woe;
> I have no doubt that it may well be so.[8]

Even sotto voce, this skepticism would have sounded incomprehensible to any sensible person before 1300. Chaucer raises the moral questions as to whether eternal awareness is fair for humans to bear, and whether we are not better off with true rest, which even the humblest beast enjoys. It is bad enough to live in woe; must we also spend eternity rehashing the memory of it? And if we have a happy life, will we not spend eternity missing the good days? The very thought mocks Christian charity. For Montaigne, the answer was clear. On balance we are happier creatures without everlasting life: "Do but seriously consider how much more insupportable and painful an immortal life would be to man. . . . If you had not death, you would eternally curse me for having deprived you of it."[9] Death provides the guarantee of an exit and therefore the sense that life has one direction. Montaigne believed that life without this kind of eventuality would be inhuman, but it would also be truly amorphous, neither forward nor backward, neither moving nor stationary. As infinite, it would be therefore shapeless. This idea invites a paradox: it now seems that the undrawn boundary of death that makes life open-ended is that by which life has any shape at all.

This is surely no life for the faint of heart. It seems as though, with the retreat of medieval dogmatic certainties, a measure of existential security went out of the world. Some historians have spoken in this regard of a "depressive" Renaissance and certainly the ostentatious tombs and cenotaphs beginning with the late the fifteenth century bespeak some new existential anxiety.[10] The purpose of a grave is to mark death and palliate its mystery. Marking makes the invisible visible; it transforms nothingness into something. The grave also palliates by substituting something for nothing, and thereby giving the survivors a concrete reference to their grief. It is constant in the comparative study of cultures that strongly integrated, collectivistic societies tend to favor unassuming or

fungible funerary displays whereas individualistic, competitive societies plumb for the monumental. An example of the former, medieval society built tombs of modest proportions, even for monarchs and high-born persons. The Renaissance on the contrary saw even clerics, who should have known better, splurging on sumptuous sepulchers and commissioning the very best artists to design grandiose mausoleums on a scale never seen since the parades of Roman triumph.

Notable in these funerary grandiosities, especially in Italy, is how little they have to do with the afterlife. Their purpose seems not to lay the dead to rest, but to dispute nature's or God's right to reclaim a human life. Out went the medieval recumbent figure carved on the cathedral floor, whose slab sculpture (eyes closed, arms folded) expressed trustful capitulation before the power of death. In came the Renaissance tomb and its swellings of marble pomposities, its emoting pathos and grief and protest. Michelangelo's *Tomb of Giuliano de' Medici* (1525–31) is designed not to ease passage into the afterlife, but to vent grievance. Two hundred years before, an uncomprehending believer would have gaped in bafflement at a tomb that featured a convulsed naked female flanked by a scowling gymnast. These Renaissance marbles proclaim muscular defiance and despairing pride, affirming the very thing undone by death: the willful, embodied, restive human being. Man is mortal, they seem to say, but he does not take it lying down.

There is more represented by these new types of funerary displays: they are protests, but they are also strategies to ward off the void. Their efflorescence, the billowing self-importance of it all, signals a scramble to *make* something—anything—out of death. The more elusive its limit is felt to be, the more fuss and froth needs to be stirred up. The more empty death is, the more gilded and swollen the framework around it. As this emptiness grew and skepticism overtook medieval quietism, so the sentimentalism that consists in turning out a star performance at one's own funeral reached histrionic extremes (see the next two chapters).

Humanism suggested there was nothing inherently valuable about the intellectual effort to hoist ourselves up to the divine vantage point and see things as God sees them, or wants us to see. All we have is the temporal, and the temporal is where our attention must set to work. *Carpe diem,* "seize the day," became the cultural motif of choice for this new society. But how does one seize the day? When does the past end, how long does the present last, and when does the future wash in? If time is a passing away, where does it pass into and whence does it come? Thinkers such as

Montaigne meditated on Aristotle's famous passage of the *Physics* and saw the abyss therein: "One part of time has been and is not, while the other is going to be and is not yet," argued Aristotle, "yet time is made up of these. One would naturally suppose that what is really made up of things which do not exist could have no share in reality."[11] The Renaissance mind, however, felt too intimately the constant, erosive brushing past of time to accept Aristotle's conclusion regarding its nonexistence. Could not the present at least be rescued from this vanishing? But the more we focused on the "now," the more we found even less to hang on to. The present runs away the very moment we try to lay hands on it. (Ronsard dedicated entire sonnets just to this vexing new problem.) Indeed, the present is *boundless.* It too is horizon, steeped in *sfumato.* And if the present is a misnomer and absence its actual substance, then where and when do we actually exist? The past is gone, the future yet to be, and the present does not pause long enough to say, "Here I am." It is around the Renaissance that time tensed up, grew anxious. This theme runs through the length of Montaigne's *Essays,* the leitmotif of which is the shortness of life, parsimony, the limited supply of one's will, energy, and time. Though time was an unreal quantity, one could never get enough of it. It had become the cherished enemy, the bitterness that makes life sweet.

Sociologically, this urgent mindset is an offspring of urban culture, of a people, as Montaigne put it, "bred up to bustle."[12] The peasant or farmhand has little use for the idea of linear, progressive time. He observes the seasonal and climate cycles and adjusts his labor and knowledge to the yearly rhythm of sowing and harvesting. On this practical ground, it is difficult to reflect about which way the winds of history are blowing. What is the use of projecting far into the future or conjecturing about the destiny of humankind when a drought or a pestilence may lay all of one's fortune to waste. A future that hangs on a spell of good weather is not one worth planning much and does not extend beyond the next harvest. To take hold, the idea of progress needed a citizenry confident enough to draw investments against future payoff. This situation first arose in the commercial cities of Italy and Holland, Florence, Venice, Ghent, Brugge where an administered economy, well-managed municipal granaries, order on the street, compliance with contractual agreements, and confidence in the word of law enabled people to draw long-term plans. This managerial outlook alone is a practical disproof of the dreary shadow of religious millenarianism under which, so long as the apocalypse was round the corner and life was a slough of despond, stifled the idea of progress. The Renaissance

saw less resignation and more voluntarism, but also, in equal proportion, greater anxiety: talk of investment and return on dividends; the habit by traders, speculators, shopkeepers, and guildsmen of charting their ventures against a timetable—all this meant that the cities were becoming excessively busy and time-starved places. The public clocks in Milan and Bologna now struck every hour, and the growingly common portable clock reminded citizens (as Alberti asserted in a treatise) that time is "precious" and dawdlers are pariahs.[13] Time had become money, as the saying goes—and money is, by nature, always in short supply, sought for, calculated, and measured in diminishing returns. The upshot was a peculiarly restless outlook on existence, the feeling that to exist was essentially to be pressed for time. *Tempus fugit* was not just a trope of lyrical poetry; it had become the stuff and taste of everyday existence.

Tellingly, it is this same well-to-do urban class of burghers who commissioned and bought landscape paintings, a genre virtually ignored or unknown up until the Renaissance. A broad panoramic landscape first of all assumes a far-seeing gaze, indeed the very sort of special and temporal outlook maintained by the merchant-banker. Seeing the horizon in art correlates with a managerial mindset that looked to reality with an eye to reason it out, to see whence and whither. Before spoken use adopted the word *landscape* (from the Dutch word *landskip,* 1606), people referred to painted panoramas as *prospects,* a word that aptly describes an expectant, enterprising attitude toward space and time. It is, in any case, the prospect of someone who sees reality as bound to some horizontal destination.

Together with the aesthetic horizon, there sprang the habit of gazing prophetically into the social horizon: enters utopia. It was then that, setting their imagination out to the not-yet, writers dreamed openly of better tomorrows, of man-made Edens, beginning with Sannazaro's *Arcadia* (c. 1480), More's *Utopia* (1516), Doni's *La Città Felice* (1553), Campanella's *Città del Sole* (1602), and Francis Bacon's *New Atlantis* (1626). The Renaissance utopia overturned Augustine's gloomy injunction to keep "the City of God as far removed from the city of man as the sky is from the earth."[14] That Eden could be built here on earth meant earth and sky were not so distant after all. Salvation was a matter not for prayers, but for strong enterprising hands. If we were clever enough to dream better tomorrows, then perhaps it was a matter of technical wherewithal to build them. The future was not etched in stone; it was like the horizon, a misty, colorful something that loomed in the offing, one step forward at a time. Pieter Bruegel's painting *The Tower of Babel* (1563) conveys something of this toilsome, hopeful entrepreneurship.

His tower—a building site heaving with stoneworkers, masons, scaf-
folds, carts, planners, and architects—has nothing Promethean or
meekly cautionary about it. It is Jacob's Ladder tackled as an engineer-
ing problem. There the divide between earth and sky, it seems, is a work
in progress—the work of human ingenuity. The almighty Yahweh has
not struck and most probably never will.

This conviction that space and time are variables of the human will
also drove the spirit of scientific exploration—the idea, curious by medi-
eval standards, that the world invites getting to know. This realization
too changed the shape of reality into something more horizon-like.
Medieval knowledge was ringed around by timeless truths. Knowledge
was exhaustible on principle. The Renaissance idea of scientific advance-
ment, on the contrary, suggested the world was rife with facts awaiting
discovery. Science is knowledge by incremental steps. It submits theories
that ask to be tested, proven or refuted, open to modification and devel-
opment. Whereas the medieval mind derived knowledge chiefly through
deduction (from fixed unquestioned tenets to applications), the Renais-
sance intellect worked inductively, from empirical observation, up to
hypothesis, and finally to the general principle—itself subject to falsifi-
cation. This was a system of no foregone conclusion resolutely at odds
with the outcome-comes-first pusillanimity of medieval scholasticism.
Science fostered intellectual risk, experiment, criticism, and a willing-
ness to smash the stale and the accepted. Only then, in the Renaissance,
does it make sense to start speaking of a cumulative "horizon of knowl-
edge"—that is, of knowledge as a vanishing line.

This horizontality of knowledge looms large in the writings of its chief
advocate, Francis Bacon (1561–1626). The title alone of his treatise *The
Advancement of Learning* (1605) issues a manifesto for a ground-level
model of pursuing knowledge. Bacon berates those scholiasts who seek in
knowledge "a terrace for a wandering and variable mind to walk up and
down with a fair prospect; or a tower of state for a proud mind to raise
itself up upon; or a fort or commanding storehouse."[15] It is, in sum, the
view *sub specie coeli,* "the vertical vantage point," together with the idea
of knowledge as an empyrean survey of all knowledge under the sun, that
comes under attack. Bacon proposes, instead of knowledge, a *learning*
acquired by "dwelling purely and constantly among the facts of nature."[16]
Compare this with the Platonic model of intellectual ascension that pre-
vailed until the mid-Renaissance, exemplified by Erasmus (1466?–1536):
"Creep not always on the ground with the unclean beasts. . . . Lift up
thyself as it were with certain steps of the ladder of Jacob, from the body

to the spirit, from the visible world unto the invisible, from the letter to the mystery, from things sensible to things intelligible."[17] Erasmus saw knowledge as a means of *escaping* nature; a century later, Bacon regarded it as wading deep into nature. Bacon's reality wraps around man, for whom there can be no question of leaping into invisible, merely guessed-at regions. To him, the heavens and the earth make a continuum, cut out of a common substance, obeying "common passions and desires." Thus when the new man of learning looked at the stars, he did not really look *up;* instead he looked *out.* This reorientation had the effect of "horizon-talizing" the world and thus of laying it open for conquest.

Here we must very briefly mention the crucial role played by the Reformation in this new horizontal spirit of moral and scientific progressivism.[18] There is no indication that Bacon was a man of burning Lutheran conviction, but his view that utility and concrete human satisfaction are the aims of scientific advancement clearly connects with the Protestant outlook of human betterment.[19] Martin Luther's doctrine of justification by faith reoriented the Christian perspective on life's purpose, where righteous living was no longer a mere means of salvation but the very substance and reward of salvation.[20] The religious disposition shifted from passive-reactive to active and voluntarist: "Yes," proclaims Luther, "it is a living, creative, active and powerful thing, this faith. Faith cannot help doing good works constantly. . . . Anyone who does not do good works in this manner is an unbeliever. Because of it, you freely, willingly and joyfully do good. . . . Thus, it is just as impossible to separate faith and works as it is to separate heat and light from fire."[21] This new disposition opened a floodgate of pent-up entrepreneurial energy. Salvation by "this-worldly work," as sociologist Max Weber's thesis goes, encouraged the reformed Christian to look upon this world not as the proverbial slough of mortification, but as raw material with which to pave his personal road to redemption.[22] Christian, the hero of John Bunyan's Protestant allegorical epic *The Pilgrim's Progress* (1678), is an exemplar of on-the-go spiritual enterprise, iron determination, and psychological self-help. Endeavoring, striving, and struggling are the recurrent gerunds of his steeple course to divine good grace. It is not passive disposition toward providence but a fundamental confidence in human agency, together with an unswayable will, that typified the Protestant character. "The consciously elect man feels himself to be destined lord of the world who in the power of God and for the honor of God has laid it on him to grasp and shape the world," Ernst Troeltsch writes in a landmark study.[23]

There is no overstating the transformations effected by this new horizontal path to the kingdom of God. It changed the outlook of psychology, history, and society. Economic life, science, political reform—the Protestant spirit adjusted all these to its master narrative of practical improvement, of betterment as a way of life. The theological horizon was now a concrete, palpable road lined by concrete achievements, and travelable by wits, resolve, and perseverance, not to mention sound bookkeeping. An example is John Milton's revisionist dramatization of Adam and Eve's banishment from Eden in *Paradise Lost* (1667). Once the epicenter of the catastrophic and incurable Fall of man, this episode becomes a chance to make the best out of the worst. Even the catastrophe is the first day of Adam and Eve's life, and opportunities call. As the archangel Michael urges them,

> Add virtue, Patience, Temperance, add Love,
> By name to come call'd Charity, the soul
> Of all the rest: then wilt thou not be loath
> To leave this Paradise, but shalt possess
> A Paradise within thee, happier far. (7.585–90)

Strong with a guarantee of redemption through work, Adam and Eve go forth in a world ready to stand at their command.

> The world was all before them, where to choose
> Their place of rest, and Providence their guide;
> They, hand in hand, with wandering steps and slow,
> Through Eden took their solitary way. (7.646–49)

On these words Milton concludes *Paradise Lost,* the "lostness" of which, plainly, is not irremediable. These verses do not scan the heavy trudge of a defeated humanity; they are the stomping iambs of newborn pioneers sallying eastward (see chapter 19). It is sunrise, not sunset, that greets them on the plain. The Protestant ethic thus works the synthesis between Renaissance humanism and theology; the man-centered view is urged on us by an empowering God who, far from frowning at initiative and self-confident can-do, gives us the go-ahead. Now the horizon boomed with immanent promises and contractual engagements, and transcendental distance looks suddenly quite within reach.

History offers us a champion and poster boy of this new adventure in horizontal prospection in the person of the Renaissance seafarers—the most iconic of whom is Christopher Columbus (1451–1506). As far as

his cartographic knowledge goes, Columbus subscribed to Ptolemaic and medieval geography.[24] In temperament, however, Columbus is a proto-Baconian experimentalist. Shipping out *ad finem orbis terrae,* he is willing to test an idea against fact. He most embodies his epoch when, three weeks into the passage, he is yet to sight land, time is running short, a mutiny is afoot, and he addresses his logbook in the voice of wavering hope. His is a journey of desire, the triumph of scientific induction that observes in order to know and submits hypotheses ("the western passage") to the test of reality. It is then Columbus embodies the Renaissance fusion of space and will, the historical moment when the contour of geo-social reality was drawn by the practical will rather than theoretic belief. Finally, to this practicality, we should add the near-Promethean wish to round off the earth by proving that, when chased down to the farthest point, the horizon leads nowhere—nowhere but where we are now (that would be shown by the circumnavigating voyage of Magellan's crew in 1519). In a sense, the global sense of reality was also subjectively reflective: it threw us back on ourselves, the willing viewer.

Columbus is subjectivity sculpting the shape of the world with the push of will and longing. In one sense, he stands for the victory of the scientific method; in another sense, he embodies the supremacy of idea over fact. For he shows that space is not a given and that the world is not a fact; both are altered according to our eagerness to know them. The shape of reality had begun to seesaw with the progress of knowledge, as anyone who looked at world maps between 1480 and 1530 would have plainly noticed, the changeling world calving new islands, seas, and continents or swallowing others that existed nowhere but in the imagination.[25] This was a period when the human horizon merged, and indeed took over, the horizon proper.

For Columbus's journey reveals the ascendance of subjectivity over reality. His philosophical counterpart is the humanist who declares the world an ongoing work of knowing. As the skeptic Montaigne asserted, we experience nothing pure: "The feebleness of our condition is such that things cannot, in their natural simplicity and purity, fall into our use; the elements that we enjoy are changed."[26] Subjectivity extends as far as the mind can see; we cannot leap beyond the horizon of our own self. "No powerful mind stops within itself: it is always stretching and exceeding its capacities . . . it makes sorties and . . . is only half-alive if it is not advancing, pressing forward; its inquiries are shapeless and without limits."[27] The protoplasmic mind oozes and leaks but really never

empties out. Like Magellan's expedition, it ventures far and wide but comes round back to the starting point. In the end, Montaigne shows how the thing he most talks about is the thing he least can encircle: his own self: "If my soul could only find a footing I would not be assaying myself but resolving myself. But my soul is ever in its apprenticeship and being tested."[28] In his *Oration on the Dignity of Man* (1486), the Italian polymath Pico della Mirandola formulated the humanist manifesto of "Man as his own maker"; a century later, Montaigne shows that, this making being interminable, we are therefore permanently *undefined* creatures (not possessed of an essence, as the existentialist would someday say, but of existence): "I am chiefly portraying my ways of thinking," says Montaigne, as "a shapeless subject."[29]

This ebbing of certainties in the intellectual realm was no mere armchair thought experiment; it shaped the scientific, religious, and social life of the nascent historical period and, as it were, colored it in a chiaroscuro of subjectiveness. Much of the sensibility we designate as the Baroque can be understood as the elaborate labor to settle the mind in this new countourless reality.

Nothing

Regensburg, May 8, 1654

This was the day chosen by the German inventor and natural scientist Otto von Guericke (1602–86) to demonstrate before Emperor Ferdinand III the wondrous and mighty property of nothingness. The experiment presented two copper hemispheres the length of a man's arm, brought lip to lip to make an unfastened globe on which Von Guericke mounted a pump. Having sucked the air out, he then harnessed thirty horses, a team of fifteen on either side, to pull in opposite directions. But, marvel of marvels, all that horsepower could not yank the hemispheres apart. This, declared von Guericke to his amazed public, was because the inside was empty—an emptiness that no force less tremendous than twenty-seven hundred pounds could crack open.

Von Guericke was an instant sensation. He upped the antes with sixteen horses in Magdeburg (which promptly gave the name *Magdeburg hemispheres* to the experiment) and with twenty-four horses in Berlin before Friedrich Wilhelm I of Brandenburg. The world was opening its eyes to the tremendous power of nothing—realizing that nothing was, in some mysterious sense, something; not just the absence of objects but a force of its own, a potent lack with the power to bend and shape solid reality. The world was not universally full of Yahweh's "I am that I am"; the scientist could point out pockets of real nonbeing lurking in that fullness. Von Guericke showed that nothingness was not exclusively moral or supernatural, that reports of nature's abhorrence of the void had been overstated, and that it was time to accept the existence

of concrete nonbeing (paradoxical as that may be), which needed to be factored into the mechanics of life.[1]

The very notion fired the scientific imagination: natural philosophers all over Europe began experimenting with vacuum pumps in contempt of Aristotle's denial of the physical existence of emptiness. With a glass tube of mercury, the inventor Evangelista Tonicelli (1608–47) was able to trap some emptiness in a transparent vessel and show it to the world. There was nothing to see in it, but that was the point: nothing could be something to see and acknowledge. Yet if the tube was truly empty, then how could light travel through the test tube at all? The light particles, finding themselves in absolute thin air, with no medium or substance to support their flight, would have to disappear as they crossed the test tube. This was a mystery. And yet, as the scientist and philosopher Blaise Pascal (1623–62) confirmed in his *New Experiments with the Vacuum,* his barometer tube indeed was empty above the column of liquid. The Dutch mathematician Christiaan Huygens (1629–95) cleared some of the mystery in arguing that, though nothing, the vacuum possessed some residual physical properties. For instance, it took up space and, to this extent, was minimally something. Isaac Newton (1643–1727) built on the same idea, arguing that in fact the emptiness in which all things are enmeshed was a substance that, evenly spread out, offered a fixed reference point with respect to which things could be said to stand or move. *Absolute space* was the name he gave to this ubiquitous specter: "Absolute space, in its own nature, without reference to anything external, remains always similar and unmovable," he claimed in the revolutionary *Principia Mathematica* (1687).[2] Vacant space exists everywhere the same: it is a self-founded, self-generating, unalterable constant that, unlike any other entity in the world, needs no support or relation to any other thing to exist.

This was Newton's proposition, and many at the time, including himself, found it hard to accept it: how can an entity with no detectable properties be said to exist? Was not science flirting with mysticism? Newton denied that this was the case. His mechanics of physical bodies worked on the smooth plane of the untraceable nothing; it set down and regulated the place and movement of things. Newtonian physics literally put nothingness to work, and work it did, and indeed still does.

Nor was absolute space mathematically incoherent. Using his "vacuum-in-a-vacuum" experiment, Blaise Pascal was able to prove that total emptiness exerted pressure with a numerical value: zero. This was not much, but at least it could be worked into mathematical equations.

The point was, "nothing" now weighed in on the balance of things.[3] And as a full-time player, it proved surprisingly active. Again, it was Newton who, focusing on the emptiness between things (using, say, a branch, an apple, and the ground), argued that empty space weaves a mesh that pulls at things with invisible strings. *Gravity* (the name by which Newton described this non-thing) operated everywhere and nowhere at once. It carved the shape of waves, hollowed valleys, raised mountains, and traced the course of rivers and planets—hurrying instantaneously through short and vast distances, casually working the divine *actio in distans,* or divine remote control, all the while being nothing—an *enterprising* nothing indeed.[4]

In 1644, the French philosopher and scientist René Descartes (1596–1650) had argued in his *Principia Philosophiae* that bodies can influence one another only through contact (a theory that forced him to posit the existence of an invisible substance, called *aether,* by dint of which objects magnetized and repelled one another). Newton showed that this was not so. "The universe," he wrote in *Principia Mathematica,* "is composed of particles of matter all of which attract each other with a force proportional to the products of their masses and inversely proportional to the square of the distance between them."[5] Emptiness truly was empty, and the celestial bodies did not need aether to cruise. Newton's idea of gravitation turned Descartes's vision on its head: not only did communication between objects not require their touching; in a strange sense, it worked through their *not* touching. The gravitational force worked proportional to distance. Indeed it was the very force of distance itself. That which is not (i.e., absence of contact) is the positive force that pulls the world together and choreographs its internal permutations. In Newton's wondrous mechanical new world, distance (i.e., the negative space between two things) was *full of longing,* of invisible reaching, of self-clinging. If the universe did not fly apart, it was not because it was uniform and monolithic; it was because it throbbed with invisible, passionate attractions.

The theory of a plastic-elastic universe profited from the introduction of calculus. This new mathematical language inspired all major mathematicians of the Baroque period (Galileo, Kepler, Pascal, Huygens, Newton, Leibniz) to shift their attention from the study of solid from Euclid's *Elements of Geometry,* toward an analysis of *processes.* Fluctuations, infinitesimals, oblique forms (such as cycloids, whirls, and parabolas), or objects in motion suddenly occupied the mathematical minds. Early in the century, Descartes and Pierre de Fermat (1601–6

subordinated the study of fixed points to the analysis of coordinates, that is, of the ways in which various velocities relate across a curve of development. Invented separately by Newton and Leibniz (1646–1716), calculus translated the terms of geometry into those of variables: fluents, fluxions, evanescent increments, curves and arabesques that change and stretch over space and time. The slippery rather than the solid, the probable and not the factual, the gaps and not the facts: to the Baroque mind, reality was beginning to look less like a compendium than a moonlit communion of ghosts.

What lurked behind the mathematical language of probabilities and infinitesimals was the naught. Anything that is probable does not exist now. And anything that is infinite cannot de facto be a thing. Infinitesimals were the mathematical language in which the Baroque mind couched its intuition of a leaking, shapeless world. Newton's note on infinitesimals is pure intellectual vertigo: "These ultimate ratios with which the quantities vanish are indeed not ratios of ultimate [i.e., infinitesimal] quantities, but limits to which the ratios of quantities vanishing without limit always approach, to which they may come up more closely than by any given difference but beyond which they can never go."[7] Infinitesimals are not quantities but the limits past which the idea of quantity spirals out of sight. To Newton, the infinite was a kind of numerical slippage at the heart of reality: nature's inability to round up to any assignable quantity. Slipping from the hands of theology and joining scientific terminology, the infinite was turning into a symbol for the endless incompleteness, the imperfectability of the world—to mean not that the world ranks far below God's perfection, but that God himself, should he exist, had not been able to square the numbers at creation time.

This mathematical infinity, of course, was being confirmed by the observations of the new cosmology. In the sixteenth century, Nicholas Copernicus (1473–1543) had ventured that the firmament was in fact incalculably farther than previously thought ("the distance from the earth to the sun is imperceptible in comparison with the height of the firmament").[8] This emboldened the next generation of astronomers, including Galileo (1564–1642), to focus the newly invented telescope deeper into the heavens and by and by to destroy the millennium-old consensus on a finite cosmos. In the intrepidly titled *On the Infinite Universe and Worlds* (1584), Giordano Bruno (1548–1600) asked what would happen to one's hand if one reached through the heavenly vault. To suppose the hand would just vanish was more implausible than the existence of nothingness. "Let the surface be what it will, I must always

put the question: what is beyond?"[9] The universe therefore had to be infinite. Naturally, the old theological order did not pack up and leave. Infinite extension had been anathematized by the papacy in the Condemnation of 1277. The cost of thinking too far beyond the prescribed boundaries was heresy, and Bruno paid with his life for this and other ideas. Still, this did not stop Galileo in December 1609 from training his telescope to the moons of Jupiter, well past the authorized limits, and discovering that the pale shimmer in the night sky (the Milky Way) was actually myriads of stars. Let the Holy Inquisition wreak what it wrought. No reputable scientist or philosopher by the late seventeenth century would stand up for the idea of a closed universe (even Descartes, who argued for a version of the finite universe, was suspected of toadying to the curia). In any case, it was at no great personal risk that Newton could openly declare in 1687 that the only scientifically plausible cosmology was of a universe floating in boundless emptiness.

Less than a century elapsed between Bruno's execution and Newton's sighting of the Milky Way, yet the basic cosmic picture had changed more in this period than at any time over the preceding two millennia. In 1600 Shakespeare could still look up at the night sky and in good conscience see a vault. But let a Pascal or a Spinoza or a Leibniz gaze at the same sky seventy-five years later, and they saw bottomless depths, multiple or "possible" universes, infinite substance. When they looked up, these men saw a frightening lack of specifics. If God was a creator, he indeed was an overly abstract one, a dreamer in the worst possible sense: a maker of airy nothings.

Of course, infinite recess was not a new idea. Scholastics of the Late Middle Ages such as Cusanus, Nicolas d'Oresme, or William of Moerbeke had hinted at the infinity of creation. But in a theocentric culture, the infinite was snugly encircled by the mind of God who ruled it by a moral amd intellectual compass. As Jean de Ripa, a fourteenth-century theologian, wrote, "God is really present in an infinite imaginary vacuum beyond the world."[10] By "imaginary," Ripa means mind based. Conceived as *mental* substance, infinity is a great relief: one can stand assured that, at least in one supreme intelligence, the boundless makes complete and finite sense. It is not, in this sense, infinite.

However, there were problems with this picture: how could one kind of substance (matter) be bounded by an altogether different kind (divine thought)? For the Dutch philosopher Baruch Spinoza (1632–77), this contradiction was too crude to brush over. As he explained in the blazing first section of his *Ethics*, the world and God were necessarily one

and the same infinity. For if the world was other to God, then God was limited in scope. Thus God had to be immanent with world. And since God is infinite, so evidently is the world. No more mind-versus-matter half-baked scheme; no more finite this and infinite that. It was inconceivable for the universe to end (what would it end into?); and this material infinity is what, according to Spinoza, people (not always explicitly) meant by "God."

Spinoza (the "atheist Jew from Amsterdam," as he was called during the Enlightenment) was roundly excommunicated from the synagogue. The charge of atheism was mistaken, but it exemplifies religion's purpose to be, among other things, the maintenance of a finite, home-shaped world. To undermine this assurance was to deny God. And yet: could the Pandora of scientific questioning return to her box? When the church began burning people for their scientific views, it unwittingly gave cosmology a public platform. What we call the Baroque is the intellectual contortions of a society coming to terms with the seepage of infinity into everyday material reality.

In point of fact, it is difficult to call the Baroque a period. In all likelihood it is more the collision of two definite epochs, the late medieval age on one side, and modernity on the other. Feeling the onward pull of modernity, the Baroque is not quite ready to live in a vertiginously indeterminate nature. The door to the old Aristotelian, scholastic worldview is closing, but the warm glow of its domestic interior still exercises a considerable appeal. At the crash point between Medieval and Modern, the Baroque mind cannot choose. It reels and wakes up to the horrific charm of living in a *physically* infinite reality. It leans over the precipice and pulls back. Its psychology, its aesthetic, its sensibility sways to this contrary movement of nearing and resisting the void. The tug of war between the closed universe of religion and the open cosmos of science is what corrugates the restless, worried, contorted forms of Baroque art.

In *Landscape with the Fall of Icarus* (c. 1558) (fig. 11), the Flemish painter Pieter Brueghel (1525–69) gives a picture of this vacillating world. The painting beggars description in part because it stitches together so many conflicting worldviews. On the foreground, a plowman is tilling a field while, farther below, a shepherd tends his flock, and still farther down a fisherman is drawing up his net. In the distance, ships are sailing toward a radiant sunset, and the pinkish gleams of a harbor town can be seen in the faraway. A small splash in the right-hand corner of the painting evokes Icarus crashing into the bay, back from his catastrophic flight. The laborers, however, do not even

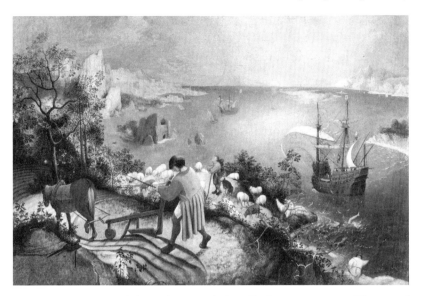

FIGURE 11. Pieter Brueghel, *Landscape with the Fall of Icarus*, 1555–58. Oil on panel transferred to canvas. Courtesy of Art Resource.

look up. Life goes on even after the hero, who sought to see *sub specie soli*, "as the sun sees," crashingly fails. Allegorically, this fall from the sun to the earth narrates the demise of the theological view of life, of the word seen from on high. So, though daily life endures, Icarus's fall does knock the world out of joint. Devoid of a god-center, the new reality flails for coherence, and *Landscape with the Fall of Icarus* indeed presents an odd patchwork of scenes, moods, and vantage points. On the foreground, Brueghel places the pastoral, sentimentally bounded world of medieval miniature to which the Baroque sensibility is still attached; over the humble folk, however, looms the cosmic landscape of scientific exploration. The pastoral scene teeters, dangerously lopsided; it hangs implausibly over vistas of caravels sailing across bewildering bays, past craggy cliffs, under fantastic rock promontories. The painting seems now a map, now a cosmic horizon, now a sea voyage, now a mystical landscape. It does not seem to know whether to look up or down, whether it is a German cosmic worldscape à la Altdorfer, a solar epiphany Grünewald-style, a panoramic hymn to exploration, a stoic farewell to book of hours pastoralism, or a frightened astronomic glance at the earth's curvature. In fact, it is the dislocated sum of all the above: the divine, the cosmic, the human, and the ever-present

temptation to backslide into the safe and homely—altogether a portrait of what it felt like to live at the turning point between the closed universe and the open-ended cosmos.

Another reeling case of the Baroque vertigo is Blaise Pascal—mathematical wunderkind, philosopher, and foremost scientist of the age. Pascal was physically, morbidly tormented by the infinite. To him it was much more than a concept, more than the symbol ∞ just then being adopted by mathematicians. It touched him in a way a poet is touched—down to the root of his being. "What is man in infinity?" he asks.[11] Everything hinged on this question. Pascal lived at the time when telescopes had flung open the limits of the sky and the newly invented microscope unveiled universes in a drop of water. "All things," Pascal reflected, "derive from a void and are swept on to the infinite."[12] The world stretches between two abysses. It is, he says, "an infinite sphere whose center is everywhere and its circumference nowhere"—a phrase previously used by Cusanus to describe God but which Pascal applies to the physical universe.[13] A small difference that makes all the difference: Cusanus's world featured a meaningful center; Pascal's has no necessary center, only contingent ones. It is a matter of complete irrelevance where one happens to be in the cosmos, Pascal realized. Measures of great and small, of far and near, do not obtain in limitless space. With respect to an infinite universe, one is nowhere in particular. "On observing the whole of the silent universe, . . . incapable of all knowledge, I become frightened, like someone taken in his sleep to a terrifying deserted island who wakes up with no knowledge of what has happened, nor means of escape."[14] Agoraphobia swings into claustrophobic panic: the stranded human animal realizes that a physically infinite universe allows no exit. The infinite becomes a terribly confining space, like a deserted island. The mind aches for a place to run to. And yet: what lunatic would complain of finding the infinite too small? It was, for Pascal, abysmally too big: "What is man in infinity? A mid-point between nothing and everything, infinitely far from understanding the extremes . . . , suspended between the two gulfs of the infinite and the void. . . . The eternal silence of these infinite spaces fills me with dread."[15] The vistas were horrifyingly out of human scale. Man needs circum-stances (literally, "surrounding stuff"), a walled-in garden, to thrive. As the astronomer Johannes Kepler (1571–1630) said, "It is not good for the wanderer to stray in that infinity."[16] But the telescope did not lie: God had apparently stranded us in the middle of some formless nowhere—for everywhere *was* nowhere, and the universe was

not anywhere in particular, since indeed it was not located at all. We could be tempted to say that, for the first time, man felt homeless in the world; but the exact phrasing is to say that man then realized there was no such place as home—that the universe was not a place at all. This, for a religious mind like Pascal's, was ghastly.

Compound this utter indeterminacy with the creeping skeptical philosophy of the day, and Pascal had to cope not just with an infinite cosmos outside, but with an infinite mental process inside. Science, Pascal understood, is infinitely perfectible; because the human mind cannot set any objective terms to its subjectivity, we can never be done inquiring: "Every science is infinite in the scope of research. . . . For who cannot see that the principles we claim to be the ultimate ones cannot stand on their own, but depend on others, which are themselves supported by others, so there can be no possibility of an ultimate principle."[17] Whatever intellectual delight knowledge afforded Pascal, it was eclipsed by science's open-endedness. After meeting Pascal, Descartes reported that the unfortunate prodigy had "too much vacuum in his head."[18] And it was not the vacuum that brings mystical succor; it was the void that bedevils—the mental torment described by Christopher Marlowe in his *Tragicall History of Doctor Faustus* (1604):

Hell hath no limits nor is circumscribed
In one self place, but where we are is hell,
And where hell is there must we ever be.[19]

Forget the spikes, thumbscrews, and branding irons: the modern hell is the mind itself, its inability to give itself boundaries and latch onto sure and absolute knowledge. "A wise man sees as much as he ought, not as much as he can," said Montaigne.[20] The Stoic knew when to stop asking questions. But the Baroque mind found it hard to apply intellectual brakes. The scientific method assumes the stressed position of permanent self-guessing—which by and by became synonymous with thinking. The thinking person is a doubting person. On the outside he sees infinite contingency; on the inside, interminable uncertainty. What is he to do? Tremble, says Pascal. "Whoever looks at himself in this way will be terrified by himself, and thinking himself . . . suspended between the two gulfs of the infinite and the void, will tremble."[21] Trembling symbolizes the inner vacillation that is the thinking life. Intensely, absorbedly skeptical, the Baroque mind sets the contours of reality atremble.

So it is in theology. Where encounter with God formerly laid a pilgrimage whose destination, beyond the punishing terrain, was certain,

the Baroque believer sets off on a far more self-searching and solitary path. Now the believer doubts, fears error, and second-guesses his own motives; he trembles on the way to God. Christian belief gets diluted in the solvent of psychological states. Pascal's theological ramblings are less about the nature of God than about the mental condition of the believer. In this, he is preceded by St. Teresa of Avila (1515–82). The end of the journey may be union with God, but St. Teresa tarries in the intimate, physical experience of trembling in the presence of Christ.[22] Her spiritual biography *Vida* (*Life*) filters belief through the language of personal affects and emotive states. Not that spiritual autobiography was a new genre; it is just that St. Teresa upended its direction. In Augustine's *Confessions,* the inner life checks off the formal stages of doctrinal clarification: personality marches in the grooves of theology. With St. Teresa, on the contrary, it is the believer's personal, psychophysical travails and tribulations (acts of oblation, fasting, deprivation, and sleeplessness) that shape the theology. At any moment in St. Teresa's vita, the divine stands to be overshadowed by her contortions, her strenuous ecstasies, her moods.

Individual experience looms large in Baroque religious exercises, whether of the Reformed conviction or in the Counter-Reformation. The Protestant traded the authority of the clergy for his own reading of the personal Bible. The saint of the Counter-Reformation sought unofficial emancipation from the clerical hierarchy in passionate personal exertions of an enthusiastic faith. In the absence of a liturgical road map, the Baroque saint is thrown back on herself and searches for God after her own fashion. The process of approaching God looms larger than God himself, diluting his figure. Where is Christ in the vapors of St. Teresa's quivering lust? His figure trembles—a lover, a mirage, a complicatedly imminent reality, the secular counterpart of which is the tentative reality touched and retouched by the incremental, experimental, second-guessing method of scientific speculation.

The Baroque aesthetic (all spasms and ripples) springs out of this individual recentering. Who or where is God? What is our distance or proximity to him? These are questions that the believer now tackles by means of unguided, often spontaneous do-it-yourself exercises. And God's whereabouts become indistinguishable from these trials of belief and devotion. Take, for example, the spiritual exercises of St. John of the Cross (1542–91). For him, *God* means *encounter with God,* which involves trudging through the solitary night of godlessness. God must be

lost to be found, and lost again after he is found. In geometrical terms, this belief abandons the direct line, the obvious, the straight-to-the-point for the roundabout arabesque. Belief seems to go into a great tremor. And so, too, the physical circumstances and instruments of belief, which, as the flamboyance of Baroque architecture attests, sprouts wild serpentine ornamentation, rivulets of growths, rambunctious putti, flowered corbels that run riot over altars and tombs and baptisteries.

Here the sculptures of Gian Lorenzo Bernini (1598–1680) set a milestone—for example, his *Ecstasy of St. Teresa* (1562), whose form so perfectly understands its subject matter (i.e., the saint in religious rapture) that it overwhelms its devotional purpose. It is all spastic whirls and swags that cascade out of a swooning female, pathological luxuries in marble that make it difficult to distinguish the religious element from the epileptic fit. The saint turns the church into personal theater. Why such emoting? What does it say of a religion when it needs hysterics to impart its message? Religious truth seems less authoritative now that it relies on the vehement protestation of inner belief for its advocacy. A belief that needs such strenuous display is one that no longer comes easy. Perhaps faith no longer springs spontaneously from the heart; it is a hard-won trophy—a labor of internal conquest, wrenched from the teeth of unbelief. If Teresa (or Bernini) believed more readily, she would presumably believe more soberly. The Baroque believer gets to God through the warp of doubt, and it is doubt that buckles the edges and planes, the folds and pleats of the Baroque arabesque.[23]

"Lord, either let me suffer or let me die!" St. Teresa cries out in one of her religious poems. This is not the suffering that God, in his goodness and plenitude, removes; it is the suffering by which God is known. It is, in other words, crucial that God hide and that the believer long and suffer.

If, Lord, Thy love for me is strong,
As this which binds me unto thee
What holds me from Thee, Lord, so long,
What holds Thee, Lord, so long from me?
O soul, what then desirest thou? . . .
What fears can yet assail thee now?
All that I fear is but lose thee.[24]

Teresa recoils from God and asks God why he alienates her so. She will not have him just now yet wonders what is taking him so long to come.

She would surrender if she could: the flesh is ardent but the spirit is meek. She, a Baroque curve of psychological indirection, is ragged with hesitation. The ambivalence she incarnates is now the very stuff of faith, no longer its opposite.

Doubt is inscribed all over Baroque statuary. Methinks it protests too much. All those raptures and convulsions in stone, the rumpled drapery, the spastic grief and billowing bombast are more the symptoms of doubt than those of serene acceptance. Take, for instance, Bernini's *Tomb of Pope Alexander VII* (1678): it all looks as though something just *had* to be made out of nothing, as though the less there is inside, the deeper the doubt, and the vaguer the goal, the louder one proclaims one's faith. If we stop wildly gesturing at God, at the world, will they suddenly vanish? These emotings of faith we understand as an exorcising ritual to conjure away the abyss which, science showed, gapes under every visible thing. Physical reality is hemmed by the void: in a sense, Bernini made visible the scalloped fault line between something and nothing, the cups and bumps of gravity, of the attraction and reaction that delineate bodies.

The void indeed lurks at the heart of the Baroque form, just as its absence produced Classical statuary. A Greco-Roman statue squarely takes possession of space: the *Winged Victory of Samothrace* (third century B.C.E.) spreads her wings and plows ahead with possessive confidence. She conveys the victory of muscular power over the passive stuff of space. Bernini's sculptures, by contrast, speak of a body tussling with invisible forces that pull at the marble. Here space is not a background; it carves the body, digs into it, and the body fights back, desperate to stand its ground because the ground is missing, and reality is not given but constructed. Where doubt lurks, emptiness reigns, and where emptiness rules, the body flounders for existence. Nothingness, death, the infinite, the void close in on man, and it is against them that the Baroque body wrestles its way. Bernini showed the void eating at the human form, digging into it, pulling at it: the human self does not occupy space; it flails at the void, fights it for its right to exist.

Barroco, so the story goes, was the word used by Portuguese artisans to designate the imperfect, uneven pearls that were of lesser use to jewelers. *Imperfection* is just another way of saying *incomplete* and *indirect*. For the Baroque mind, there was no straight path between man and God. Nor is there a straight path between mind and world, argues sixteenth- and seventeenth-century skeptic philosophy.[25] The

world is fraught with subjectivity, and we exist in a fog of our own making (see the discussion of Descartes in chapter 15). But the mood is not triumphantly subjectivistic. Afraid to slip into godless unreality, the Baroque mind equivocates, glances sideways. It takes the elliptical way home because it fears there may be no home to get to, no indisputable terminus to the driving forces of science, philosophy, art, and history.

The pearl of the world's oyster, indeed, is barroca. Teresa's flesh crinkles because the divine can no longer infuse the believer, as when the Holy Spirit fills Mary in Renaissance Annunciation paintings. The mortal flesh balks at this sort of surrender. Flaunting its rapturous sacrifice, the believer underscores that the terms of uniting with the divine do not come cheap. The body must be set upon, violated, pummeled by God because man is born a skeptic and does not easily submit to centralities beyond his own. A sonnet by the English metaphysical poet John Donne (1572–1631) gave a memorable expression to this tortured faith:

> Three person'd God . . .
> That I may rise, and stand, o'erthrow mee, and bend
> Your force, to breake, blowe, burn and make me new.
> I, like an usurpt towne, to another due,
> Labour to admit you, but Oh, to no end . . .
> Divorce mee, untie, or breake that knot againe;
> Take mee to you, imprison mee, for I,
> Except you enthrall mee, never shall be free,
> Nor ever chast, except you ravish mee.[26]

Only by breaking and burglary does the divine gain entrance into the hard-to-crack human shell. But the upshot of this violent rapture is, in the end, that the divine becomes hardly distinguishable from the self-lacerating surrender. We do not receive God; we *produce* God by tearing ourselves open. The passion of belief trumps the object of belief, which is no longer the absolute otherness and externality of God.

A similar twist is found in Pascal. One of his chief arguments *for* Christian belief is that it contradicts reason. Man, he says, should believe the supernatural Jesus of the miracles because it is unbelievable. The very implausibility of a belief argues for its truth. The reasoning is that, since God transcends reason, anything about the scriptures that baffles reason must be of divine origin. As arguments go, this is weak because no belief is ever proven true by being mind-boggling. Of interest is that Pascal equates evidence of truth with reason's masochistic

self-abasement: this is true because it humiliates reason. Violation—the pain of being knocked and mauled by a force superior to the self— which St. Teresa experienced in the flesh, Pascal visits on the mind.

In sum, the human being and God eye each other across the wrestling mat. Between the medieval believer and the divine ran an unbroken bond; it is this continuum that propelled the trustful style of the Gothic. But where man and God stake their separate claims, as they did when scientific reason began to question scriptural authority, the union of intellectual life with God can only be worked out with one of the parties desisting, which, at this moment in the history of secularization, meant the self. This abdication—that is, reason's violation by reason— marks the Baroque stage: "The final step which reason can take," Pascal writes, "is to recognize that there are an infinite number of things which are beyond it. It is merely impotent if it cannot get as far as to realize this."[27] But even here we find a further twist. The medieval mind accepted reason's ineptitude as a matter of course. The Baroque intellect, for one, wants to understand why it cannot understand: "As God is hidden, any religion that does not say that God is hidden is not true, and any religion which does not explain why this is so does not educate."[28] Pious as it is, the feeling really runs against traditional faith, which, as in Aquinas, may seek help from reason but never ultimate justification. This faith is different from Pascal's, who asks religion to come with philosophical recommendations: one must explain why God is mysterious. Whether God's mystery can survive this explanation, Pascal does not say. But it is clear from his *Pensées* that when reason capitulates to faith, it does so not by external compulsion but by identifying where and when it is logical to give in. This means that reason decides what is beyond its grasp. In the end the concession that reason is powerless before God really affirms reason through the backdoor.

This ebb and flow of intellectual affirmation and resignation produces the nervous lunging and retreating plasticity of the Baroque style. The Baroque cannot just run a firm, soaring line. What it thrusts forth with one hand, it yanks back with the other. The visual impression of unfettered exuberance and assertion is mere posturing. Any religious faith that goes to the mat against skepticism cannot be genuinely free. The Baroque intellect understood what silencing of reason goes into religious faith. Aware of this self-mutilation, the Baroque developed a tragic, or at any rate melodramatic, sense of the finite. Its gnarled volumes are the remains of a crash, of liberated momentum (the Renaissance intellectual springtime) that butted headlong into an obstacle (the

Counter-Reformation, the Roman Office of the Inquisition, the flexing of dogmatic intransigence). This crash is the Baroque. The spiral, the curl, the involute—they are the artistic equivalent of an athlete nursing a cramp. The Baroque knew what it could be but did not dare be it. Its look is the fear of freedom.

The taste for temporizing, for ambivalence, for having it both ways (faith *and* reason, God *and* humanism, the closed world *and* the open universe) explains the twilit palette of Baroque painting. Earlier in the period, the painter Pontormo (1494–1557) bathes his scenes in a light veiled in layers of brown fog. Out goes the energetic enamel clarity of Michelangelo and Raphael. And instead, we get the smoky, bizarre, off-kilter world of Tintoretto (1518–94), the chiaroscuro dramatics of Caravaggio (1571–1610), where objects seem to stumble by chance out of inky recesses where they belong. Anything that exists hatches out of its opposite, light out of darkness, energy out of lethargy, belief out of unbelief. Titian's nudes are regular posters of health, whereas Rubens's nudes melt even as they strive to stand up. In music, the fugal style made an art of postponement and sinuosity. In decorative arts, the arabesque superseded the wheel, the vault, and the orb (all symbols of cosmic containment). Unsurprisingly, when astronomer Johannes Kepler worked out the mathematical equations for Copernicus's planetary motions, he found not a ring, but a circle that was not a circle: the ellipse. He had, by his own reckoning, "laid a monstrous egg" because elliptical orbits jarred with the classical and medieval sense of beautiful perfection.[29] Nature was bent; it worked asymmetrically, by approximation. Perhaps the music of the spheres was not particularly melodious; perhaps it was tangential, fugal, all in chromatic half-tones. Some equations, the French mathematician Pierre de Fermat averred, are mathematically coherent yet have no solution: they both are and are not mathematical. To be, or not to be; to be, *and* not to be. In *The Tragedy of Hamlet* Polonius shows it is possible to discourse at great length and say nothing (2.1)—a rhetoric of circumlocution that some decades later would set the fashion at the French court under the name of *preciosity.* A decoction of aristocratic salons, préciosité perfected the art of skirting the point and the rhetoric of hyperbole and understatement to exquisite lengths, demonstrating that the mind was ever more reluctant to reckon with blunt reality perhaps because, as Descartes volunteered, reality never appears but in the mind's eye. Likewise Hamlet's speech postpones, dilates, wanders, puts off until the very end of the play the dynastic duty any other self-respecting prince would have settled in a trice in

the first act. His tragedy is that he (his fertile mind, his soliloquizing imagination, his solipsism) is the only real thing in an unreal world. He does not know how to find his way back to fact: hence his lack of "pith" and "enterprise," his enervated lack of action. He doubts and therefore he is—but his existence hangs by a thread.

It is this thread that, to rescue the Baroque from paralysis, René Descartes spun into a rope, and then a basket, then a vessel of certainty in the otherwise vast, formless world. Through him the Baroque learned to live with itself, and in doing so, inched toward modernity.

Night

Neuberg, November 10, 1619

I was then in Germany, summoned there by the wars which have not yet con-
cluded. As I was returning to the army from the coronation of the emperor,
the onset of winter stopped me in quarters where, not finding any conversa-
tion to divert me and, by good fortune, not having any cares or passions
to trouble me, I spent the entire day closed up alone in a room heated by a
stove, where I had all the leisure to talk to myself about my thoughts.[1]

Withdrawing from society, Descartes thus begins the monologue that
will become modern philosophy. It would be eighteen years before the
philosopher would set in writing the revelation of that fitful night of
November 1619—a dramatic night Jacques Maritain has called Des-
cartes's "Pentecost of Reason."[2] Then, the twenty-three-year-old doubter
envisioned a plan to build sound scientific knowledge—knowledge that
does not derive from received opinion, religious doctrine, tradition,
conjecture, and so the like, but from certainties. What can I be certain
of? Why? What beliefs of mine are indubitable? Descartes believed that
by answering these questions he could cast the bedrock from which to
launch the scientific adventure.

Descartes relates his seminal crisis in his *Discourse on the Method*
(1637). The great revelation, he recollects, followed three dreams. In
one of them, he comes across a book of poetry on which he reads this
line: "What path of life shall I follow?" This is not as innocuous as it
sounds. To begin with, the question implies that the path of life is not

set by family, king, or divine providence. Instead, it arises by personal choice, underwritten by no authority other than one's intelligence. (Descartes, one must recall, dreamed his go-it-alone method in Protestant country.) Life is personal and autobiographic: it has no reality until one sets his mind to make something of it. The staging of Descartes's epiphany (nighttime, solitude, interior) emphasizes this contingent, subjective, inner dimension of experience. The world outside is almost nonexistent, sunk in the darkness of the deep; it is the intellect, resolving to get up and go, that draws it out of formlessness and makes it real.

To elaborate his method, the young thinker shuns the counsel of philosophers and doctors of the church. His first step is to forget everything he has learned and make his mind as pristinely empty as von Guericke's sphere. A Protestantism of the intellect, this emptying-out individualizes knowledge and cut outs the intermediaries. The mind, Descartes insists, is quite capable of thinking very well without knowing, assuming, or even thinking about anything at all. It casts its own light, and this light is fed by nothing but its own inner fire, a *lumens naturale,* or "natural light," that outshines any other source of light.

The quest for certainty justifies this great housecleaning: beliefs, Descartes argues, often bear us false; the senses play tricks on us, and facts are open to interpretation, correction, and so forth. The philosopher must therefore jettison all acquired material, including belief in the existence of the world, even belief in his own person. What remains after everything is chucked out? Almost nothing, Descartes admits. But nothing is not no-thing. It, like the "darkness upon the face of the deep" of Genesis, is a tremendous source of reality. A person without any belief at all, even the belief that she is the person she thinks she is, cannot drop the belief that mental activity is going on whilst it is busy throwing off ballast. In doubting everything, Descartes discovers, I cannot doubt that I am doubting. The only certainty is that I (whoever this beast may turn out to be) am thinking; and if I am thinking, it means that I am something rather than nothing; hence, I exist. Cogito, ergo sum.

Self-certainty, however, is not a fact but a kind of *nothingness.* As Descartes discovers, "From the fact that I thought to doubt of the truth of other things, it followed very evidently that I was; while if I had only ceased to think, although all else which I had previously imagined had been true I had no reason to believe that I might have been, therefore I knew that I was a substance whose essence or nature is only to think and which, in order to be, has no need of any place, and depends on no material thing."[3] What matters for our purposes is not whether the

reasoning is correct (it is not) but the worldview it implies. Descartes reasons that he could be wrong in the belief that he has two hands, is French, or has a daughter named Francine, but he cannot be wrong in the belief that he is thinking those things. Having a body is a piece of data one may be incorrect about, but *entertaining* this doubt is a mental event that assumes the existence of thinking. Hence, Descartes concludes, the self exists primarily as thought. (Descartes's misstep is to think that, just because a thing's existence can be indubitably established only by thought, it follows that that thing is thought-like in essence.)

And so Descartes spirits the self into thin air. Just as experimenters worked their vacuum pumps to prove the life-giving activity of the void, the self became a nothingness that thinks itself and the world into existence. Von Guericke and Newton pointed at the surrounding emptiness and claimed it was the cement holding the universe together. Descartes meanwhile argued that the mind was the emptiness that constitutes reality. As in Genesis, the world comes out of no-thing. In the beginning was the word, and the word by definition stands for the absent thing.

Of course, Descartes's idea of the insubstantial self connects with a commonplace mental experience. Can consciousness observe itself whole? Evidently not: as soon I think back on myself, a part of me (the observer) steps aside to look at the "observed." And when the mind tries to catch a sight of this observer, lo! it creates another observer who steps backward: the observer is never observed. What I wanted to grasp as a thing known (an object) actually does the knowing (a subject). It is never as an *I* that I know myself—only as a *he* or *she*. Which means that I never *know* myself as subject, only as object. But since the essence of subject is subjectivity, then it follows I never know myself. This discovery of the ungraspable self conforms with the Baroque reversibility of darkness and light. For the self is, in Descartes's view, unquestionably a source of light. Only this *lumens naturale,* the natural light of reason, shines out of a well of darkness. The self is chiaroscuro: its radiance is born of darkness, and its darkness sheds light on the world.

"Like a man who walks alone and in darkness," says Descartes, "I resolved to go so slowly, and to use so much circumspection in everything, that if I did not advance speedily, at least I should keep from falling."[4] The Baroque mind needs darkness to see light; needs to get lost to find the path; needs to loiter to hit the bull's eye. The trial by darkness is crucial. Descartes carves light out of the surrounding darkness, certainty out of doubt, the solid out of the inchoate—a philosophical analogue

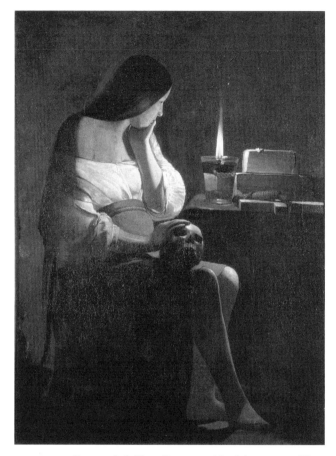

FIGURE 12. Georges de la Tour, *Repentant Magdalene*, 1643. Oil on canvas. Courtesy of Art Resource.

of the painter Georges de la Tour's shadow-theater world (1593–1652) where the human figure is a mere flicker between existence and the void. In *Repentant Magdalene* (1643) (fig. 12), the courtesan holds a skull in her lap, a reminder of the nullity at the heart of being, and it is the same ontological hollow that in-sculpts the folds of her red frock. Her candlelit face seems on furlough from the void, and it looks as though the candle flame could snap the whole world back into darkness at any moment. The difference between life and death hangs on a blink. Any second now, reality may tip from being to nonbeing and back.

In dialectical thought, as in chiaroscuro painting, everything is conditioned by its opposite. Descartes establishes clear reality by detouring

through the nothingness of doubt. The positive borrows its essence from the negative. It is a convoluted mind (a mind entranced by contortion) that arrives at the existence of one thing by affirming what it is not. Each entity is what others are not, and is not what other entities are. Thus Descartes's proof of his own existence: I know that I exist because I am justified in doubting that anything else exists. I clearly conceive that the world lies beyond the reach of my perceptual horizon, and therefore I exist: in other words, I have form because the rest is very much formless.

As philosophers made this mental journey into the formless, nighttime descended on European art. The cobalt skies of the Italian Renaissance blurred and dimmed their naïve bright sheen, and instead, moonlit, murky, off-centered scenes spread over the painted landscapes of Tintoretto, enigmatic scenes that hang ajar, experiments in half-tones; Caravaggio's indoor world of doubting Thomases, and the solar eclipse atmospheres of El Greco (1541–1614), whose glinting figures ooze blackness—not muddy or dull blackness, but a sharp, radiating lacquer of pitch: nothingness visible, nothingness spawning worlds. Light is the child of darkness, as belief is the child of doubt, as knowledge is begotten of skepticism.

We also find the thrill of the night in the seventeenth-century craze for midnight masquerades and pageantries, fireworks, blindfold capers, mazes, and magic shows.[5] The Baroque mind thrills at frustrated knowledge. There is scarcely a play of Shakespeare's in which the pivotal episode does not occur at night or involve hallucination or madness (Hamlet and the ghost, Macbeth and the dagger, Lear on the heath, the whole of A Midsummer Night's Dream). The darkened chamber, the crypt, the benighted heath, the abysmal graveyard—the very things that in Dante's days would cause barren horror now fire the imagination. Everything lovely about Juliet derives from the masquerade and moonlit garden that are her natural element (whereas everything lovely about Beatrice, Dante's egeria, concentrates in the eye-piercing brightness of her face). The French aphorist La Rochefoucauld (1613–80) compared death to the sun.[6] What was once regarded as the symbol of truth, evidence, and goodness now metes out extinction. For once the truth is spoken, there is nothing left to say, whereas what the Baroque mind wants above all is to go on rambling. It needs the darkness to think, and imprecision is literally its lifeblood. In a sense, Caravaggio's doubting Thomases and hesitating Matthews really struggle for the faith. His Paul on the road to Damascus may look like an epileptic youth; he may

have his eyes closed to the divine light. But this is because light kills doubt, and there is no faith that is not apoplectically given to doubt.

Thus the je ne sais quoi, *il pico piú*, the "undefinable something," an expression that people of taste in the seventeenth century append to anything refined and worthwhile.[7] Nothing, Leibniz argued, can genuinely please that lacks the confused knowledge of "something, I know not what."[8] What provides complete spiritual satisfaction eludes definition. Without some je ne sais quoi, the world is static, airless. Life needs room to bloom: the je ne sais quoi gives that leeway of indeterminacy and volume, the darkness that magnifies. Having meditated reality into nonexistence, Descartes in his solitary retreat gains all the room in the world to declare the thinking self a kind of je ne sais quoi, a stream that cannot objectify itself, a hidden recess that is and is not at the same time.

Descartes takes his meditation to the brink of solipsism, feels the thrill of unfettered subjectivity; then, in a typically Baroque move, he pulls back from the precipice. It cannot be, he observes in the "Third Meditation," that reality exists solely in his mental construct. For were his mind to contain reality, there would be nothing he could fail to know: "Were I myself the author of my being, I should doubt nothing and I should desire nothing, and finally no perfection would be lacking to me; for I should have bestowed on myself every perfection of which I possessed any idea and should thus be God."[9] But whence comes the idea of that I am lacking in perfection? A perfectly solipsistic creature would be, like the inmate of a dream, unaware of its self-imposed captivity. Whereas, "when I reflect on myself," Descartes says, "I know that I am something incomplete and dependent on another, and which incessantly aspires after something which is better and greater than myself."[10] What is the inner power that allows the mind to see itself as a limited whole? Why, in sum, do we perceive horizons?

Descartes's explanation is not altogether satisfactory but at least averts the inward free fall of solipsism. His reasoning is enough to prove that Descartes is not God and that a world exists outside his mind; but does it prove that God exists? To clinch this point, Descartes has recourse to a variation on Anselm's ontological proof (see chapter 10). Among the ideas I carry around in my head, says Descartes, is that of the infinite. But how comes it that I, a creature finite in apprehension, know of the infinite? And how, to start with, do I know my knowledge is finite? Why is the horizon of my knowledge not perfectly self-contained? Why is the horizon of our knowledge also a knowledge

of the horizon—that is, an awareness that there is something beyond the current frontier of cognition? Descartes's answer basically says that man knows he is cognitively imperfect not because past experiences tell him so, but the reverse: it is because man innately knows he is imperfect that he seeks knowledge. The idea of progressing toward a perfectible view of reality would never occur to us unless there dwelt in us an a priori idea of perfection. The *experience* of perfecting oneself is made possible by the primordial *notion* of the perfect. But since the imperfect cannot beget the idea or ideal of the perfect, something that is perfect must have placed it there. And this something, Descartes maintains, is God.

Perhaps we can gloss it thus: I am a finite being who intuits something too great for his understanding. But how can I, being finite, harbor a notion of infinity? If I have the idea of something I cannot comprehend, then clearly this idea does not come from me. For I can only think things I understand; to think the incomprehensible means that the self is teased by a force greater than its own intelligence, that the mind is therefore picklocked by the divine. Our horizon is not hermetic; this is why we orient ourselves toward the outside. This turn comes from beyond the horizon, not from us.

Through this reasoning, Descartes saved himself, and us, from a hopelessly locked-in, human-shaped world. Thanks to this reasoning, he maintained the sense that human life is oriented toward a transcendental destination. The danger was an infinite self (unable to jump out of its subjective ring); the solution was an infinite God imparting the knowledge of our limitedness.

But things are not so simple. In reality, Descartes reestablishes the finite self by wishful thinking rather than sound philosophy. Descartes's reasoning hides a paradox: subjectivity is limited because it has intuition of the unlimited. It is because the self entertains the idea of the infinite that it knows it is finite. Consciousness gains awareness of its limitation from the infinite that somehow dwells within. Had solipsism been clearly averted?

Voices of the imagination were quick in relaying this atmosphere of subjectivity out of bounds. Literature tested its active presence, often to tragic-comedic effects, as in the quintessentially Baroque *Don Quixote* (1605).[11] The dramatic force of Cervantes's mock romance hangs on a character (the deranged Quixote) who heroically maintains the truth of his hallucinations in the face of objective reproof. His is a mind that will

not bow to the reality principle. Reality wins out in the end, of course, and the dying Quixote admits his delusion and adjusts his perception to that of society. The ultimate lesson, however, is that the world is badly stitched up in clashing viewpoints, and that each person is bound by his or her subjectivity. Sancho Panza will never see as Don Quixote sees the world; through them, the reader experiences both the captivity, not just of madness, but of sanity too. Our inability to hook our worldview onto Quixote's testifies to his alienation as much as ours. Being an *I* is saddled with the poignant realization of the mutual isolation of selves. The same is true of the other great masterpiece of Baroque literature, *The Tragedy of Hamlet* (1601). Shakespeare took up the potboiler Jacobean plot of revenge and spun it into a drama of a mind crippled with self-doubt. The prince hesitates, tries on masks (rogue, lover, actor, son, madman), finds out that none fits, ponders awesome philosophic questions, and finally dies, fulfilling his avenging duty almost inadvertently. Hamlet is too busy thinking about what to do and who to become to be someone in particular. He is infinite mind ("What a piece of work is a man! how noble in reason! how infinite in faculty! in apprehension how like a god!" [2.2]), floundering for a foothold in the finite world. In the end, he has nothing but his rambling script, his monologue, to bequeath. ("Tell my story" are his dying words to Horatio: he knows his existence holds only in words, in his tremendous world-making eloquence.)[12] All of Shakespeare's towering characters (Lear, Othello, Macbeth, Hamlet) have a scrape with madness or suffer the obduracy of their own mind.[13] *Hamlet* stretches this episodic motif to the very length of the play so that *The Tragedy of Hamlet* is really Hamlet himself, his incurable inwardness.

The momentum in gothic and Renaissance art was outward-bound. The great cathedral apotheosized the soaring élan, and the Renaissance landscape boomed with exploration. Common to both epochs was the assumption that a work of art throws a bridge between perception and the perceived. But the Baroque is not sure about the mind's outwardness; so it coils inward. Out go the stained-glass facades and the floating tracery of Gothic churches; the flying buttress is rolled back in. Instead, comes a bizarre preference for dark, thickly adorned, theatrical interiors heavy on enclosure and make-believe. Baroque interiors are padded with pilasters, loaded with plaster cascades of stucco angels, cherubs, corbels, knobby pendentives. Windows were banished to upper-story skylights that convert the chance sun-shaft into a decorative effect, a spotlight in the service of this or that dramatic "angle." Everything in the Baroque church, palace, or library (a new must-have of stately

homes and monasteries) lures the eye *intra muros*, into the deliciously half-lit oyster shell. To step into the Benedictine Abbey Church (1691) in Einsiedeln or into the St. Nicholas Cathedral (1702) in Prague is like entering an elaborate tableau—so complete is the impression that every element has been designed to dissemble, to bedazzle, to symbolize, to charm, to ward off contact with hard objective reality. The same principle underpins the gorgeously trompe l'oeil ceilings of Giovanni Battista Gaulli (1639–1709) and Andrea dal Pozzo (1642–1709). Art and decoration had not rubbed shoulders so closely since Michelangelo worked to disunite them. Their common enemy is prosaic utility. Decoration is not a means but the end of Baroque architecture. The contrast between the painted ceilings of Renaissance artists such as Michelangelo or Raphael and those of Baroque mural painters such as Guercino, Guido Reni, or Pozzo is telling: with his church fresco, the Renaissance artist exalted a place of worship. Art was still understood as servant to God. Pozzo or Guercino, by contrast, are concerned with glorifying the work of art, the delight of illusion. Far from playing servant to the liturgy, the fresco enchants it away from its religious source and transforms it into pure theater, in whirls of trompe l'oeil where impression supersedes fact to impart this one idea: reality is not a self-begotten fact but the child of mind. The church ceiling apotheoses (of Romulus, the Virgin, St. Dominic, or St. Ignatius Loyola) of the Baroque period are really apotheoses of the mind triumphant.

A trompe l'oeil ceiling takes vision through three steps: first, we look at a ceiling; second, we notice it masquerading as a sky, which, by trying to make us forget the ceiling, thirdly impresses upon us the fact that it is a ceiling. The unbounded springs out of the bounded. And the bounded knows it is bounded by harboring the image of the infinite, just as in the Cartesian dialectic. "O God, I could be bounded in a nutshell and count myself a king of infinite space," says Hamlet (2.2): where outer reality is swallowed by the imagination, a nutshell is all that's needed to simulate a universe. For the infinite is a conceit of the mind, as the Baroque cupola folds the outer into the inner.

Even when it turns to landscape, Baroque painting serves a universe the size of the brain. The skeptical dictum that there is no breaking through to the other side of perception, hence that all depiction is really interpretation, soaks the landscape in an indoor light. The Flemish countryside seen by Rembrandt (1606–69) is as sepia toned as the lamp-lit cabinet wherein he worked; as for Rubens (1577–1640), his trees and fields are there to serve the stylistic meanderings of a fevered

brush that reinterprets everything after its own nervous energy. Facts are seen in terms of the perception that muscles through them. The sensuousness of reality—the human worm trail through it—is also what we glimpse in El Greco. His lanky saints strain rapturously toward heaven, but their very elongation, mannered and tortured, staves off contact with the transcendent. They are too busy stretching to heaven to reach heaven, in which, perhaps, they do not wholly believe—not, at any rate, as a place that exists independently of the nervous endeavor. Even Ruisdael (1628–82), one of the few genuine Baroque landscape artists, dresses his horizons in theatrical cloudscapes that hustle the immensity off behind bunches of playhouse curtains. The same is true of El Greco's famous *View of Toledo* (1597), where the sky endomes the world like a painted apse, a frescoed vault speaking of an artist who wished to paint his way to God but whose mad longing somehow threw the momentum into a spin.

Life is emoting action, movement, muscular strain. Space does not exist independently of gesture and effort: this too is the mindset that underpins the science of Newton, Spinoza, Leibniz, or Pascal. "Moving is the definition of life," the Spanish writer Gracián insisted. Spinoza coined a concept, the *conatus*, to convey his very Baroque intuition that life gamely entails exertion, that any living thing "endeavors to persist in its own being," and that such endeavor is in fact "the actual essence of the thing."[14] Life, in other words, is not patient or passive; any existent *seeks* to be, strains on the way to existence. This is another way of saying that everything gives birth to itself—as Descartes does in his meditation, as Hamlet does through in his self-questioning. His identity, a *conatus* in human form, is the process of working itself out—as it happens, for naught.

Life-as-strain correlates with the denial of self-given space. This denial posed interesting problems to sculpture. Where space is thought to be a by-product of movement, the body has to create the surroundings in which it moves. This paradox accounts for the muscular strenuousness of Baroque statuaries. Bernini's sculptures are of bodies that wrestle the void for every inch of their physical existence. His figures wring themselves alive out of the raw uncut stone, their every sinew clamoring to break free, as on the *Triton Fountain* in Rome (1643) or the *Fountain of the Four Rivers* (1651): the four titans heave themselves alive, their existence rolled up in the exertion they are able to muster. A horse bucks forward, muscles bulging, mouth chomping at the air. Either one is frenziedly alive, desperate against the void, or one simply is not. Newton unveiled

a world in which every particle of matter is possessed with gravity (the power to attract other bodies) and inertia (the power to resist intervening change). Every object thus wants to move other objects and not to be moved by them. Existence is struggle, and motion, its application.[15] Everything strives to push or be pushed aside in Bernini's theater of tussle. Proserpina wrangles herself free of her assailant (*The Rape of Proserpina,* 1622), Daphne pushes off Apollo (*Apollo and Daphne,* 1625), and his St. Jerome clutches the crucifix with manic hungriness. The Baroque body pulls or is pulled, grips or is gripped. Bernini was much praised for his mastery of the plastic, almost pneumatic elasticity of the flesh, in showing how a hand (say, the rapist's) digs into the flesh of his victim. Form is the clash of gravitational masses, and space their arena. Life is a race for spatial domination that throws all measure, all aesthetic balance into nonstop touch-and-go. A Baroque statue is nothing if not, on the whole, nervously off-balance.

Again, this sets a sharp contrast with Classical and Renaissance standards. Take Michelangelo's *The Dying Slave* (1516). The youth clearly has not spent his life fighting nature or God for a space of his own. He dies as he has lived, in harmony with his surroundings. The same is true for his famous *David* (1504). Here is a young man who does not need to emote to prove that he exists; his very form proclaims it. Whereas, without its glowering gymnastics, we fear Bernini's *David* (1624) will slump to the ground. Likewise Rubens's figures. Even when nude, his bodies are never really naked. They are girded up in their muscles and dimples, armored up to the hilt in their nervous sinuosity. Even in death, the Christ of the *Descent from the Cross* (1614) frets and flexes and endeavors to persist in his deadness more stubbornly than the liveliest Renaissance statue ever clung to life. Here is a Christ for whom, evidently, being dead was no cause for lethargy.

But the core message of all this Baroque curving and snaking is the urgency of postponement. Sinuosity signals both momentum and protraction. Historically, it signals an intellect emboldened by science, reason, and social optimism; yet this intellect also balks at the void opened by its creative freedom. It is intrepid and timorous at once and, like Hamlet, seems not to want what it seeks, to be and not to be, to play for time. This spirit of temporal dilution is best evidenced in the narrative arts where, in literature and theater, the plot twist becomes relished for its own sake, not as it furthers the plot, but as it delays, scrambles, and soon replaces it: Lope de Vega, Corneille, and Calderón are masters of the plot twist, and d'Urfé's novel *Astrée* (1607–27) is an exercise in

narrative (and publishing) dilation. But it is Shakespeare who, in *Hamlet*, managed to protract the plot without any twist at all, simply and unabashedly making postponement the subject of the play. In society, temporal dilution produced its own argot, known in the France of Louis XIII as *préciosité*, which embodied the art of circumlocution—of not directly saying what one means—to spectacularly silly effect.

Sinuosity of course was best expressed in music, to which the Baroque contributed the fugue. At first blush, the fugue only seems to amplify the medieval form known as the canon. But the canon was all about creating *volume* by spacing the melody in time, speed, and pitch. In contrast, the fugue seeks less to open up a sonic space than (as per its name) to *escape*, to slip away from the base melody, to veer into side themes that play catch-up or hide-and-seek with the melodic line. The aim, if one can call it that, is never to end, to always start anew, and to postpone the eventual lapse into silence.

Why does the Baroque mind spend so much time postponing? Why labyrinths, curves, and detours? Why does Hamlet spend the duration of his play not making up his mind? Why put off the point?

> To die, to sleep.
> To sleep, perchance to dream—ay, there's the rub,
> For in that sleep of death what dreams may come
> When we have shuffled off this mortal coil,
> Must give us pause. There's the respect
> That makes calamity of so long life. (*Hamlet* 3.1)

In short, better to wait than find out, for the outcome is unsure. Or, as Shakespeare suggests, the afterlife may turn out to be an eternity of mind-made conceits, "dreams," that is, the very sort of mental monologue in which Hamlet is already caught up in life. "Dreams" indeed do not sound like a genuine exit from human existence. Not wanting to delve too far into this hideous possibility, not daring to establish what it has begun to suspect, the Baroque mind delays in darkness: Hamlet dawdles in word games, artists corrugate the straight line into delaying arabesques, musicians swap the canon for the fugue, and sculptors punched and harassed the Olympian pose to produce sculptured spasms. Behind these patterns of sinuosity looms a common existential terror: the fear of finding there is nothing to find at the end.

As the historian Philippe Ariès argued in his landmark study, it was during the period spanning the late Renaissance and the Baroque that,

along with individualism, there came a new apprehension for death—
now less a social and religious rite of passage and more, increasingly,
the mysterious "undiscover'd country from whose bourn no traveler
returns."[16] Death always grows more mysterious the farther it is removed
from the setting of collective liturgy and ritual. No single person ever
returns from death. It is a subject about which, if he abstracts himself
from the church or from social credence and myth, man knows nothing
about. Alone and silent before death, the Baroque individual faced a void
whose reality began tormenting him like no other time in literate history.

The Baroque was the first historical period that used the word *modern*
to distinguish itself from earlier times. But *modern* in the language of
seventeenth-century thought did not mean technical progress or ratio-
nal inquiry. *Modern* meant "belated" or "informed by the cumulative
knowledge of the ages." In *A Digression on the Ancients and Moderns*,
the French writer Fontenelle (1657–1757) argued that the moderns sur-
passed the ancients, not because they were organically or essentially bet-
ter or brighter, but simply because the moderns came after the ancients
and therefore could build on their knowledge (the reverse is plainly
impossible). Fontenelle's point was that as soon as we are aware of the
historical past, we cannot *not* improve on it. Progress is unavoidable
because it is in the latecomer's nature to know more than a forerunner.
But progress also means that we know where we come from but not
where we are going. We know who we have been, not what we are to be.
And with half of the picture missing, as it were, human identity hangs
on the brink.

One cannot overemphasize the moral earthquake caused by this per-
ception.[17] It started the cycle of cultural and political upheavals that
have shaken the Western world since the seventeenth century. The idea
that we are sentenced to the future (as one heads for a cliff or a gold
mine) sustained the Enlightenment credo of boundless progress. It is
then that a truly hands-on managerial notion of progress really took
hold, and in so doing calmed the Baroque jitters. In the explicitly titled
Outline of an Historical Picture of the Progress of the Human Mind
(1795), the Marquis de Condorcet (1743–94) popularized the horizon-
shaped sense of existence and summarized the conviction, shared by the
Encyclopédistes and by Kant and Hume, that nature had assigned no
limit to human development. "The perfectibility of man . . . has no other
limit than the duration of the globe on which nature has placed us,"
de Condorcet declared.[18] Now this idea so deeply underpins modern

consciousness that we forget the jolt it once delivered, that is, the implication that neither nature nor God exercise a veto on human development. A built-in valve of our mental apparatus tells us where and when to stop, and this valve has a way of tolerating more and more pressure and sustaining higher and higher levels of output. Here, perhaps, was the perpetual motion machine dreamed of by seventeenth-century mechanical science. The principle of an ending is foreign to knowledge and society. The human world weaves and unweaves itself, like Rubens's tremulous meandering flesh or like the braided piers of Bernini's baldachin in St. Peter's.

Naturally, given its indefinite size, the future is always bound to dwarf past achievements. What a society can be is infinitely larger than what it has been. The same is true for the storehouse of what can be but is not yet known. Isaac Newton's confession, made shortly before his death, evokes this forward immensity. "As to myself, I seem to have been only like a boy playing on the seashore, and diverting myself in now and then finding a smoother pebble or a prettier shell than ordinary, whilst the great ocean of truth lay all undiscovered before me."[19]

Newton felt he ended his life an ignorant man. But equally ignorant is whoever becomes a votary of progress. Cumulative knowledge creates a void ahead of itself. A future-shaped world is fundamentally shapeless. The spiral, the serpentine, the scalloped line—all that Baroque waffle and ruffle signals a moment in history when the mind awoke to this new reality, a moment when man faced himself as pure possibility, as invention-in-progress. The slide between what-is and what-can-be follows no established law, and human nature is not a nature at all, set down by a divine artificer, but an ongoing "I think, therefore I am": it is intellection producing substance, a search producing the searched. Then intelligence began seeing in the horizon not a foreglimpse of the transcendental beyond, but a realization that such a grandiose destination had always been a mirage of the imagination.

How to live with this realization was a labor that befell those who, following the Baroque period, relinquished the idea of a transcendental objective destination. But unlike its Baroque and Neoclassical forebears, the new generation was not content to stifle their skepticism. Its story is the subject of the following chapters.

The Subjective Age

Formless

Königsberg, 1780

A story holds that, after listening to a composition by Ludwig von Beethoven (1770–1827), Joseph Haydn (1732–1809) concluded that such music had sprung from the mind of an atheist.[1] Theological listening sounds puzzling to our modern ears; in the intellectual context of eighteenth-century deism, however, the claim is not devoid of sense. Music obeys an internally coherent language, a ratio—not unlike, as the Enlightenment *philosophes* saw it, the created world which evidenced a kind of clockwork, like a music box, a harmonious piece of machinery. Most of the eighteenth-century intelligentsia had stopped praying to the peevish, capricious god of the Old Testament. The Enlightenment had fashioned a theology in keeping with what it believed to be the rational, mechanical nature of reality. Known as *deism*, this theology of God-as-nature underwrites Haydn's remark. Where God is synonymous with rational order, atheism is analogous to contingency. To Haydn's ear, young Beethoven's music sounded erratic and distempered. Where was the unity, purpose, pattern, and sense of harmonizing with a larger reality? To Haydn, it sounded like a brilliant stampede of erratic notes, fits and starts, booms and whimpers: not the building blocks of an universe legislated by Euclid and Aristotle, but of a creator who severally changes his mind, forgets his point, mislays his formulas, and succumbs to vague, manic ups and downs. No one who believes in a natural order—so Haydn must have thought—could have created *that*.

And there is something to be said for this judgment. Beethoven's compositions, particularly the late ones, do brush with chaos. The melody surges and dips, the stream revolves into eddies, blares out "anthems of indefinite music," as R.W. Emerson put it.[2] From the twelfth-century Gregorian plainsong to the great Bach sonatas, European music was firmly wedded to the principle of melodic development.[3] Listening to the Toccata and Fugue in D Minor, it is easy to visualize a sonic ribbon winding toward a foretold end. Though it splits in tributaries, the current always subsides neatly back to its banks. But not Beethoven: there the listener finds no river but swells and rapids, tumbling one over the other, temperamental, unschooled. He begins themes the better, it seems, to run riot over them, disfigure and restitute them in quick turnaround. In his treatise *De Musica,* the sixth-century philosopher Boethius set down that the essence of music was harmony, a concept with applications well beyond the music room. Underpinning this central notion of harmony were certain prevailing ideas about the cosmos, the so-called music of the spheres, the divine chorus, and so forth. A harmonious piece of music was harmonious precisely for playing in tune and in rhythm with God's creation. Yet it is this very tuneful agreement that Beethoven had begun to tamper with. Driven by a perverse willfulness, Beethoven's music appeared to satisfy itself alone, its mood, its psychological torrent. Listening to the *Waldstein* Sonata, one can hear the music making up its mind which way to go. Strung in hesitant pauses, it seemed poised to strike in any direction at any moment. As creations go, it wallowed too delightfully in its own contingency.

At the heart of sacred and Baroque music was the liturgy, the ballet, the masque, the dance—social forms that set limits to where the music could go. The Romantic symphony, by contrast, recognized no master but itself. Its raison d'être was not to adorn or consecrate the world but to replace it. This was particularly true of Beethoven, who, the German Romantic writer E.T.A. Hoffmann (1776–1822) believed, had invented the first genuinely independent musical form, indeed the first autonomous work of art—one that illustrated or endorsed no idea, system of beliefs, or institutions other than itself. "It is," he says of music, "the most romantic of all the arts—one might almost say, the only genuinely romantic one—for its sole subject is the infinite."[4] The infinite that Hoffmann had in mind was that of inner feeling. As Haydn might have said: this new music does not believe in external reality, in causality, in connecting what has been with what will necessarily be. It believes only

in the present of expression. It believes in itself above all, and this is why it does not believe in God.

As it happens, Beethoven was not an atheist, though his notebooks speak of a God distinctively not from the Christian mold. As he confides, "God is immaterial; since he is invisible he can have no form. . . . His spirit is enwrapped in himself. He, the mighty one, is present in every part of space—his omniscience is in spirit by himself and the conception of him comprehends every other one. . . . For it there is no threefold existence. It is independent of everything."⁵ Beethoven's Vedic-inspired vision is of the formless Being inside all beings, the life force, the shoreless flux of life. The Romantic philosopher Arthur Schopenhauer (1788–1860) believed that music, especially Beethoven's, was of all the arts the best suited to convey this universal stream. For music does not represent thoughts or objects. Rather than parse and explain, it beats to the tumult beneath our conceptual mat—the magma under the harlequin floor. Schopenhauer thought that Beethoven even intensified the indefinite character of music. If the work of art was to imitate nature, then it ought to be proximately shapeless, which is the state in which (to Haydn's dismay and admiration) Beethoven threw musical expression: art without boundaries, or, as Beethoven said of God, "self-enwrapped" and "independent of everything."⁶ "Beethoven's instrumental music," Hoffmann insisted, "opens up to us the realm of the monstrous and the immeasurable, . . . sets in motion the lever of fear, of awe, of horror, of suffering, and wakens just that infinite longing which is the essence of romanticism."⁷

The new word, *Romanticism,* was out. Artists are beholden to no reality other than their own thoughts and feelings, which, without a rulebook, thunder on indefinitely, entranced by their own singing.

Paintings offer a tangible record of this transition from the Classical (objectively-minded, contained, teleological) to the Romantic (self-guided, inward-looking, fitful). We see this in the theme of "voyage to distant lands" as it changes from Claude Lorrain (1600–82) to Jean-Antoine Watteau (1684–1721). The first painter epitomizes the epic-teleological soul of seventeenth-century Classicism; the second hails from the Rococo period, which, in the early eighteenth century, saw the slackening of theological tensions and a general easing into worldly consolations.

Purpose and tension rule Lorrain's *Embarkation of the Queen of Sheba* (1648): a Greco-Roman seaport lined with temple facades and high embankments open out toward the sun-shot distance. The limpid majesty, the harmonic convergence, the perspective—everything

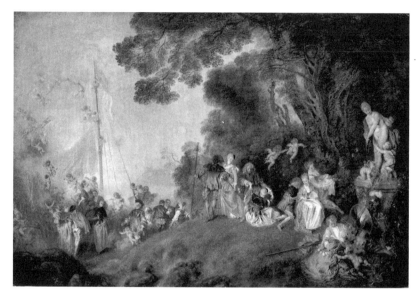

FIGURE 13. Jean-Antoine Watteau, *The Embarkment to Cythera*, 1717. Oil on canvas. Courtesy of Art Resource.

proclaims faith in destiny and destination. The setting is august, the mood, prophetic. The vista celebrates stone-paved transcendence, earthly life bathed in futurity, where "here" guarantees safe conduct to the ultimate and definite "there."

Contrast this with Watteau's variation on the theme, *Embarkment to Cythera* (Louvre version, 1717) (fig. 13). Something has grown nebulous around the idea of appointed tomorrows. Gone is the booming call of distance; gone is the skyward momentum, the leap into the eternal. Watteau's attention dawdles in the here and now-worldly; his watery, languid brushstroke risks nothing by way of statement or promise. The atmosphere mists over in Giorgione greens and browns; the mood is autumnal, epicurean, bucolic, unheroic. A strange embarkation it is, too, as it features no vessel, no sea to speak of, and no light to indicate where the sun is headed. A cottony haze drifts over amorous couples who saunter here and there, creatures of an idyll given to decorous pleasures, unashamed of their limited ambition. There is no grand Gothic scheme of salvation, no muscular doubt or Baroque-style nervousness. The Baroque flourished in a society still anchored in the institutions of court and church, both brimful of vertical metaphors. Whereas the eighteenth century saw the victory of a new social reality, driven by the

middle class, that harkened to a stoutly domestic ideal of life—an ideal less about transcendence than about coping with the material concerns of life how to implement marital harmony, family, prosperity, friendship, and happiness in everyday life. Watteau bids a melancholic farewell to the heroic courtly society. If there is an island of Cythera, we are quite sure none of the figures have any intention to bother with the voyage. The painting points to no "elsewhere." We are entering an age that no longer convulses over theology, an age that will soon replace the directionality of belief (belief is always transitively belief in *something*) with the amorphousness of feeling. We are entering the age of romantic emotionalism.

In general, we can describe the dialectic that connects the Gothic, the Baroque, and the Romantic as follows: the Gothic minted its forms out of the perspectival mold, guided by belief in an "out-there"; the Baroque began to doubt the relevance of "out-there" but hesitated to test this doubt, frightened by its own boldness; now it was left for Romanticism to declare that the "out-there" is really "in-here" and that we can consequently paint it everywhere we wish. The horizon is a creation of will and therefore lies in the will, and the will is supreme: we, in some way, are the infinite we have been looking for.

In theological terms, this three-act drama goes like this: by submitting to God, the Gothic mind submits to the primacy of an external order; by struggling toward God, the Baroque mind highlights the role played by will in unveiling this external order; by asserting that this external order is a figment of will, the Romantic mind states that God and world are the passion thereof, and therefore the only direction for man lies inward, to the god within.

It would be nice to proceed into the Romantic age with a workable definition of what Romanticism is, but the thing—this is a small measure of its charm—resists categorizing. Romanticism, the historian of ideas Isaiah Berlin declared after a lifetime of studying the topic, is an amorphous idea, a changeling reclining on a Procrustean bed, a trend that accommodates the most discrepant opinions, forms, ideologies.[8] At the end of the Romantic period, the poet Charles Baudelaire decided, "Few people today will want to give a real and positive meaning for this word."[9] One could argue that this absence of definite feature *is* Romanticism's definition and at least accommodates all its manifold expressions, which have in common the rejection of fixed and eternal frameworks. "The eighteenth century saw the destruction of the notion

of truth and validity in ethics and politics, not merely objective or abso-
lute truth, but subjective and relative truth also—truth and validity as
such," Berlin eventually proposed.[10] Romanticism is the symptom that
the West gave up objective self-validation as a requisite of civilization.
It gave up the notion that, at bottom, the world is made of objective
things and facts and that a healthy civilization must strike in that bed-
rock. To the Romantic, the human world was a floating island. And it
was motion rather than rootedness that now earmarked a bright and
healthy society. From this idea came an aesthetic, an ethos, a politics
that promulgated the world as motion, event, process, change: in Scho-
penhauer's terminology, *will.*

When the Romantic looked at nature or society, he saw not entities,
but their mutation, interplay, transition. "Can you say that anything
is, when in fact it is all transient?" the German poet, novelist, play-
wright, and all-around zeitgeist-maker Johann Wolfgang von Goethe
(1749–1832) asked. "All passes by as fast as any storm, seldom endur-
ing in the full force of existence, but ah! torn away by the torrent, sub-
merged beneath the waves and dashed against the rocks? There is not
one moment that does not wear you away."[11] Existence is occurrence:
"The Godhead is effective . . . in the becoming and the changing, not
in the become and the set-fast," Goethe insisted.[12] Things do not, not-
withstanding Aristotle, exist to fulfill a prefabricated essence. A tree does
not seek to fulfill the unconditioned idea of the perfect tree that exists
in God's mind. A tree simply grows; it wants maximum extension. If, in
its arboreal willfulness, it should happen to grow into something decid-
edly untree-like, this would be no aberration. As Charles Darwin would
propose a century down the road: mutation is not the exception but the
law of the land. The machinery of existence changes its mind always;
the blueprint is redrawn at every turn. Before Darwin, the naturalist
Jean-Baptiste Lamarck (1744–1829) had hinted that nature reinterprets
itself with every new biological generation, each worthy of existing,
not for embodying the acme of its species (there is no such ideal arche-
type) but for excelling at the game of becoming. Perfection is not a self-
defined, autonomous quality; it is a lucky match between one's internal
evolutionary engine and the external environment. The most stunted,
twisted, arrant, untree-like tree of today may turn out to be best suited
to endure tomorrow's changing ecosystem. Mutations are random, as
are the circumstances that prove these mutations fruitful or fatal. Just as
the meaning of Beethoven's music is internal to its creative unfolding, so
the meaning of Darwinian nature lies in the occurrence thereof. As the

Swiss theologian Georg Christoph Tobler said in 1782, "She [nature] flings her creatures out of nothing, but never tells them whence they come or whither they are going; their task is but to run."[13] Being is contingency. Biological life does not build up to a paragon. It is not teleological; it simply is. And because it intends nothing outside itself, it means nothing.

The Classical world assumed that nature as a whole evolved toward an independent benchmark—a divine origin and terminus that guided the process from outside. The mechanistic world of modern science, on the contrary, does away with supramundane landmarks and referee lines. The point of being is not to glorify a plan or a maker or to celebrate the preeminence of a game plan; the point of nature is to go on. There is no world but this world, no purpose to existence but the momentum thereof, and consequently no way to understand the universe from a physical or spiritual point situated beyond the pale.

A further victim of the demise of transcendental frameworks was the idea of objectivity. The God's eye view of the world basically assumed a closed universe: if the universe can be seen as a whole, it is because it is a whole to begin with. But with the new immanent philosophy, not even the universe (should it possess consciousness) can establish an objective standpoint from which to gaze back at itself. (God, if he exists, cannot step aside to observe his own person.) To know the world is to exist within it; and to exist within it means we cannot know it perfectly or wholly. Knowledge is hemmed in by its own subjectiveness: this is the modus operandi of post-Descartes philosophy that wired all the core problems of philosophy (i.e., what is reality, what is man? and what is God?) back to the thinking *I*. Not Locke, Berkeley, Hume, nor Kant dispute the premise that our image of the world is precisely that: an image. As such, it assumes the activity of a perceiver; and consequently, any worthwhile philosophic investigation into the nature of what is of necessity begins with the self. Ontology (the science of what is) henceforth answers to epistemology (the science of how we know). Being is therefore anthropological.

Romantic thought is the story of cultural adjustment to the experience of living in the human-centered, anthropomorphic world sketched by Descartes. Of course Descartes himself was no runaway subjectivist. Having philosophized himself into a tight spot where he doubts the veracity of anything but his own thought, he promptly beats a cautious retreat and sets his "Third Meditation" to the task of reestablishing God's towering precedence over human subjectivity. His demonstration

runs as follows: if the world were my dream work, there would be nothing in the world that did not originate in my mind. So I would be perfectly all knowing. But evidently there are things I do not know. Insomuch as I am always learning and perfecting my knowledge, my knowledge is not universal: ergo, I am not the world; the world preexists me. This preexistence I must attribute to a universal and eternal principle, that is, God.

This reasoning satisfied Descartes, but the genie of subjectivism was out of the lamp. Descartes had derived the necessary existence of God (reality) from an analysis of the self (mind): it is by understanding how the *I* thinks that God is proven to exist. This inward turn is what stuck in the mind of the next generation of philosophers such as Bishop Berkeley (1685–1753) and David Hume (1711–76). These thinkers reasoned that since all we know the external world is filtered through our ideas and impressions, it is fruitless to imagine there is another world but the one we perceive. Therefore, the world is the perceived world, which means there is really no way out of human perception. The most important thinker to come out of the Enlightenment, Immanuel Kant (1724–1804), drew out the full, clear-eyed philosophical analysis of this situation. What he produced is, unwittingly, a modernly tragic philosophy—one that set man on the modern journey of alienation.

Kant initially set out to refute both Berkeleyan idealism (of the sort that says reality exists only as perceived) and Lockean empiricism (which declares the mind is wholly molded by factual experience).[14] In a virtuoso weave of arguments, Kant demonstrated that even those categories we take to be central to the fabric of universe, such as space, time, and causation, are actually mental projections we interpose to make sense of nature, but that do not inhere in nature. Kant did not deny (like Berkeleyan idealism) that there existed a nonmental world at the far end of our perceptions; to him, there was a world beyond the categories through which we screen it, but it is not one we can reach. This situation inspired one of the few lyrical sallies in the *Critique of Pure Reason:* "This domain [the self] is an island . . . surrounded by a wide and stormy ocean, the native home of illusion, where many a fog bank and many a swiftly melting iceberg give the deceptive appearance of farther shores, deluding the adventurous seafarer ever anew with empty hopes, and engaging in enterprises which he can never abandon and yet is unable to carry to completion."[15] The world, then, is the home of appearance, and behind that appearance, a shore we can never reach.

Reality is not reducible to the self, nor the self to reality. There is a world out there, but it is not for us.

But could not one supreme thing at least be salvaged out of this vaporous world? Could there not be a God-island in this sea of human perception? Kant did not rule either for or against the existence of God (at least in his early writings); in his view, the case could be settled simply by reason. This is where he broke ranks with rationalist philosophy—of the sort that, like Anselm's and Descartes's, thought that merely to conceive of the absolute proves that the absolute exists. His rebuttal (laid out in his *Religion within the Limits of Reason Alone,* 1793) yields the none-too-catchy clincher that "Existence is not a predicate"—a thought perfectly and lethally simple: ideas are one thing, and reality another. To think that a thing exists does not make that thing be. No concept, however compelling, implies its physical instantiation. There is no magical passage between the concept and the thing, thought and reality.

Thus Kant did not deny or affirm God; his interest was simply in drawing the limits of reason (the meaning of the title of his magnum opus, *Critique of Pure Reason*). Which means that to adduce God required a suspension of thought. Now, all this is well for anybody who believes that thought *can* be suspended or that it is possible, by means of thought, to cease thinking. Such cessation is what is usually meant by the word *faith.* But is faith really an escape from the mind? It is certainly a break from reason, but from the mind? This is doubtful. And this doubt, for some, fed the suspicion that there may not be more to God than faith in him—a conclusion finally drawn by Kant, who, having begun by declaring God off-limits to reason in his earlier works, ended up with a very different conclusion: "Every man creates his God . . . and even if He should reveal Himself to you: it is you . . . who must judge whether you are permitted [by your conscience] to believe in Him, and to worship Him."[16]

Kant did not so much solve the problem of skepticism (i.e., this line of reasoning did not settle the question, How do we know that we know for sure?). Instead, it declared the resounding, marvelous irrelevance of the problem. When Kant claimed that his enterprise had sketched where reason ended to make room for faith, he did not mean that he had established the necessity of faith and the ineluctable existence of God. His tracing of the limit between reason and faith did not run between man and ultimate reality. It split one mental order from another. In simple words, the human scope does not end where God imposingly begins; it is not God's necessary existence that demarcates man; rather, man *limits himself* by his reason. Which means that the human scope is

not objectively bounded. Instead it trails off. It ends where perception grows dim, not where the imposing God-curtain comes up. If and when we choose to embrace faith, we do not then hear God. We hear our own silence. Or, to switch metaphors: when we behold the outermost outline of human knowledge, we do not behold the battlement of the City of God; we simply see our inability to peer any further. And that inability is not God given but human made. With Kant, the human intellect stepped squarely into a shapeless world and did not shrink from its shapelessness; instead, as we shall soon see, the Romantic dove right into it.

For Kant's ideas on the cosmos were, if possible, even more dizzying. Following a century of vigorous philosophical and theological wranglings over whether the universe is finite or infinite, Kant gave himself and his contemporaries a shock by discovering that it could be neither. Kant argued his case as it applies to time, but the argument works equally with space. Suppose (he writes in *Critique of Pure Reason*) that the universe has an infinite number of years. By definition, an infinite number of years can never elapse (there are always more to go). Yet, if we look at the present moment, we must conclude that a definite stretch of time did elapse to reach us today, or else time would still be on its way here. Therefore the universe cannot be infinite (in time and therefore in space).

But suppose the world did have a beginning. Before time started ticking, Kant argued, there must have been a vast emptiness of non-time, unbounded and indeterminate. Yet this cannot be true, because obviously this non-time came to an end when time began. Therefore, empty non-time is bounded by time, and to this extent is part of time. It follows that the world cannot have begun; hence it is infinite. The same logic holds with respect to space: space cannot have spontaneously popped out of non-space without making this non-space a kind a space, with a location of its own, and so forth.

The upshot was that the universe, taken as whole, could not be conceived to be either infinite or finite. Indeed, if Kant was right, it was as impossible to say that it had a shape as to say that it had none. The one concession that Kant made to cosmic infinity went, in keeping with the spirit of his age, to the open-ended future. In the essay "The End of All Things," he argued that "the end of time" could never happen because it entails time changing into a changeless state. The problem is the contradiction inherent in something *changing* into the unchanging is not clear. So long as the changeless originates in change, timelessness can have no reality.

How did Kant solve the antinomy of a universe that could be neither finite nor infinite? He did not. The contradiction simply showed that our thinking about space and time couldn't square with reality. The categories (space and time) worked well for the world we perceived but broke down when applied to the world taken at its incalculably broadest span. This philosophic cosmology cast the universe into vagueness. Objectively, the world cannot be said to be either shapely or shapeless; subjectively, we are locked into the circle of our perceptions. Of the two, it was especially the mental cosmos that especially enthused the philosophers of Weimar idealism. "We live in a world we ourselves create," reflected Johann Gottfried Herder (1744–1803).[17] This was also the conviction of Fichte, Schiller, Schelling, and other figureheads of German Romantic philosophy. Whatever shape the world may have inheres in our interaction with it: it is the battle line of a campaign that, someone like Fichte believed, we creative world-makers are born to win. Any element of objectivity in reality is helplessly annexed by our creative mind. Only in this active subjective colonization—so insisted the German idealist—is the self truly free, truly human.

But was the self really completely above the incoming tide of subjective vagueness? To Descartes, the self was self-evidently aware of its own existence. This crystalline self-evidence towers like the Rock of Gibraltar. But the Romantic juggernaut of indeterminacy and radical freedom (freedom from definition of all kinds) was only revving up—beginning with Bishop Berkeley. His famous dictum, according to which reality is perceived reality (*esse est percipi*, "to be is to be perceived"), raised an interesting question about the self: Are we, too, an idea of our own mind? If reality is the perception thereof, then I am real because I perceive and think that I exist. Berkeley wisely saw the madness of such an idea: to state that the self is made real by perceiving itself assumes there is some physical engine producing thoughts behind the curtain. So Berkeley concluded that the self is not an idea; but this landed him, and us, in worse trouble. For if there is existence only in ideas, if *esse* truly *est percipi*, and if the self is not just a perception, it follows that the self (we) might not exist at all. Spinning himself into the rabbit hole, Berkeley came close to talking the self into nonexistence, which is plainly absurd (though redolent of religious notions about soul-existence).

A more reasonable conclusion was that the self could not know itself: it was, in a sense, off-limits, nebulous, uncertain. So long as we can never uncover the bedrock of the self, self-knowledge is an illusion. At

best we can say that in being aware of one's own self, one is aware of something, though what that something is, one does not have, nor can have, any idea. And so Gibraltar, too, sank in the Romantic sea.

Still, there remained one length to go before the reef of selfhood went under the tide. Arthur Schopenhauer gave the final push. In many ways, the situation he received downstream the tributaries of Cartesian, Berkeleyan, and Kantian idealism was deeply unsatisfying. Let human consciousness be a current. It was indefinitely open at both ends: on the blurry side of the perceived (the object) and on the unfathomable side of the perceiver (the self). Both were equally off-limits to knowledge. The self was an unknowable gazing over a sea of unknowability. For Schopenhauer, the situation raised two questions: Given two indefinites, what allows us to tell one from the other? and, If subject and object are intrinsically amorphous, how are they distinguishable at all? Was it not nonsensical to postulate the separation of an indefinite knower from an indefinite known? Schopenhauer indeed thought so, and from this intuition derived this stunning insight from his masterwork *The World as Will and Representation* (1819):

> On the path of *objective knowledge,* thus starting from the *representation,* we shall never get beyond the representation, i.e., the phenomenon. We shall therefore remain at the outside of things. . . . So far I agree with Kant. But now, as the counterpoise to this truth, I have stressed the other truth that we are not merely the *knowing subject,* but that we *ourselves* are also among those entities we require to know, that we *ourselves are the thing-in-itself.* Consequently a way from *within* stands open to us to that real inner nature of things to which we cannot penetrate *from without.* It is, so to speak, a subterranean passage, a secret alliance, which, as if by treachery, places us all at once in the fortress that could not be taken from outside.[18]

Things-in-themselves are off-limits to knowledge. But the self, too, is a thing of sorts, and unknowable to boot: we can observe what comes out of consciousness (our ideas), but we can never glimpse the source. It is intractably its own thing. Now it happens that we live in extreme proximity with that thing; in fact we are made of it. When we practice to enter this pure thingness (by wordless meditation, kenosis, silence, etc.), we reach the bare core of the *it* of reality. World and self close the loop. The deep unknowable self is unknowable reality itself. Consciousness is reality contemplating itself.

With Schopenhauer, Romanticism finally blurs all remaining distinction between self and not-self. At the heart of selfhood is nature in the

raw, but nature in the raw (as per Schopenhauer's philosophy of world-as-will) behaves very much like the creative self. Like the self, nature keeps redrawing itself and commits to no permanent shape, only fantastically free-flowing, protean, plastic creativity. Nature is a consummate artist. The plasticity of reality explains why the artist superseded the clockmaker and legislator as the figure of choice for God or nature or man. For where, as per Herder's dictum, "We live in a world we ourselves create," the artist becomes the epitome of human consciousness. And it is no coincidence that the Romantic's *generation* ran to artists (rather than priests or scientists) for their idea of reality.

One challenge facing the Romantic was to inhabit a world without the old rift between self and world, or man and God. Could we make sense of a shapeless world? Could we live happily in it? These were the questions that pressed on the Romantic artist and enflamed his imagination.

Severance

Wetzlar, November 1772

On getting wind of the rumor that his friend von Goué had killed himself, the young Johann Wolfgang von Goethe wrote a letter commending the suicide for its bravery and independent spirit: "I honor such a deed."[1] Happily, the rumor turned out to be false. But suicide was evidently in the air because another report, this one well-founded, shook the little town of Wetzlar, where Goethe made his occasional residence. On October 30, Karl Jerusalem (philosopher, poet, unrequited lover) retired to his garret, set his papers in order, and shot himself in the head—messily, as it happens, because his manservant found him at dawn still groaning in a pool of blood. The doctor was sent for and bled the moribund wretch; by noon, Jerusalem was dead.

The occurrence shook Goethe. "Unhappy Jerusalem!" he writes in a letter dated November 1772. "The news was shocking and unexpected to me. . . . Poor lad! When I returned from a walk, and he met me yonder in the moonlight, I thought *he is in love*. . . . God knows loneliness has undermined his heart!"[2] Two weeks later, however, Goethe decided that sentimental reasons alone could not explain the taking of one's own life. A metaphysical act required a metaphysical explanation. In his letter of November 20 to Sophie von La Roche, Goethe therefore read deeper motives into Jerusalem's death: "It was his anxious striving after truth and moral integrity which undermined his heart; it was the failure of his attempts in life and in passion which brought about his tragic decision— how easy it is for such to be impelled by their extraordinary sensibilities

to such an end! And what life is—need I tell you? I am contented to have erected in my heart a monument to our departed and unhappy friend, whose deed will be so callously analyzed by the world."³ The death of a spurned lover had mutated into metaphysical drama. Jerusalem's suicide was too deep for the ordinary mind to fathom. "Truth and moral integrity" had killed him. He had died for wanting to live life on his own terms. It was an act not of resignation, but of proud protest, condemning an objective world too poky and prosaic to host a great-souled individual. Jerusalem's death will be misunderstood by the world, writes Goethe. Yet this misunderstanding was the gist of the affair. A perfectly explainable suicide is not done by a genuine individual. Self-killing is by someone who has not found the available explanations satisfying. Rather than compromise with the world, the suicide turns heroically inward—and slams the door. Suicide is selfhood writ large— the very larger-than-life monument that Goethe began to arrange for his Jerusalem. It was then, Goethe reports, that "the fable of *The Sorrows of Young Werther* was found."⁴ At that moment, the incidental became emblematic, and the age found its standard-bearer: Werther, herald of the zeitgeist, incarnation of the weltschmerz, of the belief that the world presented rather small living quarters for the real self.

"To call oneself a Romantic and to look systematically to the past is to contradict oneself," writes Baudelaire in "What Is Romanticism?"⁵ Insofar as Romanticism imbibed the Enlightenment's taste for progress, Baudelaire was right: the Romantic temperament radicalized the yearning to reject the past and betray the ancestors. The new ethos was sincerity, being true to oneself, even if that meant putting oneself beyond the pale of human fellowship.⁶ "To be misunderstood is my fate," Werther muses.⁷ Such alienation was cureless because the individual's first duty was to his own way, intuition, and sensibility, to dare to say "no" to other people's notion of what one should be. Nothing expressed this refusal of compromise more loudly than suicide. It inspired a whole generation to glorify suicides, chief among whom was Thomas Chatterton, the English teenage rhymester who took arsenic in 1770.⁸ Shelley, Wordsworth, Coleridge, Keats, Vigny—it seems every poet took a bash at immortalizing Chatterton. Suicide was the badge of courage, the litmus test of the pure soul martyred in the name of life-as-it-ought-to-be-but-is-not.

"You are looking for something that cannot be found on earth," says Werther to himself.⁹ The Romantic personality simply *knows* that consciousness outsizes the world and therefore cannot fit in. Faced with the dilemma of craven capitulation or solipsistic alienation, the

self-respecting individual roots for himself—even when the choice ("to thine own self be true") leads him to self-destruct. For the generation of 1770, this self-destruction found a home in art and poetry. For if art be creation, then the suicide was the ultimate artist. Autobiography is de rigueur vein of the self-respectedly modern artist: he writes himself into forms, he is his own creation. And no one better than the suicide acts out this Romantic individualism, the chief duty of which was to be, in Hegel's idea, "a free artist of himself."[10]

Officially, the society of Goethe's time roundly condemned *The Sorrows of Young Werther* (1774). This tale of a lovelorn young man who falls in love with a married woman, forgoes his duties, squanders his prospects, prefers his diary over society, and finally takes his own life— it struck many as a harbinger of decadence. What was religion and society coming to now, that every green horn started taking life into his own hands? Religion condemned suicide because it challenged the belief that in matters of birth and death, we exist by the good grace of God and king. Our bodies are not our own. Aquinas ruled that it was a sin tantamount to usurping God's role, who alone sets the limits of existence.[11] "There's divinity that shapes our ends" (*Hamlet* 5.2). Just as man does not beget himself, so he must not terminate himself. To appropriate this shaping power is sacrilege.

But something deeper about self-slaughter rankled the religious-minded: suicide poaches on religion's monopoly control of world detachment. The suicide brazenly states that actual existence may bully us only so far, that there is a part of us (call it freedom) that does not cling to survival at any cost. This notion is not far removed from the Christian sermon, which lauds the transcendence of spirit over matter. "My Kingdom is not of this world," says the Christian soul (John 18:36). The suicide claims no less than this otherworldliness. He taps right into the hallowed Neoplatonic and Christian tradition of denigrating immanence. Traditional religion generally wanted believers to fix their gaze on ultimate things and brood over the hour of their death. It wanted believers eyeing but not trespassing the existential horizon: our duty was to wait and repress the urge to draw the map of life. God will swing the gateway when he sees fit. This is the sense in which, in the religious worldview, the horizon transcends believers. But suicide challenges this transcendence. People who take their life decide where the horizon stops. They subordinate Being to the self, committing, as G. K. Chesterton put it, "not only a sin, [but] the ultimate and absolute evil,

. . . the refusal to take the oath of loyalty to life."[12] Who indeed cannot *not* be envassaled to existence? Does existing not mean immersion in life? Self-destruction is the fantasy triumph of human autonomy. Whoever draws the shape of the world brings down God. He lives in a world that is not God's creation, a godless world, or one where only the self is god (which conceit, Augustine believed, puts one beyond the pale of forgiveness).[13]

The punishment Dante reserved for suicides was to turn them into trees whose limbs and leaves are eternally torn off by harpies (*Inferno*, canto 13). There is nothing they can do to shake off the punishment. They cannot wriggle or express pain. The suicide is stuck in vegetative materiality for having overplayed his human spirituality. They who seek to overstep life will be crammed back into it. But the force of Dante's image is not just poetic justice. As it happens, the punishment describes the sin. By drawing the shape of his world, the suicide deprives himself of an external boundary. The reason is this: suppose I draw the limit of my existence; this limit is not absolute but relative to my will. But where, then, is a true exit out of existence? Can I transcend myself if I am the creator and destroyer of life? I have laid hold of the horizon, but behold, the horizon is no more, and along with it, the sense that my life offers a gateway, that there is a world beyond the self. I am as stuck inside my all-encompassing subjectivity as a tree is stuck on its patch.

The suicide becomes master of his existence, but existence without an outside master (as per Hegel's famous dialectic of master and bondsman) is amorphous, slack, enervated, devoid of action and reaction. It lacks context. The self wraps around itself and withers. The Romantic hero soon discovers that metaphysical emancipation brings existential solitude. The emptiness of unqualified freedom sets in. Lassitude with the world engenders weariness with one's own self. In time the *I* begins to yearn for connection, for encounter.

This is where we meet Werther at the start of his story, deliquescing in a solipsistic haze. "The particular questions we probe is no more than a dreamy resignation, since all we are doing is to paint our prison walls with colorful figures and bright views . . . everything swims before my senses, and I go my way in the world wearing the smile of the dreamer."[14] Werther means to keep this dreamy smile afloat as long into adulthood as possible. It is difficult because he falls in love. Now, one necessary step to falling in love is, of course, to meet a reality charmingly other

than one's self (the meaning of *falling*). But Werther contradictorily uses love to delay acknowledging the separateness of reality. To love the motherly Charlotte is to keep up the dream of childhood, oneness with Being, and to reject the adult world of separation, the world that repeatedly asks him to grow up and "be a man."[15] "I am treating my poor heart like an ailing child; every whim is granted," he says.[16] To be a child, in Werther's lexicon, is to never know lack, to never see that human desire and reality are at loggerheads. A child is one who has not yet confronted the world's inability to meet his wishes. The child exists in a world without boundaries, unworried by horizons. Musing over a landscape, Werther draws an interesting cultural analogy: "The water flowed on, and so did my imagination, till I was quite lost in the contemplation of an invisible distance.—That, my dear fellow, is how our ancestral fathers were: their lives as limited and yet as happy, their feelings and poetry with that quality of childishness! . . . What use is it if I, like any schoolboy, can now parrot that the earth is round? Man needs only a small patch of earth for his pleasures, and a smaller one still to rest beneath." Werther wants it both ways: the spiritual expansion in the "contemplation of the invisible distance," and the traditional comfort of a bounded universe, "limited and yet happy," happy because it is limited. He wants the horizon to enfold him and hush the adult questions of why, wither, and wherefore. In sum, he wants the uterus. There the unhatched little solipsist fills out the shape of the world, a world that is homelike, intimate, "inwardly and closely felt."[17]

"The sun and the moon and stars can go about their business as they please," Werther says, musing on love, "but as for me, I do not know it if it is day or night, and the whole world is as nothing to me."[18] "The whole world is as nothing to me": these are the words of the solipsist curling up in the fetal position. The Romantic climax of subjectivism will be infancy or speechlessness (Latin, *in-fant*). At the babbling stage, there will be no need to express, represent, or in any way symbolize our relation to Being. "I do not know how to express myself; my imaginative powers are so weak, and everything slides and shifts before my soul, so that I cannot grasp the outlines."[19] To express oneself is to mark the gap between self and world: it is to objectify one's situation, to stand back from it. Werther's immersion in Charlotte ("You are all around me," he coos) yearns for the sweet cessation of speech. Both infancy and solipsism cater to the fantasy of a world without limits, where the ego does not need to express the world because (as in the climax of

Hegel's great rhapsody of subjectivism, *The Phenomenology of Spirit*), the world *is* the self.

Young Werther wants this paradox: the comfort of limits without the terrible realization that a limit signals beyond itself. It is when reality checks our desire that we become aware of its power. It is then we fall in love: when we perceive the shape of the world, which marks the difference between thought and reality. But not for Werther the tragic realization that "the earth is round": he wants love without paying the price. He will go to any lengths, including giving up life, to avoid the confrontation with otherness. He dies so he may never have to grow up. "To die!" he proclaims ecstatically, "What does it mean? When we speak of death we are only dreaming. I have seen people die; but there are such constraints on human nature that we have no feeling for the beginning and ending of our existence."[20] Once dead, one no longer has to contend with reality (i.e., the fact that it hems in the self). Suicide, Werther deliriously believes, will reunite him with Charlotte, her mother, his mother, and even the Ur-Mother, who is the womb of being. Suicide will abolish mortal reality. It will sing the Napoleonic victory of Romantic solipsism.

Thirty years after *The Sorrows of Young Werther*, Goethe revisited the drama of modern subjectivity in his drama *Faust Part I* (1806). Imagine Werther bungling his suicide and growing up a full-fledged solipsist. When the curtain opens, Doctor Faust (polymath, scientist, alchemist, and all-around Enlightenment *philosophe*) has grown weary of the intellect. All human knowledge is futile; he realizes the mind never sees farther than its own nose.

> I have, alas! Philosophy,
> Medicine, Jurisprudence too,
> And to my cost Theology,
> With ardent labour, studied through.
> And here I stand, with all my lore,
> Poor fool, no wiser than before.
> Magister, doctor styled, indeed,
> Already these ten years I lead,
> Up, down, across, and to and fro,
> My pupils by the nose,—and learn,
> That we in truth can nothing know! (1–11)

Knowledge is vain and impotent. It creates phantoms. Thus *Faust* begins where *Werther* leaves off: face-to-face with the pitiful self-captivity of knowledge. Understandably the great doctor too contemplates

suicide. Better to be done with life than endure this insufferable captivity. But suddenly Goethe snaps out of the Wertherian blues: what if the romantic accepts grownup separation? This is Faust's experiment. Exile from Being, the impotence of knowledge—all this may be his curse. But it is *his* curse. It gives meaning to his existence. It *defines* him. Faust champions his own desolation; his alienation is his badge of honor. Thus equipped, he dares Mephistopheles to lay before him a thing or creature so absolutely lovely as to make him want to leave the mental fortress.

> When to the moment I shall say,
> "Linger awhile! so fair thou art!"
> Then mayst thou fetter me straightway,
> Then to the abyss will I depart! (1699–1702)

The devil takes the wager: Faust can have eternity, knowledge, unfettered spiritual existence, on condition of never wishing to step down from the skyhigh (but barren) perch of mind to the mundane (but lovely) congestion of real beings. If Faust succumbs to the loveliness of the world, he will burn in the flames of unrequited desire. Faust signs the contract: I, he says, will be better than Werther; I will build a mental realm so triumphantly solipsistic that it will never be sorry for its separation from reality. Unlike Werther, I will never try to melt my boundaries. I will claim them, wear them proudly, and never wish to leave them.

Who, in the end, wins? It is no use denying that *Faust I* disappoints the expectation hanging on its dramatic pact; in part the play's charm derives from not living up to the stakes. Goethe perhaps realized he could not decide who, between Mephistopheles and Faust, should win the bargain. Satan does manage to make the doctor love the delectable Gretchen, but Faust never succumbs to the temptation of begging to "linger awhile." He is in love but not so in love as to forget himself. In other words, Faust is not prepared to scupper the proudly battened-down self. Knowing the fond world he is in want of, he still prefers severance over its cessation.

> The outcast am I not, unhoused, unblest,
> Inhuman monster, without aim or rest,
> Who, like the greedy surge, from rock to rock,
> Sweeps down the dread abyss with desperate shock?
> While she, within her lowly cot, which graced
> The Alpine slope, beside the waters wild,
> Her homely cares in that small world embraced,
> Secluded lived, a simple, artless child. (3111–18)

Immaturity is a fond and lovely land, and to abandon it is bleak. But such resignation is the source of poetry. Existentially out-of-doors, Faust hankers after home. Being at the hearth, on the other hand, would hush his poetic powers. He prefers poetry and homesickness.

Goethe's *Faust* paints a nuanced portrait of the Romantic. The hero is still unhappily housed in the Enlightenment world of reason. He longs for union with reality, but the immanence he craves, he does not really want to reach. Beyond the horizon of human cognition is love, communion, and simple faith, Charlotte or Gretchen, Eden or eternal childhood. But this horizon, though heavy, is *what* we are. We must not wish our finitude away. Life in the arms of God would be lovely; absolute consciousness might be bliss; but it is exile that makes us human. It is loss and loneliness that make poetry sing. The aim of spiritual life is not to plunge in the divine sky; it is to keen about the moral horizon that keeps us from it.

Only the individual who has been cast out of Eden can truly love. We would not see the glory if the glory were not out of bounds; we would not intuit the infinite if we were not stuck in the finite. It is limits that beget poetry, the Wordsworthian "thoughts that do often lie too deep for tears." Poetic expression speaks from within the mortal horizon. Without acknowledgment of this, there is only fantasy, magic, and myth. Within it, there is death but also, thanks to it, love and poetry. At its most mature, when it leaves behind the "tears" and the Wertherian weltschmerz, Romanticism learns to live tragically (that is, beautifully) missing God, transcendence, the great Other.

The painter Francisco Goya (1746–1828) left a remarkable portrait of the grownup Romantic personality, titled *The Giant* (1818). And growing up is indeed the almost burlesque subject. The enigmatic aquatint depicts a titan sitting as if on the edge of the world. Reversing the ratio between landscape and figure, it is the human form that dwarfs the diminutive dales and forests; his head touches the sky. Something about humanity, it seems, has outgrown the world. Sitting on the edge of his cradle, the giant can now gaze beyond the curvature of the earth. But this trespass fills him with distress, and he looks grimly over his shoulder, back toward the immanence he leaves behind. Ahead of him is the infinite; beneath him the finite. But he, a *modern* figure, is at home in neither. He faces forward but looks backward. All we know is, we are too big for the world. But then, where will we live?

Once upon a time, the world was a house. Beyond the walls of the house, the infinite began; death was the doorway. God told us when to

step out and enter his kingdom. The infinite, we were quite sure, would blaze open on the last day of creation. But now look at us and God and the world. Our mind is too airy, too chimerical, too dreamy to catch reality. It belongs nowhere. There is a kind of rueful madness to this state. Man hangs at the edge of the world, feet adangle: neither a land-dweller nor a creature of the sky, neither immanent nor transcendent.

So we sit on the edge between earth and heaven, the finite and the infinite. It had always been the job of magic and primitive religion to span the two. But now the horizon is unhinged, and we are achingly, mournfully, poetically undefined. Can we make ourselves at home in the world? Can we find a way to *dwell?*

Blue Yonder

Tübingen, 1810

By April 1802, it was becoming alarmingly clear to his employers in Bordeaux that Hölderlin could no longer serve his tutorship. His "hypochondriac" temperament had lately begun to show worrisome streaks of lunacy. It was imperative he be sent back to Germany.

So Hölderlin wandered his way across France, no longer the brilliant student of theology who debated Hegel and Schiller, but, according to a witness, a stuttering wretch, "pale as a corpse, emaciated, with hollow wild eyes, long hair and beard, and dressed like a beggar."[1] Once in Germany, and after stammering stints in psychiatric clinics, he found refuge in the home of a carpenter in Tübingen, where he spent the remaining thirty-six years in a cloud of mental derangement. Outside of a circle of initiates, Friedrich Hölderlin (1770–1843) remained a little-known idealist poet. Then, forty years after his death, Friedrich Nietzsche lauded him as one of the finest poets in the German pantheon and, if we believe Martin Heidegger, one of the most profound too.

The poet's madness is undeniably part of his charisma. We scan his poetry for a hint of the tipping point. Sentimentally, we would like to think that the poems' profundity itself is a kind of madness. But what *is* their profundity? Hölderlin contemplated the possibility of a world without God, that is, a world without a top and a bottom. The poet never lost his religious faith, but something worse befell him. He saw the rational case for losing it; he saw that, taken all and all, atheism made *sense*.[2] Unable to accept this and cut his losses, Hölderlin

suffered a fate unknown to theist and the atheist alike, who in their own way are persons at peace (both have both found, in journalistic parlance, *closure*). In contrast, Hölderlin always felt on the brink of losing God.[3] Very often fear of loss is a greater torment than loss itself. It shadows all our actions. In the end, we would sooner fling ourselves at the danger, cut the rope, and let the sword of Damocles fall where it may. In 1882, Nietzsche had taken this step and declared the death of God; but eighty years earlier, Hölderlin lived in the "departed season of the gods" and made himself mad with the fear of losing sight of them altogether.

Hölderlin frequently spoke of "gods" rather than "God" (he also spoke of "the Holy Ones") to honor the ancient pagan sense of a god-suffused world, and to mourn the passing of these immanent deities. In the hymn "Bread and Wine," the poet journeys to Delphi to find traces of the former friendliness of heaven and earth. He arrives too late.

> My friend, we have come too late. Though the gods live,
> Over our heads they live, up in a different world.
> Endlessly there they act and, so much do they avoid us,
> Little they seem to care whether we live or not.
> For not always a weak vessel can hold them,
> Only at times can our kind bear the fullness of the gods.
> Life itself becomes a dream about them.[4]

Without the sacred sense that reality is God's, that it is unconditionally real and other, life becomes, Hölderlin says, a dream. But to know oneself dreaming is hardly a happy state because it leaves us pining for reality outside the dream (the only happy solipsist is never quite aware of his solipsism). As he was, Hölderlin could enjoy neither the dream nor the reality: this is—was—enough to drive anyone mad.

Why have the gods vacated nature? In his poem, Hölderlin ascribes the cause less to a cosmological drama (as he does in "The Ground of Empedocles") than to human pusillanimity. We, he says, are weak vessels: "Humans can endure the fullness of the gods only at times." What's so difficult about divine presence? The very thing that makes reality often hard to bear: its difference. What we desire, reality does not always serve. Faced with noncooperation, it is easy to retreat into the twilit world of fantasy. But this regression, Hölderlin warns in "To the Young Poets," must be resisted: "Hate intoxication like the frost!"[5] Intoxication is fantasy, unbridled subjectivity. The inebriated drunkard is a weak vessel: in him, there is only room for his dreams. And

a pot that can hold nothing other than itself is really empty. All the great Romantic poets (Blake, Wordsworth, Coleridge, Jean Paul, Vigny, Nerval, Hölderlin) felt and fought the lure of self-absorption. But can it be fought all the way? Wanting to overcome subjectivity is not the same as overcoming it. Wanting to believe in God is not enough to make one believe in him; in fact, it rather spoils faith.

This was Hölderlin's predicament, and it inspired some of his most beautiful lyrics like the prose poem titled "In Lovely Blueness. . . ": "As long as kindliness, which is pure, remains in his heart, not unhappily a man may measure himself against the divine. Is God unknown? Is He manifest like the sky? This rather I believe. It is the measure of man. Well deserving, but poetically, man dwells on this earth. . . . Is there a measure on earth? There is none."[6] The tender blue shows lovely transcendence but also its remoteness. The historical arc of Western religion describes the progressive abstraction of divinity—from the Hellenic river- or mountain-dwelling gods to the unutterable Yahweh to the etiolated god of eighteenth-century Deism. Hölderlin absorbed Deist theology and saw the growing removal of God in the lovely, unapproachable blue sky.

Can we get our bearings just by the aloofness of God? Is the blue sky enough of a *presence?* From the night sky we can make out the runes of constellated stars, but the blue sky? It is wearingly translucent. Hölderlin's quandary was to decide what man becomes now that the gods are no longer around to tell him what and where he is *not.* How do we measure ourselves? All measurements are relative: that object is big only if I can find a smaller one by comparison. Man used to derive his size (small) by God's greatness. In the absence of God, what is man's size? Can anything measure itself? Indeed it cannot. By saying that there is no measure *on* earth, Hölderlin points to the necessity of measuring man by something irreducible to the human scale. But how does one attain this perspective? Hölderlin spent his university schooling with his friends Hegel and Schelling and, initially at least, shared the idealist credo that no outer limit must be imposed on the human mind.[7] "The first idea is the presentation of *my* self as an absolutely free entity. Along with the free, self-conscious essence there stands forth—out of nothing—an entire *world.*"[8] This fragment, ostensibly by the young Hegel, has also been attributed to Hölderlin. A thinker is less a seeker than a creator of truth. As Hegel put it, "The philosopher must possess just as much aesthetic power as the poet."[9] But this did not turn out to be Hölderlin's more mature view of poetry. If the first step in the

life of man was self-creation and the second was world invention, the third step for Hölderlin was considerably more measured. This measured pace, in fact, was poetry.

To Hölderlin, unlike his idealist acolytes, poetry was not mercurial daydreaming; it was utterance keenly aware of what language leaves out. Poetry sees the hazy blueness of subjectivity spreading limitlessly around the self, but this blueness is lovely (not smug, not insular) because it keeps God out of sight—sacrilegiously, guiltily, helplessly. This hiddenness is the measure of man. That God's shore cannot be seen *is* the human (Romantic) lot. The loss of measure is our measure. Our existence is poetic in just the sense it watches over the withdrawal of God.

But should the blueness not be "woebegone" rather than "lovely"? But no loveliness with a religious nimbus can be altogether forlorn. Sanctifying the absence, Hölderlin seems to have believed that losing God was the heart of religious life. In an essay "The Ground of Empedocles," he says that the One painfully split itself into the Many: only by thus talking to Itself from many parts can the One be conscious of itself. Among these parts, man of course is the most conscious. Our role in the great scheme of things is to embody the self-estrangement by which the deity knows itself. The farther we know ourselves to be from God, the more we partake of God. We are here to grope and go blind missing God so God may be self-conscious. Thus Hölderlin translated the withdrawal of divinity, the world's disenchantment, into a pious emotion, a kind of spiritual refuge. The interminableness of subjectivity could be livable so long as it despaired of its interminableness. Self-satisfied subjectivity is happy but blockheaded; dissatisfied subjectivity is woeful but spiritually fecund.

Hölderlin's image of the measureless blue signals a new timid willingness to carry on the religious life in the ashes of transcendence. Where the divine manifests itself by abandoning reality to its own devices, everything, including godlessness, takes on religious meaning.

At the cusp of the modern age, someone like Pascal gasped with horror at infinite space (i.e., space devoid of God's tracing hand); a hundred and fifty years later, however, it is anything *less* than the infinite that caused disquiet:

> The Mind of Man naturally hates everything that looks like a restraint upon it, and is apt to fancy itself under a sort of confinement when the sight is pent up in a narrow compass, and shortened on every side by the neighborhood

of walls and mountains. On the contrary, a spacious horizon is an image of liberty, where the eye has room to range abroad.

Whatever is artificial calls for enclosure; but to what is natural not even the infinite is enough.

The finite has no genuine being. . . . A philosophy that ascribed genuine, ultimate, absolute being to finite existence as such, would not deserve the name of philosophy.

We may be quite sure that what is not infinite cannot be true.

This sampler of remarks (respectively by Addison, Goethe, Hegel, and Ruskin) points to a new alignment.[10] On the side of the ignoble is measure, form, restraint. By instinct, the hale and true personality ("the Mind of Man") seeks boundless reach. The infinite mirrors what is ours to begin with. We could never apprehend the universe as infinite if the infinite were not a category of thought. It is our true home. What roof, besides the blue sky, is vast enough for the infinite mind?

Aesthetics played an important part in easing the eighteenth century from Classical to Romantic, that is, from delight in definition to delight in infinity. Through art, the eighteenth-century individual came to see how formlessness, once a nexus of horror, could spark intellectual delight. This transition was conducted in large measure through the debate on a peculiarly vexing and fascinating word, the *sublime*.

The term *sublime* (from the Latin world *sub-limis*, "exalted and lofty") seems to have resurfaced with the translation into French (1674) and English (1680) of the first-century Latin treatise *On the Sublime* by Longinus. A term of rhetoric, Longinus's *sublime* described noble actions clothed in high-flown poetry. In the eighteenth century, however, the sublime steals out of the camp of poetics. It is not just language that is sublime; a perception, an object, a scenery, a gesture, an occurrence can claim sublimity. Moreover, the word designates not what speech can express, but rather the exceptional thing or event that baffles expression and stuns eloquence dead in its tracks.

Indeed the sublime was an aesthetic paradox: what satisfaction can be derived from dumbfoundness? What artist relishes coming up speechless? The idea was as puzzling as that of morality delighting in depravity. Yet delight was what the eighteenth-century public experienced when, bored with the milquetoast delicacies of rococo art, it shivered for awesome, forbidding, untamed spectacles. "La poésie veut quelque chose d'énorme, de barbare, de sauvage," Denis Diderot (1713–84) said, already looking beyond Enlightenment rationalism.[11]

Poetry hungers for out-of-bounds, barbarous, wild things. The Irish thinker Edmund Burke (1729–97) offered a systematic description of this phenomenon: *A Philosophical Inquiry into the Origin of Our Ideas of the Sublime and the Beautiful* (1757) explains why a spectacle that oppresses the imagination, overwhelms eloquence, and flouts the order, measure, harmony, and form traditionally embodied in art forms was now the stock-in-trade of art. The sublime, Burke explained, arises from taking a "delightful horror" in displays of immense power and scope: "The passion caused by the great and sublime in nature . . . is Astonishment; and Astonishment is that state of the soul, in which all its motions are suspended, with some degree of horror."[12] Horror comes from being crushed by indomitable power; "delightful horror," therefore, is the vicarious enjoyment of being destroyed. The pleasure consists in the frisson of witnessing our own make-believe destruction.

Kant was one thinker who found this explanation undignified. How can the law-giving, rational mind enjoy the spectacle of its own debasement? How can we relish our enslavement by uncontrolled emotion? Was Burke saying that mental self-control likes nothing better than to be damaged?

Kant spotted a flaw in Burke's theory. "A source of the sublime," Burke writes, "is infinity." But the Irishman also contended that "there are scarce any things which can become the objects of our senses that are really and in their own nature infinite."[13] For Kant, Burke had missed a good insight. For if it is true that the infinite is a source of the sublime but that the infinite never actually materializes, it follows that sublime feelings spring from within the mind, not without. Thus Kant's line of argument in the *Critique of Judgment* (1790): given that infinity is an object of the understanding, the sublime emotion occurs when the mind glimpses its own powers of intuition and imagination. The sublime is our capacity to imagine more than we perceive. This fact explained the *delightful* nature of sublime horror: it is simply the mind delighting in its own vastness. Hence, "true sublimity must be sought only in the mind of the [subject] judging, not in the natural object."[14] "In the immensity of nature . . . we find our own limitation, although at the same time in our rational faculty we find a different, nonsensuous standard, which has that infinity itself under it as a unit, in comparison with which everything in nature is small, and thus in our mind we find a superiority to nature even in its immensity."[15] In plain terms: sublimity bursts forth when in our heart of hearts we commune, not with finite things, but with our dreams and intimations of them. "Eternity and its

world, the past and the future lie in us, or do not exist at all," wrote the Romantic German poet Novalis (1772–1801).[16] Indeed Romanticism secularized the infinite. Descartes, who kept one foot in scholasticism, held that the finite cannot beget the infinite: only something originally boundless (God) can seed the idea of the infinite in our finite mind. Kant disagreed. Since nothing external ever manifests the infinite, not even the starry sky, it follows infinity is an idea born of mind. Hence there is something infinity-like about the mind, something godly. As Kant scribbled in a posthumous note, "I am God": if only we in our brain can conceive God, then God owes a great deal of his existence to the mind. This idea, Kant could have argued (and Hegel did), follows from the Christian story of divine Incarnation: there, already, was the inkling of a God in need of human mediation.[17] But this meant that the idea of God was poised to eclipse the fact of God.

Artistic representations put these sublimities before the eyes of the Romantic public, in particular through depictions of the landscape. It is through Romanticism that landscape painting finally won the prestige it would maintain over the next century, until the waning of Impressionism.[18] Particularly striking in these depictions is the space given over to the sky. We shall consider images of these sky-scapes in three painters: Friedrich, Constable, and Turner.

Moonlit peaks and forests, fogs, moonrises, seas of desolation and tranquility, of clouds and ice floes: these are the elements of the landscapes by the German artist Caspar Friedrich (1774–1840). It is nature at its most sweeping, raw, colossal—not the decorative afterthought that puts a dab of arcadia at the back of portrait sitters or in the corner of a window. To Friedrich, nature was *everything*, an all-embracing everywhere. "Man is not as free to rise above time and place as many believe," Friedrich wrote.[19] A painted landscape should therefore depict the immersive experience of man in the landscape, which in Friedrich's case entailed scrapping certain picturesque conventions about drawing views. Etymologically, *picturesque* designates "picture-like" and "picturable" scenes. Seeing the contradiction in "framed nature," Friedrich devised a visual rhetoric to convey the undesirability of "prospects," of those views too neatly arrayed for the benefit of an ideally placed viewer. "Everything [in a painting]," he said, "must and can be executed with care without each part immediately pressing to be seen."[20] The job of a painter is not to pin down objects. His approach should be as smooth and liberal as possible. Nothing should be demonstrably set forth

FIGURE 14. Caspar David Friedrich, *Monk by the Sea,* 1809. Oil on canvas. Courtesy of Art Resource.

or emphatically circumscribed. In point of fact, the painter should not try to cast the best view of the landscape because *there is no view.* The landscape is not something one sees; it is where one is.

This holistic sensibility produced paintings like *Monk by the Sea* (1809) (fig. 14), which, even to an eye jaded by Mark Rothko or Gerhardt Richter, are feats of minimalist washout. The land is a wan, straggling, sandy remainder overspread by a soaking gray immensity of ocean and mist. The German writer Heinrich von Kleist (1777–1811) recalls his amazement: "The picture stands there like the apocalypse, . . . and since in its uniformity and boundlessness it has nothing but the frame as a foreground, it seems, when one looks at it, as if one's eyelids had been cut away. Without a doubt, the artist has opened up a completely new path."[21] Where should we look? Nothing in the painting orients the gaze. Everything is far; everything is indefinite; everything lacks intention. Small wonder Kleist thought of an apocalypse: of a posthuman world, a world from which the human perspective is gone. And so it is as though we saw without eyelids—the shutters that allow us to pack our intercourse with reality in tidy visual parcels. The human figure is lost in the immensity which, though it gives a sense of scale, gently sweeps us off.

Friedrich had little taste for landmarks and milestones. He dealt in the ephemeral, in the slow dissolve, the permanent fadeout of mists and fogs. If this was landscape painting, the land was oddly missing. Nature herself is mere coagulant in the watery concoction, all whipped into a booming orchestral mix that brings the viewer to spiritual overload. So much effect-mongering tumult and thunder in the service of spiritual tourism! "When a landscape is covered in fog," Friedrich writes, "it appears larger, more sublime, and heightens the strength of the imagination and excites expectation, rather like a veiled woman. The eye and fantasy feel themselves more attracted to the hazy distance than to that which lies near and distinct before us."[22] Haziness is less a property of nature than of frustrated vision, and frustrated vision is always aware of itself. For a landscape as such is never hazy; it is the eye that projects its frustrated sight on the scenery. The blurred landscape simply reveals the blur that *is* perception. Haziness asserts the primacy of perception, and Friedrich's fogs are really projections of a complacently ethereal mind. His landscapes spring from a psychology more interested in the spectacle of being amazed than in the external cause of that amazement.

Hence the recurrent motif of placing a lone back-lit human observer who gazes over an aerial view, a valley, a cosmic sunrise (*Wanderer over a Sea of Clouds,* now an icon of Romanticism, is a good example). Whatever the celestial immensity, the observer in the foreground reminds us that it is a *sky being seen.* Human apprehension is paramount. "The painter," Friedrich averred, "should paint not only what he has in front of him, but also what he sees inside himself. If he sees nothing within, then he should stop painting what is in front of him."[23] Perhaps Friedrich is not a painter of landscapes after all, but a painter of the landscaping. "Close your bodily eye, so that you may see your picture first with the spiritual eye," Friedrich urges the apprentice painter.[24] Where all is vision, only the perceiver exists. The poetic feeling for infinity trumps infinity proper.

This intellectualism dooms Friedrich's achievement in the end. There is an awkward lag between Friedrich's heady visionarism and his technical aptitude: he imagines more than he knows how to paint. He could resist the cliché of a picturesque nature but he could not resist the cliché of the picturesque viewer. Hence the peremptoriness of his skies: they wear their infinity on the sleeve. They tend to be intellectual manifestos rather than living infinities.

The English John Constable (1776–1837) was by temperament more practical. Friedrich worked from a theological feeling for the infinite; Constable, for one, worked his way *to* it. Whereas the German painter thought big but painted small, Constable thought small but painted on a very large scale. The English painter never felt he was seriously at work unless he stood head-to-shoulder before a six-foot canvas. Only then did the experience of painting a landscape connect with what it is like to stand inside a landscape. Over the course of his career, we see the sky claiming larger and larger swaths of his canvases. In later paintings such as *Chain Pier* (1827) or *A Storm of the Coast of Brighton* (1824), it swallows up the whole painting. As he confided in a letter, "That landscape painter who does not make his skies a very material part of his composition, neglects to avail himself of one of his greatest aids. . . . The sky is the source of light in nature, and governs everything. . . . It will be difficult to name a class of landscape in which the sky is not the key note, the standard of scale, and the chief organ of sentiment."[25] Though above, the sky really grounds the picture. It governs everything: it is the circumstance and the enfolding principle, it dictates the mood, it sets the measure. To paint the sky was, for Constable, to uncover something fundamental about reality.

To find this essential condition, Constable left the studio (where the sky is only a corner of the window) and went out in the open—trekking up and down his native Suffolk in what he called "skying" expeditions: "I have done a good deal of skying, for I am determined to conquer all difficulties," he declared in a letter.[26] Sketchbook after sketchbook of watercolored sky and cloud studies attest to this dedication. Behind every finished landscape of Constable's, there pile up notepads of oil sketches of skies.[27]

This obsessive sketching draws circles around a riddle. On the one hand, as Constable put it, the sky "governs everything"; on the other hand, it is nothing tangible or definite. It is a kind of frameless framework. How was a painter to represent it? "Certainly, if the sky is obtrusive, as mine are, it is bad," Constable mused, "but if it is evaded, as mine are not, it is worse."[28] By nature, an artist makes something manifest. But how does one manifest the sky? Overeagerness, Constable felt, would chase away the sky or cause it to hang like a "white sheet," while omission to paint leaves human existence without its spiritual roof.

Constable trod a tightrope between over- and understatement: "The difficulty of skies in painting is very great, both as to composition and execution; because, with all their brilliancy, they ought not to come

forward, or, indeed, be hardly thought of any more than extreme distances are."[29] The difficulty of painting distance was nothing less than the difficulty of depicting the Romantic soul. How does one draw a personality that orients itself by the indefinite? Contemporaries were seized by an odd sense of disorientation before Constable's landscapes. Perhaps it is because they withhold focus and vantage. They deny there is a right perspective to take in our surroundings. This lack of perspective is the result of empirical honesty. Who are painters to impose vantage points when nature itself does not? Who are they to define where nothing in nature is still and clear and unalloyed? The importance of the sky in Constable's paintings stems from the sky-like nature of reality itself. Every appearance is a vanishing. But, unlike in German idealism, it is not the longing for reality that blurs reality; it is reality itself that blurs as a matter of being.

This is less the rediscovery of a Heraclitean universe than the loomings of the Darwinian biosphere, of nature spinning not like glockenspiel clockwork but churning like rapids. It is not the mind that warps reality; reality itself *is* a warp. Natural phenomena are clouds of organic forces: they swirl in and out of sight in delightful disarray. Any arising is a vanishing. In Constable's paintings of his middle period, such as the *Cottage and Lane at Langham* (1815) (fig. 15), the flinging, flurried brushwork he learned painting the sky now works furiously over the landscape proper. The barley field, the oak, the horse, and farmhouse are trellised in hurried, lashing brushstrokes. Nothing comes forward; nothing is imposed. Every appearance is accidental, provisional. Nature whirls and races away. Constable was poised on a great revolution in form—the one unleashed by the most adventurous of the Romantic masters, J.M.W. Turner (1775–1851).

Turner is the artist who most unapologetically knocked perspective out the landscape. (Ironically, the man drew a lifelong salary as Professor of Perspective at the Royal Academy.) The formal duality of earth and sky, far and near, place and event: Turner swiped it all aside, or rather threw it all into the same crucible, doing away with almost all vestiges of landscape and landmarks. His are not sceneries but organic, thermal, cosmic disturbances. Nothing stays put; nothing abuts anything else. No single thing is a thing. "If you yet have no feeling for the glorious passages of mingled earth and heaven which Turner calls up, art will never touch you," Turner's greatest champion, John Ruskin, said.[30] Art is the feeling for the transient: this is not Impressionism but straight-up Naturalism. For in nature there are no such things as lines.

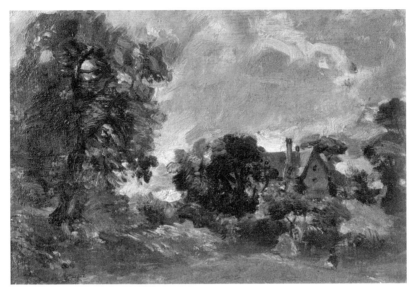

FIGURE 15. John Constable, *Cottage and Lane at Langham*, 1815. Oil on canvas. Courtesy of Art Resource.

No object stays curled up in its shell. Turner's world is the hot cauldron at the origin of life, the great seething burst of matter that still boils under the crust of what we mistakenly call objects.

The sea was best suited to convey this fissile world, and Turner immersed himself in the watery expanse, stormy seascapes that mingle water and sky, wash over landmarks, capsize the vessel. In *Ulysses Deriding Polyphemus* (1829), Turner depicts the Greek hero's escape from the cyclops's cave. Inside his cave, the one-eyed giant plans to devour Ulysses and his companions. He represents captivity, gravity, matter, the archaic world of landmarks and quiddities. Ulysses's flight symbolizes the escape from permanence into the open-ended, the interminable. Through this escape Turner issued his manifesto: the daredevil leap from the Classical thing-world and into the Romantic process-world. The painting is art's waving farewell to the canon of representation in place since the Renaissance.

The leap, of course, is a one-way trip. There is no sailing back to harbor, and the end of the journey, for many of Turner's storm-tossed steamers, is shipwreck. The theme was something of a motif among Romantic painters (Géricault and Delacroix produced dashing variations on the theme): shipwreck of course signals submersion in *nature*, the

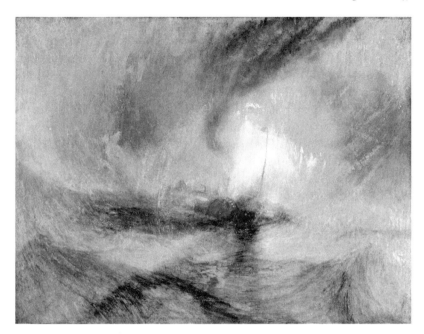

FIGURE 16. J.M.W. Turner, *Snow Storm—Steamboat Off at Harbour's Mouth*, 1842. Oil on canvas. Courtesy of Art Resource.

pantheistic drowning of the perceiver by the perceived. But only Turner worked out fully the consequence of this consummation: it leaves no room to play spectator. There is no time and place in a storm to compose a picture of sea, sky, and a horizon in-between. In the storm that is organic life we are always submerged, always in the roll and toss. The deluge, tellingly, was another one of Turner's choice motifs—no better reminder that reality floods us utterly and leaves no perch from which to draw leisurely pictures of the mayhem. Hence the sense of urgency in Turner's works, of paintings dashed off in the storm of the action.

Nature, Turner saw, is creative destruction: nothing appears that does not disappear and by disappearing draws the fuel to flare up again. This is the throb of reality: not things but whirlpools of transforming, transitive energy. An anecdote holds that, like Ulysses, Turner had himself tied to a ship mast to sketch the great inky blue and gray swirl of *Snow Storm—Steamboat Off at Harbour's Mouth* (1842) (fig. 16).[31] Turner saw the fallacy of separating subject and object. To perceive is to take part. A storm is the stormy experience thereof; to see is to sink.

Nor is the beholder's drowning solely the storm's doing. The perceiver too is a leaky vessel. Perception is full of gaps and chinks, a precariously stitched-up raft that barely stays afloat. We perceive but in part: nothing we see is ever contoured in the round. In this respect nothing is ever perfectly individuated. The outline we draw around things is mental shorthand for edges that in truth are only guessed at. A painter committed to showing what we see (rather than what we know) will reveal the slippery fraying fringes of perception. Turner understood that vision takes in water: it cannot contain itself, let alone the sea.

The wreckages Turner depicts, he means unreservedly for himself and for the viewer. His clippers always depart, always flounder, and when they come home, as in *The Fighting* Téméraire *Tugged to Her Last Berth to Be Broken Up* (1838), it is to suffer organized shipwreck. Better to die than stay put. And so Turner's hand: it sketched and sketched to the point where sketching took the place of painting, and the finished picture floated there, a defiantly and carelessly seaworthy craft—a sketch gloriously never to be perfected. What is more venturesome and dynamic than a sketch? And what feels more like artistic surrender? Turner honed his trade in watercolor, but the spirit of watercolor he never abandoned (he even horrified the purists by mixing oil and watercolor on the same painting!). In practice and in impression, watercolor is tentative; it hints, skirts, shadows its subjects. It is this suspended touch that Turner applied to his great oil paintings. Always loath to finish a canvas, the painter would often wait until the day of the exhibition to scratch the nick of paint that would mark a masthead in the formless whirl. Yet there is nothing about the supposedly finished works that looks more accomplished than the unfinished ones (such as *Norham Castle*). Turner labored to keep his paintings hanging in sketch-like suspense as long as it was feasible, staving off the moment they would betray their raison d'être by boiling down to a congealed state. At times, they appear to dilate to the breaking point, seeking maximum expansion and minimum compositional structure. They dilatorily smear and stretch—till that smearing and stretching becomes a work of art. Not just his paintings but also his *painting* practiced the interminable.

All is horizon in Turner. Everything is far, everything rushes away. Nothing obtrudes. The horizon isn't out there, an object of longing; nor is it consciousness gazing at its own infinity or at the disconnect between perception and imagination. The horizon is the substance of

reality, it swallows up the length and breadth of the landscape. We were fools to believe there was ever this or that. The horizon is all there is.

To summarize: we have uncovered two roots of Romantic formlessness. One is subjectivism (which begets a psychomorphic nature); the other is a biological pantheism (which sees nature as a maelstrom of creation and destruction). Both these visions are averse to fixed form. This aversion coincided with the social and political rejection of *Ancien Régime* society. It would be a stretch to say that all Romantics were sans-cullotists or Bonapartists; all, however, were conscious of loosening the screws of social restriction; all fought *against* something, *for* something. And whether one was a reactionary or a progressive, the great hidden arbiter was somehow always history—as either an old ballast to throw overboard, or an old god to propitiate.

This, at any rate, goes for European Romanticism. Imagine, however, a situation where the subjective thirst for unbridled expansion met a historically virgin land? What if, instead of historical hand wringing, it found a place and a moment that celebrated can-do spirit and opportunity? What is a Romantic in a land where everything is possible? For an answer, we must travel to the continent that was slowly drifting away from its European cultural dock, a new nation where the horizon was not just a philosophic conceit but the very landscape of life; where lives, politics, travel, commerce, and the arts stood before a frontier aglow with futurity: the American horizon.

Eden

Upstate New York, September 22, 1827

Joseph Smith (1805–44) was the fourteen-year-old son of a farmer from the tiny town of Palmyra, New York, when God the Father and Jesus the Son appeared to him in person. All religious creeds and denominations, they told him, were wrong. God was yet to hand down his final revelation. By and by, Smith began receiving the visitations of the angel Moroni, who, one day in September 1827, led him to a secret spot where an ancient race had buried golden tablets written in reformed Egyptian. An improvised philologist of the Holy Spirit, Smith proceeded to translate this unknown language (subsequently mislaying the plates) and collect its sayings in a new bible known as the Book of Mormon.[1]

The book brims with astonishing claims. Smith tells of ancient Hebrews sailing from Israel in the sixth century B.C.E. and founding a Hebraic culture in the wilds of New England. There, according to Smith's dictation, Jesus chose to resurrect and walk and talk with the American Hebrews. Their Hebraic civilization thrived until around the fall of Rome, whereupon the dark-skinned race of Lamanites (the forebears of native Indians) massacred the fair-skinned Israelites to the last man. Of this civilization, nothing remained except for the buried tablets, discovered fifteen centuries later by Palmyra's own prophet cum archeologist.

Amazing as it is, Smith's tale is fairly run-of-the-mill Mosaic and Mohammedan revelation stuff. Its prose is standard Sunday-pulpit lore, its rhetoric a sonorous rehash of Bible-thumping cadences. Its

success (it still propels the young and thriving Mormon religion to an apparently bright future) stemmed less from theological subtlety than its timely birth in the religious hothouse that was the early-nineteenth century United States.[2] Its other lucky talent was to meet the psychological need of an adolescent nation that itches to emancipate spiritually from the parent civilization; the necessity to vindicate this emancipation by throwing a direct line to a more authentic, more ancient, and less degraded religion; and finally to anoint the rebellious upstart with promises of an irresistible destiny. Smith's revelation indeed scoops out the entire European history of Christianity and claims direct descent from biblical Israel. Christendom drops out of sight. America is a beachhead of the Holy Land, more venerable than Europe, while Jesus himself, a proto-American, had once walked upon these shores. Modern Americans were therefore his spiritual descendants. The New World managed the feat of being at once more ancient yet and more pristine than Europe: Jerusalem and Eden in one package.[3] In America gods had walked among humans, the immanent and the transcendent had met, a gateway had opened between the temporal and the eternal.

There henceforth could be no doubt as to what being an American meant: to swing this gateway open again by restoring Jesus to his chosen land. As Joseph Smith stated in his spiritual testament, the Wentworth Letter: "We believe in the literal gathering of Israel and in the restoration of the Ten Tribes. That Zion will be built upon this continent. That Christ will reign personally upon the earth, and that the earth will be renewed and receive its paradisiac glory."[4]

In truth, not even the vision of restored Eden bore much originality. The blending of the theological and the historical colored the first sightings of the American continent. Columbus whetted Ferdinand and Isabella's interest claiming he had mapped his voyage from the Book of Isaiah, in which God promises to gather the tribes of Israel into a land that would be "an ensign for the nations" (11:12). Amerigo Vespucci also believed that, sailing westward, he would land on God's very shore: "And surely," he insisted, "if the terrestrial paradise be in any part of this earth, I esteem that it is not far distant from these parts."[5] Travel literature of the Renaissance is aglow with Edenic sightings, and it is a similar utopianism that animates the framers of the American nation who, however thoughtfully they worked to keep the cross and the flag separate, could not resist the theological shimmer of the American circumstance. Thomas Jefferson (1743–1826) lyrically described Pennsylvania as "a

veritable Eden, with its streams swarming with fish, its meadows with hundreds of songbirds."[6] In his *Rights of Man,* Thomas Paine imagines the United States existing in the margin of human history: "The case and circumstance of America present themselves as in the beginning of the world. . . . We are brought at once to the point of seeing government begin, as if we had lived at the beginning of time. The real volume, not of history, but of facts, is directly before us, unmutilated by contrivance, or the errors of tradition."[7] By wiping the slate clean, America offered a glimpse into the beginnings of history, freeing its participants to build a secular Eden, the city on the hill where man would live as man and be all that he is and can be. Humankind had been given another chance to do it right and *was* getting it right. To those of a religious mind—and there was no shortage of them in New England—this meant that America would actualize what is eternal, unchanging, and divinely decreed in us. The term *Manifest Destiny,* coined by John O'Sullivan's tract of 1839, gives off a strong enough whiff of this theological brew: "In its magnificent domain of space and time, the nation of many nations is destined to manifest to mankind the excellence of divine principles; to establish on earth the noblest temple ever dedicated to the worship of the Most High. . . . This is our high destiny, and in nature's eternal, inevitable decree of cause and effect we must accomplish it. All this will be our future history, to establish on earth the moral dignity and salvation of man—the immutable truth and beneficence of God." This heady stuff was actually a staple of nineteenth-century American oratory. The notion that history features a rational terminus was of course not an American invention (Renaissance utopias and Enlightenment theories of the perfect and terminal social order, whether Kant's Kingdom of Ends or Hegel's Supreme State, had cleared the path); the American originality was to crossbreed secular utopianism with the prophetic biblical tradition.

In comes Joseph Smith. His revelation lined American Adamism with religious reinforcement, a religion not of kingdom come but of kingdom fulfilled, the New Jerusalem which, glimmering in Isaiah (65:17–18), fired the religious revivalism of America's early nineteenth century. Known as the Second Great Awakening, this evangelist fever saw waves of mass conversions, camp meetings, and collective ecstasies that spread out from the Eastern states to the South and West.[8] As Europeans deserted churches and many in positions of influence openly professed atheism (George Eliot, by her own report, stopped going to church in 1842,

as did many others: Michelet, Renan, Burckhardt, etc.), Americans flocked en masse to the temple, built religious colleges and universities galore, produced at least one messiah, and saw major thinkers such as Ralph Waldo Emerson and poets such as Walt Whitman speaking in an unapologetically religious vein.

A recurring feature of this motley Second Great Awakening was a millenarian conviction of Jesus's proximate return and the end of history.[9] One William Miller, self-anointed leader of the Seventh-Day Adventists, even penciled the end of the world for October 23, 1844. At first blush, it may seem paradoxical for a young, hopeful nation to brood over history's end. But millennialism really sees no distinction between the kingdom of man and the kingdom of God: the former's job is to bring forth the latter. American millennialism was really of a piece with its Adamism: both played on the conviction that America extended Jacob's Ladder to the divine, that the theological horizon was crossable. This divinity of the land, of the present moment, the rapture of the immanent by the transcendent—these elements all magnetize Joseph Smith's vision of man suffused by the divine essence. According to his gospel, God had once been a man, and it was in every human being's potential to become a god. The Mormon believer lived as a god-in-waiting, and Smith's Follett Discourse proclaimed the difference between God and man to be a matter of time, not essence:

> God himself was once as we are now, and is an exalted man, and sits enthroned in yonder heavens! This is the great secret. . . . We have imagined and supposed that God was God from all eternity, I will refute that idea, and will take away and do away the veil, so that you may see. . . . It is the first principle of the Gospel to know for a certainty the character of God and to know that we may converse with him as one man converses with another, and that he was once a man like us.[10]

America was the cosmic corner chosen by timelessness to burst forth: the floodgate between history and eternity. In the religious heart of the Mormon believer, history had already come to an end. The American edge of humanity had, for all we knew, gone beyond the horizon of time.

Two opposite visions therefore tugged at the American landscape. The first, that of Manifest Destiny, sang high the praise of America, land of human endeavor—canny, grounded, entrepreneurial, future oriented; the second imagined an America floating in divine pre- or posthistory. In *Leaves of Grass* (1860), the poet Walt Whitman (1819–92) brings the two myths lip to lip. Now, America stands for historical self-determination:

All the past we leave behind,
We debouch upon a newer, mightier world, varied world,
Fresh and strong the world we seize, world of labor
and the march,
Pioneers! O Pioneers! ("Pioneers! O Pioneers!" lines 19–23)

Now it is the land of divine prehistory:

To the Garden the world anew ascending. . . .
By my side or back of me Eve following,
Or in front, and I following her just the same. ("Children of Adam,"
lines 1–3)

How did Whitman match infinite reach with the divine garden?

We will sail pathless and wild seas,
We will go where winds blow, wave dash, and the Yankee
clipper speeds by under full sail. . . .

To see nothing anywhere but what you may reach it and pass it,
To conceive no time, however distant, but what you may reach it and
pass it,
To look up or down no road but it stretches and waits for you, however
long but it stretches and waits for you. ("Pioneers! O Pioneers!" lines
128–30, 170–75)[11]

This is the future seen not as promise but as entitlement. American
Protestant theology has nothing but suspicion for the redemptive pow-
ers of self-maceration.[12] Human will—the house of history—is not the
twisted wayward thing Augustine bemoaned but a guide to the house
of eternity. The American horizon is a property of America, not a mere
aspiration. This is where it breaks with the European Romantic, quietist
poetry of the horizon. To the American soul, the distance can be reeled
in, the unreachable is within reach, and transcendence is immanent. In
short, the horizon is already here, in us or even behind us. It is always
happening: Americans are it.

There is, on the one hand, nothing quite so American as the horizon:
the land of the setting sun, of the Western prairie, of the vast frontier:
"the great nation of futurity," as O'Sullivan said. The horizon is an oblig-
atory fixture of the American myth: From Lewis and Clark, the Get-
tysburg Address, *Moby Dick,* the Western movie, the Apollo Missions,
Rothko's paintings, to *Star Wars,* the horizon provides the common
metaphor. Alongside this futurity, however, is the belief that America has
it right *today,* that, again in O'Sullivan's words, it establishes "on earth

the moral dignity and salvation of man." The future of America is the eternity of history's end: it promises ever-better tomorrows, but these tomorrows really bring nothing new, for perfection already suffuses the believer's heart. As Harriet Beecher Stowe, the nineteenth-century evangelical, put it: "If we *know* we have the power to do all that God requires—if we *feel* that we have—nay more, if we are so made that we never can *help* feeling it—what matter is it if we cannot see *how* it is."[13] No human falling short of God's plan do we find here; passionate self-belief absorbs belief in God and becomes a religious emotion in its own right. Joseph Smith's clever move was to transmute this conviction into a full-fledged theology of man-become-God.

America is the land of tomorrow but also land of the end of tomorrows. This bizarre duality, I want to argue, gave birth to the first genuinely American artistic style—the Hudson River school. The Hudson River school was not an academe but a group of like-minded painters who, in the persons of Thomas Cole (1801–48), Frederick Church (1826–1900), Albert Bierstadt (1830–1902), and John Kensett (1816–72), lived and worked in the eastern United States and shared an affinity for grand-scale landscape painting. They produced an artistic landscape blending radiance, innocence, and bombast, which is unmistakably original.[14]

What first strikes the viewer is the monumental size of these paintings—sometimes up to ten feet across. A big landscape, so these artists must have thought, demands comparable bigness in depiction: big bay windows for a big sky, a matching logic that climaxed in 1849 when one Henry Lewis rolled out his titanic forty-five-thousand-foot painting, superfluously titled *Mammoth Panorama of the Mississippi River*, at the Louisville Theater. A similar though less gimmicky one-upmanship guides the paintings of the more accomplished artists Cole and Bierstadt. Cole's eight-foot-wide *Niagara Falls* (1857) seems to want to match the great waterfalls inch for inch. America is big. Bigness requires a big eye. And a big eye not only sees big, but also sees *everything*. For all its scope, the Hudson River school landscape goes for the supernaturally detailed. An obsessive, scrutinizing eye has polished each detail back to its specific, God-given individuality, no matter how far or seemingly incidental in the overall composition. In Bierstadt's *Lander's Peak* (1863), every moraine, every blue boulder, every pine and alder on the foothills, every tent and packhorse of the Indian camp is rendered with piercing photographic accuracy. The Hudson River painter combs his landscape the way God toured his creation on the seventh day, with

crystal-clear awareness of both sum and items. An equal-opportunity recorder, the painting depicts reality as only the Supreme Being sees it: clairvoyantly.

Hence the odd blend of pragmatic realism and airy-fairy idealism. The Hudson River school scenery kindles practical concerns (one catches oneself estimating the cubic tonnage of all that cataract in Cole's *Niagara*); meanwhile it sparkles with the diamond dew of Eden. It is both photograph and pious illumination. History and eternity, existence and essence, progress and permanence tug at the landscape. By wanting it all, the American painter fused artistic strands that, in Europe, had been laboriously picked apart since the decline of the Gothic. Living in a land beyond history, the American artist bundles all historical style (Gothic, Classic, Realist, Romantic) into one mix and serves it on a grand stage Barnum-like in size and bigger-than-life in effect.

Gothic the Hudson River school is, given the inescapably theological directedness of the American landscape. To the nineteenth-century settler, the land was more than mere "stuff." It was a plan, a destiny, a biblical foldout. Nature was allegorical and pointed beyond itself. As America's chaplain Jonathan Edwards (1703–58) said, "The immense magnificence of the visible world in inconceivable vastness, the incomprehensible height of the heavens, etc., is but a type of the infinite magnificence, height, and glory of God's world in the spiritual world: the most incomprehensible expression of His power, wisdom, holiness, and love."[15] Behind the colossal scale and wonder and danger, the hand of divine wisdom holds steady. For all the terrifying forms, it is clement: a garden. The corresponding aesthetic is therefore Classical (contained) and Gothic (transcendental).

Yet the Hudson River school painters could not fail to be Realists either. There was an aboriginal rawness about the American wilds that no European painter could have found in the deforested, manicured, bucolic European countryside. The transcendentalist poet William Cullen Bryant (1794–1878) pitied Europe for bearing "everywhere the trace of man, / Paths, homes, graves, ruins, from the lowest glen / To where life shrinks from the fierce Alpine air" ("To an American Painter"). But there was nothing tame or shrunken about America. Its immensity recommended a rugged, clear-eyed approach, not French topiary niceties. Blunt reality called for a steady brushstroke, and the flurried apoplexy of a Delacroix or the glum-eyed patchiness of a Manet were clearly not called for. Besides, the world is a sum of raw materials and resources; it is important to be precise

about these contents. For all his majesty, you can feel Bierstadt's daubing in each blade of grass with a precision that smacks of the counting house.

But pragmatic clear-sightedness did not rule out Romantic bluster. The American landscape was not just a natural setting; it was a conquest foretold. To be sure, the Californian Sierras were mighty things, but how much more magnificent were the men and women who blazed new trails over mountain passes! The landscape itself proclaimed human agency. It challenged but in the end bowed before the pioneer spirit. For Americans had conquered the land, brought its natives to heel, plowed railway lines into the wild. These epic achievements alone were an apotheosis of the Romantic will and demanded epic treatment. The land cannot limit the American soul because the American has no other measure than his power. "I know I have the best of time and space, and was never / measured and never will be measured," sings Whitman ("Pioneers! O Pioneers!"). Nature is awesome, but conquering man proves more awesome still. "Is there a measure on earth?" Hölderlin had asked. The American conqueror had no trouble asserting that this measure was man. There is nowhere human will power cannot penetrate. One finds plenty of fiery sunrises and sunsets on the Hudson River school paintings. But the razzle-dazzle of their horizons is really the refracted glow of the pioneers who march into it, as in Bierstadt's *Emigrants Crossing the Plain* (1867). The light that shines on the world is really the light man casts on it.

Now, juxtapose these stylistic layers (the Gothic, the Classical, the Realist, the Romantic) and one gets the huge and beautiful thing that is the Hudson River style. At first blush, the paintings seem too beautiful—like the cloying gild of a Victorian grand hotel. "Some of Mr. Bierstadt's mountains," said Mark Twain in a backhanded compliment, "swim in a lustrous, pearly mist, which is so enchantingly beautiful that I am sorry the Creator hadn't made it instead of him, so that it would always remain there."[16] These landscapes are too beautiful indeed to be true, too eager to impress. The alabaster cumulus clouds on Frederick Church's paintings are too windswept, too engorged; when they are big, they are plump; when they are thin, they zip through the sky like comet tails; they are everything clouds can be but never are at any one moment. The tangerine tints are too nacreous, the pinks too cherubic, the blues too baby-eyed; the waterfalls are diluvial, the forests awesomely primeval, and the world generally too compliant with our insistence that it be beautiful.

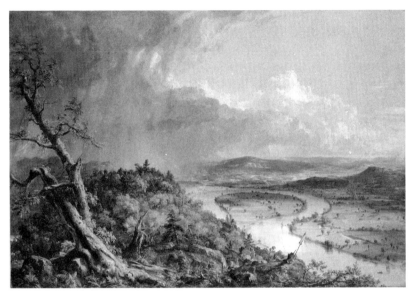

FIGURE 17. Thomas Cole, *The Oxbow*, 1836. Oil on canvas. Courtesy of Art Resource.

Who says a landscape cannot be heroic, bucolic, pastoral, idyllic, ancient and modern, tamed and wild, sunny and forbidding all at once? Thomas Cole, for one, will have it all. In *The Oxbow* (1836) (fig. 17), the landscape manages to be prim farmland and Arthurian mountainscape all at once, with fairytale clouds here and Wagnerian thunderheads there, happy woodlands and a blighted petrified forest, sun and rain. It is not a landscape but a compendium of all that a landscape can and should be, an early specimen of, in Arthur Danto's phrase, "the genre of American overstatement."[17]

Overkill, of course, is excessive with respect to a stylistic canon. But the example of precedents and authority did not intimidate American art. The artist does not belong to a history of styles; rather, the history of styles belongs to the artist. In this sense, the American artist worked in the eternal, pristine present of creation. As that philosopher of the American frontier spirit, Ralph Waldo Emerson (1803–82), says: "Our age is retrospective. It builds the sepulchers of the fathers. It writes biographies, histories, and criticism. The foregoing generations beheld God and nature face to face; we, through their eyes. Why should not we also enjoy an original relation to the universe? Why should not we have a poetry and philosophy of insight and not of tradition, and a religion by revelation to us, and not the history of theirs?"[18] A new land called for a new way of

seeing, uncowed by predecessors. "Let me admonish you, first of all, to go alone; to refuse the good models," Emerson urged his audience.[19]

Of course, the more frantically we disown our models, the more we acknowledge their importance. In terms of composition, the Hudson River landscape owes a great deal to Claude Lorrain, the seventeenth-century classicist; in chromatic terms, it is difficult to ignore the debt to Turner. The charm of the Hudson River school lies in its belief that it could have them both, regardless of the conflicting worldviews. Either the world is a garden à la Lorrain or it is a volcanic eruption Turner-style; either it is teleological or it is organic. A particular painting by Cole, *Expulsion from the Garden of Eden* (1828), presents a rare example of reckoning with these clashing worldviews. The painting shows a rocky alpine bridge thrown across the chasm between lush Eden (painted in the twinkle-eyed, prismatic palette of illuminism) and a sulfurous, wind-blasted mountain-scape à la Turner. Adam and Eve are chased out of the east gate; they leave behind the crystalline right half of the painting and head into the turbulent left half. It is an oddly divided canvas. Two artistic universes stand side by side as though in admission that we cannot have it both ways, timelessness and history, innocence and awareness, the bounded garden and the open universe. Their dissonance is glaring and, if intentional, marks a rare moment of artistic self-consciousness.

By temperament, however, the American soul believes it *can* have it both ways, the Edenic and the epic, history and eternity. Because the American born-again soul did not recognize the history of Europe as its own, it was able to borrow its styles as mere ornaments disconnected from their native worldviews. (The only style it left alone was the Baroque, because the Baroque aesthetic is doubt, and the nineteenth-century American is anything but skeptical.) This hybrid of the Edenic and the epic accounts for the surprising and, on the face of it, counterintuitive claim I am about to argue: though the horizon features sumptuously on the Hudson River landscape, it is a trumped-up horizon; its whole candied splendor covers for spiritual vacuity.

On the horizon, nature outstrips human perception. It forces man to acknowledge his finitude in the cosmos. This is why artistic horizons arose, together with landscape painting, at the turning point in Western history where men and women began contemplating mortal limits in a secular frame of reference: when, during the Renaissance, the finitude of human existence was profiled against the earthly landscape rather than the eternal heaven. The horizon arises out of a feeling of transcendence

unfulfilled. It is the *hope* for transcendence rather than transcendence proper. One must be *mortal* above all, not one of the redeemed, to see horizons.

For this very reason no horizon can loom in Eden. The born-again American religion is prelapsarian: it is not a religion of human fallenness and sin but of man reborn in God and returned to moral infancy—a human being who carries on as though death is no more. The pristine American soul does not need to long because, as Harold Bloom argues, it sees itself as already fulfilled. The twinkling turquoise and peach-pink horizons of Church's or Kensett's landscapes are not there to instill the longing for infinite things. Eden knows no longing. They are a pictorial code the Hudson River school painter lifted out of quattrocento art without subscribing to the moral sentiment that originally nurtured it. The fluorescent gorgeousness of these distances, their caloric charge is inversely proportional to their spiritual content. They are sumptuous toys.

A toy indeed is what becomes of the horizon in one of Cole's most curious paintings, *The Titan's Goblet* (1833). This tellingly smaller canvas depicts a colossal chalice towering over a landscape. Inside the goblet is an entire sea, complete with ships and a harbor: it is the proverbial ocean in a cup, the fulfilled fantasy of drinking up the sea, of the part embracing the whole. It conveys that there is nothing too vast, not even the horizon, for the irrepressible human spirit to consume. The transcendent *can* be captured. As Whitman wrote, "The boundless vista and the horizon far and / dim are all here, / And this is ocean's poem": "here" being the poem, that is, human utterance. Says Emerson: "The whole of nature is a metaphor of the human mind."[20] Emerson and the Hudson River school painters were emissaries of European Romanticism finding in America a place of minimal social restriction where the soul could fully indulge freewheeling subjectivity. Where man faced an unclaimed land, it was indeed easy to believe that the boundaries of nature and those of human power matched toe to toe.

"The paintings of Cole," the American Romantic poet W. C. Bryant declared on the occasion of the painter's death in 1848, "are acts of religion." It depends on what is meant by religion. If religion means bending the knee before a being infinitely beyond grasping, if it implies spiritual vassalage, then the American soul is unwittingly irreligious. If, on the contrary, it means democratic kinship between humanity and God, if it suggests that man can perfect God's work, and that holiness lies within, in the human heart rather than in some unnamable Other, then indeed a painter like Cole is religious and a poet of the immortal

self, like Whitman is also religious. But this means accepting that a verse by Whitman such as "And nothing, not God, is greater to one than / one's self" is not blasphemous, that to blot out the distinction between divinity and humanity is sound religion, and that man's role is to sink the horizon into the human goblet.

In a basic sense, the American divinization of man pressed the Protestant revolution to its logical outcome. The Reformation had placed religious authority with the inner self. God, it asserted, spoke preferably out of the believer's individual conscience rather than the mouth of priests. The philosophy known as Transcendentalism is America's first original contribution to philosophy, and it shows how quick the three-stop journey is from church religion to inner religion to the religion of selfhood. Emerson argued that the *I* can act as a divine intercessor because the self partakes of divine nature: "Man is the soul of the whole; the wise silence; the universal beauty, to which every part and particle is equally related; the eternal ONE."[21] To honor this deity who rents space in us, therefore, we must honor our self: "The Sublime is excited in me by the great stoical doctrine, Obey thyself. That which shows God in me, fortifies me. That which shows God out of me, makes me a wart and a wen."[22] Given that "the Highest dwells in me," it follows that whoever dedicates himself or herself to the Highest, to God, learns to live as the Highest. As Emerson puts it, "The simplest person who in his integrity worships God, becomes God."[23] It is no small irony that to call Transcendentalism a philosophy thus finishes off the transcendental. For when paradise is within, man need not yearn for a kingdom over the horizon: transcendence is superfluous; transcendence is dead.

In general, the American religion leads not man to God, but God to man; it seldom asks the believer to submit to the difficult otherness of God, nor does it force us to acknowledge the insuperable limit between the earthly and the numinous.[24] Its theology is this-worldly, its liturgy exalts the believer on the lone frontier of conviction. As the theologian Reinhold Niebuhr (1892–1971) said, the American experience "tends to define religion in terms of adjustment to divine reality for the sake of gaining power rather than in terms of revelation which subjects the recipient to the criticism of what is revealed."[25] In religion, this pragmatic habit of adjusting beliefs to utility begets a believer who is temperamentally indifferent to the transcendental, and who is given to regard God as an obliging helpmeet rather than the immutable ground of Being.[26]

This reluctance to strain the imagination past the human, this incuriosity about the cosmic and trivialization of the Godhead, threads

through the Mormon revelation. Thus Joseph Smith's Follet Discourse: "Yea, that God himself the Father of us all, dwelt on an earth the same as Jesus Christ himself did. . . . I might with boldness proclaim from the house-tops that God never had the power to create the spirit of man at all. God himself could not create himself." Smith asks, "What kind of a being is God?"[27] His astonishing answer, as we have seen, is that God is just *a* being, not Being. Though now immortal, he was once born. Having de-deified God, Smith's next move is bolder still. He asserts that God was never in the position to create the immortal spirit of man. And if God could not create the human spirit, it must mean that it is more enduring or eternal than God himself: this is not far from the transcendentalism of Emerson, except that it is radically indifferent to what transcends the human scope, hence not in the least transcendentalist. What is being? Whence does it come? Smith displays stunning indifference to these perennial questions. God is customized to fit an epic of human self-empowerment, which is grooming the American soul for conquest. The American circumstance produced a theology strangely devoid of awe: a religion of no horizon; a religion of the nongodlikeness of God, which enshrines the banality of the cosmos. In sum—and herein lies the utter strangeness of Mormonism—it is a religion of atheism. And the American miracle of it all was to pass Mormonism off as religion, though it was perhaps religion's empty husk.

To be sure, Smith's vision is highly eccentric—even though, a century and a half later, his religion inches ever deeper into the Protestant mainline. For our purposes, the idea that Mormonism is actually a religion of atheism casts an intriguing light on the alleged "American exception," that is, its fervent religiosity amid the growingly atheistic West. The religious feeling that spoke through the prophets, philosophers, and poets of the American experience was not God centered. In fact, it followed the modern tendency to sideline the transcendental and create a world made to man's measure. American religiosity did not rebuke the Enlightenment trust in human agency or humble the Romantic assimilation of world to self; instead, it worked their anthropocentrism into the religious canon.

Time will tell whether Smith's revelation is destined for the global success of his predecessors, Jesus and Mohammed. Meanwhile, it is probable that the current religious revival marching under the battle standard of evangelical Christianity and that speaks of "maintaining a personal relationship with God" in some way or another harbors a version of Smith's vision of deified humanity. (The relationship with

God, as mystics have always known, cannot be personal: *God* entails release from human self-regard and egotistical attachments, indeed anything related to the personal—whereas the evangelical born-again cant about "accepting Jesus into one's life" sands down God's edges to fit the human vessel.) These are the symptoms of a disaffection with the religious sublime from which, it seems, the horizon is bound to vanish.

In its wake, there arises the ironbound world of modernity, the machine society, the annexion by science of all facets of life. To this world we now turn.

The Mathematical Age

Flatness

Murnau, Bavaria, 1908

Until 1908, Wassily Kandinsky (1866–1944) had been a talented, unassuming artist who had taken up painting after a bumbling start in the legal profession. Soon a figure of the Munich art scene, Kandinsky made his name painting attractive landscapes in the smudged manner of Fauve artists like Henri Matisse, with elements of Paul Cézanne's paneled style and Paul Gauguin's crazy-quilt color schemes. They were pictures of Bavarian towns and waterfalls, of horse riding in autumn, dachas in the countryside, boats on the Volga, with evocative titles like *Old Town, Moscow Environs,* or *Landscape with a Locomotive.*

Then in a matter of months, there came an astonishing, sudden change: the landscapes simply vanished. There were still tokens of real-life objects wedged here and there in the kaleidoscope of pigments (a belfry, a footbridge), but by and large the thread of reference to the external world mostly was lost. Gone, too, were the evocative titles, replaced by numbered compositions, improvisations, and impressions. What happened to break the concord between painting and the world was Kandinsky's artistic epiphany of 1908.

It occurred during one of the painter's stays in the town of Murnau at the foothills of the Bavarian Alps. Returning from an afternoon of sketching landscapes, he stopped dead before the following sight: "On opening the studio door, I was suddenly confronted by a picture of indescribable and incandescent loveliness. Bewildered, I stopped, staring at it. The painting lacked all subject, depicted no identifiable object and

was entirely composed of bright color-patches. Finally I approached closer and only then saw it for what it really was—my own painting, standing on its side. . . . One thing became clear to me: that objectiveness, the depiction of objects, needed no place in my paintings, and was indeed harmful to them."[1] It begins with misrecognition, a lopsided painting that throws Kandinsky off his visual guard. A picture, he discovers, still remains a picture when it mimics nothing from the real world. A work of art need not be a mirror of external things; it is a reality in its own right. Take representation out of art and art still stands, as strong as ever.

Nonobjective art (later known as *abstraction*) was born. In actuality, it had been a long birthing effort that had run over the better part of the nineteenth century. By the time the Impressionists astonished the Parisian public in the 1880s, the ocular impression of reality had clearly nudged ahead of reality proper in painterly circles: *how* a painter saw trumped *what* he saw. Abstraction radicalized this shift. Composition, internal play, forms, and colors eclipsed veridical representation. The terminology of Kandinsky's titles (*composition, improvisation, and impression*) relates to process and craft, not imitation. In a broad sense, Modernist abstraction brought Romanticism to fruition: it finally secured the ascendance of the subjective over the objective.

This idea that there was no "other side" to the painting, that the work of art needed not appeal to any reality other than its own internal balance, struck at the already tattered ideal of transcendence. It is hard to overstate how thoroughly this vision upended long and deeply held ideas about art. "Anywhere out of the world!" shouts the title of a prose poem by Baudelaire: this hunger for the otherworldly animates Western art up to the twentieth century. Inasmuch as a work of art projects an image, it looks beyond the actual into the virtual. It thus leaps "out of the world," *transcends* reality, and beckons to a place beyond the line at the end of the world.

But the age of Kandinsky called into question this otherworldly flight and soon ordered it back to the ground. For the Modernist, the leap "out of the world" was mere escapist denial, craven, effete, anti-art. A work of art worth its salt should not detract from the image it is made of; it should emphasize the material stuff, the assembly, the nuts and bolts.[2] In equal measure, it must hustle out of sight the scene, the landscape, the moral instruction, indeed anything in terms of which the work of art may acknowledge a social master.[3] God or the world or man or society was no longer the whole of which the work of art was

the serviceable part. The work of art could be a world in its own right, a windowless totality.

Socially, the nontranscendent work of art marched in step with the age of science, with the retreat of religious ideals and the rise of the machine spirit. A machine is a logical arrangement whose excellence is determined by function. Science and large-scale industrial mechanization gradually trained people in the nineteenth century to regard nature, society, and even the human psyche as machine-like (sociology, biology, and psychology all cast their style of inquiry in the terminology of systems). Artists were alive to this systematic new way of redrawing the world. In the last decades of the nineteenth century, painters like Paul Cézanne (1839–1906) took to referring to their works as self-contained engines of form production. If the painting turned out to look like the landscape in the end, it was not for slavish imitation but because the "system" worked. The pointillist Georges Seurat (1859–91) sought to break color down to the basic building blocks and laid out his paintings into systematic chromatic tables. Like every living thing, art was thought to adhere to laws—laws not dictated by the Academy of Beaux Arts but by the Academy of Science.[4]

A principle common to artistic representation since the Renaissance was the desirability of *depth*: an image, be it plastic or musical, *leads* out to the world. It is two dimensions pretending to be three. But this is just the pretense that Kandinsky and his fellow Modernists no longer wished to keep up. Why should the work of art apologize for its material existence? What can't it stop feigning coyness and step frankly up center stage? Modernism arose from this newfound self-assurance that, among other things, brought flatness back to the picture plane in a way not seen since medieval icons.

In fact it is the Byzantine style that the Viennese artist Gustav Klimt (1862–1918) resurrected in his hieratic gold-leaf backgrounds of bejeweled nudes. Immodest his female figures are, not just for their sexuality, but because they make no secret of being creatures painted on a gilded panel. They don't pretend to be ethereal. Their flesh is the flesh of the world. The German poet Hugo von Hofmannsthal (1874–1929) was vainly reviving a dead idea when he declared that "our present is all void and dreariness / If consecration comes not from without."[5] After 1910, the expression of this thought was all but a faux pas. In any case, it struck Cubists, Futurists, Supremacists, and assorted Constructivists as profoundly irrelevant. Flatness and matter-of-factness were not the sworn enemies of aesthetic genius. It was wrong to suppose

that art always sides with enchantment in the face-off between science and fantasy. Art and knowledge, the Naturalist Émile Zola argued, need not be at loggerheads. In fact, there was aesthetic delight to be had from the actuarial tables and branches of scientific nomenclature. The artist put on a white frock and approached the piece of art like a laboratory experiment. Scientific determinism even gave off a kind of tragic fatality not averse to a good story (Zola, Thomas Hardy). At any rate, the age-old link between art and lyrical, soulful, misty expression was not irrevocable. A group of poets and artists, fronted by the Italian Filippo Tommaso Marinetti (1876–1944), called for a machine-age art they labeled *Futurism*. Futurists exalted the bang and rattle of engines, the sharp angularity of modern design, the beauty of relentless, blunt juxtapositions. Many were drawn to the purity of machines: their austerity, their lack of guile or affectation, their economy of means.[6] It was a commendable model. Geometry was a sign of moral purity and truthfulness—qualities essential to the making of beauty. In 1915, the Russian Constructionist artist Kasimir Malevich exhibited a painting titled *Black Square,* which was exactly that: a painted black square on canvas. At the start of his career Malevich sought to unveil the geometrical structure of reality; later he tossed out reality and kept only the geometry. His black square was a tight-lipped statement awaiting neither consecration nor justification from without. The concept (square) fulfilled itself in the presentation; and the presentation was nothing more than the geometrical idea. The painting flattened perception and meaning alike: a work of perfect nontranscendence.

Ever since the Gothic, the work of art had quietly defended the ideal and virtue of depth: depth of space, of feeling, of meaning. But is space *in itself* deep? Near and far stand relative to a viewer. Depth of space is merely the perceived distance between the observer and a given object. It is this primacy of percipience that Modernism disowned. Flatness was a desideratum that bore not just on the object of expression but on its subjective source. Thus a tone, a style, a diction could be flat, that is, devoid of sentimental self-preening. Among the offshoots of Modernism, Cubism militantly and patently set to demolish the myth of a deep, central, Romantic subjectivity. Cubism, the painter Georges Braque (1882–1963) said, sprang from the wish to destroy perspective painting, which he called "a ghastly mistake, . . . a bad trick."[7] Why a bad trick? Because it lies. Real space does not spread out from an ideally located observer. The latter is always embedded in space that flows

under, above, and inside of us. This much the Romantic artist had made grandiosely clear. But, consistent with the mechanistic bias of modernity, the Cubist artist was not so sure about the homogeneity of space. Space opened between one's foot and head, or one's hand and elbow. But was it the same space in every case? And could we really smooth it out evenly? Influenced by Henri Poincaré's non-Euclidian geometry, Braque aimed at "materializing space" by showing the blunt, manifold, almost solid volume and mass of space—indeed *volumes* in the plural because space splinters infinitely across objects and perceptions. This inspired Braque and Picasso to depict an object concurrently from multiple viewpoints—showing, as it were, the kaleidoscopic nature of space.[8] Faceting the object smashed up the seamless world and the seamlessly single observer: no one can see the back, side, and front of an odalisque simultaneously. By showing back and front at once, the cubist painting presented something no one could have seen, hence a *depersonalized* image of reality. "Picasso and I," Braque wrote, "were engaged in what we felt was a search for the anonymous personality. We were inclined to efface our own personalities."[9] So long as there is a perceiver, there is a personality and therefore lyricism. Cubism wanted both out of art, and in doing so hammered the picture flat and broke it up, leaving minute samples and shards of reality. A good representation will show the fault lines between acts of perception and expose the mendacity that consists in welding space. This assault on the synthesizing force of subjectivity came to a head when, after 1910, Braque and Picasso began experimenting with collage.

Collage is a signature creation of twentieth-century art; its influence runs through abstract expressionism to pop art to film and advertising. It de-romanticized the role of the artist, from creator to rag picker. Collage meant quoting reality rather than expressing it: cutting and pasting it on the canvas, free of transfiguration. As Hugo von Hofmannsthal stated in 1905, "The nature of our epoch is multiplicity and indeterminacy. . . . Everything fell into parts, the parts again into more parts, and nothing allowed itself to be embraced by concepts."[10] Collage (T. S. Eliot's "heap of broken images") did not pretend to conjure up a livable world: it picked up its fragments one by one and laid them "as is" on the table. It was both flat in tone (laconic) and in appearance (two-dimensional). In literature, collage inspired the technique of automatic writing practiced by surrealists such as André Breton and Philippe Soupault in *Les champs magnétiques* (1920) to replace

intentional expression with the impersonal jottings of the unconscious mind. The surrealist who let his pen run free on paper was not exercising freedom (which assumes conscious choice) but allowing the nameless machinery (the seismographic needle of free association) to replace his personality. He was not projecting a world; he merely opened a valve. Squashing the Romantic self was paramount there too. The tutelary spirit of surrealist chance poetry was of course Sigmund Freud's theory of the unconscious, which burst upon the scene with the publication of *The Interpretation of Dreams* (1899). Seemingly a vestige of the Romantic creative self, the unconscious in reality opened a well of impersonality in the human psyche. The *id* was the "it" that hummed inside the human animal. At bottom, the self was not a soul at all, but a system of upward and downward pressures, bursts and sluicegates whose laws Freud, who fancied himself a scientist, believed could be scripted—at least initially. Later in life, when the idea of the interminableness of analysis took hold, he came around to the cubist notion of a self that cannot be stitched together. The self is not a world, but slices of psychic realities in disarray. The unconscious sounded like a deus ex machina but really was more machina than deus. When ill, the human psyche required not prayer or exorcism (i.e., calling on the god to descend or the demon to exit) but the psychoanalyst's how-to manual. The self, in other words, was an immanent system: a thing of the "here," not of the "out there."

Neutrality and flatness of tone naturally filtered into music, beginning with Igor Stravinsky (1882–1971), whose collage compositions in the first two decades of the century rattled the late Romantic echoes of Richard Wagner and Claude Debussy. His ballet score *The Firebird* (1910) asked the listener to hear the separate parts of instrumentation almost independently—jostling strains of folk song, lullabies, and orchestral music calling attention to how the bits bumped together, sometimes by playing two harmonies in different keys in grinding juxtapositions. Music, too, was a system, not the voice of angels, and systems run on rails and belts and pulleys.

The step into full-fledged machine-like neutrality really was taken by the Austrian composer Arnold Schoenberg (1874–1951). He called it "the emancipation of dissonance," but the Viennese audience at one premiere heard it more like "a convocation of cats."[11] In much the way a Cubist painting dismissed the conceit of a single center of perception, atonality rejected the single tonal center. Schoenberg's Second String Quartet

throws several key signatures into the same sonic mix that skitters in multiple directions, and instead of choral depth, strings out flat strands of logical, but not particularly tuneful, progressions. There seemed to be no unitary vision or personality in the granular chaos; the music did not swell, did not express. In 1921, Schoenberg took this depersonalization a step further with the introduction of twelve-tone serial music: a strictly mathematical technique that consisted of playing none of the twelve notes more often than the others.[12] The aim was to keep a motif or harmonic focus from emerging, indeed anything that bespoke the presence of a creative voice. A neutral system is what Schoenberg wanted in place, and the method, as exact and free of affect as Malevich's squares, found disciples among innovative composers such as Alban Berg and Anton Webern, who created musical landscapes at once gaunt and disorienting—in fact less landscapes than jagged traceries of sounds sprung from an oscillograph rather than a heart. But this, of course, was the point.

Common to these stark artistic statements was a determination to scrap the idea of the artwork as a natural whole. The Modernist work did not create a world; its reality was not organic and spatial but grammatical and structural. Again, Cubism pioneered the path. Gazing at glued strips of newspaper and bits of wood and cloth, one was made aware of looking at a *language*. The "little cubes" (or angles of perception) on Braque's landscapes of 1909 aborted the attempt to inhabit the work of art. The gaze tripped over every ledge and angle, fumbled for bearings, gave up. Besides, the Cubist universe lacked extension, and it is hard to imagine living inside a landscape of no amplitude. Ever since Van Eyck or Brueghel, a painted scenery served as an invitation to step in and partake of a world. But the cubist scenery was neither a different world, nor a worse or better world. It was not a world at all.

This crumbling of the choral, aerial feeling for space explains the indoor retreat of art after 1900. Out went hearty Impressionist outdoorsiness. The Cubist theme of choice, at least originally, was the still life: tables, violins, pitchers, candlesticks, newspaper clippings—the thingy stuff of everyday life. These brown quiddities crowd around the viewer, tumble out to the foreground rather than quietly wait for his attention. Their emphatic density, weight, and angularity are a bane to the mind that seeks repose. Where are these objects situated? The background, whether a room, a window, a sky, is nowhere in sight. The Modernist does not gaze into faraway places. "In or about

December 1910, human character changed," Virginia Woolf famously said in a 1924 essay.[13] To begin with, the world doubled back on itself, doubled again, and grew very small and cramped indeed.

Inspired by Cubism, the French poet Guillaume Apollinaire (1880–1918) composed poems by splicing together found bits of urban sights and sounds (*Alcools*, 1913). The journey from here to there, from Paris to Rome to Amsterdam, is a mere scissors snip away. Geographic simultaneity kills the feeling of distance and, so too, the sentiments of longing, hope, patience. "I am everywhere or rather I start to be everywhere. . . . / Already I hear the shrill sound of the friend's voice to come / Who walks with you in Europe / Whilst never leaving America," he wrote in "Zone."[14] Another French writer, Blaise Cendrars (1887–1961), conveyed this same nullified space in the poem "Le Panama ou les aventures de mes sept oncles":

> Poetry dates from today
> The Milky Way round my neck
> The two hemispheres on my eyes
> At full speed
> There are no more breakdowns
> If I had the time to save a little money I'd
> Be flying in the air show
> I have reserved my seat in the first train through
> The tunnel under the Channel
> I am the first pilot to cross the Atlantic solo
> 900 millions[15]

"Here" and "there" become abstract coordinates, no longer milestones. The distinction among earth, sky, and the underworld is moot: there is no more delay, no more distance. Space had a history, and that history has come to an end.

The machine age towers high over this aesthetic revolution. The telegraph, the telephone, the wireless, the airplane, and the automobile one by one ate away at the experience of deep, distant space. They partly explain the twentieth-century decline of landscape art, which survived either as kitsch or nostalgia: what awe, what majesty, what sense of sublime otherness could the artist behold in the open landscape when flying machines and instant telecommunication devices could trounce it in a trice? The horizon—the symbol for the intractableness of time and space—hung like an old useless relic. In the machine age, the sky belonged not to the gods but to the distance-crunching inventions of Thomas Edison and the Wright Brothers. Until the airplane, the sky was

the unassailable limit—the symbol of our humble earthliness. Piercing the sky through and through, the airplane demystified the azure. Not only could the lovely blueness be touched; it could be punched right through. The sky turned into a means of locomotion, as good as if railway tracks ran across it. It was not the measure of man, but man its measure. It was not the abode of the gods, but a mechanical part like the rest of nature.

Among twentieth-century distance-canceling inventions, the cinematograph holds a special place. To begin with, it was the first fully *mechanical* artistic medium—a medium singularly well suited to reflect the new machine-made shape of reality. Officially the cinematograph saw the light in 1885 in the workshop of the Lumière Brothers, at Lyons, where the two inventors shot a forty-six-second film of workers leaving the factory. Seven short years later, Georges Meliès, a theater man, produced the first fiction film, *Trip to the Moon* (1902). Like Cubism, its subject is conquest of space—in this instance, the distance between the earth and the moon. The story has a group of scientists board a bullet-shaped spacecraft, zip off to the moon, run into trouble with the moonlings, kill a few, depose their king, and return to earth. The general tone is burlesque, but the message deadly triumphant: man is the undisputed master of nature. The unapproachable sky is unapproachable no more. Distance is dead. So proclaim both the story and its medium.

Interestingly, with respect to the medium: film watching gave the viewer an experience hitherto known only to sprites and spirits. Before cinema, to watch an occurrence meant to stand contiguous to the event. No more: one could watch *real* people walking out of a factory in Lyons without having to be in Lyons. The film spectator is not *present* at the events taking place on-screen. In fact, he is invisible to the participants of the action, literally occupying no place relative to them. The cinematograph gave the viewer the thrill of disembodied vision, of being an invisible observer endowed with the ability to move through space effortlessly and instantaneously.

Of the many arresting images in *Trip to the Moon,* one captures this particular thrill: until mid-film, the story consists of tableaux whose static, fixed-camera staging strongly savors of the theater proscenium; midpoint, however, just when the action moves to the moon, the viewer is transported outside theatrical space. The turning point from earth to the moon, from theater to film, occurs over a sequence that can happen only on film and be conveyed by film. This sequence

simulates the vantage point of the approaching spacecraft. The moon is seen growing larger on the screen: to read this lunar swelling correctly (i.e., as an approaching moon), we must understand that we are *in* the cockpit. To follow the action, the viewer therefore needs to stop identifying with his physical self seated in the theater. The shot divorces us from our earthy bodies: the body is in the theater but the eye is elsewhere. It flies through space. Off to the moon without moving a finger, we nullify space. Lyons or Jupiter—it is all just a blink away.

It is perfectly fitting that space travel was chosen as the very first theme of film. The trip to the moon was the cinematic trip: it dramatized film's space-abolishing property—its ability to dissociate vision from the body. Like Apollinaire's Modernist *I*, the cinematic eye was everywhere; it cut from one place to another in the blink of an eye, without turning one's head, swiveling the telescope, or changing the perspective. The Modernist saw not through but *in spite of* space.

This prowess went beyond just controlling space. In many ways, mastery of space belonged to an earlier industrial age, the age of the steam engine, trains, air balloons, and the kind of record-smashing devices that electrified Jules Verne's Boy Scout imagination. The Modernist sensibility of 1910 aimed higher: not to make do with space, but to deny it altogether—in effect to reject Newton's absolute space. If that could be abolished, if it could be shown to be not a necessary feature of the universe but a discretionary variant, then the entire mystique of distance would disintegrate, the whole *mysterium trememdum* in which the sky had cloaked itself since archaic times.

Startlingly, this vision informed the dream not just of poets, but of those who dream worlds into existence: scientists. Around the time Meliès spirited space away, a German scientist employed at the patent office in Berne was working on a set of equations, published in June 1905 under the unprepossessing title of "On the Electrodynamics of Moving Bodies," which seriously undermined Newton's absolute space. With his theory of special relativity, Albert Einstein (1879–1955) demonstrated that space was rather more pliable stuff than hitherto believed.[16] In a sense, this revelation fulfilled Kant's insight that space was a trapping not of reality but of the understanding. With a radical twist: Einstein's relativity indexed space and reality to the action of who is doing the measuring, where, when, and at what velocity. In other words, circumstance was not in space; rather, space was in

circumstance. As Einstein argued, two reliable observers recording the same event from two separate vantage points were not bound to see that singularity occurring at the same place and time. One observer could swear seeing it at point and time A, while the other observer could produce evidence of its happening at point and time B. Nor was the size of an object identical for all observers: measure, too, was a function of perspective, in particular of the velocity at which observers are moving with respect to the measured object. In sum, Einstein showed that the shape of the world is determined by what goes on inside it. Special relativity slices up space into as many cuts of perception as there are observers in the world—a regular cubist smashup.

Special relativity disturbed the conventional view of *perceived* space but on the whole left Newton's absolute space pretty much alone. This changed when Einstein published his theory of general relativity in 1916. That work buried forever Newtonian space—that is, the idea that the world had a definite form. Building on Newton's gravity, Einstein suggested that an object of sufficient mass and energy was capable of altering the very stuff of space. This was startling news. Newton had held space to be an absolute that did not shape-shift to suit circumstances. Likewise, in traditional geometry and physics, circumstances were pinned onto the background fabric of space. Space told things where and how to move. In Einstein's universe, however, the mass of an object (roughly speaking, its gravitational force) can pull and cause space to bend and pleat. The duration of time and therefore the length of space between two fixed objects vary according to their respective mass. An object of great mass pulls space in from the straight path and shortens it in its vicinity; while, far from fast-moving or very large celestial bodies, space tends to relax and smooth out. And Einstein did not mean that it was just distances and measurements that varied, but the very *stuff* of space.

Until 1919, this idea had only mathematics to back it up. Then the solar eclipse of May 29 allowed the English astrophysicist Sir Arthur Stanley Eddington to confirm Einstein's theory. Eddington demonstrated, as Einstein's model predicted, that a beam of starlight traveling near the sun was actually deflected five ten-thousandths of a degree by the solar disc's gravitational pull. And since nothing, not even space, travels faster than light (indeed space *is* the speed of light), the observation showed beyond doubt that the velocity at which space spreads, and therefore its length, undergoes alteration. In other words, space is not absolute.

Other conclusions followed from the equations, not least of which was that the universe had to be expanding or contracting, but in any case was not static. It did not have a set shape. God was still toying with it. Einstein himself balked at the notion and, in what he called "the biggest blunder of [his] career," tinkered with his equations to obviate a rubber-sheet universe.[17] Methodical observations by astrophysicists, however, proved Einstein's initial estimates correct and his sentimental qualms wrong: the universe was, as it turned out, expanding. Which meant that, the universe being all the space there is, it was formless—or at any rate that its shape was only a circumstance, not a Platonic essence.

It is hard to overstate how utterly mind-bending Einstein's discoveries were and how profoundly they shook perennial intuitions about the texture of reality. Of all the things in the universe, space had traditionally been thought to be the most immutable: without it, indeed, there was no universe to speak of and no way to situate earth and heaven. It was the cosmic referee that stood still while celestial bodies cantered to and fro. Space was the ultimate framework, impartial, supremely reliable. The seventeenth-century religious philosopher Henry More observed that, unlike anything else, space never fails; it never tears and drops objects out of existence. It was a home, a rock, a divine certainty—the conviction that had Newton's call space a "spiritual substance."[18] Spiritual it had to be, because it was more fundamental than matter: we can more readily conceive of space without matter than matter without space. Things presuppose the space in which they occur. *Spirit* was as good a word as any to designate that which the existence of all things assumes. To Henry More, this was enough to call space god-like. ("In the beginning God created the heavens and the earth," says Genesis: God is not shown first creating space and then heaven and earth. Space is inherent in God's existence. There is no need of a "let there be space," in the same sense that there is no need for a "let there be God.") In the theological age, space was where the chain of questions stopped: insofar as Being could be made visible, space did it.

Einstein's theories overthrew all that. Space was just a cog in the mechanics of being. This demotion, it seemed, pulled the ground from under landscape representation. Though it seemed at the time like an apotheosis of the open-air style, in retrospect Impressionism was really a swan song. The Modernist sensibility, like modern science, does not believe in the coagulant of space. You and I have our different separate spaces, horizons, and views. It is useless, and indeed deleterious, unnatural, to reconcile them. Already in Cézanne, the flowing unity of

space splinters around hair-thin cracks of misaligned realities. As the nineteenth century turned into the twentieth, the waves of artistic styles (Impressionism, Pointillism, Touchism, Fauvism, Cubism, Vorticism, etc.) stressed the jigsaw puzzle, rubbery stuff of reality with growing vehemence. Nothing globalizing should be said about reality. The landscape of modernity is not a landscape at all but, like Cubist artworks, a collection of smallish vignettes, samples, snapshots of a reality that is thus and otherwise at the same time.

Could Modernism ever rouse itself to say something far seeing and inclusive about the moral horizon of our time? Picasso's *Guernica* (1937) attempted at resuscitating the old epic ethos. If only by its twenty-three-foot span, it harks backs to the art of the monumental statement, to the great cathedral, the Sistine Chapel ceiling, the Wagnerian *gesamt-kunstwerke*—works in which a whole epoch stands up in unison and speaks to the ages. But if Picasso's painting borrows the rhetoric of the grand tapestry, it is in this instance to show its futility. The painting depicts a village under aerial bombing that mangles people and animals, all chopped up in a cubistic onslaught, every living thing reduced to a sliver of voiceless pain. The idea of common space, of membership in a metaphysical order, is a shambles. There is no more universal anything in the machine age. The death of a human being is a silent wedge stuck in blackness that fetches no echo from the sky because there is no sky, no vault, no horizon to carry the sound. Picasso places a bombshell in a horse's silently howling mouth, as if to say to say that our powers of self-expression—of shaking our fist at the sky, of taking the cosmos to task and calling on God—are all as dumb and inchoate as an animal scream or the grinding of an overstressed mechanical part. In *Guernica*, the anti-transcendental expression of Cubism finds a reality that has become more cubistic than itself, more serried, more dreadfully boxed in. "A painting," Picasso once said, "is a sum of destructions."[19] In 1937, he discovered with horror that reality too was in shards.

In summary, Modernism signals the ascent of a mosaic style of thought and representation that reflect the decay of belief in a common world. Modernism meant living with the fact that, for the first time in five hundred years, we lived without a credible notion of what constitutes an embracing landscape—in science, art, or philosophy.

Naturally, the landscape did not just drop out of twentieth-century painting. But where it featured seriously, it did so in valedictory self-doubt. In the short fertile years between 1909 and 1918, Giorgio de Chirico (1888–78) painted small, forlorn paintings of an enigmatically

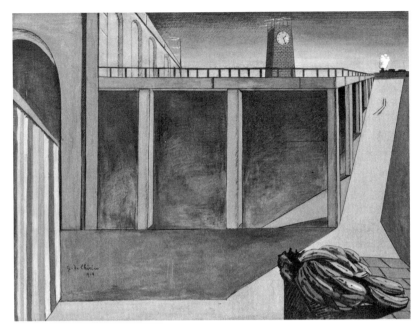

FIGURE 18. Giorgio de Chirico, *The Melancholy and Mystery of a Street*, 1914. Oil on canvas. Courtesy of Art Resource.

depopulated town (fig. 18): incurably empty street corners, windowless walls, a clay-red tower, a hoop, a bleak portico, tombstone shadows. A sullen, desolate horizon bisects the scene—the whole thing airless, stillborn, uninhabitable; landscapes daubed like still life crockery. If this is a world, nothing can come in or out of it. With titles like *Anguish in the Morning* or *Nostalgia for the Infinite*, de Chirico's landscapes gather the bone-dry remains of Renaissance perspective for a mock memorial: extension is dead, and there is nowhere to go. The psychic landscapes announce there is no exit from the psyche, and the gluey lime of neurotic obsession congeals the scenery. Nostalgia for the infinite indeed.

There is no room here to dilate on the role of Freud's theories in flattening the (moral and aesthetic) landscape of modern life. At the core of Freudian psychology is a phobic and adversarial mind ever leery about reality. The overall function of the psyche is to buffer. When facts encroach too hard on the mind, the unconscious kicks in to reinstate the default position of the ego, its narcissistic, mollusk-like pullback. The unconscious is psychic immunological defense: it stands guard, filters, transmogrifies. It adapts reality to its uses and (like Einstein's

relativity) recognizes no absolute either in time or in space. In the id, time is riddled with shortcuts; an event imprinted long ago can surface anew with the freshness of a recent occurrence. The unconscious also knows nothing of the distinction between foreground and background. Short circuits and crossovers abolish distance, as in a flat Cubist collage where here and there are grammatical variants, not real anchors.

Of all the Modernist movements, Surrealism was surely most in thrall to Freud's psychological theories. There are elements of Freudian paraphernalia in de Chirico, but it is really Salvador Dalí (1904–89) who painted the world seen from the analyst's couch, that is, the world of the dream work. His oeuvre lays out a sumptuous requiem to the idea of space. "Tonight for the first time in at least a year," he writes in his diary, "I am looking at the starry sky. It seems small. Am I getting bigger or is the universe shrinking? . . . I am grateful to modern science for corroborating by its research that most pleasant, sybaritic, and anti-romantic notion that 'space is finite.' . . . When all is said and done, the universe—expansible even with all the matter it contains, however abundant it may seem—is nothing but a simple and straightforward matter of adding up marbles."[20]

The world is what it is—the sum of its marbles and no more. A child of Freud and of the scientific age, Dalí believes in no landscape but the psychic kind and the physicist kind. But Dalí was also heir to a meta-physical tradition, and the Platonist Spanish-Christian mystic in him could not give up on an ultimate escape hatch. There is an unregenerate Dalí that hankers for maximum expansion, for the light outside the Cave. Dalí is a paradox: a landscape painter who loses the heart to believe in the external world; a solipsist who aches for the cosmic and the faraway. His landscapes manage to be both vast and claustrophobic, transcendent and disenchanted. And disenchantment, it seems, has the upper hand. Some terrible stickiness, a sagging languor drips over the enamel flesh of Dalí's figures. His open skies and seas and deserts are indeed so vast, so open, so panoramic that their emptiness in the end seems more a gaunt theorem of expansion. An invariably limpid, metallic blue sky tops the land like a persistent headache. The depth of field is consciously trompe l'oeil, overstated, fantastical. The hour is timeless—it is the light of neon-lit interiors, of X-rays, of the atomic bomb. Like de Chirico, Dalí caricatures Renaissance perspective to the point where none of the world-directed sympathy remains, just the barren mathematics (fig. 19). For all their cosmic reach, his perspectives are

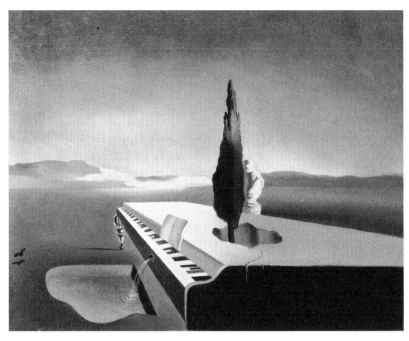

FIGURE 19. Salvador Dáli, *Fuente necrofílica que sale de un piano de cola*, 1933. Oil on canvas. Courtesy of Art Resource and Artists Society.

depthless. Creatures that ought not to exist or that regret existing can be seen lopping across these desert-scapes: pachyderms with elongated legs, melting clocks, globs of goop propped up on crutches—a world that betokens lassitude, gravity, inertia. The plastic gloss of his skylines, like the skin of his crucified Jesuses, gives off the nonabsorbent gleam of polymers.

Dalí captured something shallow and impermeable about modern life. Plastic, an invention of the 1930s, indeed changed the look and texture of everyday reality. Objects previously made of organic, grainy, absorbent materials were suddenly shelled in Plexiglas, cellophane, and neoprene—substances that, unlike wood, flesh, marble, or silk, look and feel ageless, hermetic. Plastic laminates are the building material of efficiency. Creatures seemingly made of Bakelite, Dalí's holy Virgins deny the transfiguration of flesh into spirit that is their theological message. The skin of modernity, it seems, is numbingly airtight.

In his late career, Dalí turned out bizarre pastiches of shrink-wrapped figures by Michelangelo and Velazquez: almighty plastic taking over the human face. Pop Art, another child of Modernist flatness, drew similar

inferences. Psychological vacuity, the absence of soul, and the triumph of surface rule the portraiture of midcentury Pop Artists Andy Warhol (1928–87) and Roy Lichtenstein (1923–97). There the human face does not invite the viewer to commune with psychic moral depths or the mystery of a person's soul. Pop Art is militantly unmysterious. In the world of total plastic, appearance is existence, and existence is biology, psychology, sociology, economics: immanent systems in which the only reality that matters is that of numbers. The truism that photography killed off the art of portraiture is a half-truth. Portrait painting died because we stopped believing in depth, and Pop Art is its death mask. Photography, which picks up surface patterns, sprang from the mindset of flatness; it did not cause it. Modern portraiture by Warhol, Lichtenstein, or Chuck Close (1940–) is consciously photographic, granular, cartoonish: the surface is the message.

Fragmentation, flatness, artificiality: these are the structure of the Modern aesthetic. Its material is the pliable, gummy stuff (e.g., Einstein's rubber universe or Dalí's rubber people). It is a world that sees the dual triumph of all-out subjectivism and scientific materialism. Subjectivism: because the bias of twentieth-century philosophy is psychomorphic; and materialism: because, scientifically, the human psyche is viewed as neurological stuff. Thus mind swallows reality and is in turn swallowed by reality. For many artists and thinkers, this no-exit situation needed reckoning with.

No Exit

Buenos Aires, April 1941

> The universe (which others call the Library) is composed of an indefinite and perhaps infinite number of hexagonal galleries, with vast airshafts between, surrounded by very low railings. From any of the hexagons one can see, interminably, the upper and lower floors. . . . Also through here passes a spiral stairway, which sinks abysmally and soars upwards to remote distances. In the hallway there is a mirror which faithfully duplicates all appearances. Men usually infer from this mirror that the Library is not infinite (if it were, why this illusory duplication?); I prefer to dream that its polished surfaces represent and promise the infinite.[1]

Thus begins "The Library of Babel," the short story by the Argentine writer and essayist Jorge Luis Borges (1899–1986). *Short story* is an awkward term because "The Library of Babel" really is not a story (rather the description of a building) and because it does not do to call a piece that encompasses the infinite "short."

A literary heir of Kafka, Borges perfected the art of the labyrinthine, sibylline tale that sends characters chasing after the Great Questions (God, the Absolute, the Origin of the Cosmos, Time, Eternity) only to finish tangled up in paradoxes, mad with riddles, or simply dead. Like Dalí, Borges harkens to the age of theological transcendence; yet he knows how to express this transcendence only in the language of rationality. His universe-library is a case in point. The structure harks back to medieval mysticism: "The Library," he writes in a pastiche of Cusanus, "is a sphere whose exact center is anyone of its hexagons and

whose circumference is inaccessible."[2] It is infinitely greater than human understanding. Yet it is also made of human understanding, that is, of books. The universe-as-library is not God proper but what *we* have written *about* God. The object is mystical but the structure is linguistic. So the question for Borges is, can we transcend the limits of human intelligence by means of intelligence? "The Library of Babel" puts the problem thus: "It is not illogical to think that the world is infinite. Those who judge it to be limited, postulate in remote places the corridors, stairs, and hexagons would inconceivably cease—a manifest absurdity. Those who imagined it to be limitless forget that the possible number of books is limited."[3]

The universe cannot be conceived to stop somewhere (anything beyond that limit would be a de facto part of it); and, given that it is made of stuff and that stuff is by nature quantifiable, it cannot be imagined *not* to end. Given that both infinite world and finite world are equally unthinkable, Borges opts for the solution of a circle: "I venture to suggest this solution to the ancient problem: *The Library is unlimited and cyclical.* If an eternal traveler were to cross it in any direction, after centuries he would see that the same volumes were repeated in the same disorder."[4] The payoff of cyclicality is that it obviates questions as to whence and wherefore. A circle is self-contained, like clockwork. And so, too, the Library: its books gloss, quote, or repeat verbatim other books ad infinitum. Borges substitutes the linear infinite for the infinite of linguistic self-reflectivity. He understands how central to the human condition is the thirst for what transcends human understanding; but rather than face the silence and mystery of God (who is the destination of most of Borges's narrative meditations), he tricks this longing by leading it into halls of mirrors—exercises in logic, games, permutations, systems, theorems, and paradoxes. What is infinite is our infinite ways of talking about the infinite. In other words, Borges's solution to the problem of infinity (God) is to point to the human mind's infinite ability to mystify itself. There is no outside to the Library of Babel just as there is no outside to the human mind. We have language (libraries) not to connect with an ultimate reality but to look away from it, to spend the rest of eternity in language games. Inside the Library, we are in our element (language), and this element is so indefinite, it spreads so far, that eternity is not time enough to sort out all the conceivable permutations and arrangements. Bound in a nutshell, we are kings of infinite space: the Library may be too immense for any single person to travel, but at least it is an infinite of our own making; it is the infinity of the human

mind—and it allows us to digest God, to enjoy the heights of transcendence without religious encumbrances.

Symmetry, recursive nomenclatures, reversibility, convexity, reflexivity: these trappings of Borges's cosmology are characteristically mental. The horizon of modernity is not external; it consists in dialectical deferment. In "The Aleph," the narrator discovers an object that, like the Library of Babel, encompasses the universe: to look into it is to see all things simultaneously, including oneself looking at the Aleph. Characteristically, this universe-encompassing object is made of "a terraqueous globe between two mirrors which multiplied it without end": the sphere and the mirror. The sphere stands for the earth, the world, or God (a sphere whose exact center is everywhere and circumference nowhere). But the globe stands between two mutually reflecting mirrors—mirrors that infinitely reflect themselves reflecting the world. The world may be very large indeed, but it is flanked by the even greater looking glass of human reflection.

Mirrors abound in Borges's fiction. For the personality that fears finality, a mirror is the perfect amulet. It, like fiction, lures the eye away from the real. And fiction has no other psychological function for our Argentine Scheherazade than to postpone death, that is, the point where consciousness hits an inexorable limit and the world asserts its terrible finality. The task of Borgesian fiction is therefore fiction: to put off an encounter with the actual. Death (meaning the limit of the human world) is unimaginable: it does not belong in the mind, literature, art, imagination, or the short story. Often (this is the case in the stories "The Secret Miracle," "The Dead Man," "Death and the Compass," "Funes the Memorious," and "The South"), the last sentence heralds the main protagonist's death. Beyond that, nothing can be said. But that nothing can be said turns out, in the end, to be our saving grace. For it means that death is alien to fiction, to language, to the Library, and therefore to the human world. The typical Borgesian tale thus wraps around itself in the end. Faced with the intractable realness of death, fiction exercises the right to turn toward the mirror—as when, in "The Circular Ruins," Borges swoops in at the eleventh hour and converts the ultimate limit into the reflection of a limit. In this particular tale, the explorer finds out upon dying that he is a thought in someone else's mind, who is in turn a thought in yet another person's mind. Likewise in "The South": "He felt that if he had been able to choose, then, or to dream his death, this would have been the death he would have chosen or dreamt." And thus the stone-hard boundary

swings into a soft mental horizon. Fact becomes word, object turns into subject, the substantially finite turns into the insubstantially indefinite: as if to say, the story must never stop. We never die for the simple reason that we never awake from the dream of language.

"The world, unfortunately, is real; I, unfortunately, am Borges," the author wryly concludes in his essay "A New Refutation of Time."[5] All of Borges's fiction seeks to alleviate the plight of being a limited being in a terribly real world. Art exists to make the world delightfully less real; it erects scaffoldings of words to put off encountering nonverbal reality. "The certainty that everything has been written," Borges says from inside his abysmal Library, "nullifies or makes phantoms of us all." This is hardly a curse: for phantoms—this is their godsend—never have to die. That everything has been written means there is no exit from the mental cocoon; space and time are only our words for them, and words have limitless possibilities of combinations. The universe is a word; God is a word, or, as Borges says in "From Someone to No One," "a respectable chaos of unimaginable superlatives."[6] Can God or the universe be larger than our power of conceiving them? If they were truly transcendent, we would not even have the first inkling of their existence. But since we do, since they are entries in our library, and since superlatives are figures of speech, it follows that God is language, and therefore that nothing is greater than the inventive intellect. God, if he exists, *definitely* knows who he is; not so human thought, which can never catch up its own tail: it alone is structurally infinite. In "The Secret Miracle," a Borges-like librarian delivers this message: *"What are you looking for? a librarian wearing dark glasses asked him. I am looking for God, Hladík replied. God, the librarian told him, is in one of the letters on one of the pages of one of the four hundred thousand volumes in the Clementine Library. My parents and my parents' parents searched for that letter. I myself have gone blind searching for it."*[7] The egress of Borges's labyrinths is never trivial: it promises no less than God, that is, the totality of Being. "Perhaps behind the Zahir I shall find God," sighs the protagonist of "The Zahir." But a skeptical Modernist above all, Borges does not seriously contemplate a theological epiphany. For if human beings have always sought God, it is doubtful they have ever found him. Perhaps God is a synonym for this search. "His descendants still seek, and will not find, the word of the universe," Borges writes in "The Parable of the Palace." The only theology to which the Modernist temperament subscribes in the age of the "death of God" is negative theology (the contemplation

of what God is *not*). Yet whereas the medieval *via negativa* held fast to the belief in God, modern allegorists such as Borges, Kafka, or the Samuel Beckett (1906–89) of *Waiting for Godot* (1950) pursue the negative path for its own sake: their characters search for God knowing God is not to come, or cannot come.

Estragon and Vladimir, the two protagonists of *Waiting for Godot,* are the notorious priest figures of this modern religion of God's absence. Every day they wait for someone named "Godet . . . Godot . . . Godin" who never comes. Their days blur into a timeless stretch. Their one certainty is that they will be always on the outlook. They live on faith—not in Godot, but in the fatefulness of their waiting. Neither of the two protagonists remembers what they expect of Godot:

> *Vladimir:* Oh . . . Nothing very definite.
>
> *Estragon:* A kind of prayer.
>
> *Vladimir:* Precisely.
>
> *Estragon:* A vague supplication.
>
> *Vladimir:* Exactly.
>
> *Estragon:* And what did he reply?
>
> *Vladimir:* That he'd see.
>
> *Estragon:* That he couldn't promise anything.

The promise of religion is promise itself, that is, hope. Religion is belief in an Other, be it God or Godot, who, from the margins of life, pulls the whole into shape. But hope, the jewel of the apostle Paul's theology, is also the first step in the eclipse of God. Hanging by the worn-out thread of hope, Vladimir and Estragon will always wait. "They stay put" is Beckett's final stage direction. Belief in transcendence is not *knowledge* of transcendence: if we knew for a fact that the immanent world opens up to another world, we would not need to believe in it. Transcendence would be a fact (and therefore not transcendent). So the emotion of transcendence requires the eclipse of what it believes in. The message of *Waiting for Godot* is that God need be hidden if we are to believe at all. The paradox is that only a world within which we feel locked up can spark belief in an exit.

Behind Borges and Beckett looms the long, spindly shadow of Franz Kafka, whose two great novels set the template of twentieth-century spiritual claustrophobia. In *The Trial* (1925), a man accused of an unstated felony wanders the corridors of a formidable legal administration to

bring his case to a final ruling, only to find there is no exit from the law. He is trapped in a maze of legal writs, a man-made prison that canvases the earth and colonizes the sky. God himself, it turns out, may be just another pencil pusher of the universal politburo. *The Castle* (1926) presents a man who seeks admission into (rather than escape from) a closed world, the castle, whose "flawless administration" devises temporizing obstacles to his petition. In both novels, the antihero is trapped either inside or outside: in no case can he move across from one side to the other. He finds himself helplessly part of a totality he cannot contour: the human-made world spreads to the ends of conceivable reality and brooks no escape. Slavishly, the petitioner waits on the administrative machinery and soon forgets to ask the why and wherefore of his waiting. The rationalistic order has no external justification. It serves neither God nor man; its purpose, if it has one, is internal and, like a machine, seeks self-replication. In this respect, it is like the universe.

Kafka's novels and tales are allegories of a human world that no longer dares put big questions to the sky, only procedural queries. All the modern world offers by way of intellectual adventure is technical permutations. In the same decade Beckett produced his important works, the playwright Eugène Ionesco (1909–94) wrote plays where, we soon understand, the point is not to prosecute a plot or lead the characters to release and catharsis, but instead to piece together words, sentences, and bits of conversation whose sole purpose (if this is one) is to keep the logorrhea going. At the end of the play *The Bald Soprano* (1950), the action (aimless chitchat, verbal pantomimes, word games) loops round to the beginning and so on, ad infinitum. Though we may look for an exit, all escape strategy musters is indifferent moves across the mental checkerboard—what the Austrian philosopher Ludwig Wittgenstein called "language games."

Ludwig Wittgenstein (1889–1951) gave the mechanical age—the age of no exit—its own philosophical signature. Wittgenstein was a doctoral student in mechanical engineering at Cambridge when he heard the lectures of Bertrand Russell and G.E. Moore, two thinkers who were then involved in translating the problems of philosophy into mathematical language to reduce all intellectual operations to a finite system of parts and combinations. To show the workings of this system was the implicit aim of the school of Logical Positivism to which Wittgenstein contributed his *Tractatus Logico-Philosophicus* (1921).

The *Tractatus* purports to compress all that can logically be said in philosophy into a series of decimally indexed propositions. Wittgenstein's

intention was unsentimentally anti-transcendental: he wished to draw the horizon of human knowledge with no reference to external reality, purely on the basis of the rules of logic (thus subordinating ontology [the knowledge of what exists] to epistemology [the knowledge of how we articulate our knowledge]). Thus: "6.53. The correct method in philosophy would really be the following: to say nothing except what can be said, i.e. propositions of natural science—i.e. something that has nothing to do with philosophy—and then, whenever someone else wanted to say something metaphysical, to demonstrate to him that he had failed to give a meaning to certain signs in his propositions."[8] Something that can be said, according to Wittgenstein, is something for which a corresponding fact (i.e., a verifiable or logical piece of knowledge) can be supplied. *Lemons are yellow* is a fact. *I like lemons* is not. (How I feel about lemons is not a feature of lemons; they go on being lemons without my feelings.) Philosophy must establish not what we could say or would like to say about the world, but what must be said. This means stripping it of sense—since sense is the intelligible direction in which *we* see things moving. As the *Tractatus* states, "6.41. The sense of the world must lie outside the world. In the world everything is as it is, and everything happens as it does happen: in it no value exists. . . . If there is any value that does have value, it must lie outside the whole sphere of what happens and is the case. For all that happens and is the case is accidental. What makes it non-accidental cannot lie within the world, since if it did it would itself be accidental. It must lie outside the world." We need must check our selves at the door before entering reality. The love of truth (i.e., *philo-sophia*) requires objectivity. Which means eliminating our wish that the world as a whole lead somewhere or border on a greater reality—a sense that humankind has traditionally conveyed through the word *God*. As proposition 6.432 states: "God does not reveal himself in the world." Otherwise put: the word by which we mean that reality has an origin and an aim—this is not a word that makes sense *inside* the world. There is no passage from this world to another. In this sense, the human world is finite (the structure of human thought can be described as a whole); and it is infinite (there is no meaningful way out of it).

Wittgenstein presses this conclusion thus: "Death," he says, "is not an event in life: we do not live to experience death. . . . Our life has no end in just the way in which our visual field has no limits" (6.4311). Human existence is a voyage without end. But this eventual horizon is resolutely nontranscendental: it promises no exit. A twentieth-century

Nicolas Cusanus might have put the matter thus: the human world is a sphere whose center is everywhere and circumference, nowhere. It is no use waiting for Godot because Godot, however he may try, cannot step into the world. Nor can we step into his. (Kafka: "there is hope but not for us."[9])

Wittgenstein chastens the trespassing soul who seeks meaning for the voyage of existence in some eternal harbor. What solution to the why of existence does immortality solve? asks Wittgenstein. Will the immortal soul be free from the vexation of wondering what the point of living forever is? And will it not then stumble into the same problem it sought to evade, that is, of facing an answerless horizon? (In like spirit, the existentialist Jean-Paul Sartre asserted that we would still be finite if we were immortal: the horizon of life would stretch ahead no less indefinitely). This is the hard truth Wittgenstein wants us to swallow: *asking about the aim of existence is unintelligible.* There is no objective horizon. All is horizon. The human world does not end, and that's the end of it. So goes one of the runes in the *Tractatus:* "6.521. The solution of the problem of life is seen in the vanishing of the problem. (Is not this the reason why those who have found after a long period of doubt that the sense of life became clear to them have then been unable to say what constituted that sense?)" This is modernity distilled to its essence: a terse acknowledgment of our mortal immanence, free from Romantic pathos and from the impulse to scratch away the itch of death. Life is no more a problem than a square is a problem. To look impersonally at our own selves: this does not mean gazing at life from God's height; it means standing on a plane of existence stripped of projections, as bare and flat as Beckett's stage. The human world is all there is, and we can no more transcend it than jump out of our own skin. This is neither to be celebrated nor bemoaned, since no alternative can ever present itself.

In later life, Wittgenstein repudiated his earlier method of hanging human reality dry on the logical trellis. The style of *Philosophical Investigations* (1953) is notably extemporaneous. So, instead of a central logical structure, Wittgenstein adduces a mosaic of "language games"— ways of speaking that organize how we think, perceive, and behave and behind which it is fruitless to look for a deep, subjective self: When we speak, Wittgenstein says, we do not express thoughts that bubble up from the proverbial back of the mind. Thoughts are not preexisting floating entities that get translated into words; thoughts *are* the words that make them up. An unformulated idea is not an idea. "Meaning just *is* use," he insists.[10] As in Cubism, there are only facets of expression

and no live center of perception. As it is for Ionesco's characters, so it is for us: by speaking we do not express a reality deeper than words; we merely maintain our persona as language speakers.

Of tremendous influence, this philosophy depleted the world-oriented transcendence (the philosopher could confidently assert that there was no more to the horizon than the word *horizon*) and mind-oriented transcendence, that is, the idea that consciousness lies "too deep for words," as Wordsworth put it. In the view of Wittgensteinians such as Gilbert Ryle (1900–76) and A. J. Ayer (1910–89), there is nothing more to consciousness than its physical or verbal manifestations. A sorrowful soul is simply a person showing signs of sorrow; the meaning of *red* is how the word *red* gets used in a particular linguistic context. "But what is the meaning of the word five? No such thing [is] in question here, only how the word five is used!"[11] What is the meaning of my legal case? Kafka's protagonist asked. Its meaning is its current administrative slot in the bureaucratic honeycomb. Meaning is procedure: it does not go beyond the form in which it occurs. Language exists neither to prod reality or uncover the self but to organize "a form of life" within which social functions can deploy. The activity of mind is functional and regulatory, not expressive or transcendental. It creates a habitat of reality, locks us up in it, and throws away the key.

But who is the prisoner? Is he in fact distinct from his prison? Not really, Wittgenstein thought. There exists no hidden metaphysical self inside the language user. Our prison ought not to feel like a prison since our thoughts are identical to their formulation. He who feels restrained by language, who suffers claustrophobia inside the human world, labors under a Romantic misconception. We are so perfectly and seamlessly our prison that we cannot feel imprisoned. In summary, Wittgenstein removes all metaphors of inner and outer from the human world. At the external edge of subjectivity, there is no transcendent objective world to justify our meanings (*red* is the word *red*); while at the internal edge, there opens no deep wellspring of expressive meaning (again, *red* is the word *red*). The human world blankets all reality yet has no depth of its own. Enters the depthless Minimalist sensibility (see the next chapter).

Like Russell and Alfred North Whitehead, the Austrian logician Kurt Gödel (1906–78) dug his philosophical pick into the bedrock of mathematics; going one better, he postulated that this bedrock cannot be explained in the language that uncovers it, that is, mathematics. In the words of his famous theorem, "The coherence of any formal system cannot be proven within that system." This means that, as a logical

system, thought cannot peer into its own foundations. It cannot demonstrate, from within its language, why this language has the ultimate contours it has. Gödel cranked mathematics up to the heightened state of Modernist self-consciousness. Even at its rigorous and most objective, thought projects inner boundaries that it cannot outstrip. "The human mind is incapable of formulating . . . all its mathematical intuitions," said Gödel. "This fact may be called the 'incompletability' of mathematics."[12] Mathematics is like Borges's Library, the law in Kafka, or the stage in Beckett's and Ionesco's theater: a self-contained system about which we cannot ask why because we do not have the language it would take to describe or objectify it from the outside.

This vision has had a simultaneously depressive and exhilarating effect on thinkers of the twentieth century, whether of the Anglo-American Positivist kind or of the Continental (German and French) persuasion: Structuralism, Poststructuralism, Deconstruction, and other strands of anti-Realist thought spin on the notion that human knowledge is systematically self-referential (as opposed to organic and reality bound). Inasmuch as the language of science is language, we can never establish a definitive picture of the world. Discourse cannot furnish the proof of its own truth.[13] No description of reality is self-justifying. Human thought is a self-inflated bubble.

But then what about the world beyond the bubble? What about the infinite? What becomes of the intimation of a place beyond cognition and language? Wittgenstein argues that the infinite is only a way of speaking. "*We only know the infinite by description,*" says Wittgenstein. "Well then, there's just the description and nothing else."[14] Or, as he contends: "The expression 'and so on' is nothing but the expression 'and so on.' . . . [It] does not harbor a secret power by which the series is continued without being continued."[15] What would count as experiencing, encountering, touching the infinite? No experience that we can think of. (Or at least none in which the idea of *experience* and that of *we* remain intact; we, finite beings, could only experience it in a finite way. To encounter the infinite would mean therefore having to stop being ourselves.) The infinite can therefore only be a mathematical extrapolation visited on finite entities, such as things, numbers, or positions. In that sense, Wittgenstein would argue, the finite contains infinitude. "We say space and time are infinite but we can always only see or live through finite bit of them. But from where, then, do I derive any knowledge of the infinite at all? . . . Experience as experience of the facts gives me the finite; the objects *contain* the infinite."[16] The infinite does

not stretch an inch beyond the horizon, that is, beyond the intimation thereof. The horizon is thought's reflexivity mistaking itself for a passage out of thought. When we gaze at the horizon, we are really looking at a mirror of consciousness mistaking itself for a window. Nothing beyond. The piece of sky we paint on the wall, as the paintings of the surrealist René Magritte (1898–1957) remind us, is just a wall. The blue sky exists in the mind's eye: on Magritte's painting *The False Mirror* (1928), the iris of the human eye is a painted sky. A false mirror indeed: it thinks it mirrors the blue yonder, whereas the blue yonder really seeps out of its own pupil.

In summary: the first half of the twentieth century produced an intellectual and artistic sensibility tightly pegged to the idea of self-reference. Whether in art, literature, or philosophy, the Modernist mindset is functionalist. It tends to reduce nature to its mechanics, the res publica to its administration, reality to its mental processing, and the mind to its logical grammar. Functionalism is also the name of an aesthetic school that, in line with the Bauhaus, believed that artistic forms should be reduced to their basic geometric articulations and that design (architecture, decoration, applied arts) should follow use (a cement cubelike house advertises its function, i.e., to give shelter—all other concerns are extraneous): a house is a house is a house. Ornamentation, as the Rationalist architect Adolph Loos declared, is a form of deception and therefore objectionable.

This ascetic reduction of form to function yielded the strangely skeletal world of planes, lines, and angles known as Minimalism—perhaps the most unsentimental expression of our science-dominated Modernism but also, as we shall see, a last-ditch rescue from its exitlessness.

Here

Woodstock, NY, August 29, 1952

The period following the Second World War saw a time of skepticism and sullen soul-searching in the house of culture. If all Western civilization could ratchet up was two horrendous global wars, mayhem, and butchery on an unconscionable scale, then clearly something was wrong with the formula "science + rationality + humanism = civilization." Science evidently did not safeguard society from barbarism. And secular humanism (with its magic equation of "will + rationality – God = progress") had some deep reckoning to do. Fascism, whether of the Stalinist, Hitlerian, or Maoist breed, advanced a cult of human determination and self-mobilization. All three, together with Mussolinian fascism, revolved around a personality writ large, a mortal god worshiped for overturning worlds. Such societies seemed at times a fanatical denial of the Enlightenment but at others the culmination of its vision of man's unfettered willpower. In the wake of the social catastrophes and devastation this willpower visited on the West, the cultural mood turned against the human personality and the tempestuous Romantic will. Where human motives and emotions wreaked such appalling results, distrust of these emotions set something of a moral imperative.[1]

This left two paths for artistic culture to tread: either to embrace nature or to cultivate impersonal machinery. The problem is that both inlets, naturalism and technologism, had colluded with the fascist onslaught. Darwinism made it hard to idealize nature or expect much by way of its goodness; and if machines had held a way out of

Romantic subjectivity at the turn of the century, in the theater of war they had proven instruments of the most savage and brutal form of human willpower. Neither nature nor science was pure enough for the moral expression that now sought to go beyond man and nature.

In some artists the search for the impersonal took on self-pitying vindictiveness directed at the last throb of Romantic indulgence that was Expressionism. In Europe, the sculptor Alberto Giacometti (1901–66) fashioned razor-thin, emaciated figurines that spoke of sackcloth and ashes, of self-flagellating subjectivity, self-doubt, and a humanist faith in ruins. It is the human being who can neither absorb nor give any more. So thin that it would rather not exist, this wedge of humanity scrapes the wall and begs leave to go quietly: all man ever creates is ruin. And yet, hanging on to life by the merest thread—it does not let go.

A great deal wittier, the artistic works produced under the banner of Pop Art in the United States of the late 1950s took a jauntier crack at the human idol. When Andy Warhol (1928–87) stacked tomato soup cans and soapboxes, he produced art in which craft, creativity, and confession were absent. Unlike Marcel Duchamp's urinal, Warhol was not advertising the artist's Midas's touch to turn banality into rarity. Warhol presented objects devoid of affect, neither clean nor foul. They were neither shocking nor original nor conventional. They were merely bland: the products of an artist who meant nothing by them and would not be caught dead making a point. If *Brillo Boxes* (1964) were the portrait of an artist, it was the artist as everyone, anyone, and therefore no one.

The world represented by Warhol's *Brillo Boxes* was devoid of artists; and where there are no artists, there is no one bothering about the existential contours of the world or trying to bring existence into shape. It is a world in which the soulful, creative self is absent. And this world is as near to being blank, flat, and matter-of-fact as ever a world can be.

While entranced by this image of a human-voided world, the sensibility known as Minimalist sought to vindicate a concept that was absent from Pop Art, that is, beauty; or, if not beauty, at least the clean equanimity of theological impersonality, the last glimpse of which flashed up in Bach's music. Minimalism was the creation of mostly American artists born around 1930 and was bound by a common interest in purifying artistic expression. Alive in the works of Donald Judd (1928–94), Sol LeWitt (1928–2007), Robert Morris (b. 1931), Carl Andre (b. 1935), and Dan Flavin (1933–96) was a resolve to silence the artistic voice. Unfortunately artists cannot help meddling with nature. They take something simple and make it complicated; or they take something

whole and break it down, draw distinctions. In metaphysical terms, man touches nature with finitude, with the taint of mortality. "Let me wipe it first," King Lear says of his hand, "it smells of mortality" (4.6). This is just the corruption that Minimalism wanted to expunge from art.

As Donald Judd put it, "The big problem is that nothing that is not absolutely plain begins to have parts in some way. The thing is to be able to work and do different things, and yet not break up the wholeness that a piece has."[2] What is so wrong with the composite? To begin with, it is unnatural. Nature is not made of parts. It is human intelligence that breaks down a tree into trunk, twigs, bark, leaves, sap. In reality a tree is a seamless whole. Leaves for example do not hang on the tree; they are just what being a tree is about.

Now, at first blush it seems counterintuitive to speak of nature together with Minimalism because nothing seems less natural than the rationalist, geometrical look of Minimalist art. But its revolt against artificiality did hark back to a strain of primitiveness which, from Hawthorne and Thoreau to the hippies, runs deep in the American soul. This primitiveness first signals itself in the Minimalist's use of plain, nononsense materials and supplies. No object should pretend to be what it is not. Make-believe is duplicitous, and duplicity is unnatural. In nature nothing pretends; nothing strives to go beyond what is. Whereas an image conjures up false distances. It doubles up and divides reality, opens a duality between what is and what is represented, between the factual and the ideal. It divides the present from itself, creating horizons of expectation. In a word, an image causes tension, and tension is what we inflict on nature by wishing it to be other than what it is. Like images, tension smells of the human hand. As Robert Morris explains, "Surfaces under tension are anthropomorphic: they are under the stresses of work much as the body is in standing. Objects which do not project tensions state most clearly their separateness from the human. They are more clearly objects."[3] A genuine object, on this score, is indifferent: this is true of all natural things, such as Mount Everest, a storm, or an asteroid. And so, thought the Minimalists, it should be true of a work of art.

The look of Minimalism is puritanically sparse: cubes, rectangles, squares, triangles in bare materials, mostly in primary colors or in gray, which, Carl Andre liked to think, was not a color. There is also a marked dislike for representation: for instance, rather than draw or paint a cube, the Minimalist prefers to make a three-dimensional cube: first, because this is what a cube actually is (three-dimensional); second,

because producing it requires minimal creativity (there is only one way to make a cube, which is that it be cubical); and third, because, by producing the cube and not its image, one eliminates theatricality.

What is wrong with theatricality? It creates tension, distance, and longing. What is staged smacks of make-believe, and art is too serious-minded a pursuit to toy around with illusion. To counter illusion, Modernist art emphasized materiality. What Clement Greenberg said about Abstract Expressionists, that is, that they invited the eye, not to see *into* their paintings, but to *see* them intensely, was true of much of twentieth-century art.[4] Artists such as Jasper Johns (b. 1930) or Jackson Pollock (1912–56), to name two, saw no point in creating portals onto realities other than the painting proper. They kept the painted surface unabashedly front and center.

The Minimalists went one better by dropping the painting and leaving only the material. Through Minimalism, art tested whether we could exist without otherworldly longing, free from the malady of distance gazing and of wishing ourselves out of the world. The straight lines, the stripped-down solids, the plain surfaces, the geometric rigor: these were antidotes to daydreaming. When Carl Andre said of his slabs of capstones that "their subject is matter," he meant essentially that there was nothing to read into them.[5] Dan Flavin's neon tubes rebuff the dusky halo of mystery and *sfumato* in which the traditional work of art wraps itself. The fluorescent tube kills the half-shades: there is no recess, no ambivalence, nothing more than meets the eye. It does not slip away, nor does it call us into never-never land. It is plainly anti-horizon. Like direct sunlight, it is depthless, timeless, complete.

Unlike the geometric artists of the 1910s, the Minimalists were not enamored with the purity of geometry for its own sake. They did not believe geometry unveiled fundamental properties of the visual world. Geometry was a means, the goal of which was simplicity. But in their pursuit of simplicity, the Minimalists stumbled on a concept left for dead by Modernism: the infinite. In general, the Minimalists spared little thought to the unseen or the transcendent—all those vague and vacant places that, as opposed to the *here,* exist out *there.* Yet, stripped of *there,* the *here* becomes a kind of universal. Unbounded immanence is infinite. Suppose LeWitt's cube silences our escapist urge; suppose it stills all desire for interpretation and deeper meaning. Does it not achieve a kind of eternal quietude? It is the infinity of the here and now, the tranquil infinity of the truth that 2×2×2 = cube, that there is nothing left to add or subtract, nothing left to think about. And if there is

nothing to see beyond the cube, the cube therefore extends to the very size of the universe. *Here* without *there* is boundless. The cube now seems to deliver us into a plane of existence beyond objectivity. The clean white lines (on Judd's white wall or on Andre's bare floor space) do, in the end, make a vanishing point. It does not take much to lose oneself in those blank spaces.

This art of the indefinite statement came to a head on an evening of contemporary piano music of August 1952 in upstate New York, when the concert pianist David Tudor sat down at the keyboard to premiere the new piece by composer John Cage (1912–92): 4'33" in three movements.

Tudor closed the piano lid for the first movement; opened and closed it again to mark the second; repeated the same gesture for the third. At the end of four minutes and thirty-three seconds, he rose, took a bow, and what people had hitherto understood by *music* had come to encompass all and nothing. Not a single note had been played. Not that the score was devoid of directions: for one, it required that orchestral instruments be present and that the context be clearly a concert setting. Was it an avant-garde prank? Not in the least. To the end of his life, John Cage insisted 4'33" was his most important musical work.[6] It certainly is his most capacious: finite in time, it nevertheless encompasses something that, within its boundaries, harbors infinite possibilities.

As a rule, music breaks silence. As paint stains a white canvas or a dancer disturbs empty space, music "pins" notes on silence—or more exactly weaves sound and silence. For silence dwells in the tiny rhythmic interstices between notes, and without which melody would blend into sonic mush. Insomuch as silence hyphenates music, it is part of its fabric, and, as it were, sings through it. Cage's idea was to take this essential ingredient and push it to the forefront—doing with sound what his friends Robert Rauschenberg (1925–2008) and Mark Rothko (1903–70) were doing with paint: putting the material (paint, sound) ahead of representation. Materiality always played an important part in John Cage's compositions. In his early years, he was wont to place iron scraps, bolts, and rubber strips inside the piano strings to "materialize" the sound production. 4'33" hiked up the effect: while acknowledging the materialness of music, it also liberated this materialness from form. The raw material of 4'33" was the whole world. Cage simply let *everything* in.

Cage wanted his listeners to *hear* the silence. Silence, however, is heard only if noise dents its polish (unbroken silence is not silence but deafness). This is how the composer remembers his first solitary rehearsals

of 4'33": "I have spent many pleasant hours in the woods conducting performances of my silent piece. . . . At one performance, I passed the first movement by attempting the identification of a mushroom. . . . The second movement was extremely dramatic, beginning with the sounds of a buck and a doe leaping to within ten feet of my podium."[7] 4'33" did not make a sound, but it did not exclude any either. Cage never prescribed that his piece be performed in a soundproofed environment. Actual life was always welcome to take part, be it in the guise of a doe, a sneeze, or a scraping chair. Of course, the sound of trying to name a mushroom is sublimely tricky, but it reminds us that the patter of our thoughts always runs through silence.

A doe, a scraping chair, a thought about mushrooms: Cage invited all these things into his composition, as well as the incalculable score of any random sound (a plane, a cell phone, a barking dog, an earthquake). Open, nonspecific, unscored: all the sounds in the world (the sound *of* the world) belonged *in potentia*. Far from being the emptiest and most simple musical composition, 4'33" was perhaps the vastest and most replete ever devised.

We can approach the matter in temporal terms: what *sound* marks the beginning or the end of 4'33"? What distinguishes the sonic atmosphere *before* the piece starts from the sonic atmosphere while it is playing? The matter cannot be settled by the stopwatch. Starting the countdown is not a sound and therefore does not qualify as a musical beginning. So far as we hear anything, nothing distinguishes Cage's composition from what precedes or follows it. It has no boundary—it is as vast and unbounded as reality itself. It is an infinite work of art: to allow oneself to hear it is, in a sense, to admit it will always go on, that we shall never get to the end, and that it had always been playing in the background. Its exact duration (four minutes and thirty-three seconds) is meaningless; the chronometric time does not encapsulate the contents. The piece would essentially be the same were it to last one millisecond less or a trillion years more. (Cage wisely insisted that its duration could be stretched or lengthened indifferently and at random.) Its music is the backdrop resonance that goes on everywhere and for all time. "I am speaking of nothing special, just an open ear and an open mind and the enjoyment of daily noises," said Cage about his piece.[8] The title is telling: 4'33" is literally nothing special. It does not stand apart; it does not stop at, nor is stopped by, reality. "An open ear" and "an open mind" are all that's needed: as if to say, openness is the key. Openness is what it is made of. In this respect, it is perhaps the first genuinely cosmic work of art, one

that transcends the Modernist duality of subjectivity and materiality. For it is not just the work of art that vanishes as object, it is also we, as listeners, who disappear. Since we do not listen to anything *in particular,* we stop analyzing, breaking down reality into forms and concepts. We give up trying to impose sense onto the world. In this respect, we stop being separate from it. The true cosmic Oneness has no shape, and no resident human tries to clap a form onto it.

A later composition, titled *o'oo"* (1962), shows Cage attempting a more complete eradication of space-time boundaries. Of no timing whatsoever, the score of this composition requires no instrument, only that a somewhere and a someone be present: "In a situation provided with maximum amplification (no feedback), perform a disciplined action."[9] Two requirements: place and mind. The particulars of the action are of no consequence; only the degree of mindfulness matters. (Cage later modified his instructions to specify a beneficial action: his concession to [moral] harmony.) Of importance in *o'oo"* is the complete assimilation of art to the quality of attention that, once at maximum intensity, unites creator and spectator. What is the duration of total awareness? What is its location? In truth, it is boundless: for when the mind is thoroughly absorbed in some occurrence or object, it is not torn between *before* and *after; here* is not shadowed by *there.* Complete awareness is timeless, limitless, and impersonal; it does not draw distinction between self and world. Anything occurring within the *now* extends infinitely in all directions. Hence the timing zero minutes and zero seconds: quantity is irrelevant; the quality of mental absorption is all.

The idea of stripping form of all its material layers—until only the ghost remains—can be seen to have played in Cage's imagination since the very start. This is a conversation he recalls having with his teacher Arnold Schoenberg:

> After two years it became clear to both of us that I had no feeling for harmony. . . . Therefore he [Schoenberg] said I'd never be able to write music.
>
> Why not?
>
> You'll come to a wall and won't be able to get through.
>
> Then I'll spend my life knocking my head on that wall.[10]

An artist often bumps against his creative limits. But this wall of silence between what the musician *wants* to do and what he *can* do is not absolute. For the artist really knocks against his own creative possibilities.

What he is up against is the possible, not the impossible. Cage's stroke of genius was to make the possible (that "wall") into the stuff of his art. The silence he was up against *became* the music; the possible entered the actual without ceasing to be indeterminate, that is, infinite. The wall of silence turned into the hall of silence.

Cage was not the only artist to seek a cosmic infinite expression. Five years before Cage's 4'33", the French artist Yves Klein (1928–62) premiered his *Monotone Symphony*, which consisted of a full orchestra playing an unbroken single note ideally ad infinitum—a requirement liable to daunt even the most sanguine performer. The idea, however, was for the unchanging note to lull the mind into a tranquil state where one quickly stops fussing about beginning and end and duration. *Monotone Symphony* starts nowhere and goes nowhere. It features no before and after, no beginning and end. After a while, it blends into the sound of background space, indistinguishable from the absence of music. The single note is the everlasting now, the primal hum, the basso profundo of infinite space. Though it lacks dimensions, its world is completely familiar and restful.

But Klein was really a visual artist, and it is in painting that his originality shines. To Klein, the nonobjective art of the Russian Constructivists was still too objective. Of course Malevich's *Black Square* had never sought to picture an anecdotal, actual black square. Nevertheless Klein believed *Black Square* did put a definite square before us: that was something. In contrast, a truly nonobjective artwork should *partake of* the black square—not objectify it but enter its being. This union Klein practiced, not in black but in his famous blue.

Klein began his blue monochrome paintings in the mid-1950s after a year spent blending various pigments of aquamarine blue to come up with the perfect hue. This perfect blue (patented as International Klein Blue, or IKB) he poured on series after series of canvases—large, frameless pools of absorbing underwater caves, swaths of cloudless sky, floating relics of cosmic or uterine happiness. Blue's capacity for immersion was in fact Klein's reason for his devotional use. "Blue," he said, "has no dimensions. It is beyond the dimension of which other colors partake."[11] When removed from the company of other colors, a color stops being a color: like a note played continuously, it becomes an environment. Moreover, blue taps into a neurological peculiarity of human perception that sees blue as the most uncontrived and agreeable of all colors. Yellow, red, black, and white tend to call attention to

themselves as pigments. Thus a yellow canvas is a canvas that happens to be yellow. This is why, after experimenting with red, orange, and yellow monochromes, Klein opted for blue exclusively. Only blue has the power to make us forget it. Blue is the default tint, the background hue, the mother of all shades. The blue of the air, of water, of the night; the blue of Hölderlin's "lovely blueness"; the cerulean blue of quattrocento perspectives: the very blue by which Klein wished to convey, as he said, "the far side of the sky."[12] Not, in other words, the sky (which is an object) but the expansiveness of the sky, the aerialness and boundlessness of it. Blue was the noncolor to convey the non-thingness of essential reality. As Klein said, "I have chosen as my ally the palpable space of the entire, boundless universe. This is the first time that anyone has taken it into account. It's like finding the master key."[13] Some painters depict landscapes, others water lilies, and others yet soup cans. Klein painted the element that all these objects assume: space. Blue was the color of the universe, of the nonobjective hereness in which all things have a home.

Nor was the idea to *show* space: in the same way the hand cannot point to itself, so no artwork can expose the substance of which it is made. Seeking intimate contact with their subject matter, the blue paintings are surfacings on the sea of space in which they and we swim and sink. We are not meant to observe them but to let them float and drift around us, till they melt into the backdrop of life.

Yet in the end it seems even the blue paintings proved too thing-like for Klein's taste. "Let's be honest," he said, "to paint space, I have to put myself right into it, into space itself."[14] On the night of April 28, 1958, Klein opened his exhibit *Le vide* (the Void) at the Iris Clert Gallery in Paris. Invited guests were ushered into a room emptied of all furniture. The walls, floor, and ceiling had been freshly painted white from top to bottom. The exhibition room itself was the exhibit. This way of putting the matter, however, fails to grasp Klein's idea: for space evidently cannot become an object in space. Klein wished not to stuff space into a room, but to set us in space. He did not paint the room in IKB precisely for this purpose, so as not to draw attention to the room as an object. The point was that space is not before or behind or around us. It is not an object of perception. It is that by which there is perception and things and beings.

To be in space is really to be in infinite space (never mind what the gallery walls suggest: they, too, belong in space). Space has no exit. It is the all-encompassing, wonderfully universal home we cannot even

point to as being *there* since *there* too dwells in space. It is universal and unsurpassed. The horizon (that which cannot be reached into) is in this sense less a feature of space than its essence. Like the horizon and *as* horizon, space has no shape; it quietly lets us in on the fact the world is without form: not because it scutters away from us or because human perception is flawed, but because it is in the very nature of space to elude circumscription.

In the end, *Le vide* also proved too confining for Klein's unswerving vision. Whoever exhibits something controls it. But who can control space? Space has us, not we it. Though we cannot overcome this condition, we certainly can embrace it. Klein's last word on space, a photomontage titled *Leap into the Void* (1960), expresses this glad spirit of surrender. It gives up all exhibiting and framing tactics. Subtitled *The Painter of Space Throws Himself into the Void, Leap into the Void* is a black-and-white photograph of the artist hurling himself from a rooftop and falling spread-eagled toward the pavement (fig. 20). Klein was a lifelong judoka; the first thing one learns in judo is how to parry a fall. In the picture, the artist renounces this protective, space-controlling reflex. His arms wide open, he entrusts himself to the fall. Life is a going-forth, and self-centeredness is an illusion: we are the children of space and never leave its bosom. We are absolutely safe, Klein reveals with childlike abandon, for space will never let us down, literally. There is no such thing as falling out of space. It enfolds us. When we understand this, we can cheerfully let go and relax our grip on forms, our desperate cling at mental parachutes and seatbelts.

Then Yves Klein literally vanished—died of a heart attack at the age of thirty-four. In a biographical sense, death interrupted his work; thematically, it made it perfect. Shortly before dying, Klein presciently suggested that his next artistic step should be to disappear. For love of space, he had to become fully he who falls and not just his representation: "Now I want to go beyond art, beyond sensibility, beyond life. I want to enter the void. My life should be like my symphony of 1949, a continuous note, liberated from beginning and end, . . . I want to die, and want people to say of me: he has lived, therefore he lives."[15] To enter the void, we must let the void enter us. For if one exists as a body in space, be it a falling one, one is not yet as pure and smooth and simple as space. To be liberated from form means for the artist to slough off the form that he, as an object in the world, is.

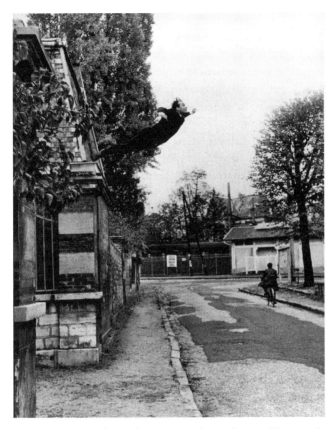

FIGURE 20. Yves Klein, *The Leap into the Void*, 1960. Photograph.
Courtesy of Art Resource and Artist Society.

A beautiful harmony thus ties Klein's art and life. Had he precipi-
tated his disappearance (say, by suicide), his destiny would have curled
back on itself (the artist as Romantic master of existence). To die for
love of the open, the artist must not stage his demise. Artful death came
with obliging timeliness. It was Klein's final work of art, his nonwilled,
total artistic surrender to being. The infinite work of art can have no
maker. Klein vanished into it.

Klein encapsulates a tendency, at work since the Romantic period,
that aimed at breaking art from the straightjacket of form. Reality (as
twentieth-century science gave convincing evidence) is not thing-like.
At the subatomic heart of matter, the proportion of emptiness between
particles exceeds by staggering magnitudes the size of the particles

themselves. There is vastly more emptiness inside matter than actual stuff. In this respect, Minimalism was strictly realistic. But unlike the Romantic, the Minimalist refused to grandstand before open space. This pose is false because man standing before the infinite thereby limits the infinite. The German Romantic Schlegel was right to say that "the longing for the infinite must always be a longing."[16] Touch the infinite and it goes up in smoke.

Minimalism interestingly presented the infinite even without the longing. Longing residually betokens a self and therefore a duality between infinity and man. Klein's leap is a selfless going-forth, not a pulling-to-himself. Part pratfall and part prank, it thumbs its nose at grandiosity. When the infinite sweeps us away, it will be with comic relief—the opposite of tragic longing. Most Minimalist art is archly noncomic, yet knocks the ego from its soapbox no less than comedy. Wanting of nothing, expecting nothing, alluding to nothing, the Minimalist object evokes the world before Adam began naming things. Partaking of infinity requires giving up personality, perception, the objective, and finally the subjective. Klein luckily went to this ultimate length. He broke the stranglehold of finitude that plagues art (i.e., the stricture of form) and man alike (i.e., mortality). Klein, according to his own words, "overcame the problems of art" when he overcame the problem of existence—that is, our anxious concern over its limitedness.[17]

Death is the great, indeed the archetypal, limiter. It claps the general framework onto life. It keeps our clock ticking, and we plan our days and years against this background ticktock. It is the anxious apprehension of the boundary that gives shape to life. Since time immemorial, art has been involved in representing this mortal limit. The origins of art begin with funerary artifacts: the figurines, carvings, and death masks that served as funeral offerings. It is through art man began trafficking with death; through art, he put faces and forms on that whirlwind of nothingness in the midst of life. The art of ancient Egypt had no other goal but to objectify death. The very first journey of fiction, *Gilgamesh*, tells of a man who seeks to etch the horizon of his life. And thus it continues on down to Beckett's Estragon and Vladimir.

But is there another way to face finitude than by drawing its horizon? The Minimalist works of art suggest that there is. Seen from one angle, death really means the end; seen from another, it means the end of the end. The ultimate moment will lift the need to count down to the finish line, to save time, to look ahead. Thereafter, whether there be eternal life

or eternal nothingness, there will be no more cause to draw the map of existence. To die is to be "liberated from beginning and end."[18] It is to be rid of the mindset of finitude.

Minimalism heralds the era of postfinitude. In one sense, death is everywhere in the Minimalist object. Its sparse, stone-faced austerity savors the tombstone. Carl Andre's slabs of zinc or Tony Smith's black steel plates beg comparison with recumbent funerary slabs. And yet even this we should not trumpet. The only right attitude before a grave is silence. And so with Minimalism. Expression is at an end. There is nothing more to say, nothing to say at all. Silence settles over the history of art—over the history of finitude.

This silence opens a way out of subjectivity. Like the funeral artifact, the Minimalist object pictures a humanity freed from worry. It is everyone's tombstone and, in this sense, no one's. In truth, it does not even ask for contemplation. Even its form is irrelevant. Is a geometric figure a form? In an obvious sense it is; in another, the Minimalist cube or rectangle or square is just a mathematical axiom that obtains today as it did eons ago, and will forever. If anyone ever invented the square, his or her name deserves oblivion. It was not a personal discovery but a self-imposing conclusion. In this sense, Minimalist simplicity discards the existential drama of finitude. Its serenity is that of philosophical wisdom, the one that speaks through Socrates quietly assenting to his death. "What has happened to me is a good," he says in the *Apology*, "and that those who think that death is an evil are in error. . . . The hour of departure has arrived, and we go our ways—I to die, and you to live. Which is better, God only knows."[19] Though rare, this detachment is as human as mortal anxiety, and belongs in art as much as the anxious melodramas of Romantic death throes.

A good question is to wonder why this detachment filtered into the artistic sensibility of the late twentieth century. Are there historical forces that compel this abandoning of the sentimental horizon? What are the social, scientific, or moral reasons behind aesthetic impersonality? The final chapter of our journey explores some answers.

Nowhere

The Moon, July 21, 1969, 3:58 A.M. BST

To silence Job's sermonizing dirge, Yahweh reminds the mortal of how little humans can know: "Hast thou perceived the breadth of the earth? Declare if thou knowest it all" (Job 38:18). The Yahweh of the Hebrew Bible is given to pulling rank and does so here, suggesting that Job would have to be as mighty and omniscient as God to criticize God. The jealous gods would roundly smite the social-climbing Icaruses and Prometheuses of the world who dared climb to that panoramic perch. Job, for one, gets off easy with a warning. Job meekly admits that human knowledge indeed cannot see beyond the curvature of the earth. Then not believing his luck (God forgives his impudence), he shuffles off in silence.

In the end, however, Job did get the last word. In April 1961, the Soviet cosmonaut Yuri Gagarin orbited the Earth and became the first human being to perceive, with his naked eye, "the breadth of the earth." The terrestrial way of seeing the old earthly home was of the past. Job had objectified—and therefore mastered—the horizon. We had seen past it, and it, like the rest, joined the rising heap of demystified objects.

Seven years later, the *Apollo 8* astronaut William Anders took the birth picture of this new extraterrestrial reality in the form of a photograph of the earth seen from lunar orbit: there it hung, an ocean-blue sphere stenciled against an unimaginable abyss of black, terribly alone. As chance dictated, Anders took this picture on December 24, 1968—as though to symbolize that a new breed of human beings had been born,

perhaps a new spiritual phase heralded by the advent of a new god-man who had leveled the playing field with God.

And then most famously, on July 21, 1969, the astronaut Neil Armstrong waddled down the landing module of the *Apollo 11* spacecraft and took humanity's first step on a planet not our own. We had definitely left home. This triumph of technology and planning crowned the age-old belief in the extraterrestrial nature of man. A creature made in God's image, Adam is fashioned of mud but receives his operating system from heaven. For all the dirt in his sinews, he cannot but remain an interloper. Yahweh scolded Job for daring to pass judgment on the creation; yet Job could have easily pointed out that, given his ancestry in Adam and Eve and given *their* ancestry in God, he could claim the gene of cosmic judgment. He could have said that, for instance, the very fact of arguing with God hinted at supramundane powers in man, powers of comprehension that allowed him to take in, if only conceptually, the very breadth of the earth. It is not every creature that can swap arguments with the Supreme Being. Although the interview does not entail matching levels of intelligence, it does assume a creature capable of comprehending the concept of "breadth of the earth." To grasp this concept is—almost—to behold the thing.

And behold the thing we did. Icarus came back down unpunished from his space mission with a snapshot in his travel pouch: an earthrise, seen from the moon. The earth floating in the abyss. Our terrestrial home caught on film.

A single image cannot change humankind, but it can symbolize the visible crest of a slow-moving moral sea change altering human identity at large. This identity, earthly though it is, has always looked to the celestial vault as a mirror, a distant kin bearing messages for us. Our most durable structures, Stonehenge or the Great Pyramids of Giza, were dialogues with the stars.[1] They placed human existence under the whisper of astrological runes, messages from celestial bodies which reminded us that, though we be stuck on earth, we took our marching orders from heaven. Which is why seeing the heavens no longer above and our planet no longer below as we did after 1968 upended the terms of our earthly reality. The Job who gazes up is not the Job who looks down. The comedian Woody Allen joked that the secrets of the universe seem petty next to the mind-boggling complexity of finding one's way around Chinatown. But in fact it does matter to our whereabouts in Chinatown whether the universe is finite or infinite, whether it is static or expansive, whether it is destined to collapse or bubble up till all eternity. Thoughts about ultimate purpose or

ultimate futility transpire from these images. After looking at them, we may not even want to find our way around Chinatown.

The discoveries of twentieth-century cosmology have not committed us to eternal torture in Tartarus, but they did make us send a message in the bottle. On August 20, 1977, NASA launched the spacecraft *Voyager 2* with a capsule containing music, a picture of a man and a woman, a message in sixty languages, and a galactic map of earth's location. Who but a castaway casts a message in the infinite sea? In leaving the earth, we kicked ourselves free and now we drift off in empty space. We want someone to know that we are here. But where? Perhaps we would like others to tell us. So we send distress signals into the galactic abyss that, since Pascal, keeps growing more abysmal by the year, so vast that it seems too much for the human mind to bear; perhaps we need to share the burden of its emptiness with other sentient beings—and here God just does not do, because God cannot know what it is like to inhabit fathomless, eccentric cosmos. The gods have not rained down thunderbolts on us for encroaching on their turf, but worse happened: they have left us the field all to ourselves. And the field is infinitely vast, so vast it oppresses the imagination and leaves us pining for some lost measure of safety and companionship.

And so the *Voyager 2* capsule. We could have also loaded it with a photograph of planet earth to symbolize our shipwreck. To see home before us implies that we are no longer in it. The *Apollo* missions proved that, though temporarily out of technical reach, human existence on other planets is not intrinsically unfeasible. Emotionally we may be attached to the earth; intellectually, the umbilical cord is severed. That we are sentimentally attached to this planet in fact assumes the possibility of detachment.

Of course, the portrait photograph of planet earth reveals a psychic divorce from nature that is long-standing. Christianity is not the only religion that harps on the essential separation between man and nature (as the Gospel of Luke puts it, "The foxes have holes, and the birds of the heaven have nests; but the son of man hath not where to lay his head" [9:58]). The Chinese emperors of four thousand years ago were revered as the offspring of sky gods. So were Sumerian royalty. According to some Vedanta schools, the human soul is related to Brahman. Adam and Eve have a spark of the divine in them. It seems a part of us is at pains to imagine our origin as other than extraterrestrial. The photograph of the earthrise was as much a new milestone as an old self-portrait.

On the one hand, this photograph is a trophy of human intrepidity. We have put the earth inside a box, we have thrown off the moorings, and now we are cosmic solo travelers. On the other hand, we cannot but feel a pang of exile, the thin precariousness of our terrestrial abode, the icy breath of all that inky void. We yearn to retreat to the homelike earthly scale. Regretful of having seen so far, we run for safety in the asylum of archaic beliefs. Whence the anachronic gloatings of know-nothing biblical fundamentalism, the childish rejection of a universe too limitless, an earth too incidental, a geological record that stretches too deep—in sum a picture of reality too far out of proportion with the ordinary human scale by which we calibrate our meanings and values. The backlash of parochial sentimentalism is also in evidence in home-and-hearth reactionary politics (e.g., the connection between Hitler's rant against Einstein's Jew-science—between the blood-and-soil sentimentality of fascism and the cosmic cosmopolitism of modern astrophysics). Prometheus punishes himself by making his dreams and thoughts once again very small (e.g., a universe that is only seven days older than man, a garden, a flood, a God who tells us exactly when, where, and how to live). Finally, there are others who look at our lonely blue balloon adrift in the implacable darkness and shudder at its fragile existence, seized by the urge to nurse it. Now the image of earth from outer space is the portrait of an endangered life, the symbol of a new ecological urgency: we have nothing but it—this small home—and had better work to keep it ship-shape and lovely. The Job who has seen the breadth of the earth is no longer the one who railed against its plagues and monsters. In mind, he is now a giant; he understands that the earth, too, is frail and at the mercy of greater forces. The parenting relation has been reversed. And this, too, is a measure of our exile. For whoever guards home cannot expect full protection.

This picture of the global earth (of earth-as-a-thing-before-us) is of course a child of twentieth-century cosmology. By the late nineteenth century, the new silver-coated glass-mirror telescopes had begun to unveil a universe fathomlessly larger than imagined. Wooly patches of light in the far reaches of the sky proved to be not faint stars, but clusters of stars, nebulae, swarms of heavenly bodies as numberless as the bright dots in our neighboring Milky Way. Our galaxy was in fact one among many, and the distances phenomenally large—though not beyond calculation. In 1914, an astronomer at the Lowell Observatory in Arizona, Vesto Slipher, published studies that showed that the light coming from

distant nebulae was red-shifted. (Light waves move to the red end of the spectrum when they stretch and to the blue end when they rumple up.) It was not altogether clear what conclusion to draw, save the fact that some galaxies were moving away from us (and their light waves therefore stretched longer on the way to us). This conclusion did not jar with the common astronomical view, according to which planets, stars, and galaxies orbited around one another; it was natural some of them should be observed to be flying away from earth.

The real shock came in 1929 when the astronomer Edwin Hubble showed that *every* galaxy, in whatever corner of the night sky we observed, was red-shifted and therefore could be said to move away from us. Unless we had a compelling reason to think ourselves the static center of the universe (we did not), the conclusion was that we, along with every other point in the universe, rushed away from every other point. In other words, the universe appeared to be swelling out. This conclusion did not make immediate converts. In fact, it was superstitiously rejected even by those whose theories or observations recommended it. To his dying day, Hubble refused to accept what his sightings had uncovered. Einstein held out against the idea for a decade, even though his general theory of relativity implied it. "To admit such a possibility seems senseless," he wrote in a letter.[2] Yet the mathematician and cosmologist Alexander Friedmann independently worked out Einstein's numbers and, anticipating Hubble's observation, showed that, if the principles of general relativity held, it followed that the universe had to be expanding. His calculations furthermore implied that the farther the galaxy, the faster it should be receding. The astonishing upshot of Friedmann's equations was that not just the universe, but the very stuff of space was expanding, much like the surface of an inflating balloon. This is why, the farther we look, the universe expands at a faster rate, because there is more intervening space and therefore more intervening swelling in between us and that distant nebula.

The idea of a static universe, which general relativity kept intact, had suffered a fateful blow. The ultimate cosmic framework turned out to be not a framework at all. The universe was not context but process. The theory of cosmic expansion furthermore meant that it was possible to trace its temporal trajectory to a beginning. This led the astrophysicist and priest Georges Lemaître to posit the idea of a primeval atom, an unimaginably dense and tiny egg of pure energy out of which, following a phenomenal burst, the universe blazed open. This notion of an explosive singular beginning, known as the big bang, was initially

dismissed as the biblical vapors of a priest, but, forty years later, independent cross-calculations and observations (such as the presence of background radiation and the distribution of predicted elements such as helium throughout the cosmos) ratified the notion of an universe with a birth date (estimated at roughly thirteen and a half billion years ago).[3]

Einstein called Lemaître's calculations "accurate" but their consequences "appalling."[4] But what was appalling? Not of course that it all started with a "let there be light," but the fact that it moved, and therefore, if the theory held, that the universe was not all there was. If it expanded, there had to be something for this seed to burst into, something larger or more encompassing and primordial. For all its dizzying and incommensurate vastness, the universe could not constitute the ultimate reality. Worse yet, it could not furnish us with any clue about ultimate reality. For it probably is not the case that the universe expands across a backdrop of space-time. As most astrophysicists believe, time and space have no reality before the big bang. Time is measured in terms of motion (say, the rotation of the earth around the sun). But in the infinitely small and dense primal singularity, there was no distance whatsoever between one point and another, hence no room for time to elapse. Time and space emerged as the universe spread out after the initial microsecond of the big bang. The same principle governs its current expansion. Though it beggars the understanding to think so, the universe most likely creates the space in which it expands. (Try picturing a musical performance creating the concert hall in which it plays.)

The "appalling" novelty of this theory is that, though it cohered with almost all observed phenomena in the cosmos, it also made hash of the prospect of ultimately understanding the cosmos. Science had butted against an insurmountable limit. This is because scientific facts are expressed in mathematical language, and mathematics assumes the existence of space and time to articulate causal and geometrical relations. Now, the theory of the big bang stipulates that space and time sprang out of the singularity; as for the singularity itself, it did not take place. There was no time zero at time zero and no initial place at the initial place. It is therefore an area of reality fundamentally off-limits to mathematical description, hence to science. Our understanding is shaped by a reality that came into existence at a given point and moment to which we cannot ascribe a space-time location and therefore a mathematical value. The physicist Steve Weinberg put the matter simply by saying that past a certain point in space-time, we cannot wind back the clock

because we run out of space-time.[5] Yet this does not mean that there is nothing either. Instead, whatever there is cannot be described in terms of space-time because both are components rather than preexisting conditions. There the elementary fabric of reality breaks down, together with our understanding.

As to where the universe expands or shrinks, the mystery remains. Beyond the closed system that is the physical universe, there is no reason for or against believing that the same laws hold sway. For all we know, whatever is normally meant by space does not avail in that nether region. Indeed it may not be a region at all and may defy even our most unorthodox notions of what counts as existing. The universe, so far as we can imagine, is a mystery afloat in the inconceivable.

Many scientists are not keen to accept this picture: the unknowable carries an unpalatable whiff of theology. It is partly to obviate the intellectually unsavory solution of a universe that begins by shutting us off from its initial state that the cosmologist James Hartle and the physicist Stephen Hawking advanced the idea of a self-contained, self-creating universe. Here is how Hawking presented his hypothesis: "I want to make a proposal for the quantum state of the universe. . . . This proposal incorporates the idea that the universe is completely self-contained, and there is nothing outside the universe. In a way, you could say that the boundary conditions of the universe are that there is no boundary."[6] The Hartle-Hawking model rests on complex quantum processes that are mysterious to the layperson, but the basic picture is this: at the infinite concentration of matter at the big bang (i.e., all the mass and energy of the universe packed into one particle), quantum physics supersedes the laws of spatial geometry that rule over large material bodies. Space-time becomes a function of quantum processes, not their preexisting basis. At that extreme level, it is possible for something (*the* thing) to exist without existing in space and time. In a way, the universe funnels down not to a singularity, but to a state of being where it makes no sense to speak of singularity, time, space, development, geometry, and so forth. In fact, the universe does not taper up to an initial point but rounds off. To envision this rounded self-contained universe, the science writer Kitty Ferguson provides a useful analogy: once we reach the North Pole, the idea of going farther north is irrelevant. And yet we have not reached a limit. Rather the concept of *north* gives out. This is what happens at the singularity of the big bang in Hawking's theorem: the notion of a beginning ceases.[7]

Now, Hawking submitted his theory as a model, not a definite explanation, so there is no reason to regard it as more than a picture. We simply observe that, like the theory of a definite beginning, it steps back from the beginning: there is no knowing how or whether the universe began. In this sense, the universe has the equivocal form of a horizon: the limit of both cosmic reality and human understanding is there for sure, though we are never to say exactly where; nor are we sure there is a limit. Perhaps, trying to chase it, we like Magellan's ship will travel back to where we are now.

As narratives go, the big bang universe theory benefits from a smashing opening act; its third and fourth acts, however, are more dilatory. On the one hand, our universe cannot be infinite since it "began" some fourteen billion years ago, which, as a length of time, is clearly not long enough to house an infinite universe (no amount of time is long enough for the infinite). On the other hand, given its estimated expansion rate, we also know that we can never observe its outer reaches. Fourteen billion years is not enough time for the light of outermost stars to travel back to where we stand to observe them. On this principle, it would seem that the universe is both finite and indescribable in shape. Now, scientific culture has had over seventy years to absorb the intellectual shock of an expanding cosmic reality. Still, the aghast reception that initially greeted its discovery seemed closer to the mark than jaded acknowledgment. The inflationary universe does throw the world for a spin. In this brave new universe, the presiding laws actually derive from it. It is a house built not on solid ground, but on its own upper floor. The cosmic reality we take to be so fundamental is merely adventitious. We are asked to imagine that Being, the stuff we take to be so basic and necessary to existence, is not the precondition of life.

In general, we need to live in a world of which we can, to some extent, form a mental picture. But the big bang universe is rigged up with paradoxes. Let us, for instance, consider this twist: it is agreed that the farther we gaze into space, the earlier in time we actually see (since the farther the star, the longer it takes for its light to reach our radio telescope, and therefore the earlier it was emitted). From which it follows that the farther we look, the more we see the universe at an earlier stage of its expansion: in effect, the deeper we look, the younger, smaller, and denser the universe gets. Carrying this visual trajectory to its logical outcome, the trip into the recesses of space-time should lead us to the singularity of the big bang, that is, incidentally, to the

place where we happen to be right at this moment (the early seed, one recalls, contained all space, including where you are sitting right this moment). Every minute spot in the cosmos has equal claim as any other to call itself the center of the cosmos. As every place on the surface of a sphere is the top of the sphere, so every corner of the universe can be said to be the center from which the universe expanded. Indeed if we were to be rushed back to the split second of big bang, we would not see ourselves being transported through intergalactic space; instead we would see the universe rapidly shrinking onto us. The trip toward the outer, most remote, and earliest reaches of the universe loops back to the very spot from which we are looking. The photons streaming from the most distant light source were emitted from the same spot where we are now. The very far and the very near are one. The upshot is that, the longer we look at the infinite universe, the more it collapses in on itself. It literally disappears on acquaintance.

Einstein's theory of general relativity, as we saw in an earlier chapter, chopped up the ancestral view of smooth, uniform space. One thing, however, that general relativity maintained was the concept of space and the notion of locality, that is, the principle according to which any given body can occupy only a length of space at any given time and that interaction with other bodies mandates their coming in direct or indirect contact. This contact, whatever it be, occurs through space, assumes its existence, and is therefore subject to its constraints, one of which is that nothing can travel faster than the speed of light.

Now, a new area of physical exploration chipped away at the primordialness of space—that is, the notion that whatever occurs in the universe somehow happens in space. This new field of investigation was opened by quantum physics. Initiated by the work of Max Planck on photons in the early 1900s, quantum studies got underway in the 1930s with the research of physicists Werner Heisenberg and Niels Bohr. By even the most even-keeled estimate, quantum physics runs riot over conventional physics. Not only does it baffle our most engrained intuitions about space and time, it also draws a picture of a world so implausible, so bizarre, and so flouting of commonsense that even its exponents admit bemusement. As Bohr famously said, "If someone says that he can thinking about quantum physics without becoming dizzy, that shows only that he has not understood anything whatever about it."[8] The intellectual shock of quantum physics is indeed that it asks scientists to accept that its veracity does not depend on its making

sense. In effect, it says that an explanation can be scientifically true and valid yet nonsensical. The quantum physicist Richard Feynman told his students, "The theory of quantum electrodynamics describes nature as absurd from the point of view of common sense. And it agrees fully with experiment. So I hope you can accept nature as she is—absurd."[9]

Thankfully this absurdity obtains in corners of existence several magnitudes smaller than the visible world, at the subatomic level of matter. I make no claim to understand quantum physics beyond the bite-size dispensations of popular enlighteners.[10] What emerges from their reports, however, is staggering. For the first time in history, we may be entering an era in which reality is no longer picturable—where the very notion of world-pictures must be abandoned.

Most notorious among the principles of quantum physics is the uncertainty principle. This theorem sets a limit on how much we can ever know about nature. It states that if we can spot the location of a particle, we lose the coordinates of its velocity; and if we know its velocity, we cannot pinpoint its position. Either one or the other: either space as geometry or space as motion, but not both. General relativity argues that the latter determines the former; quantum physics does not disagree but states that, at least at the subatomic level, to look at the former obscures the latter.

A more shocking feature of quantum physics is that it contravenes the principle of noncontradiction. According to this principle, an object cannot be both itself and what it excludes. Yet, as quantum theory predicts and repeated experiments confirm, the *same* light photon can be shown to behave both like a particle and a wave. It is both a single object flying through space and a scattering of energy. In other words, nature allows a thing to be simultaneously A and B, even though being A excludes being B (how can a thing be at once singular and plural?). Weirder still, the observer is implicated in this Janus-faced reality. Heisenberg discovered that, until the moment a particle is detected, there is no way to know what its properties will be. The way in which the observer perceives the particle determines whether it is really a wave or a single particle. (In everyday terms, this is a bit like saying that until I look at him, my dog's hair is neither shaggy-curly nor short and straight. It is my perception that curls or smoothes my dog's hair.)

Annulled by this well-documented phenomenon is the principle of objective distance. According to this principle, the less we interfere with an object, the better it maintains its objective integrity. On the contrary, quantum physics says that a thing has no objective properties until it

is sampled. An object is not more fundamentally itself by keeping its distance. At the quantum level identity is no longer a function of space at all. The whatness of an object does not rest on its being distinct from another (say, from the observer). There really are layers of nature in which spatial separation does not define what a thing is and is not. Indeed at some substratum of reality, nature overlooks space altogether.

This astonishing claim was demonstrated by what the science writer David Peat has called "the most profound discovery in science," one that knocks down the cornerstone concept of *locality*.[11] The locality principle states that when object A causes any modification in object B, some sort of contact or communication has taken place between the two (this meaning of *locality*). But in the 1960s the physicist Stewart Bell worked on a theorem that argued that the act of meddling with a subatomic particle here could instantaneously modify its twin particle over there. It did not matter whether *here* and *there* were distant by a hair's breadth or by billions of light years. Distance, and therefore space, was of no importance. In 1972, the first of many independently run experiments bore this theorem out. To detect a photon in one corner of space instantaneously changes the spin of its twin photon elsewhere, no matter how far. So much, then, for the dictate of general relativity, according to which nothing outruns the speed of light. The violation of this speed limit is like outpacing the rate at which space unfolds. To go faster than light is therefore to "travel" in spite of space. And the experiments proved it again and again: there is a level of reality that simply does not acknowledge the existence of space. There, space is an old pushover variously tricked by particles to the edge of nonexistence.

Nature (so the subatomic heart of matter tells us) is not inherently spatial. Now, it is one thing to say this but quite another to picture it and then live inside that picture. How can we draw a picture of the world without factoring space in? Einstein himself insisted that the role of science is to make sense of our cosmic abode: "Physical theories try to form a picture of reality and to establish its connection with the wide world of sense impressions. Thus the only justification for our mental structures is whether and in what ways our theories form such a link."[12] The world according to quantum theory does not need extension. Indeed it does not take really place! Quantum physics ushers us into a universe that is *truly* shapeless: not uneven or unshapely or boundless. The world is shapeless because the concept of shape, which necessitates extension, is not a necessary condition. It is a world of no worldview.

The history of the plastic nature of reality is reaching a breaking point. The fundamental universe turns out not to be plastic and geometric. It is not representable. How will art, social institutions, and religious thought ever contend with an undepictable reality? How, without space, boundary, and horizon, can we picture and communicate our mortal intimations? On what picture of cosmic reality can we model our finitude? Social existence assumes that thoughts are expressible into world-views, and that those world-pictures are habitable. How do we live in an unimaginable world? Who will be the Brunelleschi and Bellini and Turner of quantum spacelessness?

In practical matters, we have only to look around to see that modern technology has altered the old-fashioned shape of space-time. High-speed telecommunications (phone, TV, internet) dismantle distances. We communicate, work, and live in contempt of geography, instantaneously seeing or speaking or doing business with people to whom we are not physically present. The idea of interaction without presence is now a humdrum feature of everyday life. It has shrunk the world, indeed has taken the sine qua non of extension out of it. Ours is factually less and less a reality of expectant horizons but of instantaneity, short circuits, and live communication relays. Satellite linkups and information wormholes punch through the old terrestrial fabric of space-time. My cell phone can hook up with any number of cameras around the globe and let me see and hear what is happening there. *Being* and *being there* are no longer synonymous. Our planet is a sphere no more but a quickly changing origami of crossovers. In the realm of social manners, patience, the habit of suffering space and time to take their course, is said to be in retreat. Those twin photons linked in spaceless quantum communication may seem strange to us; yet socially we have begun behaving like them, demanding and expecting instant feedback.

It is yet unclear whether, in apprehending this instantaneous spaceless reality, we will have to forgo visual analogies. What works of art, what buildings, what cathedrals can we fashion to testify to the abolition of space? Architecture thrives so long as the moral and religious life nurtures extension. Architectural heydays have generally coincided with periods of visual and spiritual expansionism (the Gothic period is one example, Renaissance perspective is another, and the America of Manifest Destiny, of which the skyscraper is the visual offspring, is yet another). But what formal expression can we envision for our age of self-canceling space?

The artistic movement known as Conceptual Art is a possible response. Conceptual Art was the invention of artists who, in the 1960s and '70s, brought Minimalism to its ultimate consequence and did away with form. Why, they asked, should a work of art be an object? Why must it have a shape? Why can it not consist of an idea, a syllogism, a syntax of insights? Though ideas need the support of forms, be it words or numbers, these forms are disposable. The artist Joseph Kosuth presented works that, in settings other than the art gallery, could pass for public written announcements or photocopied dictionary entries. A verbal description of them would do just as well. They require not sensual acquaintance but "getting." They want to be understood, not seen. Merely knowing about them exhausts their nature: you can beam the idea across the globe in a digital file. It is as instantaneous, disembodied, and ubiquitous as thought. Many Conceptual artworks accordingly shun being made: they consist in their assembly instructions (a chair, a wall, a written message) and do not require the self-same unique objects (chair, wall, or message). The physical content is irrelevant, only the intellectual import. Like quantum reality, Conceptual Art bypasses space and keeps to a purely intellectual plane of experience. We may imagine a Conceptual artist's take on the horizon to consist in thinking about the horizon or saying something interesting about it.

Performance Art, another significant artistic development of the last thirty years, is another way of paring aesthetic expression down to the intellectual wire. Often, as in the sets created by Joseph Beuys, the performance itself (its objective particulars) has no importance so long as it sets the spectator thinking. And if we do not know exactly *what* to think, so much the better, because an nonobjectified thought is that much less thing-like and space-bound.

Are Conceptual Art and Performance Art symptoms of a reality under the dominion of thought? Have technology, science, abstract reason, and social artifice pushed nature so far aside that physical reality no longer seriously interposes itself? Novels of science fiction like William Gibson's *Neuromancer* (1984) envision worlds made of circuits of disembodied communication: its denizens upload their consciousness, memories, and personality onto a computer chip. They exist by circulating the data they are made of. These are fictions of a humanity that transcends space. In such future worlds, we will not need a worldview because the idea of a world, and of dwelling therein,

will be moot: cyberspace is no space at all. In truth, this escape from space has been the aim of technology ever since the first prehistoric tools. From the invention of the wheel to modern electronic gadgetry, technology seeks to relieve us of the time- and space-bound body. An automobilist is a person abstracted from his legs. An air-traveler travels in spite of his body. Packing human interaction into microsecond dispatches telecommunication, technology sidesteps space. We stand at the threshold of an age when systems of information will partly or fully supersede space-based reality. Physicists have conducted experiments in teleporting photon particles, moving instantaneous space-abolishing tele-transportation out of fiction and into science.[13] Likewise the integration of the human brain with computer networks will make possible the speechless transmission of thoughts, and of thought into action: think about dialing a number and your phone will dial it. Computer-assisted modes of existence will simulate and replace the material world, including our physical identity. This is already taking place in internet social networks where we make "friends" and "interact" and "socialize" as digital avatars. These are areas where it is already possible to maintain a social identity apart from the three dimensions. Technological research is driving at the creation of a spaceless society. Perhaps the future will see human beings existing as digital constructs in a wholly artificial world—so artificial that its reality will need stretch no farther than our mental image of it.

To a large measure, this book has been about landscape—more specifically, about how landscapes come to symbolize human apprehensions about the limits of knowledge and existence. Given the anti-transcendental turn of twentieth-century thought, we should expect the landscape to become thoroughly anthropomorphized in our era—and it has. Barring some gorgeous exceptions (e.g., painters David Hockney and Gerhard Richter), depictions of natural landscapes vanished from serious art after 1930. When they do crop up, it is under a glaze of irony, skepticism, or elegiac leave-taking. Thus the large-scale environment installations by the artists Christo and Jeanne-Claude. Landscape artworks depict external reality blanketed by the human mind. Christo and Jeanne-Claude gift-wrap trees and buildings, stretch curtains across valley floors. The lay of the land becomes canvas and medium. The difference between landscape and its representation is nugatory. As to which has swallowed the other, the wrapping leaves no doubt: the artistic eye no longer goes out to the landscape; instead it pulls the landscape

to itself, shrink-wraps it, and serves it for consumption. Art does not venture out; it annexes the outside. Christo and Jeanne-Claude's installations are odd, beautiful elegies to landscape art, a kind of farewell to objective space.

Other creators who draw a picture of reality at the turn of the twenty-first century for future historians are the architects Frank Gehry and Peter Eisenman. Their architectural creations deny or deflate conventional ideas of habitat. Fractured surfaces that fold exterior into interior, multi-cantilevered pieces, torques, and spirals are the hallmarks of an architecture that bypasses the notions of mass, body, indeed of building itself. The structures seem to be bodies in motion, now about to cave in, the breath punched out of them, now ready to lunge out. Implosive and explosive at once, they precariously sidle out of the very space they occupy, unconvinced of its (and their) reality. They are the paradoxical products of an age that does not believe in the autonomy of space. How these edifices manage to be buildings at all is the source of their dynamic beauty. In aesthetic terms, they confirm that our epoch is still encamped in the mosaic style. Mental-made fragmentation, rather than homogeneous span, governs our aesthetic, our morality, our society. Reality is too fractal and complex to feature a single horizon. *Res cogitans* smothers *res extensa,* the mind is all, matter, nothing.

And what of the mortal self? What of us before the horizon? After all, twenty-first-century man still does die. The beginning and the end of life are still a mystery—even if a growing number of pathologists regard death and aging as a genetic quirk in search of a fix. As any sci-fi aficionado knows, no one is forever dead in the world of the future. Though the space-age hero still occasionally behaves like a knight of reality (e.g., Neo in the *Matrix* film trilogy), he is far more alluringly heroic as a cyber avatar teleporting through a non-world of gigabytes. Is Neo mortal? Not so long as his computer program endures and it, like the Platonic Form, is indestructible.

Artistic and architectural works of the last half-century suggest that, in the end, the horizon may turn out to have been an episode in human civilization, not a permanent baseline. Perhaps the horizon marked a time when mind and world were sufficiently misaligned for the former to project its dreads and desires on the latter. The discovery of a reality that is less and less imaginable, or less and less space-based, spells the end of this concrete projection. There may yet be a day when space

indeed no longer features in the ways human beings dream their world alive; when the mortal horizon stops looming on the skyline; when a Renaissance landscape will seem the odd hieroglyph of a bygone time when people had not surpassed the conditions of space-time; a day when, in sum, the theme of this book becomes, quite simply, incomprehensible.

Afterword

But incomprehensible the horizon is not yet. It remains (if one may be allowed) on our horizon. In its heart of hearts, Western culture remains wedded to a picture of reality stretching between immanence and transcendence: a reality full of the thrill and tragedy of *distance*. We need to inhabit a reality we ache to transcend. Our *here* leans toward a *there* which, unapproachable and fanciful though it may be, exorcises the specter of the bell jar. We would rather take the span of life with a dash of existential ache, a feeling of incompletion, Charon forever midway across the Styx.

Admittedly this picture only has poetry to recommend it. So far as facts go, human existence does not appear to last beyond its physical manifestation. No exit from this laconic world has ever been certifiably sighted. We really have no irrefutable cause to regard life as a journey toward anything at all. Of course, some yet unknown phenomenon may pop an escape hatch out of immanence; it is improbable, though as Hume might have said, not *structurally* out of question. In the meanwhile, we need not accept that an airtight self-contained world sounds the death knell of transcendent feelings. Immanence does not imply materialism, any more than transcendence implies sprites and miracles. This book has shown that an everyday, empirical kind of transcendence

guides human life, for instance, in the fact that all people regard their existence with a purposive eye. The new day that beckons, beckons to unrealized conditions. Few can live happily in the notion that existence is a jumble of inconsequential nows adding up to no meaningful pattern, whether progress or regress. Even the unregenerate loafer decides daily that drawing no plan is the plan he has for his life. The dyed-in-the-wool materialist, too, sees his days working up to a life-story, a project he has a hand in steering. The "be here now" of the mystic (i.e., the belief that human life finds bliss in the cessation of striving), too, is attained by purpose and discipline. We inescapably make something of life, draw installment on the future by decisions and resolutions. We exist before a horizon of development, a crossing from here to there, from now to later, from the actual to the possible. Going the distance and existing are a perennial pair.

This does not mean that there are not cultural ways of modulating the self-overcoming of existence. Heir to Moses, Plato, and Jesus, the Western mind has notoriously produced a progress-shaped, linear style of life. Other cultures, especially of the East (e.g., the Hindu civilization), have produced immanentist worldviews that downplay striving and overreaching. In these civilizations, the cyclical eclipses the linear, and the wheel of life shapes the moral and aesthetic outlook. Reincarnation rather than personal apotheosis and cosmic wholeness rather than self-seeking provide the existential metaphors. This book, however, has been concerned with the Western tradition, the glory and misery of which derive from its transcendental horizon. Ours is a culture in which distance, rather than presence, shapes the form of life: we, for better and for worse, live in a reality in need of drawing out. Hence the existentially anxious, fretful, hard-driven Western temperament. Linear time—the historical, the millenarian, the apocalyptic, the utopian—colors our collective myths; the Judeo-Christian worldview hinges on an agonizing, never-fulfilled exodus and rapprochement between the human and the divine; it begot a god-man hybrid that died on the rack and a Godhead that cannot decide whether it is one or a plurality of persons. We live before a horizon; we are creatures of the horizon. Our *here* is never just here, and we never quite settle for it; on the other hand, we are not irrefutably known to have ever gone beyond it either.

There is no contradiction in singing the glory of earthly life (humanism) and concurrently looking to the end of life (religious otherworldliness): exclusive focus on the latter turns man into a ghost who plays dead so as never to fear death; exclusive attention to the former

Notes

PREFACE
1. Adorno, 365.

INTRODUCTION
1. Kierkegaard, 46.
2. Plato, *Theaetetus*, 150c4–7.

CHAPTER 1
1. Frankfort, *The Intellectual Adventure of Ancient Man*, 145.
2. Assmann, 72–74.
3. Budge, *The Egyptian Book of the Dead*, 59.
4. Lichtheim, 1:42.
5. Frankfort, 185.
6. Mellars and Stringer, 214.
7. Assmann, 209.
8. Lichtheim, 2:84.
9. Ibid., 1:207.
10. Hooke, 13; Jacobsen in Frankfort, *The Intellectual Adventure of Ancient Man*, 199.
11. Jacobsen, 195ff.
12. Budge, *Egyptian Religion*, 62.

13. Frankfort, 196.
14. Frazier, 209.
15. Renfrew, 165.
16. Eliade, 91.
17. Ibid., 75.
18. See Lichtheim's translation of the Autobiography of Weni, 1:18–28.
19. Frankfort, 151.
20. Gombrich, 61.
21. Budge, *The Egyptian Book of the Dead,* 541.
22. Ibid., 421.
23. Cauvin, 67–73.
24. Foster, *Hymns, Prayers and Song,* 46.
25. Lichtheim, 1:36–38.
26. Faulkner, 44.
27. Lichtheim, 3:118.
28. Ibid., 2:50–52.
29. Boyer, 211–13
30. Wilson, 206–35.
31. Vernus, 99.
32. Hornung, 93.
33. Silverman, 35.
34. Ibid., 37.
35. Foster, *Hymns, Prayers, and Song,* 6.
36. Allen, 92.
37. Lichtheim, 2:99.
38. Ibid., 2:97.
39. The stelae, discovered in 1714, have been recently recorded anew and translated by Miriam Lichtheim.
40. Lichtheim, 2:49.
41. Lichtheim, 2:50.
42. Silverman, 161–85.
43. Lichtheim, 2:96–97.

CHAPTER 2

1. Jacobsen, 195.
2. Ibid., 196.
3. Quoted in ibid., 203.
4. Dalley, 41.
5. Sandars, 119.
6. Ibid., 61.
7. Ibid.
8. Kovacs, 4; Sandars, 61; http://history-world.org/gilgamesh.htm.
9. Given his great fame (there is evidence Gilgamesh's story was the stuff of household folklore across the ancient Near East), it is tempting to imagine his fame reached the Aegean Sea; this, however, remains only conjecture. See Sandars's introduction, 13.

10. Sandars, 39.

11. Ibid., 41.

12. Horowitz, 96–107.

13. Sandars, 100.

14. Ibid., 102.

15. Dalley, 39.

16. For Jacobsen, *Gilgamesh* marks the burial of Sumerian third-millennium hero worship (224–26).

17. Campbell, 245.

18. King, 44; Maier, 140.

19. Dalley, 155.

20. Maier, 138.

21. Sandars, 105.

22. Ibid., 61.

23. Ibid., 98.

24. Schopenhauer, 2:161.

25. Ibid., 2:160.

26. Sandars, 42–43.

27. Ibid., 43.

28. See Maier, 109–21.

29. Sandars, 43.

30. Jacobsen, 218.

31. Von Soden notes a certain waning of the Sumerian gods after 2000 B.C.E., supplanted by a more general, depersonalized idea of divinity (181–83).

32. Jacobsen, 48.

CHAPTER 3

1. Homer, *Odyssey,* 1:703–10. The date, of course, is an approximation. The scholarly consensus, however, points to the period between 750 and 550 when the various oral strands of the poem settled into the presently known form. See Sansone, 43.

2. Homer, *Odyssey,* 5.93.

3. Ibid., 7.187

4. Strauss Clay, 175.

5. Homer, *Odyssey,* 7.244–45.

6. Homer, *Iliad,* 8.635–37.

7. Homer, *Odyssey,* 5.236–43.

8. Ibid., 9.32–37.

9. Ibid., 5.247.

10. Montiglio, esp. 42–62.

11. Aristotle, *Metaphysics,* 12.9.

12. Plato, book 3.

13. Homer, *Odyssey,* 4.196–203.

14. Ibid., 23.237–38.

15. Ibid., respectively, 9.617–18; 10.81; 10.83.

16. Curd, 38.

17. Ibid., 3.269–71.
18. Knox, 1–17.
19. Homer, *Iliad*, 12.337.
20. Ibid., 22.543–44.
21. Pollitt, 36.
22. Homer, *Odyssey*, 17.260.
23. Vernant, 332.
24. Burckhardt, *The Greeks and Greek Civilization*, 179.
25. Homer, *Odyssey*, 11.139–53.
26. On this topic, see Griffin, 118–43; and the excellent essay by Weil, "*Iliad*, or the Poem of Force."
27. Homer, *Odyssey*, 2.555–59.
28. Burket, 122.
29. Starr, 283.

CHAPTER 4

1. The King James Version of the Bible is used throughout the chapter, unless otherwise indicated.
2. For Atler, the great Hebraic invention is theology in the form of prose narration (*The Art of Biblical Narrative*, 26).
3. For a balanced discussion of the various biblical exegetical traditions, see MacKenzie.
4. Chief among practitioners of biblical narrative criticism, see Robert Atler, Northrop Frye, Norman Habel, and Meir Sternberg.
5. Gunn and Fewell, 201.
6. Ricoeur, 140.
7. For a view of the world seen from Yahweh's narrative standpoint, see Miles's thrilling literary-philosophical reading.
8. Atler, *The Five Books of Moses*, 17.
9. Walton, *Ancient Near Eastern Thought and the Old Testament*, 181.
10. Ibid., 166.
11. See Patai's "Cosmogony and Cosmology" on the originality of Genesis concerning the creation by will and word alone, out of nothing (in Singer, 9–15).
12. See also 2 Maccabees: "I beseech thee, my son, look upon the heaven and the earth, and all that is therein, and consider that God made them of things that were not" (7:28).
13. In the Revised Standard Version. The King James Version seems to misunderstand this verse.
14. Stadelmann (42) notes that the Hebrew word used in Job, *hwg smym*, marks the horizon boundary between heaven and earth, or alternately between light and darkness.
15. Friedman, *Who Wrote the Bible?*, 50–70.
16. As Atler puts it, Elohim is the cosmic god who creates from on high whereas Yahweh is the hands-on god entangled in human moral ambiguities (*The Art of Biblical Narrative*, 20).

17. Buber has a more ethical-ecstatic view of the exchange (*Good and Evil*, 53–63).

18. Karen Armstrong rightly points out that the separation from God antedates the moment when Eve plucks the fruit (22). I further suggest this separation is the reason for the creation of human beings.

19. On the topic, see Friedman, *The Disappearance of God*, 7–30.

20. Augustine, *City of God*, 13.15.

21. Ibid., 19.8.

22. Buber, *Eclipse of God*, 35.

23. See, for example, Walhout.

24. Buber, *Good and Evil*, 75.

25. See Miles, 37.

26. Frazier, 15–31.

CHAPTER 5

The date refers to the final rewriting of Deuteronomy during the period of the exile in Babylon. Bible scholarship dates the first authorship of the book of Exodus back to the late seventh century B.C.E. See Childes, xvi.

1. See Weinfeld on how, following the exodus and the theophany at Mount Sinai, the faith of ancient Israel turns toward theological abstraction (37–39).

2. Sarna, 2.

3. See Childes on the theological role of the wilderness narrative, 255–56, and also Friedman, *The Disappearance of God*, 7–30.

4. Friedman, *The Poet and the Historian*, 13–19; Craigie, 18–20.

5. Walton, *Ancient Israelite Literature in Its Cultural Context*, 59.

6. Miles, 85–98. On exile as formative phase of Israelite monotheism, see Smith, *The Early History of God*, 195–98.

7. Polack, "Theophany and Mediator," in Vervenne, 118.

8. Miller, *A History of Ancient Israel and Judah*, 2–20.

9. Heidegger, 43.

10. Fretheim, 214; Alter and Kermode, 63.

11. In history, it is a long, meandering, messy process: see Sarna, 150.

12. Ibid., 3–7.

13. Polack, "Theophany and Mediator," in Vervenne, 116.

14. Meyers underscores that *YHWH* isn't a designation of God-as-entity, as its woefully gender-inflected English translation "the Lord" imparts (57–58); it is an utterance of abstract self-naming that goes beyond personality. Bruckner points out that the ancient Hebrews often simply referred to God as "the name," *hashem* (44).

15. On this theme, see Bruckner, 43–45.

16. Smith, *The Origins of Biblical Monotheism*, 157–66.

17. In Curd, 26.

18. Central to Deuteronomy, Weinfeld argues, is the shift from the "visual to the aural plane" in relating to the divine (38).

19. The Hebrew *tohu wa-bohu* for "without form and void," Alter reminds us, also designated the desert (*The Five Books of Moses,* 17).

20. Olson, 18.

CHAPTER 6

1. Strabo, 1:1, 8.

2. Ibid., 1:1, 3.

3. Kirk, 10–17; Keimpe Algra, "The Beginnings of Cosmology," in Long, 45–65.

4. See Jaspers, *The Great Philosophers* (vol. 2), on monism and pre-Socratic thinkers.

5. In Barnes, 66. The best presentation and discussion of the pre-Socratic thinkers remains Karl Jaspers's *The Great Philosophers,* vol. 2. Among the consulted studies are Osborne, Hermann, Kirk, and Long.

6. In Barnes, 68.

7. In Curd, 10.

8. In Barnes, 74–75.

9. Ibid., 71.

10. Ibid., 117.

11. Ibid.

12. Ibid., 135.

13. Ibid., 134.

14. See Reale, 137–40.

15. In Barnes, 95.

16. Ibid., 93.

CHAPTER 7

1. On Socratic and Aristotelian rationalism, see Boas. The following works were also consulted in writing this chapter: on Classical Greek philosophy, Guthrie; Taylor, Hare, and Barnes; on the history of infinity: Maor, esp. 184–90; and Moore, esp. 17–44.

2. Burnet, 366.

3. Plato, *The Republic,* 509b.

4. Cicero, 2.42.

5. Aristotle, *Physics,* 2.68.

6. Ibid., 67.

7. Aristotle, *On the Heavens,* sec. 5.

8. Ibid., sec. 6.

9. Aristotle, *Physics,* 3.72.

10. Aristotle, *Metaphysics,* 12.6, 7.

11. Aristotle, *On the Heavens,* sec. 2.

12. Plato, *Timaeus,* 63.

13. Plotinus, *Enneads,* 6.9.

14. Scotus, *Periphyseon* 2.589b-c.

15. Ginsburg, 7.

16. Ibid., 120; Roberts, 376–96.

17. Fredriksen, 82–83.

CHAPTER 8

1. On Paul's theology and beliefs, see Wilson, *Paul*, and Dunn.

2. On the history, constitution, and theology of the gospels, see Aune; Koester; Fredriksen; and Sanders and Davis.

3. See Vermes and Sanders.

4. In Morelan, 610.

5. The reader interested in the Arian and Nicene controversies will find excellent accounts and discussions in Freeman, esp. 178–216; Hicks; Young; and Taylor, *After God,* esp. 141–54.

6. In Morelan, 610.

7. Ibid., 611.

8. Fredriksen, 58–61.

9. Augustine, *On the Trinity,* 9.4.

10. In Schaff, 267.

11. For the epic history of these dualities, see Spengler.

12. Engberg-Petersen, 279.

13. Irenaeus, *Against Heresies,* 5.7.

CHAPTER 9

1. The following works on Augustine were consulted: Gibson; Harrison, *Augustine;* Teselle; and Deane.

2. See Freeman, 277–306.

3. Augustine, *On Free Choice of the Will,* 13.

4. Augustine, *Confessions,* 8.15.

5. Ibid., 12.29.

6. See Zum Brunn, 30–54.

7. Augustine, *City of God,* 12.7.

8. Ibid., 12.6.

9. Ibid., 12.9.

10. Ibid., 13.11.

11. Ibid., 13.10.

12. Ibid.

13. Ibid., 13.11.

14. In MacMullen, 60.

15. Augustine, *City of God,* 13.10.

16. Tacitus, 15.44, 2, 8.

17. See Grabar, 7–30; Jensens, *Understanding Early Christian Art,* 94–129; and Jensen, *Portraits of the Divine in Early Christianity,* 165–70.

18. See Besançon, esp. 109–46.

19. Nees, 149.

20. In Eastmond, esp. 3–12.

21. Cormack, 37–74.

22. Nees, 146.

CHAPTER 10

1. Corby Finney, 160–91.
2. Bright, 234.
3. Hieatt, 10.
4. Ibid., 11.
5. Ibid., 12.
6. Ibid.
7. Von Eschenbach, 23.
8. Troyes, 439.
9. Morris, 133.
10. Troyes, 429.
11. Aristotle, *Physics,* 3.8.208a.
12. See Vinaver, 53–56.
13. In Gage, 106.
14. See Duby, esp. 97–133.
15. In Wace and Schaff, 6.24.
16. Troyes, 438.
17. Scott, 131.
18. See Menocal; and Nykl.
19. Isaacs, 135–37.
20. For a presentation of Maimonides' thought, see Fox, *Interpreting Maimonides,* and Goodman.
21. Maimonides, 1.42.
22. Ibid., 1.34.
23. Ibid., 1.54.
24. Ibid., 2.36.
25. Toman, 49–54.
26. See Leaman, 82–118.
27. Troyes, 425.
28. On postponement in medieval narrative, see Sturges, 20–26.
29. Troyes, 425.
30. Haskins, esp. 341–98.
31. Field, 6–7.
32. Southern, 34–44; Jaeger, 118–72.
33. Azinfar, esp. 101–44.
34. Duby, 116.
35. Troyes, 457.
36. Von Eschenbach, 119.
37. Swanson, 103–34.
38. See Toman, 454–54.

CHAPTER 11

1. In Restall, 2.
2. Cusanus, 1.3.
3. On vision in Cusanus, see Watts, 153–88.
4. Cassirer, 25–27.

5. Cusanus, 10.41.

6. Karsten Harries pointed out the kinship between Cusanus and Italian Renaissance perspective painting in Casarella, 105–26.

7. Alberti, 90.

8. On the ample subject of Renaissance and landscape painting, see among many others Andrews, 25–62; Burckhardt, *The Civilization of the Renaissance,* 192–98; Harbison, 34–38.

9. Cusanus, 10.38–39.

10. Frazier, 15–31.

11. Cusanus, 10.41.

12. Lindberg, esp. 130–60

13. Petrarch, "The Ascent of Mount Ventoux."

14. Montaigne, "On the Cannibals," 228.

15. See Burke, esp. 181–209, and Goldthwaite, 29–67.

16. See Flint, 3–42.

17. Petrarca, 17.

18. Ibid., 18.

19. Among the shelf-full of volumes, see Field; Damisch; and Panofsky.

20. Panofksy, 72.

21. Alberti, 14.

22. Panofsky, 57.

23. For Burckhardt's famous thesis, see 101–28; for a corrective of Burckhardt's often sanguine idea of Renaissance individualism, see Brucker, *Renaissance Florence,* 172–212.

CHAPTER 12

1. On Leonardo in general, and the Milan years in particular, see Nicholl, esp. 185–256, and Clark, 125–39.

2. Bortolon, 104.

3. Leonardo, *Notebooks,* 276.

4. Ibid.

5. Leonardo, *Treatise on Painting,* 245.

6. Leonardo, *Notebooks,* 131.

7. Leonardo, *Treatise on Painting,* 256.

8. Leonardo, *Notebooks,* 140.

9. Vasari, 287.

10. Leonardo, *Treatise on Painting,* 205.

11. On the abundant topic of individuality in the Renaissance, see, inter alia: on the philosophical side, Taylor, *Sources of the Self,* 143–85; on the historical side, Burckhardt, *The Civilization of the Renaissance,* 105–32, and Burke, *The Renaissance,* 57–61.

CHAPTER 13

1. Montaigne, 907–908.

2. Ibid., 367.

3. Ibid., 419–20.
4. Ibid., 96.
5. Ibid.
6. Ibid.
7. Ibid., 97.
8. Chaucer, "The Knight's Tale," 38.
9. Montaigne, 107.
10. Lopez, "Hard Times and the Investment in Culture," in Ferguson, 45. Kellerhear, 105–68.
11. Aristotle, *Physics*, 4.11.
12. Montaigne, 107.
13. Burke, *Culture and Society*, 195.
14. Augustine, *City of God*, 5.17.
15. Bacon, *The Advancement of Learning*, 1.5.11.
16. Ibid., 1.5.11.
17. Erasmus, 183
18. See Harrison, *The Bible, Protestantism and the Rise of Natural Science,* and *The Fall of Adam and the Foundations of Science,* esp. 186–200.
19. Bury, 37–46.
20. Spitz, 332.
21. Luther, "An Introduction to St Paul's Letter to the Romans," Luther's German Bible (1522).
22. Weber, 39–50.
23. Troeltsch, 63.
24. Nunn, 27.
25. See Woodward's lushly illustrated *History of Cartography.*
26. Montaigne, "That We Taste Nothing Pure," 764.
27. Montaigne, "On Experience," 1211.
28. Montaigne, "On Repenting," 908.
29. Montaigne, "On Practice," 423.

CHAPTER 14

1. On Von Guericke and seventeenth-century vacuum pumps, see Grant, *Much Ado about Nothing,* 213–21, and Barrow, 95–110.
2. Newton, 1.12.
3. Seife, 83–105.
4. Von Guericke, of the Madgeburg hemispheres, writes:

Everything is in Nothing and if God should reduce the fabric of the world, which he created, into Nothing, nothing would remain of its place other than Nothing. . . . Nothing contains all things. It is more precious than gold, without beginning and end, more joyous than the perception of bountiful light, more noble than the blood of kings, comparable to the heavens, higher than the starts, more powerful than a stroke of lightning, perfect and blessed in every way. Nothing always inspires Nothing is without any mischief. According to Job the Earth is suspended over Nothing. Nothing is outside the world. Nothing is everywhere. They say the vacuum is Nothing; and they say that . . . space itself is Nothing. (In Grant, 566)

5. Newton, 1.176.
6. See Baron, 195–268.
7. Newton, 1.25.
8. In Kuhn, 157.
9. In Munitz, 177.
10. In Grant, *Much Ado about Nothing,* 132.
11. Pascal, 66.
12. Ibid., 67–68.
13. Ibid., 66.
14. Ibid., 65.
15. Ibid., 66, 67.
16. In Koyré, 6.
17. Pascal, 68.
18. In Barrow, 108.
19. Marlowe, 2.2.
20. Montaigne, 804.
21. Pascal, 67.
22. See Certeau, 188–210.
23. See Deleuze, 85–100.
24. Teresa of Avila, "If, Lord, Thy Love Is Strong" (in Crow, 70).
25. See Popkin, 18–66.
26. Donne, 177.
27. Pascal, 65.
28. Ibid., 77.
29. Brooke, 52.

CHAPTER 15

1. Descartes, *Discourse on the Method,* 12.
2. In Boorstin, 164.
3. Descartes, *Discourse on the Method,* 29.
4. Ibid.
5. Skrine offers a solid introduction to the literary culture of the Baroque.
6. La Rochefoucauld, *Maxims,* sec. 40.
7. Scholar, esp. 178–83.
8. Leibniz, *Philosophical Papers and Letters,* 1.449.
9. Descartes, *Meditations,* sec. 3.
10. Ibid.
11. Ihrie, 54–89.
12. First folio edition, 1623.
13. See Cavell's seminal work on Shakespearean skepticism.
14. Spinoza, *Ethics,* 136.
15. On the Baroque as a culture of antagonism, see Maravall, 19–57, 149–72.
16. Ariès, 297–98.
17. See Nisbet, 175–220.
18. In Teggar, 142.

19. In Campbell, 114.

CHAPTER 16

1. Solomon, 107.
2. Emerson, "The Divinity School Address," 70.
3. See Szabolcs.
4. In Strunk, 775.
5. Thayer, 2:167.
6. In ibid.
7. In Strunk, 777.
8. Berlin, *The Roots of Romanticism*, 1–21.
9. In Taylor, *Nineteenth-Century Theories of Art*, 221.
10. Berlin, *The Sense of Reality*, 170.
11. Goethe, *The Sorrows of Young Werther*, 66.
12. In Spengler, 38.
13. Harrison, Wood, and Gaiger, 847.
14. For a general introduction to Kant's thought, see Guyer; on Kant in the context of modern philosophy, see Scruton, 139–69.
15. Kant, *Critique of Pure Reason*, A 235–36.
16. In Mayo, 111.
17. In Smith, *The Norton History of the Human Sciences*, 347.
18. Schopenhauer, *The World as Will and Representation*, 2.195.

CHAPTER 17

1. Goethe, *Early Letters*, 101.
2. Ibid., 103.
3. In Lewisohn, 80–81.
4. Ibid., 81.
5. In Taylor, *Nineteenth-Century Theories of Art*, 222.
6. See Trilling, esp. 26–80.
7. Goethe, *The Sorrows of Young Werther*, 29.
8. Minois, 266; Alvarez, 193–235.
9. Goethe, *The Sorrows of Young Werther*, 29.
10. In Houlgate, 441.
11. Aquinas, 2.Q64, A5.
12. Chesterton, *Collected Works*, 70.
13. Augustine, *City of God*, 1.20.
14. Goethe, *The Sorrows of Young Werther*, 31.
15. Ibid., 115.
16. Ibid., 28.
17. Ibid., 86.
18. Ibid., 43.
19. Ibid., 55.
20. Ibid., 126–27.

CHAPTER 18

1. Sieburth, 18.
2. Del Caro, 31–36.
3. On the disappearing god in nineteenth-century literature, see Hillis-Miller, 1–16.
4. Hölderlin, 249.
5. Ibid., 57.
6. Ibid., 601.
7. Pinkard, 131–72.
8. In Harris, 510.
9. Ibid., 511.
10. In, respectively, Addison, 397; Goethe, *Faust Part II*, act 2; Hegel, *The Science of Logic*, 154; Ruskin, 32.
11. In Michell.
12. Burke, *A Philosophical Inquiry into the Origin of Our Ideas of the Sublime and the Beautiful*, 55.
13. Ibid., 96.
14. Kant, *The Critique of Judgment*, 95.
15. Ibid., 88.
16. Novalis, *Hymns to the Night*, 66.
17. Hegel, *Lectures on the Philosophy of Religion*, 458–64.
18. On the history of landscape painting, see Buttner.
19. In Vaughan, 259.
20. In Traeger, 72.
21. In Harrison, 1032.
22. In Vaughn, 257.
23. Ibid., 249.
24. Ibid., 237.
25. In Taylor, *Nineteenth-Century Theories of Art*, 301.
26. In Leslie, *Memoirs*, 73.
27. See Thornes.
28. In Taylor, *Nineteenth-Century Theories of Art*, 301.
29. In ibid.
30. Ruskin, 36.
31. Hilton, 339.

CHAPTER 19

1. See Bushman, esp. 43–115
2. On this religious awakening, see Walker Howe, 164–202.
3. On American religious primitivism, see Hughes and Allen.
4. Smith, *Wentworth Letter*, 9.
5. In Mancall, 222.
6. In Commager, 87.
7. Paine, 125.
8. See Jon Butler's *Awash in a Sea of Faith*.

9. Butler, 216–18, and Lippy, 73–107.
10. Smith, *Teachings of the Prophet Joseph Smith,* 345.
11. Whitman, *The Complete Poems.*
12. Noll, 230–35.
13. In Noll, 232.
14. See Yaeger, *The Hudson River School.*
15. McGrath, 116.
16. Casey, *Representing Space,* 16.
17. Danto, 143.
18. Emerson, "Nature," 3.
19. Emerson, "The Divinity School Address," 75.
20. Emerson, "Nature," 17.
21. Emerson, "The Over-Soul," 237.
22. Emerson, "The Divinity School Address," 69.
23. Emerson, "The Over-Soul," 248–49.
24. For a good historical backdrop of the demotic theology, see Hatch, 125–92.
25. In Hofstadter, 266.
26. See Hofstadter, 55–81; Bloom, 256–65; Fox, *Jesus in America,* 159–251.
27. Smith, *Teachings of the Prophet Joseph Smith,* 346.

CHAPTER 20

1. In Hughes, 301.
2. Greenberg, *Art and Culture,* 171, 171–76.
3. On Modernism and art for art's sake, see Bell-Villada, 125–61.
4. See Opper, 96–130.
5. In Schorske, 17.
6. See Banham, esp. 79–106.
7. In Richardson, 97.
8. On this, see Miller, *Einstein and Picasso,* 127–41.
9. Braque, "Testimony against Gertrude Stein," *Transition* 23:13–14.
10. In Schorske, 19.
11. In Everdell, 280.
12. See Harrison, *1910,* esp. 46–52.
13. Woolf, 37.
14. Apollinaire, 122.
15. Cendrars, 135.
16. For my understanding of special and general relativity, I relied on Greene's exceptionally clear presentation, 23–53.
17. In Comins, 162.
18. In Hall, 27.
19. In Porzio, 79.
20. Dalí, 59–60.

CHAPTER 21

1. Borges, *Collected Fictions,* 112.

2. Ibid.
3. Ibid., 118.
4. Ibid.
5. Borges, *Selected Non-fictions,* 332.
6. Borges, *A Personal Anthology,* 119.
7. Borges, *Collected Fictions,* 160.
8. Wittgenstein, *Tractatus,* 107–108.
9. In Brod, 355.
10. Wittgenstein, *Philosophical Investigations,* sec. 77.
11. Ibid., sec. 1.
12. In Van Heijenoort, 285.
13. See Jaki, 85–110, and Rorty, 35–63.
14. Wittgenstein, *Philosophical Remarks,* 155.
15. Wittgenstein, *Philosophical Grammar,* 282.
16. Wittgenstein, *Philosophical Remarks,* 157.

CHAPTER 22

1. See Barrett, esp. 35–121.
2. In Battcock, 148.
3. In Harrison and Wood, 821.
4. Greenberg, *Collected Essays,* 85–93.
5. In Batchelor, 60.
6. In Kostelanetz, 70.
7. Cage, 271.
8. In Pritchett, 145.
9. Ibid., 138.
10. In Dimas de Melo Pimentas, 178.
11. In Weitemeier, 28.
12. Ibid., 31.
13. Ibid., 84.
14. Ibid., 28.
15. Ibid., 88.
16. In Schulte-Sasse, 23.
17. In Weitemeier, 34.
18. Ibid.
19. Plato, *Dialogues,* 34.

CHAPTER 23

1. See Hadingham.
2. In Ferguson, 92.
3. For this section, I drew from Silk, *The Big Bang,* and Singh.
4. In Silk, *The Big Bang,* 78.
5. Weinberg, "The First Three Minutes," in Ferris, *Physics, Astronomy and Mathematics,* 395–410.
6. Hawking, "Address to the GR10 Conference," Padua, July 1983.

7. Ferguson, 112.
8. In Gell-Mann, 165.
9. In Pais, 349.
10. See Greene; and Ferris, *The Whole Shebang.*
11. Peat, 124.
12. Einstein and Infeld, 294.
13. Kaku.

Bibliography

Addison, Joseph. *Selected Essays from the* Tatler, *the* Spectator *and the* Guard-ian. Macmillan, 1973.

Adorno, Theodor W. *Lectures on Negative Dialectics.* Continuum, 1973.

Alberti, Leone Battista. *On Painting.* Yale UP, 1967.

Allen, James. *Religion and Philosophy in Ancient Egypt.* Yale Egyptological Seminar, 1989.

Alter, Robert. *The Art of Biblical Narrative.* Basic Books, 1983.

———. *The Five Books of Moses: A Translation with Commentary.* W.W. Norton, 2004.

Alter, Robert, and Frank Kermode, eds. *Literary Guide to the Bible.* Harvard UP, 1990.

Alvarez, A. *The Savage God: A Study of Suicide.* W.W. Norton, 1990.

Andrews, Malcolm. *Landscape and Western Art.* Oxford UP, 1999.

Apollinaire, Guillaume. *Selected Writings of Guillaume Apollinaire.* New Directions, 1971.

Aquinas, Thomas. *Summa Theologica.* Christian Classics, 1981.

Ariès, Philippe. *The Hour of Our Death.* Trans. Helen Weaver. Knopf, 1981.

Aristotle. *Metaphysics.* Penguin Classics, 1999.

———. *Physics.* Oxford UP, 1999.

———. *On the Heavens.* Harvard UP, 1939.

Armstrong, Karen. *In the Beginning: A New Interpretation of Genesis.* Ballantine, 1997.

Assmann, Han. *The Mind of Egypt.* Harvard UP, 2003.

Augustine. *City of God*. Penguin Classics, 2003.
———. *Confessions*. Westminster Press, 1955.
———. *On Free Choice of the Will*. Hackett, 1993.
———. *On the Trinity*. Cambridge UP, 2002.
Aune, David. *The New Testament in Its Literary Environment*. Ingram, 2001.
Azinfar, Chehregosha Fatemeh. *Atheism in the Medieval Islamic and European World*. Ibex, 2008.
Bacon, Francis. *The Advancement of Learning*. 1605. Reprint, Bibliobazar, 2003.
Bancroft, Frederic, ed. *Constable's Skies*. Salander-O'Reilly Galleries, 2004.
Banham, Reynher. *Theory and Design in the First Machine Age*. MIT Press, 1980.
Barnes, Jonathan, ed. *Early Greek Philosophy*. Penguin Books, 1987.
Baron, Margaret. *The Origins of the Infinitesimal Calculus*. Pergamon Press, 1969.
Barrett, Michele. *The Politics of Truth: From Marx to Foucault*. Stanford UP, 1991.
Barrow, John. *The Book of Nothing: Vacuums, Voids and the Latest Ideas about the Origin of the Universe*. Vintage, 2002.
Batchelor, David. *Minimalism*. Cambridge UP, 1997.
Battcock, Gregory, ed. *Minimal Art: A Critical Anthology*. Dutton & Co., 1968.
Bell-Villada, Gene. *Art for Art's Sake and Literary Life*. Nebraska UP, 1996.
Berlin, Isaiah. *The Roots of Romanticism*. Princeton UP, 2001.
———. *The Sense of Reality*. Farrar, Straus & Giroux, 1998.
Besançon, Alain. *The Forbidden Image: An Intellectual History of Iconoclasm*. Chicago UP, 2000.
Bloom, Harold. *The American Religion: The Emergence of the Post-Christian Nation*. Simon & Schuster, 1993.
Boas, George. *Rationalism in Greek Philosophy*. Johns Hopkins UP, 1961.
Boorstin, Daniel. *The Seekers: The Story of Man's Continuing Quest to Understand His World*. Vintage, 1999.
Borges, Jose Luis. *Collected Fictions*. Trans. Andrew Hurley. Viking, 1998.
———. *A Personal Anthology*. Grove Press, 1967.
———. *Selected Non-fictions*. Ed. Eliot Weinberger. Penguin Books, 1999.
Bortolon, Liana. *The Life and Times of Leonardo*. Paul Hamlyn, 1965.
Boyer, Carl. *A History of Mathematics*. Wiley, 1991.
Bright, James, ed. *An Anglo-Saxon Reader*. Henry Holt & Co., 1912.
Brod, Max. *Franz Kafka: A Biography*. Schocken Books, 1967.
Brooke, John Hedley. *Science and Religion: Some Historical Perspectives*. Cambridge UP, 1991.
Brucker, Gene. *Renaissance Florence*. UC Press, 1983.
Bruckner, James. *Exodus: New International Biblical Commentary*. Hendrickson, 2008.
Buber, Martin. *Eclipse of God*. Greenwood Press, 1977.
———. *Good and Evil*. Scribner's, 1952.
———. *I and Thou*. Free Press, 1971.
Budge, E.A. Wallis. *The Egyptian Book of the Dead*. Dover, 1967.

————. *Egyptian Religion: Egyptian Ideas of the Future Life.* Routledge, 1979.

Burckhardt, Jacob. *The Civilization of the Renaissance in Italy.* Phaidon, 1945.

————. *The Greeks and Greek Civilization.* St. Martin's Griffin, 1999.

Burke, Edmund. *A Philosophical Inquiry into the Origin of Our Ideas of the Sublime and the Beautiful.* Oxford UP, 1990.

Burke, Peter. *Culture and Society in Renaissance Italy, 1420–1540.* Batsford, 1972.

————. *The Renaissance.* Palgrave, 1997.

Burket, Walter. *Greek Religion: Archaic and Classical.* Blackwell, 1991.

Burnet, John. *Early Greek Philosophy.* Adam and Charles Black, 1908.

Bury, John. *The Idea of Progress.* Kessinger Reprints, 2004.

Bushman, Richard. *Joseph Smith and the Beginnings of Mormonism.* Illinois UP, 1984.

Butler, Jon. *Awash in a Sea of Faith: Christianizing the American People.* Harvard UP, 1990.

Buttner, Nils. *Landscape Painting: A History.* Abbeville, 2006.

Cage, John. *Silence.* Wesleyan UP, 1961.

Campbell, John C. *Mathematics: People, Problems, Results.* Wadsworth International, 1984.

Campbell, Joseph. *The Hero with a Thousand Faces.* Meridian Books, 1956.

Casarella, Peter, ed. *Cusanus: The Legacy of Learned Ignorance.* CUA Press, 2006.

Casey, Edward. *The Fate of Place: A Philosophical History.* UC Press, 1998.

————. *Representing Space: Landscape Painting and Maps.* Minnesota UP, 2002.

Cassirer, Ernst. *The Individual and the Cosmos in Renaissance Philosophy.* Harper & Row, 1963.

Cauvin, *The Birth of the Gods and the Origins of Agriculture.* Cambridge UP, 2007.

Cavell, Stanley. *Disowning Knowledge in Seven Plays of Shakespeare.* Cambridge UP, 2003.

Cendrars, Blaise. *Selected Writings.* New Directions, 1962.

Certeau, Michel de. *The Mystic Fable.* Chicago UP, 1995.

Chamberlain, Timothy. *Eighteenth-Century German Criticism.* Continuum, 1992.

Chaucer, Geoffrey. *The Canterbury Tales.* Oxford UP, 2008.

Chesterton, Gilbert K. *Collected Works.* Ignatius Press, 1986.

————. *Orthodoxy.* Wilder Publications, 2008.

Childes, Brevard. *The Book of Exodus: A Critical, Theological Commentary.* Westminster, 1974.

Cicero, Marcus Tullius. *The Nature of the Gods.* Trans. P. G. Walsh. Oxford UP, 1998.

Clark, Kenneth. *Leonardo da Vinci.* Penguin, 1989.

Cobban, Alan. *The Medieval Universities.* Methuen, 1975.

Colish, Marcia L. *Medieval Foundations of the Western Intellectual Tradition.* Yale UP, 1999.

Comins, Neil. *Heavenly Errors: Misconceptions about the Real Nature of the Universe.* Columbia UP, 2001.

Commager, Henry Steele. *The Empire of Reason.* Phoenix Press, 2001.

Corby Finney, Paul. *The Invisible God: The Early Christians on Art.* Oxford UP, 1997.

Cormack, Robin. *Byzantine Art.* Clarendon, 2000.

Craigie, Peter. *The Book of Deuteronomy.* Eerdmans, 1976.

Crow, John, ed. *An Anthology of Spanish Poetry.* LSU Press, 1979.

Curd, Patricia, ed. *A Pre-Socratics Reader.* Hackett, 1995.

Cusanus, Nicholas. *Of Learned Ignorance.* Trans. Germain Heron. Wipf & Stock Publishers, 2007.

Dalí, Salvador. *Diary of a Genius.* Solar Books, 2007.

Dalley, Stephanie. *Myths from Mesopotamia.* Oxford UP, 1989.

Damisch, Hubert. *The Origin of Perspective.* Trans. John Goodman. MIT Press, 1994.

Danto, Arthur C. *Encounters and Reflections: Art in the Historical Present.* UC Press, 1997.

Deane. H.A. *The Political and Social Ideas of Augustine.* Columbia UP, 1963.

Del Caro, Adrian. *Hölderlin: The Poetics of Being.* Wayne State UP, 1991.

Deleuze, Gilles. *The Fold: Leibniz and the Baroque.* Minnesota UP, 1992.

Descartes, René. *Discourse on the Method.* Oxford UP, 2006.

———. *Meditations.* Hackett, 2006.

———. *Principles of Philosophy.* Kluwer Academic Publishers, 1991.

Dimas de Melo Pimentas, Emanuel. *John Cage: The Silence of Music.* Silvana Editoriale, 2003.

Donne, John. *The Major Works.* Oxford UP, 2000.

Duby, George. *The Age of Cathedrals.* Chicago UP, 1981.

Dunn, James. *The Theology of Paul the Apostle.* Eerdmans, 2006.

Eastmon, Antony, and Liz James. *Icon and Word: The Power of Images in Byzantium.* Ashgate, 2003.

Einstein, Albert, and Leopold Infeld. *The Evolution of Physics.* Simon & Schuster, 1938.

Eliade, Mircea. *Patterns in Comparative Religion.* Sheed & Ward, 1958.

Emerson, Ralph Waldo. *The Essential Writings.* Modern Library, 2000.

Engberg-Petersen, Troels. *Paul and the Stoics.* T & T Clarks, 2000.

Erasmus, Desiderius. *Enchiridion Militis Christiani, or The Manual of the Christian Knight.* 1501. Methuen & Co., 1905.

Everdell, William. *The First Moderns.* Chicago UP, 1997.

Faulkner, R.O., ed. *The Ancient Egyptian Pyramid Texts.* 1910. Reprint, Kessinger, 2004.

Ferguson, Kitty. *The Fire in the Equations: Science, Religion, and the Search for God.* Templeton Foundation Press, 2004.

Ferguson, Wallace. *The Renaissance: Six Essays.* Harper Torchbook, 1954.

Ferris, Timothy, ed. *Physics, Astronomy and Mathematics.* Little, Brown & Company, 1991.

———. *The Whole Shebang.* Simon & Schuster, 1998.

Field, Judith. *The Invention of Infinity: Mathematics and Art in the Renaissance.* Oxford UP, 1997.

Flint, Valerie. *The Imaginative Landscape of Christopher Columbus*. Princeton UP, 1992.

Foster, John, ed. *Ancient Egyptian Literature: An Anthology*. Texas UP, 2001.

———, ed. *Hymns, Prayers and Song: An Anthology of Ancient Egyptian Lyric Poetry*. Scholars Press, 1995.

Fox, Marvin. *Interpreting Maimonides*. Chicago UP, 1990.

Fox, Richard Wightman. *Jesus in America: Personal Saviour, Cultural Hero, National Obsession*. HarperCollins, 2004.

Frazier, James. *The Golden Bough*. Macmillan, 1922.

Frankfort, Henri, ed. *The Intellectual Adventure of Ancient Man*. Chicago UP, 1946.

———. *Kingship and the Gods: A Study of Ancient Near Eastern Religion*. Chigaco UP, 1978.

Fredriksen, Paula. *From Jesus to Christ: The Origins of the New Testament Images of Christ*. Yale UP, 2000.

Freeman, Charles. *The Closing of the Western Mind: The Rise of Faith and the Fall of Reason*. Vintage, 2005.

Fretheim, Terence. *Exodus*. Westminster John Knox, 1991.

Friedman, Richard. *The Disappearance of God*. Little, Brown & Company, 1995.

———. *The Poet and the Historian: Essays in Literary and Historical Biblical Criticism*. Scholars Press, 1983.

———. *Who Wrote the Bible?* HarperOne, 1997.

Frye, Northrop. *The Great Code: The Bible and Literature*. Mariner Books, 1983.

Gage, John, ed. *Goethe on Art*. UC Press, 1980.

Gell-Mann, Murray. *The Quark and the Jaguar*. Freeman, 1994.

Gibson, E. *The Philosophy of Augustine*. Gollans, 1960.

Ginsburg, Christian. *The Essenes: Their History and Doctrines*. Cosimo Classics, 2005.

Gödel, Karl. "On Formally Undecidable Propositions of *Principia Mathematica* and Related Systems I." In *From Frege to Gödel: A Source Book in Mathematical Logic*, ed. Jean Van Heijenoort. Harvard UP, 1967.

Goethe, Johann Wolfgang von. *Early Letters*. Ed. Edward Bell. George Bell, 1889.

———. *Faust Parts I and II*. Harvard Classics, 1909.

———. *The Sorrows of Young Werther*. Trans. Michael Hulse. Penguin Classics, 1989.

Goldthwaite, Richard. *The Building of Renaissance Florence: An Economic and Social History*. Johns Hopkins UP, 1983.

Gombrich, E.H. *The Story of Art*. Phaidon, 1995.

Goodman, Lenn. *Ram Bam: Readings in the Philosophy of Moses Maimonides*. Gee Bee Tee, 1985.

Grabar, André. *Christian Iconography: A Study of Its Origins*. Routledge, 1969.

Grant, Edward. *A History of Natural Philosophy from the Ancient World to the Nineteenth Century*. Cambridge UP, 2007.

————. *Much Ado about Nothing: Theories of Space and Vacuum from the Middle Ages to the Scientific Revolution.* Cambridge UP, 1981.

————. *Source Book in Medieval Science.* Harvard UP, 1974.

Greenberg, Clement. *Art and Culture: Critical Essays.* Beacon Press, 1971.

————. *Collected Essays and Criticism.* Vol. 4. Chicago UP, 1993.

Greene, Brian. *The Elegant Universe.* Random House, 2000.

Griffin, Jasper. *Homer on Life and Death.* Oxford UP, 1980.

Gunn, David, and Donna Nolan Fewell. *Narrative in the Hebrew Bible.* Oxford UP, 1993.

Guthrie, William. *Greek Philosophers.* Harper Perennial, 1960.

Guyer, Paul. *Kant.* Routledge, 2006.

Habel, Norman. *Literary Criticism of the Old Testament.* Fortress, 1971.

Hadingham, Evan. *Early Man and the Cosmos.* Oklahoma UP, 1985.

Hall, Rupert A. *Isaac Newton: Adventurer in Thought.* Cambridge UP, 1992.

Harbison, Craig. *The Mirror of the Artist: Northern Renaissance Art.* Prentice Hall, 2003.

Harris, H. S. *Hegel's Development: Towards the Sunlight, 1770–1801.* Clarendon Press, 1972.

Harrison, Carol. *Augustine: Christian Truth and Fractured Humanity.* Oxford UP, 2000.

Harrison, Charles, and Paul Wood, eds. *Art in Theory, 1900–1990.* Blackwell, 1992.

Harrison, Charles, Paul Wood, and Jason Gaiger, eds. *Art in Theory, 1648–1815: An Anthology of Changing Ideas.* Blackwell Publishing, 1992.

Harrison, Paul. *1910: The Emancipation of Dissonance.* UC Press, 1996.

Harrison, Peter. *The Bible, Protestantism and the Rise of Natural Science.* Cambridge UP, 2001.

————. *The Fall of Adam and the Foundations of Science.* Cambridge UP, 2009.

Hart, David Bently. *Beauty of the Infinite: The Aesthetics of Christian Truth.* Eerdmans Publishing, 2003.

Haskins, Charles Homer. *The Renaissance of the Twelfth Century.* Harvard UP, 2005.

Hatch, Nathan. *The Democratization of American Christianity.* Yale UP, 1991.

Hegel, G. W. F. *Lectures on the Philosophy of Religion.* Oxford UP, 2006.

————. *The Science of Logic.* Prometheus Books, 1989.

Heidegger, Martin. *Poetry, Language, Thought.* Harper & Collins, 1971.

Hermann, Arnold. *To Think Like God: Pythagoras and Parmenides. The Origins of Philosophy.* Parmenides, 2004.

Hicks, John. *The Myth of the God Incarnate.* John Knox, 1977.

Hieatt, Constance, trans. *Beowulf and Other English Poems.* Bantam, 1988.

Hillis-Miller, J. *The Disappearance of God: Five Nineteenth-Century Writers.* Illinois UP, 2000.

Hilton, Tim. *John Ruskin.* Yale UP, 2002.

Hofstadter, Richard. *Anti-intellectualism in American Life.* Vintage, 1966.

Hölderlin, Friedrich. *Poems and Fragments.* Trans. Michael Hamburger. Cambridge UP, 1980.

Homer. *Iliad.* Trans. Robert Fagles. Penguin Classics, 1998.

———. *Odyssey.* Trans. Robert Fagles. Penguin Classics, 1996.

Hooke, S.H. *Babylonian and Assyrian Religion.* Oklahoma UP, 1963.

Hornung, Erik. *Akhenaten and the Religion of Light.* Cornell UP, 1995.

Horowitz, Wayne. *Mesopotamian Cosmic Geography.* Eisenbrauns, 1998.

Houlgate, Stephen. *The Hegel Reader.* Blackwell, 1998.

Hughes, Richard, and Leonard Allen. *Illusions of Innocence: Protestant Primitivism in America.* Chicago UP, 1988.

Hughes, Robert. *The Shock of the New.* Knopf, 1991.

Ihrie, Maureen. *Cervantes and Skepticism.* Tamesis, 1986.

Irenaeus. *Against Heresies.* Kessinger Publishing, 2004.

Isaacs, Neil, ed. *Sir Gawain and the Green Knight.* Signet, 2001.

Jacobsen, Thorkild. *The Treasures of Darkness: A History of Mesopotamian Religion.* Yale UP, 1978.

Jaeger, Stephen. *The Envy of Angels: Cathedral Schools and Social Ideals in Medieval Europe, 900–1200.* Pennsylvania UP, 2000.

Jaki, Stanley. *God and the Cosmologists.* Scottish Academic Press, 1989.

James, William. *The Varieties of Religious Experience.* Modern Library, 1999.

Jaspers. David. *The Sacred Desert: Religion, Literature, Art, and Culture.* Blackwell, 2004.

Jaspers, Karl. *The Great Philosophers.* Vol. 1 and Vol. 2. Harcourt, 1955.

Jensen, Robin. *Portraits of the Divine in Early Christianity.* Augsburg, 2004.

———. *Understanding Early Christian Art.* Routledge, 2000.

Kaku, Michio. *Physics of the Impossible: A Scientific Exploration into the World of Phasers, Force Fields, Teleportation, and Time Travel.* Anchor, 2009.

Kandinsky, Wassily. *Concerning the Spiritual in Art.* Dover, 1977.

Kant, Immanuel. *The Critique of Judgment.* Oxford UP, 1978.

———. *The Critique of Pure Reason.* Hackett, 1976.

Kellehear, Allan. *A Social History of Dying.* Cambridge UP, 2007.

Kierkegaard, Søren. *Philosophical Fragments.* Princeton UP, 1944.

King, Leonard. *Babylonian Religion and Mythology.* Kegan Paul, 1899.

Kirk, G.S. *The Pre-Socratic Philosophers: A Critical History.* Cambridge UP, 1994.

Kirsch, Jonathan. *Moses: A Life.* Ballantine, 1999.

Knox, Bernard. *Backing into the Future: The Classical Tradition and Its Renewal.* W.W. Norton, 1994.

Koester, Helmut. *The Ancient Christian Gospels: Their History and Development.* Trinity, 1990.

Kostelanetz, Richard. *Conversing with John Cage.* Routledge, 2003.

Kovacs, Maureen. *The Epic of Gilgamesh.* Stanford UP, 1985.

Koyré, Alexandre. *From the Closed World to the Infinite Universe.* Johns Hopkins UP, 1968.

Kramer, Samuel. *Sumerian Mythology.* University of Pennsylvania Press, 1998.

Kuhn, Thomas. *The Copernican Revolution: Planetary Astronomy and the Development of Western Thought.* Harvard UP, 1957.

Laird, John. *Theism and Cosmology.* Books for Libraries Press, 1969.

La Rochefoucauld. *Maxims.* St. Augustine Press, 2009.

Leaman, Oliver. *Averroes and His Philosophy.* Curzon Press, 1998.

Leibniz. *Philosophical Papers and Letters*. Reidel, 1969.

Leonardo da Vinci. *Notebooks*. Oxford UP, 1952.

———. *Treatise on Painting*. Saveth Press, 2008.

Leslie, C.R. *Memoirs of the Life of John Constable*. Kessinger, 2006.

Leslie, John. *Infinite Minds: A Philosophical Cosmology*. Oxford UP, 2001.

Lewisohn, Ludwig. *Goethe: The Story of a Man*. Farrar, Straus & Co., 1949.

Lichtheim, Miriam. *Ancient Egyptian Literature*. 3 vols. UC Press, 1976.

Lindberg, David. *Theories of Vision from al-Kindi to Kepler*. Chicago UP, 1976.

Lippy, Charles. *Being Religious, American Style: A History of Popular Religiosity in the United States*. Praeger, 1994.

Long, A.A., ed. *The Cambridge Companion to Early Greek Philosophy*. Cambridge UP, 1999.

Loos, Adolf. *Ornament and Crime: Selected Essays*. Ariadne Press, 1997.

MacMullen, Ramsay. *Christianity and Paganism in the Fourth to Eighth Centuries*. Yale UP, 1997.

Maier, John, ed. *Gilgamesh: A Reader*. Bolchazy-Carducci Publishers, 1997.

Maimonides, Moses. *The Guide to the Perplexed*. Trans. M. Friedlander. Forgotten Books, 2007.

Mancall, Peter. *Travels Narratives in the Age of Discovery*. Oxford UP, 2006.

Maor, Eli. *To Infinity and Beyond: A Cultural History of the Infinite*. Princeton UP, 1991.

Maravall, José. *Culture of the Baroque*. Minnesota UP, 1986.

Marlowe, Christopher. *The Tragicall History of Doctor Faustus*. 1604. Reprint, Signet Classics, 1969.

Mayo, Bernard. *The Philosophy of Right and Wrong*. Routledge, 1986.

McGrath, Alister, ed. *Christian Theology Reader*. Blackwell, 2001.

McKenzie, Stephen, ed. *To Each Its Own Meaning: An Introduction to Biblical Criticisms*. Westminster John Knox, 1999.

Mellars, Paul, and Chris Stringer. *The Human Revolution*. Edinburgh UP, 1989.

Menocal, Maria Rosa. *The Arabic Role in Medieval Literary History: A Forgotten Heritage*. Pennsylvania UP, 1987.

Meyers, Carol. *Exodus*. Cambridge UP, 2005.

Michell, Robert Bell, ed. *French Literature before 1800*. Appleton, 1935.

Miles, Jack. *God: A Biography*. Vintage, 1996.

Miller, Arthur. *Einstein and Picasso: Space, Time, and the Beauty That Causes Havoc*. Basic Books, 2001.

Miller, James. *A History of Ancient Israel and Judah*. Westminster John Knox, 2006.

Minois, Georges. *History of Suicide: Voluntary Death and Western Culture*. Johns Hopkins UP, 1999.

Montaigne, Michel de. *The Complete Essays*. Penguin Books, 1987.

Montiglio, Silvia. *Wandering in Ancient Greek Culture*. Chicago UP, 2005.

Moore, A.W. *The Infinite*. Routledge, 1992.

Morelan, James. *Philosophical Foundations for a Christian Worldview*. InterVarsity Press, 2003.

Morris, Colin. *The Discovery of the Individual, 1050–1200*. Toronto UP, 1987.

Mumford Jones, Howard. *Revolution and Romanticism*. Harvard UP, 1974.

Munitz, Milton. *Theories of the Universe*. Free Press, 1965.
Murnane, William. *Texts from the Amarna Period in Egypt*. Society of Biblical Literature, 1995.
Nees, Lawrence. *Early Medieval Art*. Oxford UP, 2002.
Newton, Isaac. *Sir Isaac Newton's Mathematical Principle of Natural Philosophy and His System of the World*. UC Press, 1934.
Nicholl, Charles. *Leonardo da Vinci: Flights of the Mind*. Penguin, 2005.
Nietzsche, Friedrich. *The Portable Nietzsche*. Viking, 1968.
Nisbet, Robert. *A History of the Idea of Progress*. Transaction, 1994.
Noll, Mark. *America's God: From Jonathan Edwards to Abraham Lincoln*. Oxford, 2005.
Novak, Barbara. *Nature and Culture: American Landscape and Painting, 1825–1875*. Oxford UP, 1981.
Novalis. *Hymns to the Night and Other Writings*. Liberal Arts Press, 1960.
Noy, Gary. *Distant Horizon: Documents from the Nineteenth-Century American West*. Nebraska UP, 1998.
Nunn, G.E. *The Geographical Conceptions of Columbus*. Golda Meir Library, 1992.
Nykl, A.R. *Hispano-Arabic Poetry and Its Relation with the Old Provencal Troubadours*. Furst, 1946.
Olson, Denis. *Deuteronomy and the Death of Moses*. Augsburg, 1994.
Opper, Jacob. *Science and the Arts: A Study in Relationships, 1600–1900*. Farleigh Dickinson UP, 1973.
Osborne, Catherine. *Rethinking Early Greek Philosophy*. Cornell UP, 1987.
Oster, Margaret, ed. *Rethinking the Scientific Revolution*. Cambridge UP, 2000.
Paine, Thomas. *The Rights of Man*. Courier Dover Publications, 1999.
Pais, Abraham. *Niels Bohr's Times in Physics, Philosophy, and Polity*. Clarendon Press, 1991.
Panofsky, Erwin. *Perspective as Symbolic Form*. Zone Books, 1983.
Pascal, Blaise. *Pensées*. Oxford Classics, 2009.
Peat, David. *Einstein's Moon: Bell's Theorem and the Curious Quest for Quantum Reality*. Contemporary Books, 1990.
Petrarca. *Selections from the Canzoniere and Other Works*. Oxford UP, 1985.
Pinkard, Terry. *German Philosophy, 1760–1860: The Legacy of Idealism*. Cambridge UP, 2002.
Plato. *Dialogues of Plato*. Colonial Press, 1909.
———.*The Republic*. Penguin, 1955.
———. *Theaetetus*. Hackett, 1992.
———. *Timaeus*. Liberal Arts Press, 1949.
Plotinus. *The Enneads*. Penguin, 1991.
Pollitt, Jerome. *Art and Experience in Classical Greece*. Cambridge UP, 1972.
Popkin, Richard H. *The History of Scepticism from Erasmus to Spinoza*. UC Press, 1979.
Porzio, Domenico, ed. *Picasso: His Life, His Art*. Book Club Associates, 1974.
Pritchett, James. *The Music of John Cage*. Cambridge UP, 1993.
Reale, Giovanni. *A History of Ancient Philosophy: From the Origins to Socrates*. SUNY Press, 1987.

Renfrew, Colin. *Before Civilization: The Radiocarbon Revolution and Prehistoric Europe.* Cape, 1973.

Restall, Matthew. *Seven Myths of the Spanish Conquest.* Oxford UP, 2004.

Richardson, John R. *A Life of Picasso.* Vol. 2, *1907–1917: The Painter of Modern Life.* Random House, 1996.

Ricoeur, Paul. *Figuring the Sacred.* Ausburg Fortress, 1997.

Rilke, Rainer Maria. *Selected Poems.* Trans. A.E. Flemming. Routledge, 1986.

Roberts, Jimmy. *The Bible and the Ancient Near East.* Eisenbrauns, 2002.

Rorty, Richard. *Objectivity, Relativism, and Truth.* Cambridge UP, 1990.

Ruskin, John. *Ruskin on Turner.* Little Brown & Co., 1990.

Sandars, N.K., trans. *The Epic of Gilgamesh.* Penguin Classics, 1960.

Sanders, E.P. *The Historical Figures of Jesus.* Penguin Books, 1993.

Sanders, E.P., and Margaret Davis. *Studying the Synoptic Gospels.* Trinity Press International, 1990.

Sansone, David. *Ancient Greek Civilization.* Blackwell, 2009.

Sarna, Nahum. *Exploring Exodus: The Origins of Biblical Israel.* Schocken, 1996.

Schaff, Philip, ed. *Nicene and Post-Nicene Fathers.* Vol. 3. Christian Literature Publishing Co., 1887.

Scholar, Richard. *The Je-Ne-Sais-Quoi in Early Modern Europe.* Oxford UP, 2005.

Schopenhauer, Arthur. *The World as Will and Representation.* Peter Smith, 1969.

Schorske, Carl E. *Fin de Siècle Vienna: Politics and Culture.* Vintage, 1980.

Schulte-Sasse, Jorgen. *Theory as Practice: A Critical Anthology of German Romantic Writings.* Minnesota UP, 1997.

Scott, Robert. *The Gothic Enterprise: A Guide to Understanding the Medieval Cathedral.* UC Press, 2003.

Scotus, John Duns. *Periphyseon.* Dublin Institute for Advanced Studies, 1968.

Scruton, Roger. *A Short History of Modern Philosophy.* Routledge, 2001.

Seife, Charles. *Zero: The Biography of a Dangerous Idea.* Penguin, 2000.

Shepard, Paul. *Man in the Landscape: A Historic View of the Esthetics of Nature.* Georgia UP, 2002.

Sieburth, Richard. *Friedrich Hölderlin: Hymns and Fragments.* Princeton UP, 1984.

Silk, Joseph. *The Big Bang.* Henry Holt & Co, 1980.

———. *The Infinite Cosmos: Questions from the Frontiers of Cosmology.* Oxford UP, 2006.

Silverman, David. *Akhenaten and Tutankhamun: Revolution and Restoration.* University of Pennsylvania Museum, 2006.

Singer, S.F., ed. *The Universe and Its Origins.* Paragon, 1990.

Singh, Simon. *Big Bang: The Origins of the Universe.* HarperCollins, 2004.

Skrine, Peter. *The Baroque: Literature and Culture in Seventeenth-Century Europe.* Methuen, 1978.

Smith, Joseph. *Teachings of the Prophet Joseph Smith.* CreateSpace, 2009.

———. *The Wentworth Letter.* Icon Group, 2008.

Smith, Mark. *The Early History of God: Yahweh and the Other Deities in Ancient Israel*. HarperCollins, 1990.

———. *The Origins of Biblical Monotheism*. Oxford UP, 2001.

Smith, Roger, ed. *The Norton History of the Human Sciences*. Norton, 1997.

Solomon, Maynard. *Beethoven*. Granada, 1980.

Southern, R.W.S. *Western Society and the Church in the Middle Ages*. Penguin Books, 1970.

Spengler, Oswald. *The Decline of the West*. Vintage, 2006.

Spinoza, Baruch. *Ethics*. Free Press, 1970.

Spitz, Lewis. *The Renaissance and the Reformation Movements*. Concordia College, 2003.

Stadelmann, Luis. *The Hebrew Conception of the World*. Pontifical Biblical Institute, 1970.

Starr, Chester. *Origins of Greek Civilization, 1100–650 B.C.* W.W. Norton, 1991.

Sternberg, Meir. *The Poetics of Biblical Narrative*. Indiana UP, 1987.

Strabo. *Geography*. Loeb Classical Library, 1917.

Strauss Clay, Jenny. *The Wrath of Atena: Gods and Men in Odyssey*. Rowman & Littlefield, 1997.

Strunk, William. *Source Readings in Music History*. Norton, 1998.

Sturges, Robert Stuart. *Medieval Interpretation: Models of Reading in Literary Narrative*. Southern Illinois UP, 1990.

Sullivan, Arthur. *Logicism and the Philosophy of Language: Selections from Frege and Russell*. Broadview Press, 2003.

Swanson, Robert. *The Twelfth Century Renaissance*. Manchester UP, 1999.

Szabolcs, Bince. *A History of Melody*. St. Martin's Press, 1965.

Tacitus. *Annals*. Hackett Publishing, 2004.

Taylor, C.C.W., R.M. Hare, and Jonathan Barnes. *Greek Philosophers: Socrates, Plato, Aristotle*. Oxford UP, 2001.

Taylor, Charles. *Sources of the Self: The Making of Modern Identity*. Harvard UP, 1992.

Taylor, Joshua C. *Nineteenth-Century Theories of Art*. UC Press, 1987.

Taylor, Mark. *After God*. Chicago UP, 2007.

Teggar, F.J. *The Idea of Progress*. UC Press, 1925.

Teselle, Eugene. *Augustine*. Abingdon Press, 2006.

Thayer, Alexander. *The Life of Ludwig von Beethoven*. Vol. 2. Beethoven Association, 1921.

Thornes, John. *John Constable's Skies: A Fusion of Art and Science*. Continuum, 1999.

Toman, Rolf, ed. *Gothic: Architecture, Sculpture, Painting*. Ullman, 2008.

Traeger, Jorg. *Caspar David Friedrich*. Rizzoli, 1976.

Trilling, Lionel. *Sincerity and Authenticity*. Harvard UP, 1972.

Troeltsch, Ernst. *Protestantism and Progress*. 1910. Reprint, BiblioLife, 2009.

Troyes, Chrétien de. *Arthurian Romances*. Trans. William Kibler. Penguin, 1991.

Van Heijenoort, Jean. *From Frege to Gödel*. iUniverse, 1999.

Vasari, Giorgio. *Lives of the Painters*. Oxford UP, 1991.

Vaughan, William. *Friedrich*. Phaidon, 2004.

Vermes, Geza. *Jesus in His Jewish Context.* Augsburg, 2003.

Vernant, Jean-Pierre. *The Origins of Greek Thought.* Cornell UP, 1982.

Vernus, Pascal. *The Gods of Ancient Egypt.* Tauris Parke, 1998.

Vervenne, Marc, ed. *Studies in the Book of Exodus: Redaction, Reception, Interpretation.* Peeters, 1996.

Vinaver, Eugene. *The Rise of the Romance.* Oxford UP, 1971.

Von Eschenbach, Wolfram. *Parzival.* Trans. André Lefevere. Continuum, 1992.

Von Soden, Wolfram. *The Ancient Orient: An Introduction to the Study of the Ancient Near East.* Eerdmans, 1994.

Wace, Herbert, and P. Schaff. *A Select Library of Nicene and Post-Nicene Fathers of the Christian Church.* Erdermans, 1954.

Walhout, Donald. *The Good and the Realm of Values.* Notre Dame UP, 1978.

Walker Howe, Daniel. *What Hath God Wrought: The Transformation of America, 1815–1848.* Oxford UP, 2007.

Walton, John. *Ancient Israelite Literature in Its Cultural Context.* Zondervan, 1990.

———. *Ancient Near Eastern Thought and the Old Testament.* Baker Academic, 2006.

Watts, Pauline. *Nicolas Cusanus: A Fifteenth-Century Vision of Man.* Brill, 1982.

Weber, Max. *Protestant Ethics and the Spirit of Capitalism.* Dover Publications, 2003.

Weil, Simone. *An Anthology.* Grove Press, 2000.

Weinfeld, Moshe. *Deuteronomy 1–11.* Anchor Bible Series, 1991.

Weitemeier, Hannah. *Yves Klein.* Taschen, 1995.

Whitman, Walt. *The Complete Poems.* Penguin, 1996.

Wilmerding, John, ed. *American Light: The Luminist Movement, 1850–1875: Paintings, Drawings and Photographs.* Princeton UP, 1992.

Wilson, A.N. *Paul: The Mind of the Apostle.* W.W. Norton, 1998.

Wilson, John. *The Culture of Ancient Egypt.* Chicago UP, 1951.

Wittgenstein, Ludwig. *Philosophical Grammar.* Ed. Rush Rhees. Blackwell, 1974.

———. *Philosophical Investigations.* Trans. G.E.M. Anscombe. Blackwell, 1953.

———. *Philosophical Remarks.* Ed. Rush Rhees. Blackwell, 1975.

———. *Tractatus Logico-Philosophicus.* Routledge, 1974.

Woodward, David. *The History of Cartography.* Vol. 3. Chicago UP, 2007.

Woolf, Virginia. *Selected Essays.* Oxford UP, 2008.

Yaeger, Bert. *The Hudson River School: American Landscape Artists.* New Line, 2005.

Young, Frances. *From Nicaea to Chalcedon.* Fortress, 1983.

Zum Brunn, Emilie. *Augustine: Being and Nothingness.* Paragon, 1987.

Index

TEXT
10/13 Sabon Open Type

DISPLAY
Sabon

COMPOSITOR
BookComp, Inc.

PRINTER AND BINDER
Sheridan Books, Inc.